VAN GOGH, GAUGUIN, CÉZANNE, AND BEYOND

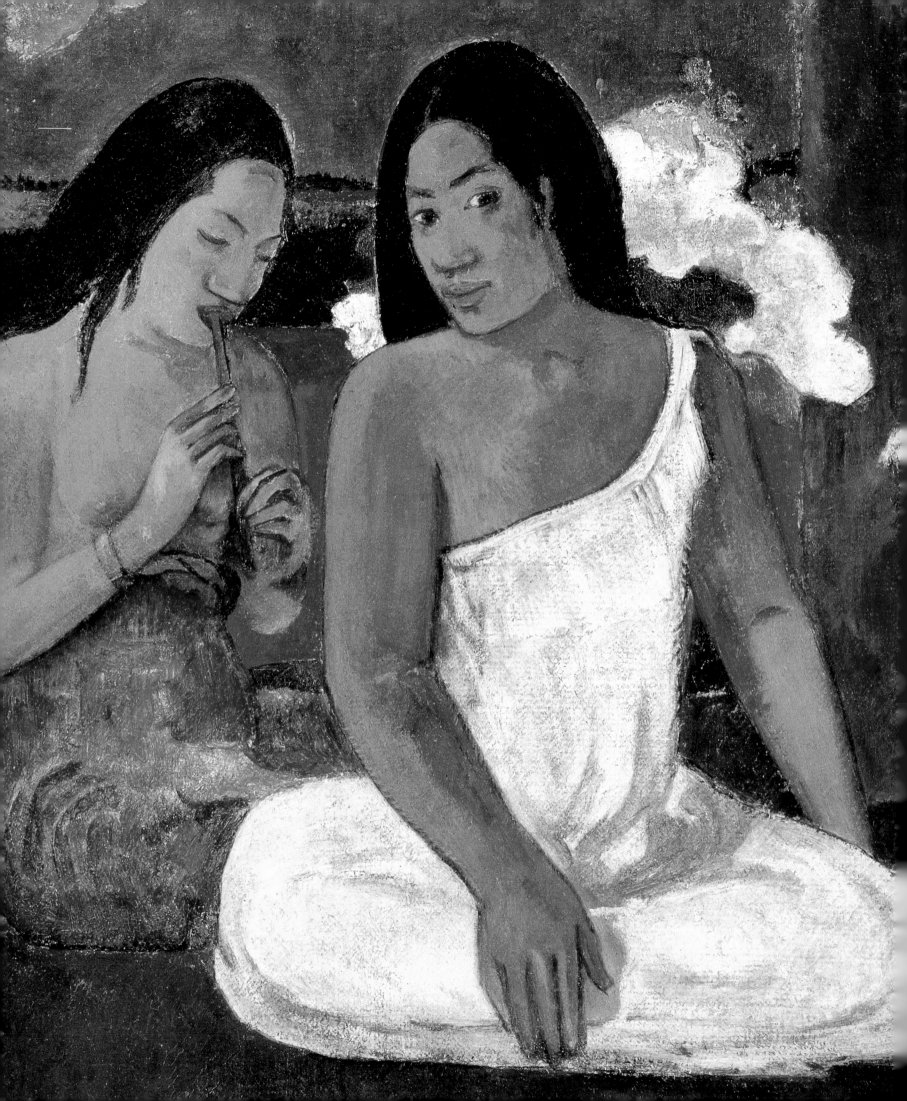

VAN GOGH, GAUGUIN, CÉZANNE, AND BEYOND

POST-IMPRESSIONIST MASTERPIECES
FROM THE MUSÉE D'ORSAY

PROJECT CURATED BY
GUY COGEVAL, SYLVIE PATRY, AND
STÉPHANE GUÉGAN

Fine Arts Museums of San Francisco

DelMonico Books · Prestel
Munich Berlin London New York

Musée
d'Orsay

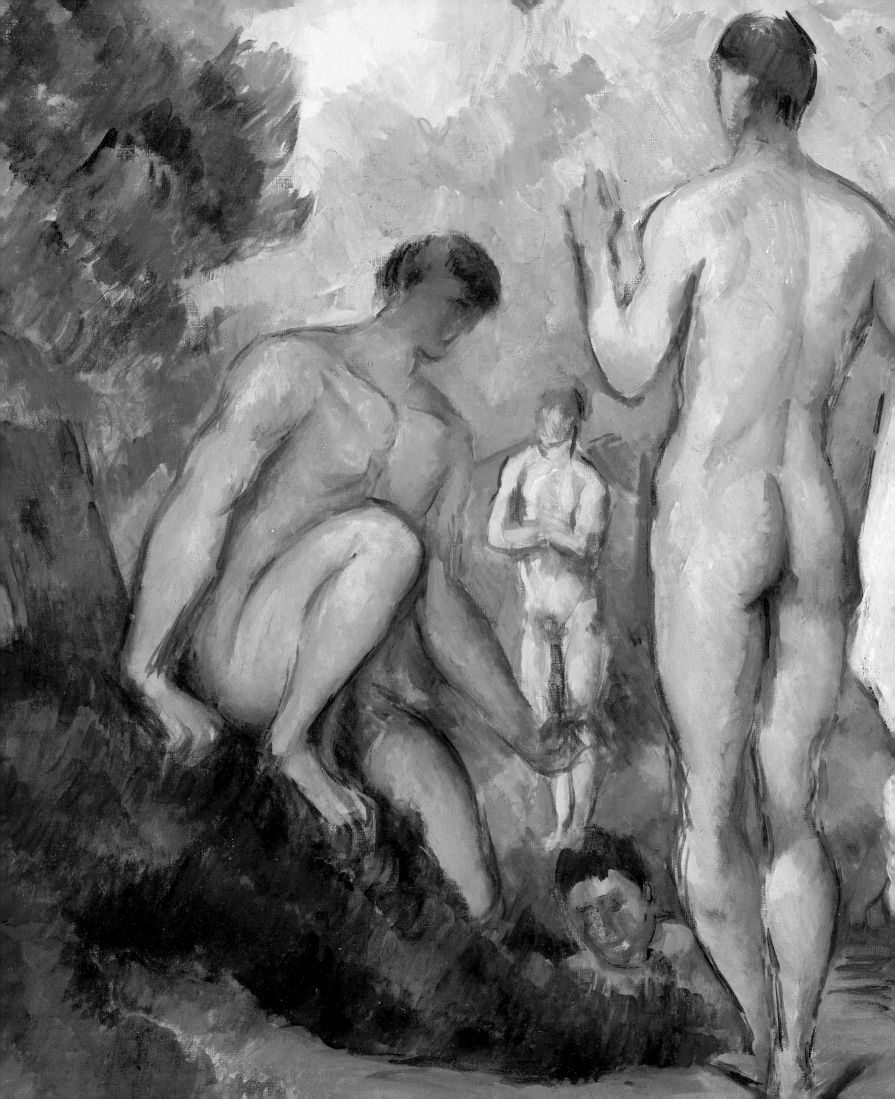

CONTENTS

FRONTISPIECES

PAGE 2
PAUL GAUGUIN
Arearea, 1892
Detail of cat. 65

PAGES 4–5
PAUL CÉZANNE
Bathers (*Baigneurs*), ca. 1890
Detail of cat. 24

PLATES THROUGHOUT
Commentary by *Nicole R. Myers*

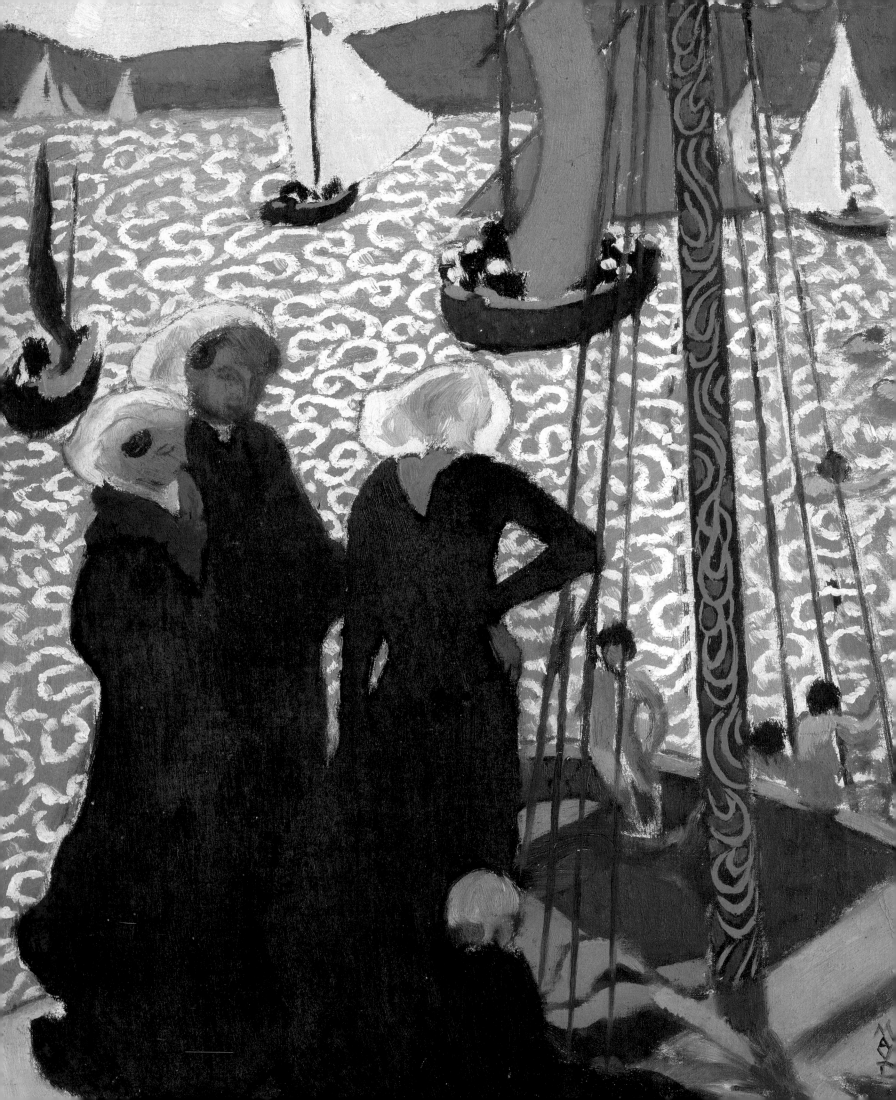

PREFACE

NICOLAS SARKOZY
PRESIDENT OF THE FRENCH REPUBLIC

•

MAURICE DENIS

Regatta at Perros-Guirec
(*Régates à Perros-Guirec*), 1892
Detail of cat. 75

Works of art are made to be seen by all, to travel across the world and across the ages. The universal nature of masterpieces precludes any one person owning them. They belong to everyone. The role of a museum is to preserve and maintain the works, to see that they are shared and circulated.

To this end, the Musée d'Orsay has for many years organized ambitious projects. For 2010, during the major renovation program of some of its galleries, the museum has organized a traveling exhibition of part of its collections in several countries that have long-standing associations with France, especially at a cultural level. Exceptionally, the Fine Arts Museums of San Francisco have decided to host two successive exhibitions, thus creating a veritable "Orsay Year" in San Francisco.

The first exhibition presents the sources, the birth, and the transformations of Impressionism around 1874, the date of the inaugural exhibition of the group that included Eugène Boudin, Cézanne, Degas, Monet, Berthe Morisot, Pissarro, and Renoir. The exhibition begins and ends with Manet, recalling the influence of Spanish art, the part played by the École des Batignolles, the legacy of Courbet and Millet, the Impressionist adventure, and the evolution of academic art, and it aims to reconstruct the unity of this period.

The second exhibition presents the stylistic development of the great Impressionist painters after 1886, the date of their last collective exhibition, and evokes the turning point that occurred around 1900, when the avant-garde encountered the renaissance of decorative murals. The works of Monet, Cézanne, Van Gogh, Gauguin, Toulouse-Lautrec, Seurat, Le Douanier Rousseau, Bonnard, and Vuillard bear witness to this revival.

Each of these two shows brings together masterpieces that, once they return to the Musée d'Orsay, will almost certainly never be lent out again for exhibition all together. I hope that they will excite the interest of the American public in order to strengthen further the links between our two countries.

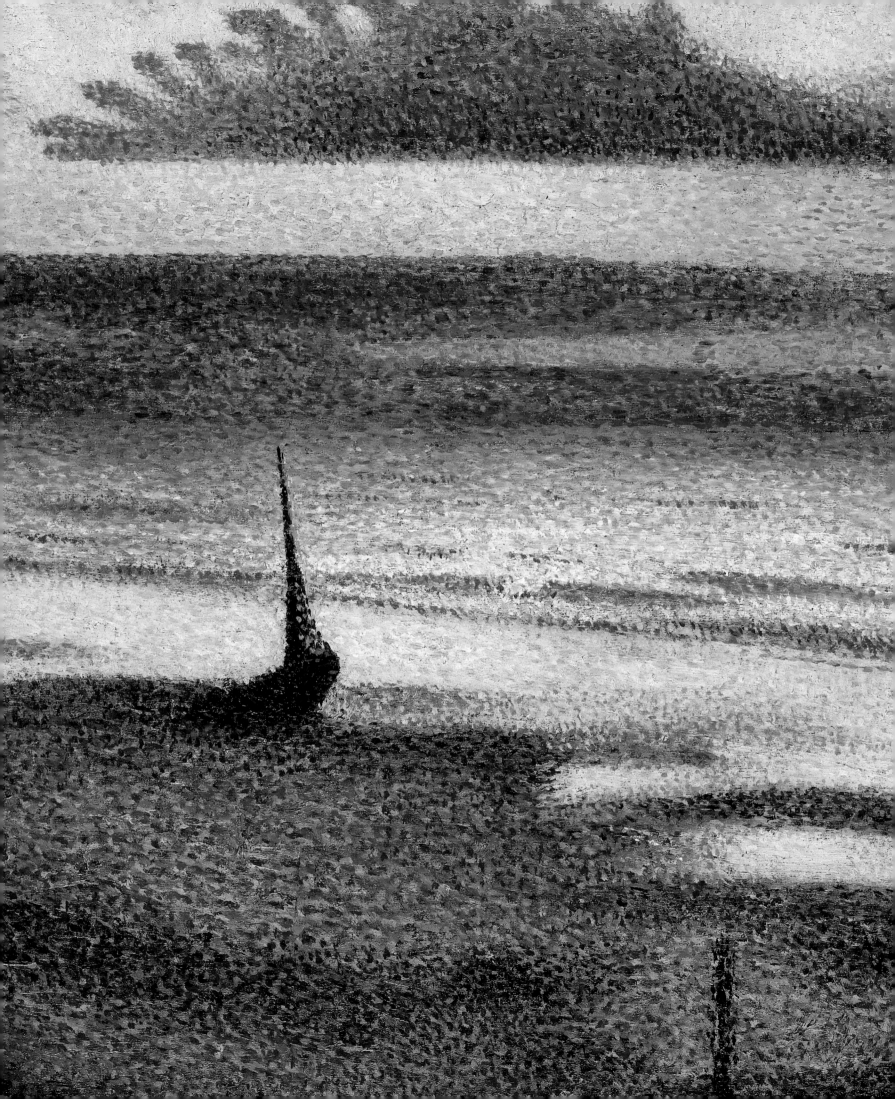

SPONSOR STATEMENT

JANET LAMKIN

CALIFORNIA STATE PRESIDENT,

BANK OF AMERICA

•

GEORGES LEMMEN

Beach at Heist (*Plage à Heist*), 1891
Detail of cat. 48

Bank of America is honored to sponsor *Birth of Impressionism: Masterpieces from the Musee d'Orsay* and *Van Gogh, Gauguin, Cézanne, and Beyond: Post-Impressionist Masterpieces from the Musee d'Orsay.* We are proud to partner with the Fine Arts Museums to bring more than two hundred of the Orsay's most famous masterpieces to San Francisco.

There are many important reasons we have chosen to make a global investment in arts and culture. We recognize that cultural resources are part of the foundation on which healthy communities are built. When we support arts education, we provide young people with experiences that will serve them throughout their lives. When we lend to museums from our art and heritage collection, we expand cultural resources for the public. And when we make grants to help institutions grow, we support the economy, our communities, and all those served by these institutions.

Our investment in the arts contributes to the growth of our business by nurturing our relationships with community leaders, by demonstrating to clients and prospective clients our commitment to the things they care about most, and by supporting the cultural and economic vitality of our communities.

We recognize the importance of investing in the development of cultural programming around the world and are delighted to support the Fine Arts Museums in their efforts to do the same.

FOREWORD

JOHN E. BUCHANAN, JR.
DIRECTOR OF MUSEUMS, FINE ARTS MUSEUMS
OF SAN FRANCISCO

•

GUY COGEVAL
PRESIDENT, MUSÉE D'ORSAY

•

The Fine Arts Museums of San Francisco and the Musée d'Orsay are proud to present *Van Gogh, Gauguin, Cézanne, and Beyond: Post-Impressionist Masterpieces from the Musée d'Orsay*, the second of two consecutive exhibitions drawn from the Orsay's incomparable collection that are traveling to the Fine Arts Museums' de Young in 2010. Rarely do renovations at the world's greatest museums create an opportunity for those collections to travel beyond their home cities. Refurbishment and upgrading of the Orsay's Impressionism and Post-Impressionism galleries have provided just such an occasion, allowing museumgoers outside France to thrill to the artistic riches of the world's foremost collection of nineteenth- and early-twentieth-century French painting. Given San Francisco's longtime commitment to exhibiting and collecting works of Impressionism and other great movements of European art, we are extremely excited that the de Young is the only venue in the world to present both Orsay exhibitions.

Birth of Impressionism: Masterpieces from the Musée d'Orsay, the first installment in our celebration, focused on the tumultuous period of the 1860s and 1870s, when social and political events in France influenced and were reflected in the art and politics of the state-run Salon. More than one hundred canvases by famous masters provided an overview of the contentious artistic community that gave rise to the innovations of Impressionism.

The finale, *Van Gogh, Gauguin, Cézanne, and Beyond*, explores the groundbreaking artistic developments that sprang forth in the wake of the "New Painting." In the decades surrounding 1900, artists liberated by the innovations of Impressionism created some of the most inventive and recognizable paintings of the modern era. Included in this compelling sequel are more than one hundred additional Orsay masterpieces, ranging from late Impressionist landmarks by Pierre Auguste Renoir to room-size decorative panels by Pierre Bonnard and Édouard Vuillard. It is an unparalleled visual experience, one made possible only when the most important repository of nineteenth-century French art opens its vaults.

It has been a great pleasure and honor for our institutions to collaborate on these unique, once-in-a-lifetime exhibitions. We would especially like to thank our enthusiastic fellow commissioners of the exhibitions, Orsay curators Stéphane Guégan, Sylvie Patry, and Alice Thomine-Berrada and Fine Arts Museums curator Lynn Federle Orr. In Paris, Olivier Simmat, Jean Naudin, Elsa Badie Modiri, and Sara Tas have been particularly helpful along the way. The de Young presentations were accomplished with the invaluable input of Krista Brugnara, Melissa Buron, Therese Chen, Bill Huggins, Bill White, and the entire Marketing and Design team, to name just some of the staff involved. For their work on this lavish catalogue, overseen by Ann Karlstrom and Karen Levine at the Fine Arts Museums, we thank our trade copublishing partners, Mary DelMonico and Prestel; editor Elisa Urbanelli; designer Bob Aufuldish; translators Alison Anderson and Melissa McMahon; proofreader Dianne Woo; indexer Susan G. Burke; and Nicole R. Myers, who contributed the informative extended captions to this volume. We are also grateful to our colleagues at the only other venues to host these marvelous Post-Impressionist works from the Musée d'Orsay: Ron Radford, Adam Worrall, Christine Dixon, and Julie Donaldson of the National Gallery of Australia, Canberra; and Hayashida Hideki of the National Art Center, Tokyo, working in cooperation with Nikkei Inc.

These remarkable exhibitions and catalogues would have been impossible without the extraordinary patronage of Bank of America and Jeannik Méquet Littlefield. We thank the entire Littlefield family for helping to facilitate their sponsorship of the exhibitions. Crucial additional support has been provided by Hope Aldrich and David Spencer, Athena and Timothy Blackburn, the William K. Bowes, Jr. Foundation, Frank and Patricia Carrubba, the Ray and Dagmar Dolby Family Fund, John A. and Cynthia Fry Gunn, the William G. Irwin Charity Foundation, J. Burgess and Elizabeth B. Jamieson, the George Frederick Jewett Foundation, the Koret Foundation, Barbro and Bernard Osher of the Bernard Osher Foundation, Mr. and Mrs. Steven MacGregor Read, Mr. and Mrs. John P. Rohal, the San Francisco Auxiliary of the Fine Arts Museums, Susan and James R. Swartz, Douglas A. Tilden, Diane B. Wilsey, and many other generous sponsors and supporters. The exhibition is also supported by an indemnity from the Federal Council on the Arts and the Humanities.

THE MUSÉE D'ORSAY: LOOKING FORWARD

GUY COGEVAL
STÉPHANE GUÉGAN

◦

More than twenty years after it first opened, the Musée d'Orsay is showing its age and no longer meets the expectations of the present day. Consequently, a general renovation is in order, including a careful redesign of the exhibition spaces, allowing easier access to all parts of the museum, and more appropriate lighting. The work, which has just begun as of this writing, will not be limited to selecting new decorative options; it will also address a new organization and interpretation of the collection. A modified floor plan for many of the collections will not only ensure enhanced comfort for visitors but also provide a more complete and historically representative overview of French art from 1848 to 1914. In other words, a new face—but also a new way of looking.

THE PAVILLON AMONT

The Musée d'Orsay has always been more than an art museum. Conceived in the 1980s, it inherited from that era a certain antipathy toward formalism and an attendant desire to confirm, in a multiplicity of ways, the connection between art and history. To use an expression that is becoming common currency, the Musée d'Orsay was one of the first museums of "civilization." In the course of partial modifications, the museum's original founding philosophy eroded.

It cannot be overstated that the forthcoming renovation is in large part the result of our realization that the museum's original goals need to be reaffirmed and revitalized at the same time. It is important to bear in mind that the changes begun at the end of 2009 were preceded by a few significant experiments, which were sufficiently conclusive to lead to further museological revisions. First of all, works of Orientalism and so-called Pompier, or academic, art were brought back to the galleries. Visitors requested having access to these works, and they had proven to be a success in our experiments. The time had come to satisfy an urgent demand by reincorporating two domains that, moreover, have been arousing interest in contemporary art-historical research.

After all, the Musée d'Orsay was conceived as a place to house all the riches of the second half of the nineteenth century, not just the modernist canon from Manet to early Matisse. As a bridge between the Louvre and the Centre Pompidou, this dedicated museum has always been meant to provide the public with the largest overview of nineteenth-century artistic

output, although the core has remained Impressionism and its legacy. The fascination with ethnic and cultural otherness, nourished by an appetite for travel and the exploits of colonialism, was one decisive feature of the art of this era; another was the resistance of certain artists of the so-called modern movement who sought a way of belonging to their era while rejuvenating the moribund eloquence and dissipated rhetoric of academic painting. As part of its founding mission, the Musée d'Orsay had envisioned presenting the dynamic juxtaposition between the moderns and the anti-moderns. Yet, if we take a closer look, this has never been achieved. The Orientalist and academic works, relegated previously to temporary exhibitions, will now find a permanent home, thanks to the transformation of the Pavillon Amont into an enlarged exhibition space that will accommodate a greater number of visitors.

Located in the northeastern section of the museum, the Pavillon Amont will be equipped with elevators and stairways leading to the Impressionism galleries, which will remain the hub of the museum. Another aim of the Atelier de l'Île, the masterminds of the redesign, will be to increase the exhibition areas over four stories: the ground floor will remain devoted to large-format academic paintings and will also make room for Orientalism; the middle levels will house the decorative paintings of the Nabis and the decorative arts of the foreign schools (Vienna, Glasgow, United States, and others); and the top level will include a new museum shop and offer an educational introduction to the Impressionism galleries, to which it is connected.

IMPRESSIONISM AND BEYOND

The need to improve the Impressionism galleries has been felt for a considerable time. Circulation through the space was limited, which consequently inhibited the number of visitors allowed on a daily basis and caused great frustration on busy days. The presentation had lost its logic, as it was neither stylistic nor chronological nor thematic, preventing the visitor from getting a coherent, overall grasp of the phenomenon it was supposed to illustrate. And, as the exhibition space was affected by the vagaries of natural lighting, the uneven, grayish cast only accentuated its shortcomings.

The present program, led by Wilmotte Associés, will deal with these problems by designing a new exhibition plan that will be more spacious and more didactic at the same time (figs. 1–2). Natural overhead lighting will be maintained but supplemented by lights trained directly on the works of art. To improve on the existing presentation of the paintings, which has been redone at various times over recent years, the walls will be repainted in a more appropriate color, and accessible captions will enhance the overall effect. The goal is to show that Impressionism was far from being a purely optical mode of painting that was homogeneous, devoid of content, and subject to a linear progression.

Beyond the room devoted to Paul Cézanne, a traditional point of transition to Post-Impressionism, the so-called Salle des Colonnes housed until very recently a number of our collection highlights in a space where neither the work nor the public was at ease: Gauguin and the Pont-Aven School, Seurat and Neo-Impressionism, and a few unclassifiable artists such as Le Douanier Rousseau, followed by late Paul Signac and early Henri Matisse. The decision has been made to move all of these paintings to the rue de Lille side of the building, in galleries better suited to their status and popularity. Here, too, the color of the walls behind the paintings and improved lighting will enhance the visibility of the works and the viewers'

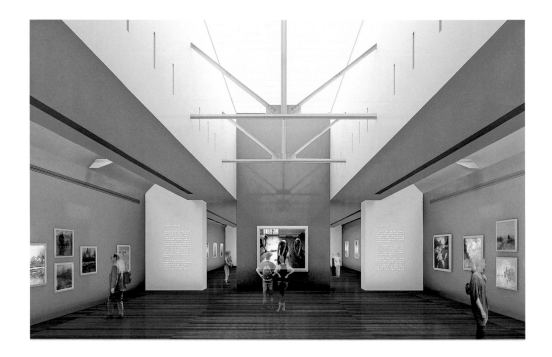

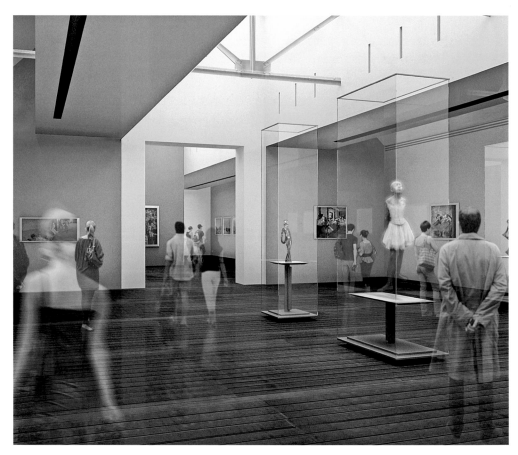

FIGS. 1 and 2 Architectural renderings of the Musée d'Orsay's renovated Impressionism galleries

satisfaction. The Musée d'Orsay's collection of works by Vincent van Gogh will be at the heart of this astonishing sequence, and Henri de Toulouse-Lautrec will at last find a place worthy of his importance.

CONTEMPORARY PRESENCE

The new Pavillon Amont, Impressionism galleries, and rooms on the rue de Lille side of the building will greatly enhance visitors' experiences of the museum, which has been enriched already by the transformations of the Galerie Chauchard and the creation of a space devoted to the Second Empire—another era somewhat overlooked in the recent evolution of the Musée d'Orsay. The former Salle des Colonnes will also be put to a radically new use. The metal elements installed in 1986, which never served to hold anything, will be removed, and the space will be used to host exhibitions that are on a more modest scale than those held on the ground floor. The network of adjacent rooms will serve to display intimate, small-format works.

This quick overview of the current transformation would be incomplete without mention of the Café de l'Horloge. The space will be enlarged considerably and its spirit totally revolutionized. A new area for refreshments and casual dining will take over the space once devoted to pastels, which needed a practical and aesthetic overhaul. Conceived by the young, internationally renowned Brazilian designers the Campana brothers, it will have two imaginative themes: Émile Gallé's floral arabesques and the underwater world of Jules Verne. The atmosphere will be warm and dreamy, with bright colors and brisk Art Nouveau brushstrokes. Visitors will be immediately transported to a place that merges the Musée d'Orsay's nineteenth-century origins and the very latest in contemporary taste. Marcel Proust would have spoken of "the beautiful today." Beneath the great clock of the former railroad station, the Musée d'Orsay will be setting its watch right. That, too, is modernity.

┌─────────────────────────────────┐
│ │
│ **INTRODUCTION** │
│ _____ │
│ │
│ STÉPHANE GUÉGAN │
│ │
│ · │
│ │
└─────────────────────────────────┘

INTRODUCTION

STÉPHANE GUÉGAN

·

Old Impressionism's ploys are failing to recruit any new members.

FÉLIX FÉNÉON

Nearly a century ago, Roger Fry organized an exhibition at the Grafton Galleries in London titled *Manet and the Post-Impressionists*. The aesthetic category that he hastily created for the event quickly became the standard reference for the "revolution" led primarily by Paul Gauguin, Vincent van Gogh, and Paul Cézanne, under the aegis of the painter of *Olympia*. John Rewald, in his seminal 1956 book *Post-Impressionism: From Van Gogh to Gauguin*, consecrated the new concept and its vision of the aesthetics governing the years between 1880 and 1900. In the eyes of Fry and his heirs, Post-Impressionism surpassed Impressionism in a way that was not merely chronological. In baptizing the latter, the former was abolished. Deposed because it was incomplete, Impressionism was reduced in a single blow to the rank of a superficial, retinal art, intuitive and limited, with a naturalistic passivity matched only by its vacuity of meaning. It is not hard to see where Fry, an earnest devotee of the writings of Maurice Denis, was extrapolating the French theoretician's ideas and the opposition that fueled them. No doubt, in 1910 the notion of Post-Impressionism, with its contemporary Darwinian resonance, was useful to enlighten the English public; however, for far too long it also has impoverished our own perception of the end of the nineteenth century.

Belinda Thomson, in her 1983 book, *The Post-Impressionists*, was one in a long line of critics to point out that this unfortunate misnomer was never adopted by the artists it was meant to illuminate, unite, and situate historically. Another disadvantage was that it gave credit to the notion that Impressionism had entered a "crisis" at the beginning of the 1880s, a crisis that allegedly freed its practitioners from the empirical limits of their initial style and thus hastened the advent of a new art. This apparent break was neither diagnosed at the time nor acknowledged by those concerned; it came about, in fact, in a manner that is fairly common in art history, where what is new emerges by virtue of a simple automatic reaction to overexposure. The favoritism that the brilliant Félix Fénéon and other early partisans of Georges Seurat and Paul Signac showed toward Neo-Impressionism—a term coined by Fénéon in 1886—at the

expense of the "anarchical forces of Impressionism" reveals a strategy of substitution: when an art form becomes worn out and dated, the older practitioners make way for the language of youth and its "lucid intelligence." This type of reasoning is no longer valid today. It merely reflects a desire to diminish the nature and impact of Impressionism, a reductive process to which Fry was a direct heir. And Denis, in seeking to "classicize" Cézanne even before his *Homage to Cézanne* in 1900 (cat. 28), was not alone in preparing the terrain for Fry.

Nor should the negation of Impressionism be seen as the only defining aspect of the era. Artists such as Van Gogh, Seurat, Gauguin, and Cézanne had received an abundant legacy from the previous generation. A few examples will suffice. Van Gogh's correspondence alone, even without his paintings, illustrates how his aesthetic ideas were rooted in all different directions, from Eugène Delacroix's use of color to Japanese *ukiyo-e* prints, from the mysteries of Rembrandt van Rijn to the most historical academic paintings. And Fry was right: Édouard Manet mattered more to Van Gogh than he did to either Claude Monet or Pierre Auguste Renoir. Nor should we forget that Seurat was initially a product of the École des Beaux-Arts and a follower of Jean-Auguste-Dominique Ingres. Gauguin and Cézanne, by virtue of the active roles they played in the Impressionist adventure, knew better than to allow themselves to be imprisoned there for life. In direct contradiction to Fry's binary formalism, this exhibition and catalogue seek to approach the art of a less divided fin de siècle. Monet, Renoir, and Edgar Degas were far from being outdated: on the contrary, they continued working as contemporaries of the younger generation. And without turning his back on Jean-François Millet's peasants, Camille Pissarro went so far as to practice the most determined Neo-Impressionism, extremely fearful of being shackled to one style.

Our journey begins with the late production of the older artists and the distinct, and more or less inventive, manner in which each one developed his art over the two last decades of the nineteenth century. Monet's prominence in this first section is due not only to the easy availability of his canvases but also, more essentially, to what might be interpreted as an unfair disproportion of attention compared to what Degas and even Renoir received. The fact is that Monet, as of the 1890s, saw increasing public exposure through solo exhibitions at Georges Petit's and Paul Durand-Ruel's galleries; he gave interviews to journalists and charmed politicians; and he reinvented monumental painting, reaching a concerted apotheosis with his *Water Lilies* (1920–1926, fig. 3, page 27) on the curved walls of the Musée de l'Orangerie. No doubt irritated, as was Pissarro, by the positions of some of the young Symbolist critics, the painter responded through his work and his statements alike to the accusations that his art was limited and incapable of change, and that its time was over. In a famous letter of October 7, 1890, to the critic Gustave Geffroy, whose portrait Cézanne later painted (cat. 29), Monet confessed to his friend: "The deeper into it I go, the more I realize that I must work a great deal in order to convey what I am looking for: the instantaneous and above all enveloping atmosphere, the same light spread throughout; more than ever, the easy things that come to me in one go disgust me." After creating paintings that embodied the flight of time, Monet was making the most of the passage of time.

Monet waited until 1904 to exhibit at Durand-Ruel's gallery the *Views of the Thames* that he had been painting in London over the course of the previous five years. The series offered a way for his public to understand the slow, mnemonic, and technical gestation process necessary

to his art. He was clearly paying tribute to James Abbott McNeill Whistler, an artist and etcher of fog. Monet's London paintings strike a risky, delightful balance between fog and fogginess. The abolition of the subject—the cliché of modernist interpretations of Monet's work—is merely hinted at in these canvases. It would be more accurate to attribute what Geffroy called their ethereal dissolution of shapes and "cottony space" to Stéphane Mallarmé's principle of suggestion, which brings "delight in gradually guessing." The friendship between poet and painter was strong: one can apply the ideas of the one to the images of the other.

The close ties between Impressionism and Symbolism were fairly common at this time, and they reflect an artistic environment that was far more complex than Fry would soon suggest. Monet belonged to several circles. The attitude that some of his younger followers adopted toward him, about 1900, is also food for thought. Long before proponents of Abstract Expressionism in the twentieth century rehabilitated Monet's late canvases—which were admired for their flamboyant style and suggestion of unlimited space—Pierre Bonnard and Édouard Vuillard were observing the work of the pseudo hermit of Giverny. This exhibition and catalogue, by following the path leading from the late Impressionist works of around 1886 to the major decorative panels that the former Nabis created before and after 1900, will dispel the commonly held view that modernity led primarily to Cézanne and Cubism.

Rather than ending with Pablo Picasso, our journey highlights the headiness to which Vuillard and Bonnard succumbed when they moved away from easel painting. Beyond the diversity of the aesthetic field and the apparent oppositions of style, we need to recall how important interactions were to the era's artists. The time had come for open competition. The art market, critics, and journals—forming a truly powerful counterweight to the official Salons, which were on the decline—ensured that each new work was accessible, available for discussion, and recyclable. This was bound to lead to an artistic landscape whose diversity was as dazzling as it was disconcerting. Our own era, fortunately, is more receptive to hybrid phenomena than it is to sharply defined visions. In its way, this exhibition offers a comparative approach. The artists are shown one after the other: Seurat alongside Pierre Puvis de Chavannes and Signac; Cézanne alongside Picasso and Pissarro; Van Gogh alongside Henri de Toulouse-Lautrec and Gauguin; Émile Bernard alongside the latter three, equally. Even the Nabi coterie hardly resembled a united force against any form of Realism or Impressionism. The works gathered here reveal the singular talent for metamorphosis that Bonnard displayed up until the outbreak of World War I and beyond. Bonnard quickly realized that if he adhered closely to Gauguin's Synthetism and the extreme experiments at Pont-Aven he would feel stifled. The final stage of our journey allows the viewer to breathe the air of liberation that the twentieth century owes to Bonnard.

What the curators of this exhibition have sought to emphasize, above all, are the differences in both ambition and style that were so abundant in the years from 1880 to 1900. To mention one particularly famous example: we are now more attentive to the elements that distanced Van Gogh and Gauguin than to their tempestuous complicity. A major event of the period was the launch in 1886 of the Symbolist movement, which had its own journals, exhibition spaces, and advocates. The notion of subjectivity that the Symbolists upheld as the central principle behind the break with Impressionism was not merely conveyed in a few formal innovations, nonmimetic colors, deliberate fantasy, and illusory abstraction. If Symbolism was epoch

making, it was because it reflected the relationships—more disquieting, less controlled—of man to himself, to the world, and to the language of expression. Its revelatory power was anchored in the present, disenchanted or not, as seen at a critical distance. Symbolism grappled with the major issues of the day, from optics to philosophy, psychiatry to psychoanalysis, social unrest to political combat. It has often been discussed in opposition to scientific positivism in order to exalt its unwavering subjectivity; this is yet another divide that our exhibition addresses, placing Post-Impressionism, a restrictive notion, within the bounds of the Symbolist culture to which the twentieth century is so indebted.

Translated from the French by Alison Anderson

PART 1

BEYOND IMPRESSIONISM

GUY COGEVAL

The idea of Post-Impressionism, as forged by Roger Fry in 1910, is in question today. Fry set up a black-and-white opposition between Impressionism—which he characterized as a form of painting without subject, limited to imitation and observation of nature—and the art that followed it. This meant, in particular, the contributions of Paul Cézanne, Paul Gauguin, and Vincent van Gogh, the bearers of a more inventive and conceptual form of art. While stimulating at the time, the ideas of the English critic need to be seriously reexamined. For Fry, overcoming Impressionism was loaded with significance. But in our perception and awareness of modernity, can we just shake off what was a genuine revolution? If we examine Post-Impressionism as a continuation of and engagement with Impressionism, instead of a simple rejection of it, the art we encounter becomes more complex and even more interesting.

Toward 1880 the Impressionist exhibitions were no longer met with a flood of attention from art critics. The movement's protagonists felt they had exhausted subjects drawn from Parisian life and its surrounding suburbs; the glamour of Italy and even North Africa began to attract Claude Monet and Pierre Auguste Renoir. Similarly, by the time the wave of Romanticism broke between 1840 and 1850, Neoclassicism had lost the innocence of its first "Greek shepherds" and other "Cupid Sellers,"[1] partly due to the rediscovery of Shakespearean theater and the Germanic saga of the *Nibelungenlied*. Even further back, Italian Mannerism of the mid-sixteenth century reflected a period marked by doubt, division, and melancholia, in which brutal tensions of religious wars followed the calm of the new order of the Renaissance. Pontormo's tormented figures and use of the *cangianti* technique,[2] Bronzino's combinations of acid hues, Parmigianino's electric intensity, and finally the unbridled inventiveness of the Fontainebleau School: all testified to a desire to push the inherited tradition of the Quattrocento to extremes—and even to pervert it. Rather than creating a coherent set of rules, Mannerism proliferated by making both nostalgic references to the past and a rupture from it.

The advent of Post-Impressionism reflected an even more complex situation. And it occurred over a much more compressed period of time, at most about fifteen years—from approximately 1885 to 1900—during which there was the sense of an uncontrollable acceleration in the evolution of pictorial language. Music, whether orchestral or lyrical, was slowly assimilating the effects of the Wagnerian revolution, and architecture was still working out the implications of its increasing mastery of iron and glass. Painting, meanwhile, exploded. After Impressionism, nothing in French art—and soon internationally—would ever be the same again. *Sensation* as a visual concept had become entrenched as an autonomous and absolute fact, necessitating an objective submission to the direct experience of phenomena. But then Impressionism shattered into innumerable fragments, dazzling like a nebula. We could say that Post-Impressionism was, in a way, the "brilliance" of this combustion.

This confused period represented the fulfillment of a long-term tendency that ran through the nineteenth century. Although Neoclassicism at the dawn of the era sought to impose the absolute authority of drawing—from Johann Joachim Winckelmann to William Blake, Jacques-Louis David to John Flaxman[3]—the century was characterized by the progressive, irrepressible ascendancy of color. In the lead-up to Fauvism, color overflowed lines—it spurted, dribbled, and ran, swarming over the whole canvas. In a certain sense, Post-Impressionism represented the high point of the philosopher Henri Bergson's concept of the vital impulse (*élan vital*)—a continuous creative force—but most of its protagonists also claimed to be returning to classical

PAGE 22
ÉDOUARD VUILLARD
Public Gardens: Girls Playing, 1894
Detail of cat. 111

harmonies and ordered compositions, and they even (in Gauguin's case and, to a lesser extent, Georges Seurat's) invoked Jean-Auguste-Dominique Ingres by way of Eugène Delacroix. This apparent contradiction spilled over into the ideological domain as well: like their Impressionist predecessors, the Post-Impressionists claimed to be living the ethos of modernity at a heightened intensity, but they also put aside its ideology. For them, sincerity remained the primary measure of the value of a work of art. In this regard, how can we not recall Monet confiding his desire to be reborn blind, so as to be liberated from the conventional schemata of sight? How can we not think of John Ruskin, for whom only a naive outlook—an attitude combining an intuitive understanding of nature with an objective search for reality—could strip the veil of illusion? In fact, no artist during the fin-de-siècle period could remain unaware of the ethical force of Impressionism, which became one of the voices that niggled at the conscience of the bourgeoisie, slowly undermining the shaky foundations of the academic and Realist idols of the Third Republic. The Post-Impressionists intensified this attitude of provocation.

The same period is marked by the rise of idealism and a resurgence of the repressed impulses of Romanticism. Unlike Gustave Courbet or even Édouard Manet, Gauguin and Seurat were symptomatic of a generation that was fairly indifferent to political events but found the surrounding atmosphere of mediocrity suffocating. This generation's denunciation of the absurdities of the government's "moral order,"[4] as well as the narrow-mindedness of the Radical movement[5] and the complacency of middle-class France, pushed the extremes together. On the one hand, a few members of the avant-garde were involved in the leftist struggles of the post-Commune period (the painters Camille Pissarro and Maximilien Luce) and anarchism (Paul Signac and the critic Félix Fénéon). And on the other hand, the aristocrats, sophisticates, and dandies were condemned to the ivory tower by their contempt for petty bourgeois positivism (for example, the novelist Joris-Karl Huysmans and the painters Gustave Moreau and Fernand Khnopff).

Disappointments weighed heavily in the post-1870 period, and not only in France because of its defeat in the Franco-Prussian War (1870–1871). In recently unified states such as Italy and the German Empire, the new ruling classes gave artists the impression of having completely betrayed the generous and democratic aspirations of 1848. Developments in the plastic arts at the end of the century were thus more than ever conceived in terms of rupture—better still, in terms of scandal, defiance, or secession—because the gulf dividing them from the average taste of the general public grew ever wider. Echoing the howls of the press at the time of the second Impressionist exhibition, held at Paul Durand-Ruel's gallery in 1876 ("a wretched group afflicted with the madness of ambition"[6]), howls of laughter greeted Seurat's first canvases (aimed particularly at the monkey on a leash and the stiffness of the couple in *A Sunday on La Grande Jatte—1884* [1884–1886, fig. 8, page 44]),[7] while the Synthetist exhibition organized by Gauguin and Émile Schuffenecker at the Café Volpini in 1889 narrowly escaped an almost universal indifference.

The freedom of the creator appeared more than ever to be a threat to the established order, a reserve of corrosive potential in relation to the arsenal of accepted values. And even an enlightened critic such as Ruskin did not hesitate, in 1878, to heckle James Abbott McNeill Whistler for "flinging paint in the public's face"[8] with a work that sold for what the critic considered to be the exorbitant price of two hundred guineas. In the court case that

Whistler brought against Ruskin to obtain some redress, the artist's right to free invention clearly triumphed compliance with norms and fetishism of the "too perfect": the two hundred guineas demanded for the work of art was, in fact, according to the painter's own words, "for the knowledge I have gained in the work of a lifetime."[9]

Not all artists, however, could afford to maintain this attitude of defiance in the long term. For those who did not attempt the path of assimilation, there remained only the retreat into the recesses of the mind (the Symbolists), exile (Gauguin), or voluntary semi-reclusion (Van Gogh).

NEW TENSIONS

This malaise was not simply a calculated reaction or a convenient posture. It was something the Impressionists—who did not merely retire from the scene following their years of splendor—felt cruelly. The third Impressionist exhibition, held at Durand-Ruel's in April 1877, marked a high point for the group, which presented a united front for the last time and launched the journal *L'Impressionniste* to respond to *Le Figaro*'s invective. In it Georges Rivière suggested that the Impressionists judged or praised the treatment of a subject more than the subject itself.[10] Critics were much more favorable toward them than they had been, from Philippe Burty to Ernest Chesneau, from Paul Mantz to Louis-Émile-Edmond Duranty and Jules-Antoine Castagnary.[11] In 1878 Théodore Duret published a small monograph on the group, *Les peintres impressionnistes*, which was not quite devotional in tone. That attitude would take another ten to twenty years to develop, during which time the group imperceptibly unraveled: Manet died in 1883, Pissarro drifted toward Neo-Impressionism, and Renoir exhibited at the Salons of 1881, 1882, and 1883—despite Durand-Ruel's admonishments—before a trip to Italy led him to "discover" Raphael. Renoir shared with Monet the conviction that a certain redevelopment of studio practice was necessary, a serious blow to the principle of composition outdoors and in front of the motif (*en plein air*). At the same time, relations between Monet and Durand-Ruel became more acrimonious, while Gustave Caillebotte complained of the divisive effect of Edgar Degas' cynicism on the rest of the group. To top it all, Émile Zola, who had been an ardent defender of Impressionism in its initial battles, showed his total lack of understanding of the movement in his novel *L'oeuvre* (*The Masterpiece*, 1886), lending the traits of his old childhood friend Cézanne to the character of the failed and misunderstood painter Claude Lantier.

Each of the Impressionists thus set off on his own path, with no dominant direction apparent. The period was given over to the most contradictory ideologies and aspirations. Certainly, the positivist school of thought, which held that the only authentic knowledge is that based on actual sensory experience, seemed more robust than ever—to such an extent that many authors have interpreted Impressionism as a sort of second coming of positivism's concern for the real in the domain of aesthetics. Yet rare are the Impressionists who escaped the formidable allure of idealism during the final decade of the century. Monet, for example, was driven by a quest for the mysterious via stylization; his 1888 series *Antibes* excited Stéphane Mallarmé, who proclaimed, "I have placed your work above all others' for some time, but I believe this is your finest hour."[12] With his *Water Lilies* series for the Musée de l'Orangerie in Paris (1920–1926, fig. 3), Monet went even further in his pursuit of a decorative art with eternal appeal. In 1882 Renoir was sent to Palermo by the *Revue Wagnérienne* to paint a portrait of Richard Wagner, the

FIG. 3 **CLAUDE MONET**

Water Lilies: Clear Morning with Willows, Reflections of Trees, Morning with Willows (*Nymphéas: Matin clair aux saules, Reflets des arbres, Le matin aux saules*), 1920–1926

Oil on canvas

Each: 78 ¾ × 167 ⅓ in. (200 × 425 cm)

Musée de l'Orangerie, Paris

living idol of the Symbolists, while Wagner was finishing *Parsifal*. Some of the most influential theorists of Symbolism, Téodor de Wyzewa and Albert Aurier, devoted very favorable articles to Monet and Renoir.

In contrast, the attitude of the aging Impressionists with regard to the new generation of painters bore a certain ill will. Degas did not refrain from mocking Seurat, Renoir could not understand why Gauguin needed to send himself into exile to find new material, and Pissarro held against the so-called Tahitian painter his indulgent attitude toward Symbolism. In return, the old guard was exposed to the criticisms of the newcomers, who considered the obvious progress of Impressionism in the area of perception to have been obtained at the expense of imagination. Odilon Redon expressed the idea very simply in *À soi-même* (*To Myself*), his reflections in old age:

> I refused to board the Impressionist ship because I found the ceiling too low. . . . Real parasites of the object, [the Impressionists] cultivated art solely on the visual field, and in a way closed it off from what goes beyond that and what can give the humblest sketches, even the shadows, the light of spirituality. I mean a kind of emanation that takes hold of our spirit and escapes all analysis.[13]

Whether strident or more reserved in their attitude, writers began to draw conclusions from the Impressionist period, which is another way of saying that it was coming to an end. This was the case with Fénéon as well as the poet Jules Laforgue:

> The Impressionist eye is, in short, the most advanced eye in human evolution, the one that until now has grasped and rendered the most complicated combinations of nuances known. The Impressionist sees and renders nature as it is—that is, wholly in the vibration of color.[14]

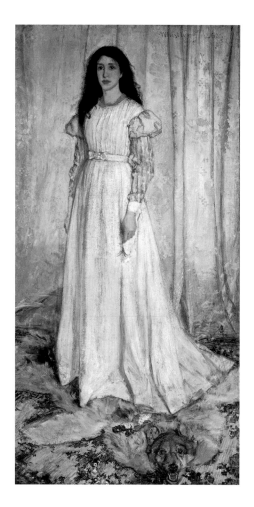

FIG. 4 **JAMES ABBOTT MCNEILL WHISTLER**
Symphony in White, No. 1: The White Girl, 1862
Oil on canvas
83 7/8 × 42 1/2 in. (213 × 107.9 cm)
National Gallery of Art, Washington, D.C., Harris
Whittemore Collection, 1943.6.2

Similarly, for the overly subtle Aurier, writing in 1891, Impressionism was simply "a refined, spiritualized, dilettantish Realism, but Realism nonetheless."[15]

Too often we have carved up the history of art into convenient slices—Neo-Impressionism, Synthetism, Symbolism, Fauvism, and so on—and imprisoned painters inside these compartments. Where materialist evolutionism meets historicizing art criticism, the temptation has been overwhelming to superimpose a host of cultural and sociological phenomena on the Impressionist canvas. These include the triumph of positivism, the emergence of the middle classes (as studied, in particular, by Karl Kautsky and Eduard Bernstein[16]), the irrepressible rise of imperialism, the monopolistic evolution of production, the atmosphere of Guy de Maupassant's novellas, and—why not?—the Impressionistic tonality that allegedly characterizes French music in the fin-de-siècle period, in works from Ernest Chausson to Claude Debussy and Paul Dukas. This kind of generalized, but ultimately reductive, interpretation has happened in part because the golden age of Impressionism occurred simultaneously with the full triumph of Realism.

But was not Impressionism's greatness as a movement precisely linked to its creation of an irreducible category of painting—namely, the *visible*—as distinct from Symbolism, which aspired to a convergence between languages and the synesthesia of different forms of expression? In reality, Impressionism was no more assimilated to Realism than it was to Symbolism. Before it recorded weekend leisure activities in the countryside or reflections cast upon water, it proclaimed a new way of painting, a new way of translating and objectifying reality through plastic means. Impressionism, while it may not have sounded the death knell for the subject in painting, undoubtedly marked the first step toward a certain dematerialization of the image.

This was what Whistler anticipated, already in the 1860s, by suppressing the conventional importance of a painting's title. A full-length portrait of a young girl was *Symphony in White, No. 1: The White Girl* (1862, fig. 4), a tactile panorama of Trouville was *Harmony in Blue and Silver* (1865, Isabella Stewart Gardner Museum, Boston), the Battersea Bridge at night was *Nocturne in Blue and Gold* (1872, Tate Britain, London), and the portrait of his mother was *Arrangement in Gray and Black, No. 1* (1871, Musée d'Orsay). There could be no more radical reduction of painting to its brute materiality, and by the same token these works capture life's visual appearance within allegories that border on the alchemical.

VISION AND PERSPECTIVE

The Impressionists taught us to see the world differently. As Ernst Gombrich observed, Western man, since the Renaissance, has recognized the world through a certain number of codes for organizing space, a set of "stabilizing habits."[17] Caught in the geometric net of natural perspective, objects found permanence within the flux of appearances. Impressionism, however, detonated these security devices and took us inside the dizzying swirl. This is no doubt the Impressionists' main legacy. Thirty years before Albert Einstein's discoveries of the relationship between mass and energy, the canvases of Renoir, Monet, Degas, and Pissarro already heralded an awareness of the fact that matter is replenished by light, which became the paradigm of movement. The idea that physical reality was not static governed this study of the dissolving effect of light. Captured in the undulating radiation, objects as well as people were both revealed and effaced within the texture of the painting. This is also the impression we get from the works of Seurat, Édouard

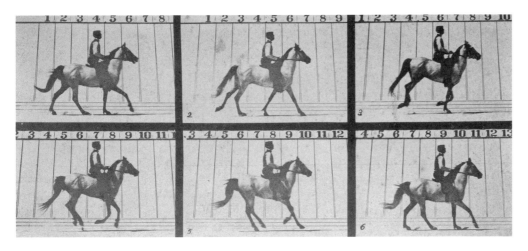

FIG. 5 **EADWEARD MUYBRIDGE**
Mahomet, from the series *Horse in Motion*, 1878
Albumen print
5 ¹⁄₂ × 8 ¹⁄₂ in. (14 × 21.6 cm)
San Francisco Museum of Modern Art, purchase
through a gift of Elizabeth Gates and Accessions
Committee Funds, 94.365

Vuillard, and Pierre Bonnard, although in a different way. In their work, the surface of the canvas is made up of generally uniform marks that blur the boundaries between the objects depicted and the shadows they project. Reality's profusion, which used to be expressed in hierarchical spatial relationships, was henceforth presented as a battlefield of energy and matter.

These painters strove to highlight the palpability of the surface, which the artists of the Renaissance had wanted to present as diaphanous. The brushstroke, which the academic tradition ingeniously disguised beneath glazes, became visible, indiscreet, and provocative. More than a sign of an artist's personal calligraphy, it came to be the fundamental—because irreducible—element of pictorial discourse. The pigments, enlivened by light hitting them, made the colored surface breathe, swell, and recede. Lured by the combination of this network of effects, the eye *experiences* movement, while at the same time color loses its attachment to traditional signifiers—a dog can be blue, a man red, a field of wheat indigo—and instead takes on a particular psychological and allegorical dimension. In this sense, we can trace an emotive color theory, stretching from Seurat to Wassily Kandinsky, in which feeling can be separated from the subject. These artists employed an autonomous system of colors, lines, rhythms, and shapes to trigger emotions and associations in their paintings.

PAINTING AND PHOTOGRAPHY

It is a paradox that painting, at the very moment it claimed its autonomy, became strongly reliant on photography—and not just in the manner that artists such as Delacroix and Courbet had used snapshots of nudes to avoid their models having to hold interminable poses. Photography gave rise to new perspectives on people, objects, landscapes, and contemporary life, whether through Nadar's views of Paris from a hot-air balloon (1858) or in the first news reports—from the Englishman Roger Fenton in Crimea (1855) and the American Mathew B. Brady during the Civil War (1861–1865)—that documented towns destroyed by battle. The technological advances came quickly, from Scott Archer's invention of the collodion glass plate (1851) to the first Kodak portable camera (1888)—which most painters rushed to buy—not to mention the first experiments in three-color printing (1869) by Ducos du Hauron and Charles Cros. Soon Eadweard Muybridge was in a position to analyze a horse's gallop (1878, fig. 5), highlighting both the glaring inadequacies of the human eye and the errors in the traditional representation of animal locomotion. Thomas Edison and then the Lumière brothers, in particular, invented

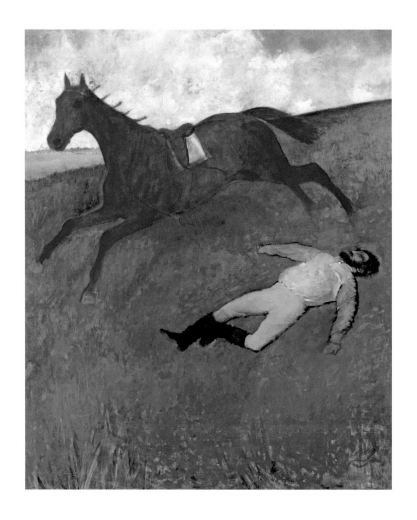

FIG. 6 **EDGAR DEGAS**
The Fallen Jockey (*Jockey blessé*), 1896–1898
Oil on canvas
71 1/4 × 59 1/2 in. (181 × 151 cm)
Öffentliche Kunstsammlung, Basel

the cinema (1895), fulfilling a major nineteenth-century aspiration: to re-create life in its real duration and full spatiality. In other words, in a narrative arc that incorporates *time*.

What was the place of these developments in photography in relation to painting? At first glance, as Delacroix had anticipated, photography achieved such a degree of faithfulness in the imitation of nature that it had the potential to render banal any art that was not innovative. Photography's ability to capture reality precisely, despite the limitations imposed by black-and-white reproduction, made the intrinsic rhetoric of all illusionistic painting seem outdated. Yet most of the recognized painters of the period were swallowed up in the imitative impasse. From Jean Louis Ernest Meissonier to Jules Bastien-Lepage, from Jean-Léon Gérôme to James Tissot, how many artists succumbed to the temptations of a photographic-style painting whose polished technique and immutably theatrical composition, despite a few superficial references to the new forms of expression, served to reassure the Salon audiences? Paradoxically, photography became for these painters a pretext for eternalizing idealized rituals, frozen in the form of *tableaux vivants*. Thus, Jean Baptiste Édouard Detaille's Napoleonic charges clearly show galloping horses whose legs are gathered up under their bellies, as documented in Muybridge's shots, rather than splayed in a wide arc as painters like Théodore Géricault and George Stubbs had believed them to be. But photographic truth, quite unlike a simple slice of life, is above all the truth of a moment, encapsulated within a succinct image. Degas manipulated such a moment for expressionistic purposes in *The Fallen Jockey* (1896–1898, fig. 6), arranging the horse's legs in a jump he knew was actually impossible.

In fact, Degas grasped photography very quickly. Despite his discreet and ambiguous silence on the subject—shared, as it happens, by all the Impressionists—he undertook a dialogue with it of the subtlest kind. Marveling at the fact that photographs had the ability to represent vantage points not seen while walking down the street, he gradually dared to adopt in his work the most acrobatic points of view, as in *Miss La La at the Cirque Fernando* (1879, National Gallery, London) and *The Tub* (1886, Musée d'Orsay). He produced compositions that relegated the protagonists to the edge of the scene, as if to throw their traditional dramatic centrality off its axis, while at the same time shrinking distant objects through a distortion of focus specific to the photographic lens. And in his endeavor to capture sudden movement, Degas used *le bougé*—the blur of motion that was poorly rendered by the photographic equipment of the time, and which haunted Manet—as a method to expressively fix in place an imperceptible transition.[18]

In painting, Degas was the gravedigger of Romanticism. After him it was no longer possible to imagine time standing still. No one was better than Degas at making points of view swirl around in confined spaces, but the other Impressionists were no less aware of the attractions of the camera. We see bird's-eye perspectives on Parisian boulevards, sunlight-flooded views that flatter the Haussmanian streetscape, tight vignettes that seem to tip toward the front of the composition, and passersby abruptly intruding into the frame. The works of Seurat, marked by a rhythmic decomposition of movement, were possibly influenced by Jules Étienne Marey's chronophotographic motion studies. For Degas, Seurat, and others, photography prompted the idea that it was no use simply to *describe* nature—rather, it was necessary to show *how* the artist felt or experienced it.

"THROUGH THE UNKNOWN, WE'LL FIND THE NEW"

So proclaims the last line of Charles Baudelaire's poem "The Voyage."[19] The avant-garde, refusing to rummage through literature for ideas to steal, turned decisively toward foreign fields: the sciences (for the study of the decomposition of white light), music (Gauguin, like Whistler, refers to "symphonies" and "harmonies of shades" in painting), and indigenous cultures, ranging from Brittany to Oceania. At a time when anthropology was still in its infancy, artists showed a passionate interest in these untainted societies, which were turned inward on their intact, primordial belief systems, unaware of the new relationships developing in urbanized and industrialized regions of the world. Whether Celtic or Maori, "primitive" art had not been contaminated by the illusionistic imperative: we can thus understand the correlations made between Symbolism's nostalgia for origins and an "untamed" language that expresses sacred significance in geometric patterns. The primitivist hermeneutic has nothing to do with relationships of dimension, spatial perspective, or contouring. From Gauguin to Paul Klee, the avant-garde became enthusiasts for straightforward arrangements of colors on common materials. Even before Marcel Mauss's sociological theories, the idea insinuated itself that only color could awaken the natural condition that slumbered within each "civilized" man, inducing a trancelike state.

More decisive still was the influence of Japanese art at the end of the nineteenth century, which, in terms of impact, can be compared only to the subsequent shock of African art around 1905–1907. Circulating in the West from the 1850s, the famous Japanese *ukiyo-e* woodcuts proved that a coherent system of reproducing reality did not have to owe anything

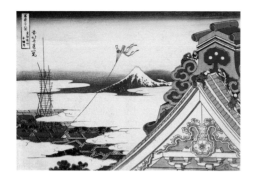

FIG. 7 **KATSUSHIKA HOKUSAI**
Fuji from the Hongan Temple at Asakusa in Edo, from
the series *Thirty-Six Views of Mount Fuji* (*Fugaku
sanjurokkei*), ca. 1831–1834
Color woodcut
9 13/₁₆ × 14 3/₁₆ in. (24.9 × 35.6 cm)
Fine Arts Museums of San Francisco, gift of Patricia
Brown McNamara, Jane Brown Dunaway, and Helen
Brown Jarman in memory of Mary Wattis Brown,
64.47.16

to the Italian Renaissance tradition of depicting perspective on a topographical grid. For the Japanese artist, spatial hierarchy was not organized in relation to the eye as the hypothetical geometric center of the surrounding world. On the contrary, the artist felt himself to be one element within a universal gravitational force in which he did not lay claim to any definitive and constraining order. Hence the longitudinal *kakemono-e* (scroll paintings) in which objects or landscapes that are subject to different perspectives can coexist; hence the woodcut scenes by Katsushika Hokusai, Torii Kiyonaga, and Andō Hiroshige, which carve up reality by accentuating the acceleration of the foreground and the vanishing of the distance—techniques that, combined with those of photography, may have inspired Degas. Perhaps it was this dual influence that Monet responded to when he undertook his famous painting series of poplars, cathedrals, and windmills. The basis of a new aesthetic sensibility, these serial paintings—conceived as fragments in a sequence that observes a succession of atmospheric effects on an immobile object—may have been partly inspired by Hokusai's *Thirty-Six Views of Mount Fuji* (ca. 1831–1834, fig. 7).

These artistic and cultural convergences had a profound impact on the fin-de-siècle period, during which civilization underwent a number of upheavals that were created by the new conditions of industrial production, the emergence of the applied arts and design, the multiplication and distribution of images through new printing processes such as chromolithography, and the affirmation of middle-class tastes. The weight of the Impressionist interlude continued to be felt in the evolution of the arts, but its ramifications ended up being barely recognizable.

The new century seemed to begin under the auspices of a rediscovered unity in the arts, formed around a magnetic core that became Art Nouveau. As the Arts and Crafts movement in England, Jugendstil in Germany and Austria, and Stile Liberty in Italy, this was the first style that was European in scope, thus prefiguring the decline of Paris as the unique and undisputed center of artistic creation, as it had been in the nineteenth century. In Brussels, the group known as Les XX (The Twenty) embraced the work of the Neo-Impressionists as well as that of Gauguin, Van Gogh, and Henri de Toulouse-Lautrec. And the destiny of the twentieth century would take shape as much in Vienna—around the artists Gustav Klimt and Egon Schiele; the composers Gustav Mahler, Arnold Schoenberg, and A. M. J. Berg; the sociologist M. C. E. Weber; the writer Robert Musil; and Sigmund Freud—as in Munich, where the composer Richard Strauss and the painters Kandinsky (in Franz von Stuck's studio), Giorgio de Chirico, and Alfred Kubin spent their formative years.

Heralded first by the decorative arts, the "modern" style quickly infiltrated the other arts, finding fertile ground in painting with the two-dimensional tendencies of Gauguin and the Nabis. Art Nouveau perpetuated the lessons of Symbolism by insisting on the fusion of architecture, mural painting, and decoration in order to produce a holistic effect. The general oscillation of the universe thus came to be expressed by the rhythmic interplay of forces specific to each form of art. Significantly, Monet's *Water Lilies* tried to forge the same path at the same time.

Translated from the French by Melissa McMahon.
A version of this essay was first published in Masterpieces from Paris: Van Gogh, Gauguin, Cézanne, and Beyond,
Post-Impressionism from the Musée d'Orsay, *National Gallery of Australia Publishing, Canberra, 2009.*

NOTES

1 Charles Baudelaire mocked the clichéd Neoclas-sical paintings at the 1859 Salon as the "hoards of Cupid Sellers." See Charles Baudelaire, *Art in Paris, 1845-1862: Salons and Other Exhibitions reviewed by Charles Baudelaire*, ed. and trans. Jonathan Mayne (London: Phaidon, 1965), 144–216.

2 Developed in Italy in the fourteenth century, *cangianti* is the painting practice of using mul-tiple tones or combinations of colors to express volume and create the effect of light and shadow. See Janis Callen Bell, "Cangianti," *The Diction-ary of Art*, ed. Jane Turner (London: Macmillan, 1996), vol. 5, 614.

3 Winckelmann was a German art historian, archaeologist, and pioneering Hellenist scholar; Blake was an English poet, painter, and print-maker; David was a Neoclassical French painter; and Flaxman was an English sculptor and draftsman.

4 The government program of the "moral order" was instituted in 1873.

5 The Radical party was a mainstream Republican movement by the end of the nineteenth century.

6 "Five or six lunatics, including a woman, a wretched group afflicted with the madness of ambition, have decided to come together here to exhibit their work. . . . And it's a pile of obscenities that the public is being exposed to, without any thought given to its potentially fatal consequences. Yesterday a young man leaving the exhibition was arrested in rue Le Peletier for biting passersby." Albert Wolff, "Le calendrier parisien," *Le Figaro*, April 3, 1876, quoted in Ruth Berson, ed., *The New Painting: Impressionism 1874-1886: Documentation* (San Francisco: Fine Arts Museums of San Francisco, 1996), vol. 1, 110–111.

7 "The monkey! The misplaced shadows! The stiff-ness of the couple!" Félix Fénéon, "Les impres-sionnistes," *La Vogue*, June 13–20, 1886, quoted in Berson, *The New Painting*, 443–444.

8 John Ruskin, "*Fors Clavigera*," letter dated July 2, 1877, quoted in Richard Dorment and Margaret F. MacDonald, *James McNeill Whistler* (London: Tate Gallery Publications, 1994), 136.

9 Whistler's statement in court in the 1878 libel case brought against John Ruskin, quoted in ibid., 138. Whistler won the case but was awarded damages of only a farthing (less than a penny) and faced huge costs.

10 "What distinguishes the impressionists from other painters is that they treat a subject for its tonal values and not for the subject-matter itself." Georges Rivière, *L'Impressionniste: Journal d'Art*, April 6, 1877, reprinted in *Art in Theory, 1815-1900: An Anthology of Changing Ideas*, ed. Charles Harrison, Paul Wood, and Jason Gaiger (Oxford: Blackwell, 1998), 594.

11 See Charles S. Moffett et al., *The New Painting: Impressionism 1874-1886* (San Francisco: Fine Arts Museums of San Francisco, 1986). Burty was an art critic for *Gazette des Beaux-Arts* and wrote for the newspaper *Le Rappel*, the avant-garde journal *La Renaissance Littéraire et Artistique*, and *La République Française*; Chesneau wrote for *L'Opinion Nationale, Le Constitutionnel, L'Artiste, and Revue des Deux Mondes*; Mantz wrote for *Gazette des Beaux-Arts*; Duranty wrote for *Paris-Journal, Gazette des Beaux-Arts, Les Beaux-Arts Illustrés, and Chronique des Arts*; and Castagnary wrote for *Le Présent, Monde Illustré, Siècle, and Nain Jaune*.

12 Letter dated June 18, 1888, in Stéphane Mallarmé, *Correspondance*, ed. Henri Mondor and Lloyd James Austin (Paris: Gallimard, 1969), vol. 3 (1886–1889), 212, letter no. 663.

13 Odilon Redon, *To Myself: Notes on Life, Art, and Artists*, trans. Mira Jacob and Jeanne L. Wasserman (New York: George Braziller, 1986), 110.

14 Jules Laforgue, "L'impressionnisme," *Mélanges posthumes: Oeuvres complètes*, vol. 3 (Paris: 1902–1903), quoted in Harrison et al., *Art in Theory*, 937–938.

15 Albert Aurier, "Le symbolisme en peinture: Paul Gauguin," *Le Mercure de France*, March 1891, quoted in Pierre-Louis Mathieu, ed., *Le symbol-isme en peinture: Van Gogh, Gauguin et quelques autres* (Caen: L'Échoppe, 1991), 18.

16 Karl Kautsky was a Marxist theoretician and Eduard Bernstein was a Social Democrat theore-tician and politician.

17 See Ernst Hans Gombrich, *Art and Illusion*, 6th ed. (London: Phaidon, 2002).

18 Literally, "the moved," *le bougé* is a term that refers to the blur when the camera or subject (accidentally) moves at the moment a shot is taken.

19 See Robert Lowell, ed., *The Voyage and Other Ver-sions of Poems by Baudelaire* (London: Faber and Faber, 1961), 37.

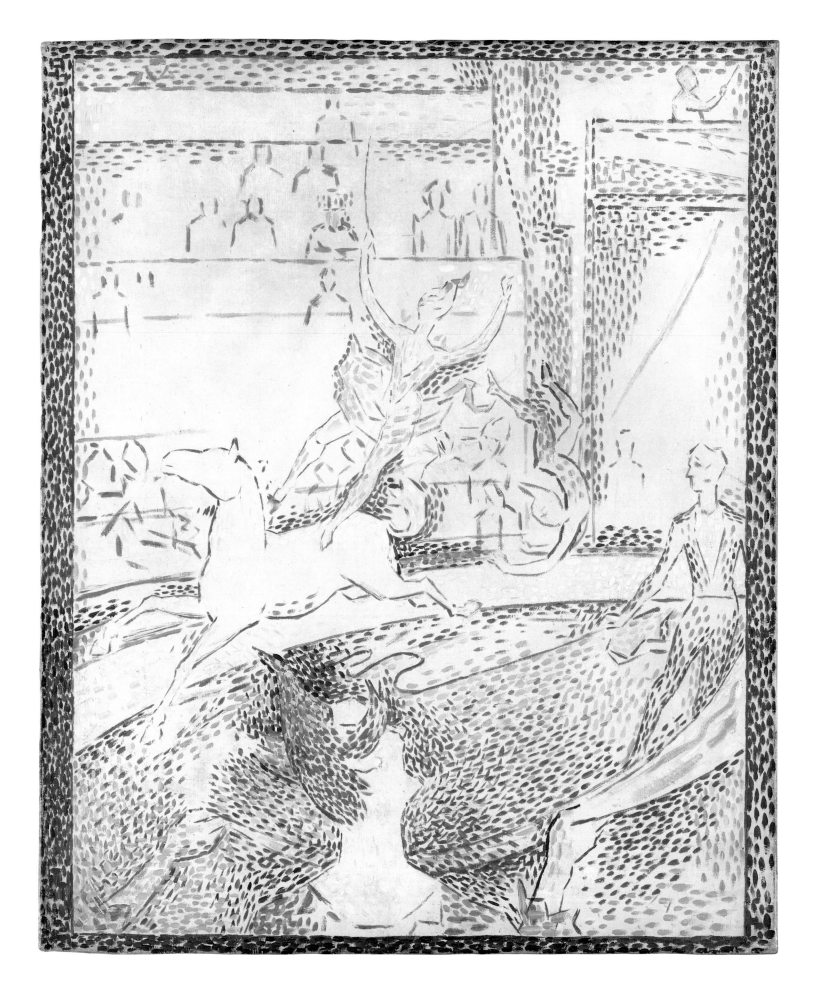

1

GEORGES SEURAT

The Circus (Sketch) (*Le cirque [esquisse]*), 1891
Oil on canvas
21 5/8 × 18 1/8 in. (55 × 46 cm)

In this preparatory sketch depicting the Cirque
Fernando, Seurat infused his modern subject and in-
novative style with the rigor and gravity of classical art.
Aligning short dashes of the primary colors red, yellow,
and blue to outline the major contours of the composi-
tion, Seurat laid bare his scientific theories on color and
on the expressive power of line. By emphasizing the
upward angles of the forms, he strove to convey the
mood of gaiety associated with this popular form of
urban entertainment.

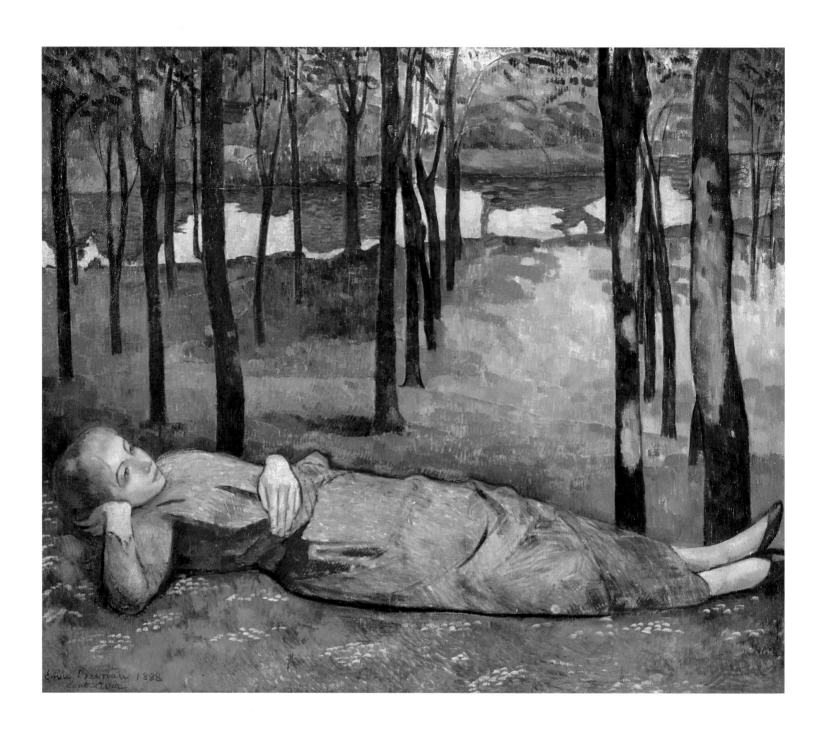

2

ÉMILE BERNARD

Madeleine in the Bois d'Amour or *Portrait of My Sister*
(*Madeleine au Bois d'Amour ou Portrait de ma soeur*), 1888
Oil on canvas
54³/₈ × 64¹/₈ in. (138 × 163 cm)

Bernard painted this life-size image of his seventeen-year-old sister, Madeleine, while summering in the Breton village of Pont-Aven in 1888. During this stay, he worked closely with Gauguin on the development of Synthetism, a new aesthetic characterized by broad patches of color, stylized forms, and symbolic content. Bernard's monumental canvas reflects their fruitful collaboration in both style and subject. Gauguin had fallen in love with Madeleine, who is shown dreaming in the "Forest of Love."

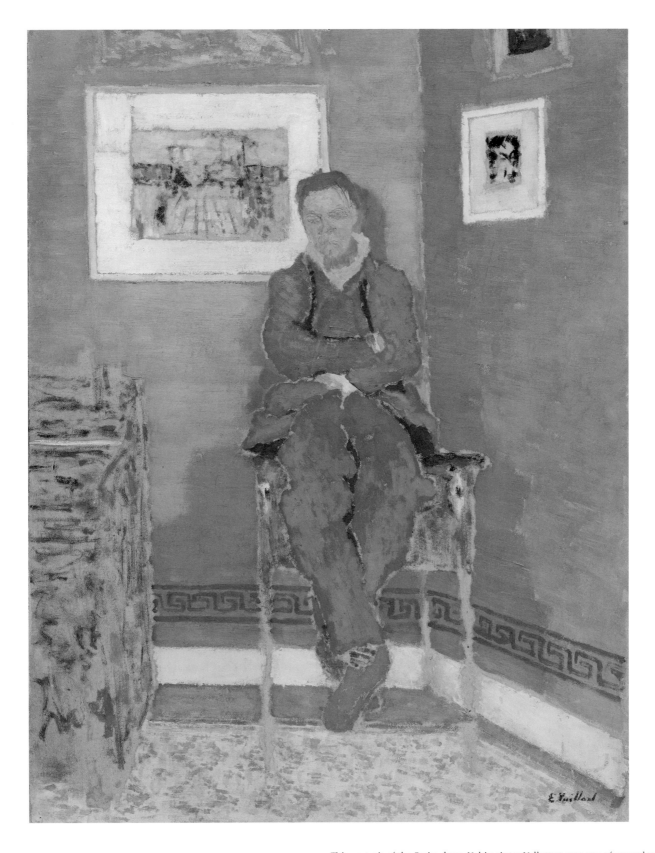

3

ÉDOUARD VUILLARD

Félix Vallotton, ca. 1900
Oil on board mounted on panel
24 3/4 × 19 1/2 in. (63 × 49.5 cm)

This portrait of the Swiss-born Nabi painter Vallotton was one of several made by Vuillard over the course of their close friendship. Rendering him with crossed arms, a slumping posture, and a downcast expression, Vuillard seems to have accurately captured Vallotton's reserved and solitary personality through minimal formal means. Vuillard's careful attention to the architectural details of his friend's studio reveals the trend toward greater naturalism in his art at the turn of the century.

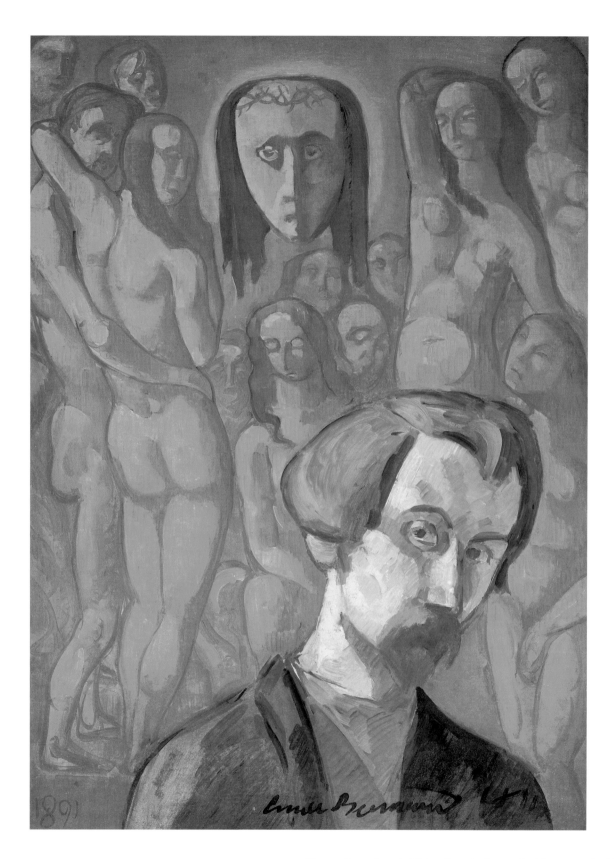

1891

émile bernard (signature)

4

ÉMILE BERNARD

Symbolist Self-Portrait (Vision) (*Autoportrait symbolique [Vision]*), 1891
Oil on canvas

31 ⁷/₈ × 23 ⁷/₈ in. (81 × 60.5 cm)

The year Bernard created this self-portrait was a decisive moment in his career. In 1891 he ended his relationship with Gauguin, his friend and collaborator, and with this painting staked his claim as an originator of the emerging Symbolist school. Bernard, who was turning increasingly toward religious and mystical subjects, presented himself before a vision of Christ's head, which floats amid a red sea of sensuous nudes reprised from his prior paintings as well as those made by Cézanne.

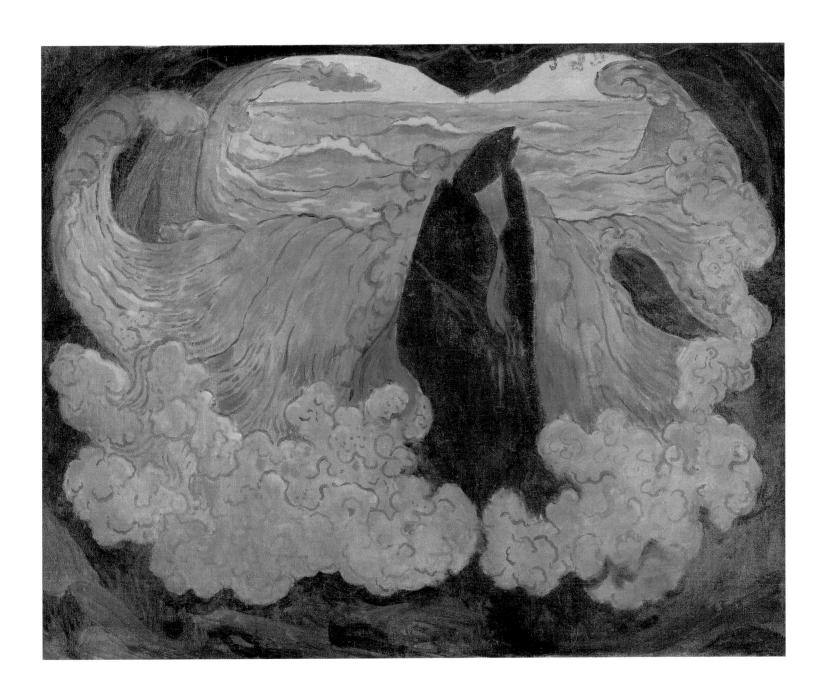

5

GEORGES LACOMBE

The Violet Wave (La vague violette), 1895–1896

Oil on canvas

28 ¾ × 36 ¼ in. (73 × 92 cm)

Lacombe's friendship with Sérusier, which began in 1892, acted as a catalyst for his artistic career. Nicknamed the "Nabi sculptor" upon joining the group, Lacombe was also a prolific painter with a highly individual style. Inspired by the art of Gauguin and Japanese prints, he created extremely stylized paintings in which the natural world is transcribed through arabesques and artificial hues. Here, the powerful crush of the incoming tide is transformed into a decorative arrangement of undulating violet forms.

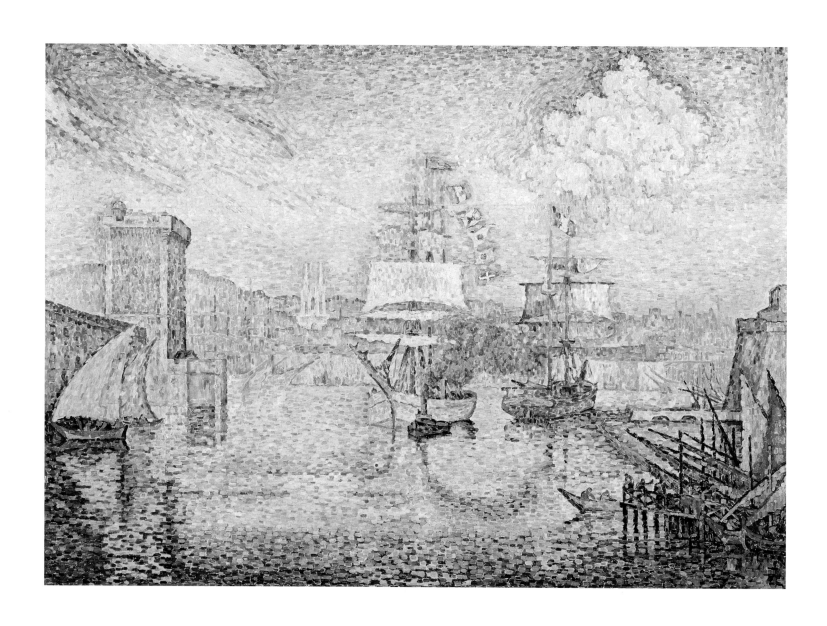

6

PAUL SIGNAC

Entry to the Port of Marseille (*L'entrée du port de Marseille*), 1911

Oil on canvas

45 ⁷/₈ × 64 in. (116.5 × 162.5 cm)

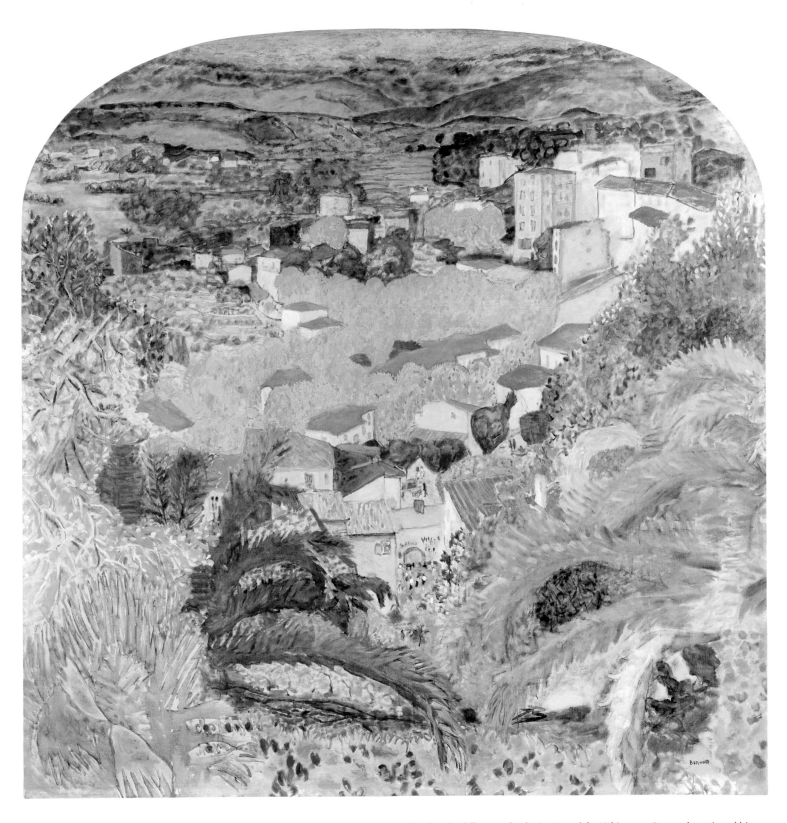

7

PIERRE BONNARD
View of Le Cannet (*Vue du Cannet*), 1927
Oil on canvas
92 × 92 in. (233.6 × 233.6 cm)

In the decades following the dissipation of the Nabi group, Bonnard continued his quest to create emotionally expressive, decorative paintings through the material properties of the medium. Having moved to Le Cannet, a small town in southern France, he adopted a more luminous palette and frequently recorded the picturesque view from his hilltop home. In *View of Le Cannet*, Bonnard contrasted the sinuous forms of the natural landscape, which are composed primarily through color, with the rectilinear shapes of houses.

1886: A PIVOTAL YEAR

SYLVIE PATRY

·

The last Impressionist exhibition was held in Paris in 1886, and the event would mark the end of an adventure begun in 1874 by artists who had grown weary of seeing their careers at the mercy of the Salon jury. Among the first exhibitors in 1874 were Paul Cézanne, Edgar Degas, Claude Monet, Berthe Morisot, Camille Pissarro, Pierre Auguste Renoir, and Alfred Sisley. By 1886, after eight exhibitions fraught with controversy and ridicule, only Degas, Morisot, and Pissarro were still in the catalogue. The time had come for the group to disperse. There were disagreements among the artists, and everything they stood for was called into question. It seemed as though the very aims that had brought them together—*peinture claire*, plein-air execution, subjects taken from modern, everyday life—had failed.

In tune with the overall mood, Émile Zola came to this same conclusion in *L'oeuvre* (*The Masterpiece*), published that same year. The novel was devoted to the artistic life of Paris, an environment Zola knew well.[1] His protagonist, the painter Claude Lantier, who has traits borrowed from Cézanne and Monet, commits suicide over his inability to finish his life's work. The book caused Cézanne to break off his friendship with Zola, and Monet was clearly upset by it, concerned that the newspapers would get ahold of it and refer to the Impressionists as "failures." In a letter to Zola, he wrote: "I have been struggling for a long time, and I am afraid that just as I am about to succeed, enemies might use your book to crush us."[2] He was indeed "about to succeed" because by 1886 the situation for the Impressionists had improved, though not across the board: some, like Monet, Renoir, and Degas, enjoyed success, while difficulties persisted for Pissarro and Sisley, and Cézanne was the victim of outright hostility and incomprehension.

In 1886 Paul Durand-Ruel, who had been the Impressionists' faithful art dealer since 1872, organized an exhibition in New York, embarking on the conquest of a market and an audience that were both new and promising. At the same time, some official Salon painters adopted the Impressionist style, offering a more acceptable version of it. For example, Albert Besnard, a former recipient of the Grand Prix de Rome and future member of the Académie des Beaux-Arts, began to display a lighter palette and greater freedom in his brushwork, far from the highly polished treatment employed by painters such as Alexandre Cabanel and Adolphe-William

Bouguereau. This "modern" style earned him a favorable reception at the Salon of 1886, where *Madame Roger Jourdain* (cat. 9) was a success. Besnard not only introduced light and movement but also painted scenes of contemporary life, to such a degree that Degas would gibe, "He is flying with our own wings."[3] As Impressionism gradually gained more widespread acceptance in the 1880s and 1890s, collectors became interested, the prices of paintings rose, and some of the canvases found their way into museums—all steps toward the spectacular commercial success of the early twentieth century.

In 1888 the administration of the Beaux-Arts purchased its first Impressionist canvas: a landscape by Sisley that was immediately relegated to a provincial museum, in Agen. Four years later, Renoir's *Young Girls at the Piano* (1892, cat. 18) was hung at the Musée du Luxembourg, which exhibited the work of living artists. This acquisition and the subsequent purchase of Berthe Morisot's *Young Woman Dressed for a Ball* (1879, Musée d'Orsay) were harbingers of the turbulent controversy that would soon erupt over the bequest of the painter Gustave Caillebotte, which resulted in the presentation of thirty-eight Impressionist works at the Musée du Luxembourg. After three years of virulent opposition, the opening of the Salle Caillebotte in 1897 had profound repercussions.

In the 1880s the Impressionists were still in a fragile position. The 1886 Impressionist exhibition came after four years of silence, a sign of the difficulties the artists faced as well as the disagreements among them. The previous event, in 1882, had been notable for the brilliant contributions of Pissarro, Renoir, and Monet. Paradoxically, what in hindsight appears to have been one of the finest expressions of the movement owed nothing to a shared aesthetic program and everything to a savvy commercial strategy controlled by Durand-Ruel. In order to organize the eighth and final exhibition of the group, it would take all the energy and financial means available to Morisot, Henri Rouart (a friend of Degas'), and Mary Cassatt. Reflecting the undercurrents of dissension, the event was called, soberly, *Eighth Exhibition of Painting*. Thus, the "crisis" that emerged into the open in 1886 was merely the outcome of an ongoing evolution. From the end of the 1870s the movement had been called into question by its own members.

The conflict was essentially strategic, aesthetic, and political in nature, and cases of both personal enmity and favoritism were inevitable among individuals in the group. At the end of the 1870s, against a background of general economic difficulties, the question arose as to whether it was relevant to exhibit outside the official channels: "Our exhibitions have helped, to be sure, to make us known, and in that respect they have been very useful, but we must not, I believe, isolate ourselves for too long. The day is far in the future when we will be able to ignore the prestige attached to official exhibitions," wrote Sisley.[4] In 1879 Sisley, Cézanne, and Renoir precipitated their exclusion from the Impressionist group by submitting their paintings to the Salon (only Renoir was accepted); Monet gained entry in 1880. Cézanne was eventually accepted—for the first and last time in his career—in 1882. Only Pissarro and Degas remained faithful to the initial logic behind independence.

Monet also sought to gain a wider audience in other ways. After a first solo exhibition at La Vie Moderne in 1880, his paintings commanded increasingly higher prices. In 1886 he left Durand-Ruel for Georges Petit, who had more aggressive business methods and did not hesitate to hang works by successful artists such as Besnard and Henri Gervex on the walls of his gallery alongside those by Monet and Renoir.

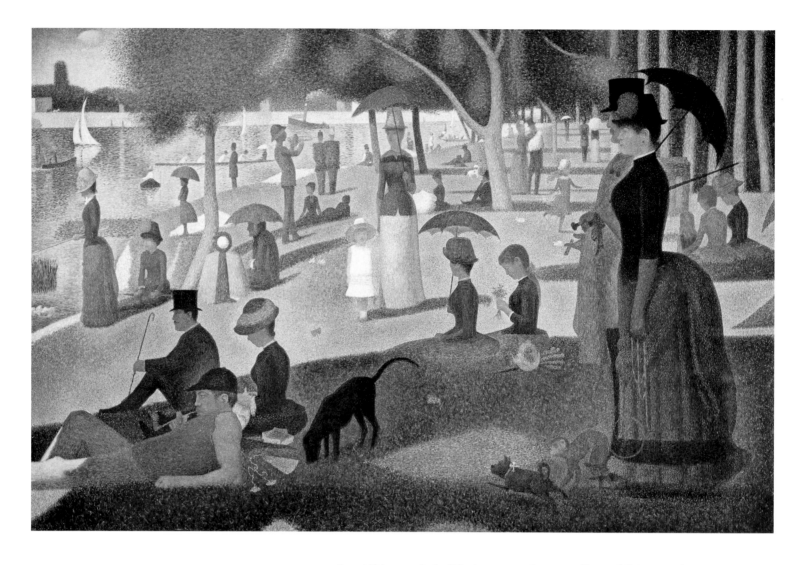

FIG. 8 **GEORGES SEURAT**

A Sunday on La Grande Jatte—1884 (*Un dimanche après-midi à l'île de la Grande Jatte*), 1884–1886
Oil on canvas
81¾ × 121¼ in. (207.5 × 308.1 cm)
Art Institute of Chicago, Helen Birch Bartlett Memorial Collection, 1926.224

In addition to their differing strategies regarding exhibition and promotion, aesthetic differences, already apparent in 1874, contributed to the crisis of the 1880s. The first Impressionist exhibition did not seal artistic unity. The Impressionists did not write a manifesto, nor did they choose their name; it was assigned to them, sarcastically, in 1874.[5] After the unbridled innovation of the 1870s, a feeling of failure arose. Renoir realized that he had reached a dead end: "In about 1883, there was a sort of break in my work. I had gone as far as I could with 'Impressionism,' and I came to realize that I knew neither how to paint nor how to draw."[6] More generally, there was a perception that Impressionism had not produced any great works by the turn of the decade. At the Salon of 1880 Zola lamented, "The great misfortune is that not one of the artists in the group has produced a single powerful, definitive work embodying a principle that each one of them has applied partially, that is scattered throughout their work. . . . One looks in vain for the single masterpiece that would make that principle the dominant one and elicit universal acclaim. That is why the Impressionists' struggle has not succeeded."[7] From this context, Monet, Cézanne, Renoir, and Degas drew divergent conclusions, which incidentally did not diminish the respect and admiration the artists felt for one another. Monet chose to delve deeper into the quality of immediacy that is apparent in his style of Impressionism, declaring, in 1880, "I still am, and always want to be, an Impressionist."[8] Cézanne, Renoir, and Degas, on the other hand, sought to surpass

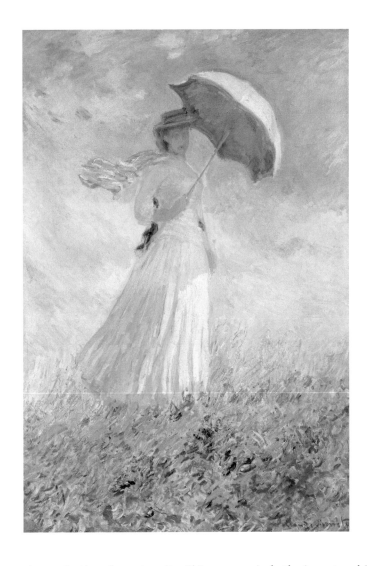

FIG. 9 **CLAUDE MONET**

*Study of a Figure Outdoors: Woman with a Sunshade
Turned to the Right* (*Essai de figure en plein-air:
Femme à l'ombrelle tournée vers la droite*), 1886
Oil on canvas
51 ⁵/₈ × 34 ⁵/₈ in. (131 × 88 cm)
Musée d'Orsay, RF 2620

the aesthetics of spontaneity. This was precisely the issue to which artists at the 1886 exhibition responded, most notably the young Georges Seurat with his groundbreaking painting *A Sunday on La Grande Jatte—1884* (1884–1886, fig. 8). A new page was turned, ushering in the Post-Impressionists and their rich, fruitful dialogue with the "old Impressionists," who were in the midst of their own renewal.

The 1880s and the years thereafter would herald a rejuvenation of Impressionism among its "old" representatives, partly in reaction to the challenge posed to its aesthetic validity by the Post-Impressionist avant-garde, but also as a result of the dialogue between the generations. The integration of the new generation, particularly Seurat's group, gave rise to a strong divide. The impetus came from Pissarro; for him, Neo-Impressionism—as it was practiced by Seurat, before Paul Signac, and to which he converted in the winter of 1885–1886—was a "new phase in the logical progression of Impressionism," a "scientific Impressionism" that was to be contrasted with "old" or "romantic Impressionism."[9]

The artists of the younger generation, in the end, viewed themselves as the authentic successors to Impressionism, to the exclusion of the "old ones," who were incapable of exploiting all the possibilities of light and color. They agreed with the critic Félix Fénéon's 1887 assessment that "the good years of Impressionism are over."[10] In opposition to this generation, Monet advanced the validity of Impressionism as he practiced it. Thus, we might consider his

paintings from 1886 to 1888 to be responses to Neo-Impressionism set against the struggle for the leadership of Impressionism[11] in its broader context as the "modern painting" of the anti-academic avant-garde—a status it still claimed in the 1880s and 1890s.[12]

In 1886 Monet returned to figure painting, which, since the 1860s, he had practically abandoned for landscapes. *Study of a Figure Outdoors: Woman with a Sunshade Turned to the Right* (1886, fig. 9) is a rejoinder to Seurat's motionless figures. The emphasis placed on movement serves as a criticism of the stillness in Seurat's canvases. Monet objected to the Neo-Impressionists' conception of light and color; to him, light and color were transitory and fugitive effects. He reinterpreted, in strictly Impressionist terms, figure painting and decorative painting (Monet conceived the two versions of *Woman with a Sunshade* as a decorative pair), challenging the terrain of the Post-Impressionists. For Monet, nature was not an ensemble of elements to be deconstructed, analyzed, and then reconstituted on a canvas. On the contrary, he believed the painter should seek osmosis with nature, to be in tune with it in order to grasp its particularities and changeable features, rather than its immutable laws.

After producing landscapes in France and Italy through the 1880s, in the early 1890s Monet changed his practice, focusing on series of paintings that represented a single motif or landscape feature under different atmospheric conditions. Whereas his work from 1886 to 1889 emphasized the aesthetic of spontaneity, in opposition to the Neo-Impressionists, the series introduced a strategy to further distance the motif from reality. Working quickly, moving from canvas to canvas, he took this aesthetic to another level. With the series, Monet subjected the motif more than ever to sensation and observation, capturing every change in light and weather. The composition of the motif obeys topographical reality less and less in order to embrace a decorative rhythm. Countering the Symbolists' attacks, which accused the Impressionists of being Realists, the critic Octave Mirbeau celebrated Monet's genius, his ability to extract from a place "in a glance, the essence of shape and color and, I would add, of intellectual life, and thought, . . . from this supreme moment of concentrated harmony, where dream becomes reality. . . . Claude Monet's landscapes are . . . the extremely sensitive shapes of our thoughts."[13] See, for example, Monet's *Mount Kolsaas* (cat. 13), painted in Norway in 1895.

A detachment from reality, an abandonment of the aesthetic of spontaneity, and a dismissal of subjects from modern life characterized Renoir's art during the second half of the 1880s. These years of "crisis," when out of "hatred for Impressionism"[14] he did the exact opposite of what he had done in the 1870s, would pave the way for a new classicism in his work. As illustrated by *The Bathers* (1918-1919, cat. 19), his goal from the 1890s until his death in 1919 was to resolve the difficult equation of the human figure and the landscape, putting him within a glorious tradition that led from Titian to Gustave Courbet by way of Jean-Auguste-Dominique Ingres and Édouard Manet. After 1886 Renoir tried to "make Impressionism into a 'solid and lasting art like the one in museums,'"[15] as an enthusiastic Maurice Denis described the formula of Cézanne, who, like Renoir, was in a category of his own.

Translated from the French by Alison Anderson

NOTES

1 Zola was Cézanne's childhood friend. He became an advocate for Manet and the future Impressionists in the 1860s.

2 Letter from Monet to Zola, quoted in Henri Mitterand, *Zola*, vol. 2, *L'homme de "Germinal" (1871–1893)* (Paris: Fayard, 2001), 814.

3 Quoted in Paul André Lemoisne, *Degas et son oeuvre* (Paris: Plon, 1954), 125; and in Octave Mirbeau, *Combats esthétiques*, vol. 1, ed. Pierre Michel and Jean-François Nivet (Paris: Séguier, 1993), 481.

4 Letter from Sisley to Duret, reprinted in Théodore Duret, "Quelques lettres de Manet et Sisley," *La Revue Blanche*, March 15, 1899, 436.

5 The term came from Louis Leroy, "L'exposition des impressionnistes," *Le Charivari*, April 25, 1874. The critic imagines a Neoclassical landscape painter mocking Monet's *Impression, Sunrise* (1872, Musée Claude-Monet Marmottan, Paris).

6 Ambroise Vollard, *En écoutant Cézanne, Degas, Renoir* (Paris: Grasset, 2005), 295. Originally published in 1938.

7 Émile Zola, *Écrits sur l'art* (Paris: Gallimard, 1991), 422. It is difficult to agree with this statement nowadays, given the rich harvest of Impressionist masterpieces from the 1870s and 1880s.

8 As related by Émile Taboureux in 1880, quoted in Charles Stuckey et al., *Monet: A Retrospective* (Westport, Conn.: Hugh Lauter Levin Associates, 1985), 89–93.

9 Janine Bailly-Herzberg, *Correspondance de Camille Pissarro*, vol. 2 (Paris: Éditions du Valhermeil, 1986), 35, 45, 47.

10 Félix Fénéon, "L'impressionnisme," *L'emancipation sociale* (1887), reprinted in Félix Fénéon, *Oeuvres plus que complètes*, vol. 1, ed. Joan U. Halperin (Geneva: Droz, 1970), 68.

11 See Paul Tucker, *Monet in the Nineties: The Series Paintings* (Boston: Museum of Fine Arts, 1990), 15.

12 The usage of the term *Impressionism* was applied so liberally that in 1891, Albert Aurier, a Symbolist theorist and strong supporter of Gauguin, asked "that we reject this inappropriate general title of Impressionists, and that it be reserved solely for those painters for whom art is no more than a translation of sensations." Quoted in Pierre-Louis Mathieu, *La génération symboliste* (Geneva: Skira, 1990), 68. In his letters, Gauguin indifferently referred to himself as an Impressionist even after 1886.

13 Octave Mirbeau, "Claude Monet," *L'Art dans les Deux Mondes*, March 7, 1891, reprinted in Mirbeau, *Combats esthétiques*, 430–431.

14 Renoir, quoted by Ambroise Vollard, *En écoutant Cézanne, Degas, Renoir*, 300.

15 Denis, quoted in *Conversations avec Cézanne*, ed. P. M. Doran (Paris: Macula, 1978), 170.

8

HENRI GERVEX

Madame Valtesse de La Bigne, 1879/1889

Oil on canvas

78 3/4 × 48 in. (200 × 122 cm)

Despite moving within avant-garde circles, Gervex remained true to his academic background and achieved considerable success in the annual Salons with his paintings of nudes and society portraits. Though his style was typically Realist, Gervex adopted the bright palette, outdoor setting, and loose brushwork of the Impressionists in this portrait of Madame Valtesse de La Bigne, a well-known actress and courtesan. Amorously linked to numerous artists, she had inspired the character of Nana in Émile Zola's eponymous novel of 1879.

9

ALBERT BESNARD

Madame Roger Jourdain, 1886
Oil on canvas
78 ¾ × 60 ¼ in. (200 × 153 cm)

After studying the art of Joseph Mallord William Turner and eighteenth-century British portraitists, Besnard developed an expressive style that earned him fame in the genre of portraiture. He created what he called "environmental portraits," which, rather than portray precise likenesses, evoke the personality of the sitter through vibrant colors, lively brushstrokes, and dazzling atmospheric effects. Exhibited with great success at the Salon of 1886, this portrait won the admiration of the Symbolists, who praised the application of tonal colors to suggest a mood.

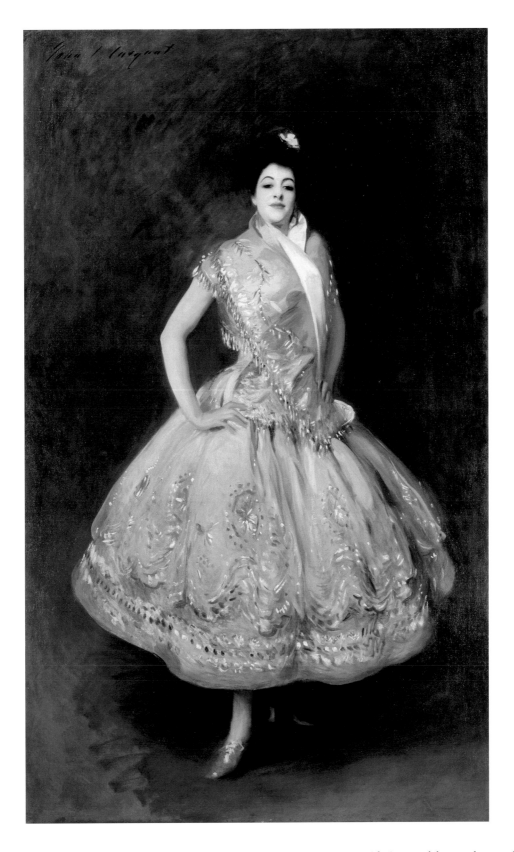

10

JOHN SINGER SARGENT

La Carmencita, ca. 1890

Oil on canvas

91³⁄₈ × 55⁷⁄₈ in. (232 × 142 cm)

La Carmencita was a Spanish singer and dancer who came into vogue in America and England around 1890, the year Sargent convinced her to pose for this portrait. Re-creating the atmosphere of a dark stage with dramatic footlighting, Sargent emphasized his signature bravura brushwork in the glimmering surface of her bejeweled costume. A sensation when exhibited in London and Paris, the portrait was both praised and criticized for its sketchlike qualities and the brazen attitude of its subject.

11

CLAUDE MONET

Frost (Le givre), 1880
Oil on canvas
24 × 39 ³/₈ in. (61 × 100 cm)

This landscape was probably painted at Vétheuil, the Parisian suburb where Monet was residing in the exceptionally harsh winter of 1879–1880. Enthralled by the effects of frost on the Seine, whose smaller branches had completely frozen over, Monet made a series of paintings that explore the subtle range of colors produced by light reflecting off water and ice. Included in Monet's first solo show at La Vie Moderne that June, this canvas was purchased shortly thereafter by the Impressionist painter Gustave Caillebotte.

12

CLAUDE MONET

Storm, Coasts of Belle-Île (*Tempête, côtes de Belle-Île*), 1886
Oil on canvas
25 ⅝ × 32 ⅛ in. (65 × 81.5 cm)

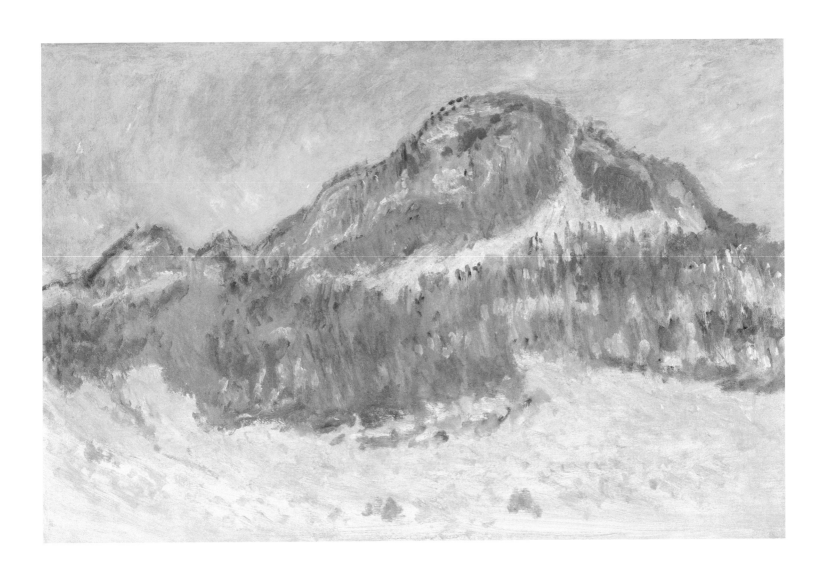

13

CLAUDE MONET

Mount Kolsaas in Norway (*Le mont Kolsaas en Norvège*), 1895
Oil on canvas
25 ³/₄ × 39 ³/₈ in. (65.5 × 100 cm)

On a trip to Norway in the winter of 1895, Monet produced thirteen rapidly painted impressions of Mount Kolsaas under various atmospheric conditions and at different times of day. Familiar with Japanese woodblock prints, he compared his subject to the motif immortalized in Katsushika Hokusai's *Thirty-Six Views of Mount Fuji* (fig. 7). Monet's series is also reminiscent of Cézanne's paintings of Mont Sainte-Victoire (see cat. 21), though instead of emphasizing the solidity of the mountain Monet dissolved it into powdery white pigment.

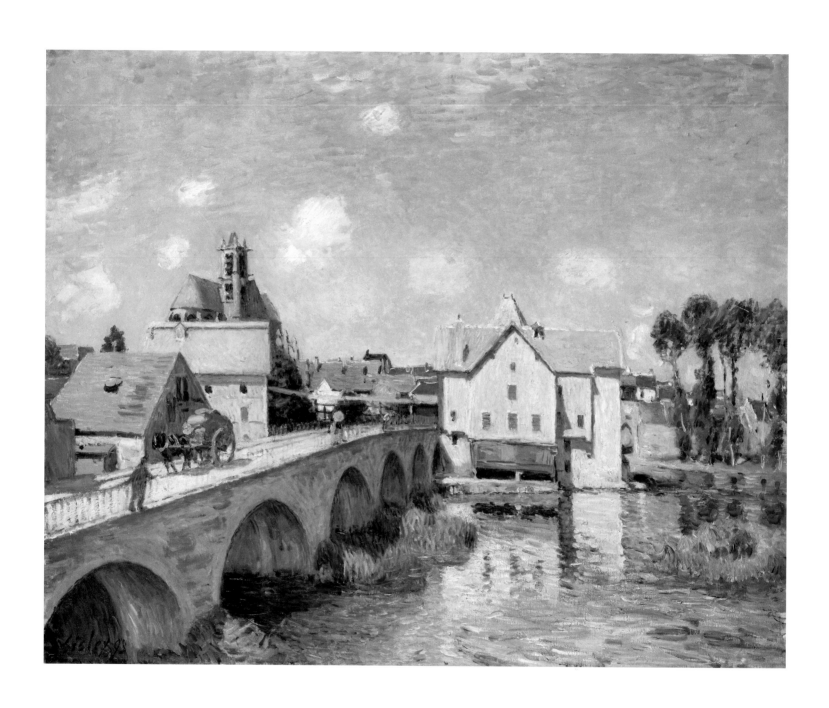

14

ALFRED SISLEY

Moret Bridge (*Le pont de Moret*), 1893
Oil on canvas
29 × 36 3/8 in. (73.5 × 92.5 cm)

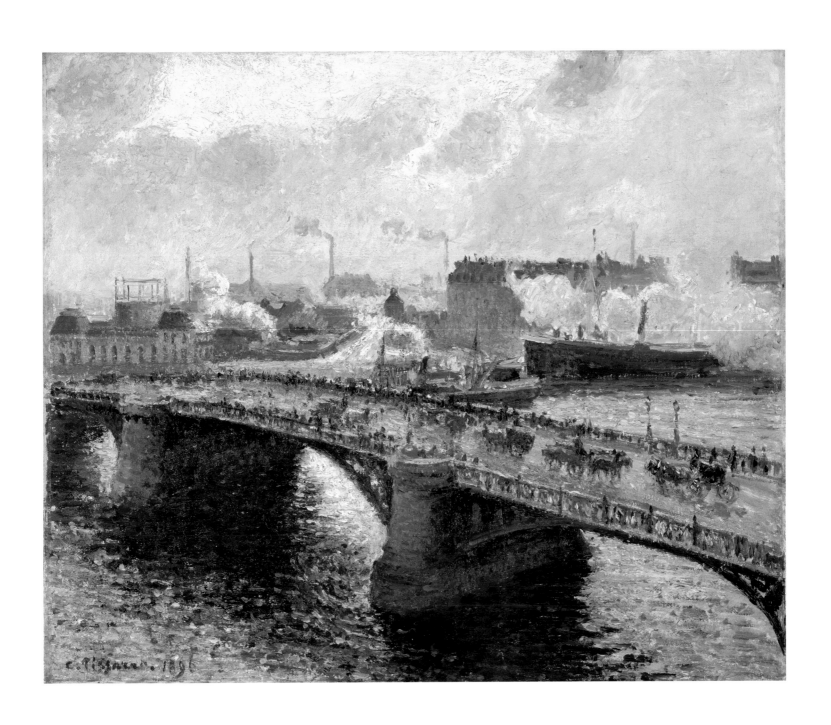

15
CAMILLE PISSARRO
Pont Boïeldieu, Rouen, Sunset, Misty Weather
(*Le pont Boïeldieu à Rouen, soleil couchant, temps brumeux*), 1896
Oil on canvas
21 ¼ × 25 ⅝ in. (54 × 65 cm)

BEYOND IMPRESSIONISM

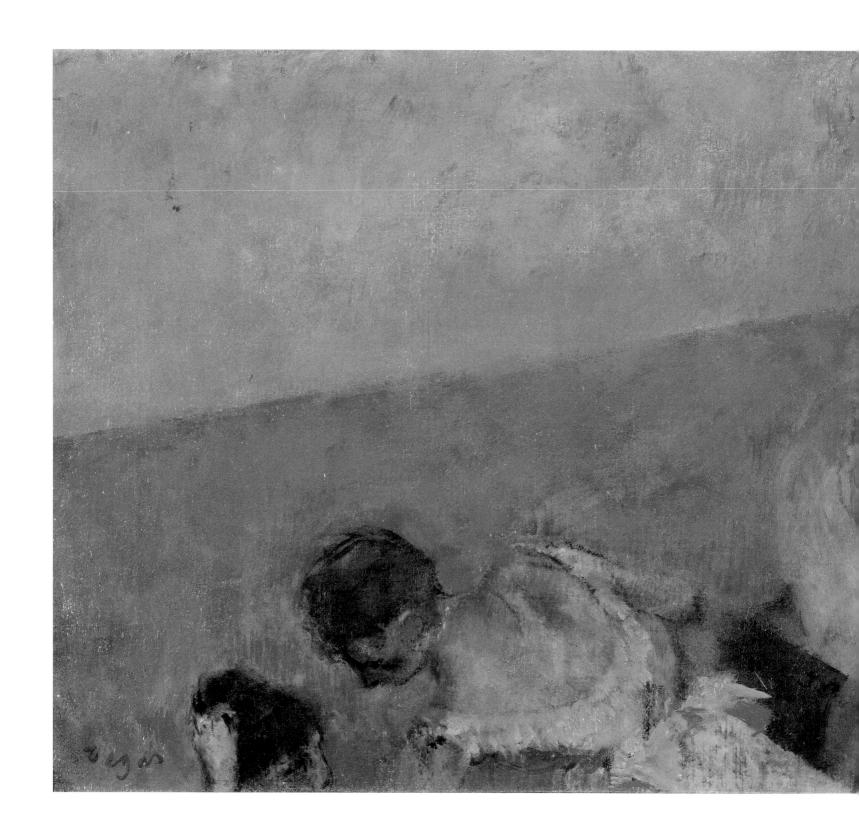

16

EDGAR DEGAS

Dancers Climbing the Stairs (*Danseuses montant un escalier*), 1886–1890

Oil on canvas

15 3/8 × 35 1/4 in. (39 × 89.5 cm)

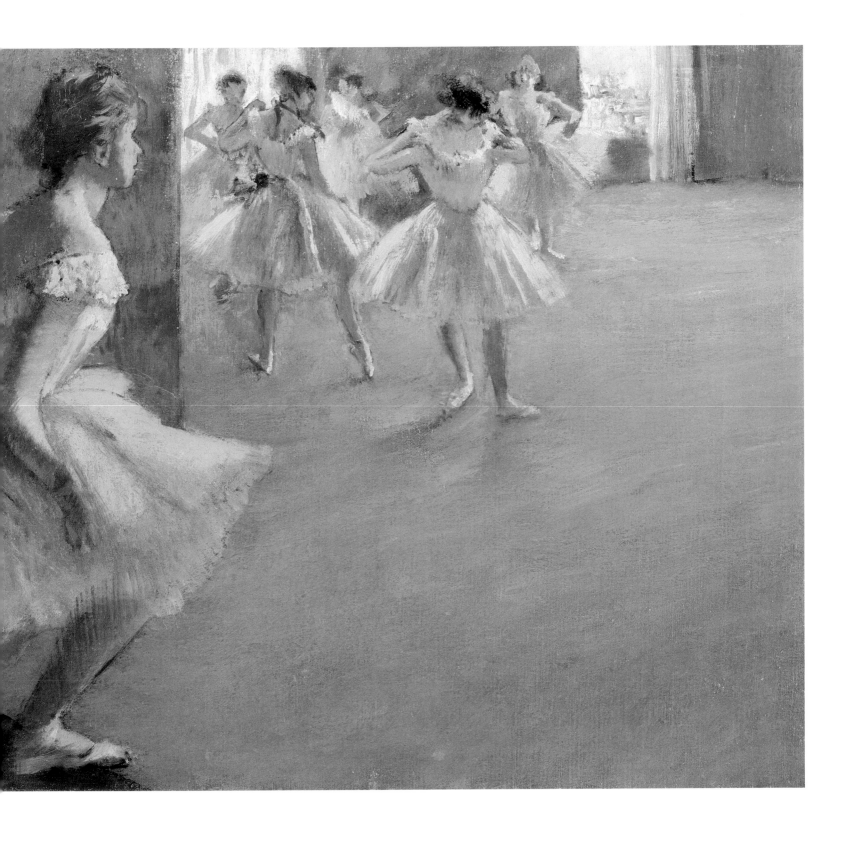

BEYOND IMPRESSIONISM

17

PIERRE AUGUSTE RENOIR

A Dance in the Country (*Danse à la campagne*), 1883
Oil on canvas
70 7/8 × 35 3/8 in. (180 × 90 cm)

Conceived as a pendant to *A Dance in the City*, an identi-
cally sized canvas featuring a waltzing couple in an
elegant ballroom, *A Dance in the Country* celebrates the
joyous atmosphere of an outdoor entertainment venue.
The man's fallen hat emphasizes the energetic nature of
the couple's dance, as does Renoir's feathery brushwork,
which adds a sense of swirling motion to the scene.
Aline Charigo, the smiling model, appeared in several of
Renoir's paintings before becoming his wife in 1890.

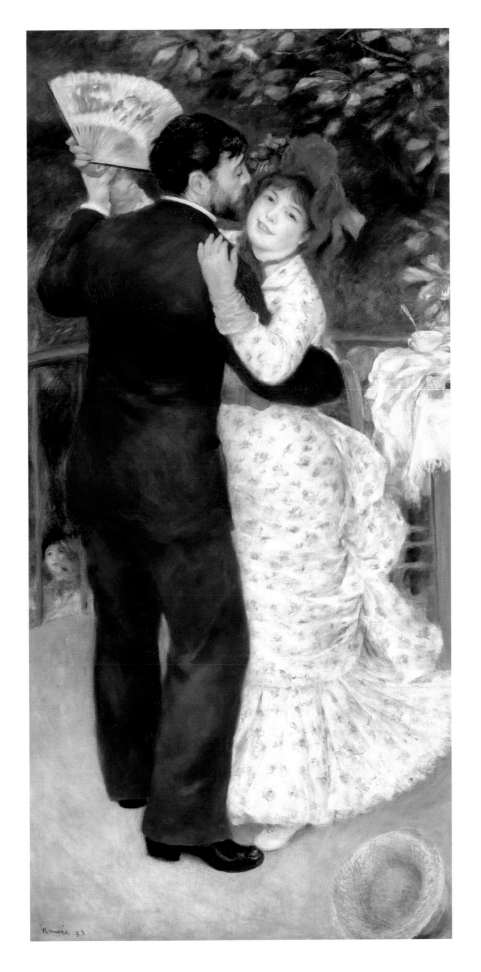

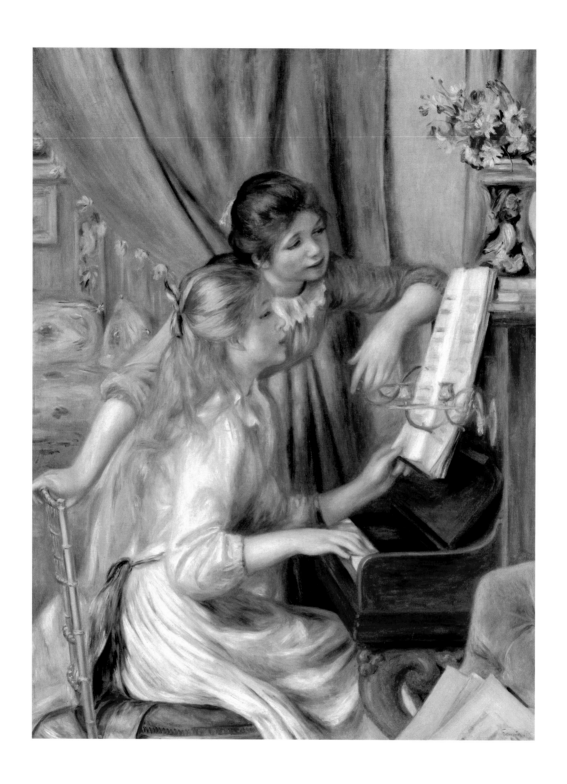

18

PIERRE AUGUSTE RENOIR

Young Girls at the Piano (*Jeunes filles au piano*), 1892
Oil on canvas
45 ⅝ × 35 ⅜ in. (116 × 90 cm)

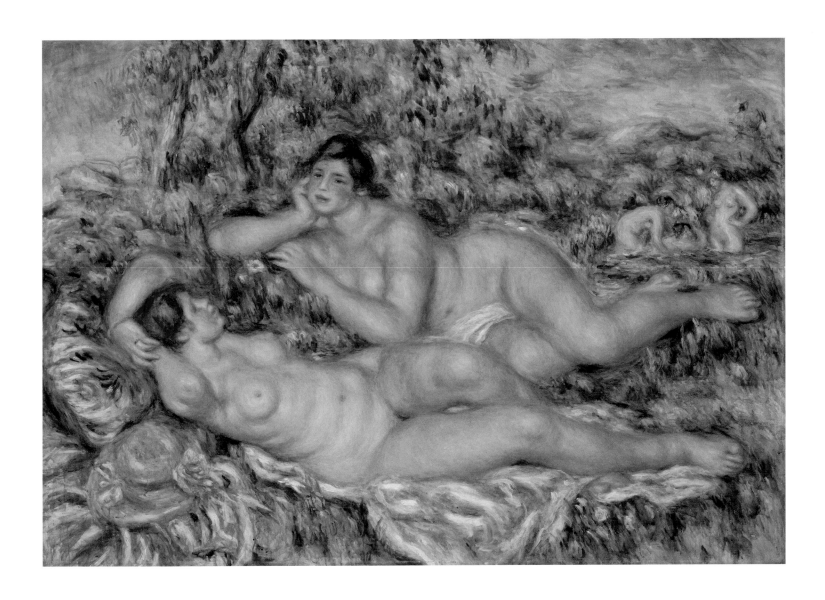

19

PIERRE AUGUSTE RENOIR

The Bathers (*Les baigneuses*), 1918–1919
Oil on canvas
43¼ × 63 in. (110 × 160 cm)

Seeking artistic inspiration, Renoir traveled to Italy in 1881 and was deeply influenced by his encounter with classical and Renaissance art. Upon returning to France, he turned increasingly to the subject of the nude, evoking the eternal feminine in his numerous images of women reposing outdoors. Finished shortly before his death, *The Bathers* was the culmination of his work in this genre. Casting aside their modern trappings, Renoir's nudes return to an Edenic state in which flesh and nature merge in pulsating strokes of luxuriant color.

CÉZANNE: A CASE STUDY

SYLVIE PATRY

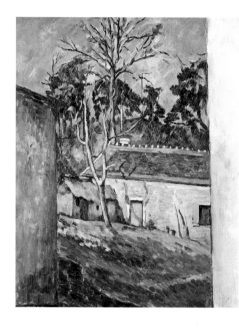

FIG. 10 **PAUL CÉZANNE**
Farm Courtyard in Auvers
(*Cour de ferme à Auvers*), ca. 1879–1880
Oil on canvas
25 ⅝ × 21 ¼ in. (65 × 54 cm)
Musée d'Orsay, RF 2760

> It is no easier to explain Cézanne's [fame] than to explain the man himself.
> MAURICE DENIS[1]

In November 1895 an exhibition devoted to Paul Cézanne was held at the gallery of Ambroise Vollard, an enterprising dealer who had opened shop three years earlier to take on the Paris art market. The event had an unprecedented impact. It marked the first recognition awarded an artist who would soon be considered one of the fathers of twentieth-century art. In fact, this surge of interest in Cézanne came very late in the artist's career, and it represented a spectacular reversal that would be further confirmed by the brilliant homage paid to him at the Salon d'Automne in 1906, the year of his death.

Cézanne was fifty-six at the time of Vollard's exhibition. He was born in Aix-en-Provence in 1839 and went to Paris in 1861 with his childhood friend Émile Zola, the novelist. The early years of his career, in the 1860s, were not easy. The Salon juries systematically rejected his paintings.[2] In the early 1870s Cézanne, while working closely with his friend Camille Pissarro, abandoned the impetuous, Romantic-style paintings of his early years for luminous landscapes and still lifes whose paint surfaces were often built up with a palette knife. In 1874 he joined the founding group of artists whose joint exhibition, in a studio borrowed from the photographer Nadar, sealed the public recognition of Impressionism. However, his participation in the Impressionist exhibitions was ultimately minimal, as he appeared in only two of the eight events, in 1874 and in 1877.

Among his peers, Cézanne was exposed to the most violent criticism: "For fifteen years no one has been more maligned and attacked in the press and by the public than M. Cézanne. There is no outrageous epithet that has not been used together with his name, and his work has enjoyed enduring—and ongoing—success in the domain of irrepressible laughter," wrote Georges Rivière in *L'Impressionniste* in 1877.[3] The only collector who supported him at the time was Victor Chocquet, a great admirer of Eugène Delacroix. Cézanne later celebrated his patron's discerning taste by including him among the painters in *Apotheosis of Delacroix* (1890–1894, cat. 23).

FIG. 11 **PAUL CÉZANNE**
Still Life with Fruit Dish
(*Nature morte au compotier*), 1879–1880
Oil on canvas
18 ¼ × 21 ½ in. (46.4 × 54.6 cm)
Fractional gift of a private collector to the
Museum of Modern Art, New York, 69.1991

In the 1880s Cézanne moved away from Impressionism. His work of this period is characterized by rigorous compositions laid down with "constructive" parallel brushstrokes,[4] and he limited himself to a number of simple themes (still lifes, landscapes around Aix, portraits, and nudes). However, this "classicism" did not earn him any new admirers. And opportunities to view his work were extremely rare. With the exception of exhibitions in Paris in 1889, at the Exposition Universelle, and in Brussels the following year, Cézanne stopped showing his work publicly after 1882. His family's wealth allowed him to paint without being obliged to sell his art. He settled in Aix and led a simple, regular life with his wife, Hortense Fiquet (seen in his *Portrait of Madame Cézanne*, cat. 22), who was one of his former models, and their son, Paul. He maintained his independence from the art market and collectors, and he deliberately avoided artistic circles; his stays in Paris were brief.

When the Impressionist works from the collection of Gustave Caillebotte first entered the holdings of the Musée du Luxembourg, Cézanne's canvases aroused the most virulent opposition and threatened the fate of the late painter's intended bequest. After bitter negotiations from 1894 to 1897 between Caillebotte's executors and reluctant administrators, the state accepted thirty-eight paintings from the initial offering of sixty-five. The artists Claude Monet, Pierre Auguste Renoir, Alfred Sisley, Edgar Degas, and Pissarro were represented in the final selection by six to eight paintings each, whereas only two works by Cézanne were accepted of the five initially offered with the collection: *Farm Courtyard in Auvers* (ca. 1879–1880, fig. 10) and *The Gulf of Marseille from L'Estaque* (1878–1879, Musée d'Orsay).[5] Cézanne remained misunderstood; above all, he was so little known that a young artist as curious and well informed as Maurice Denis doubted his existence: "[Cézanne] has fled Paris. Does he really exist? Is he not a myth?"[6]

BEYOND IMPRESSIONISM

FIG. 12 **PAUL GAUGUIN**
Woman in Front of a Still Life by Cézanne (*Portrait de femme à la nature morte de Cézanne*), 1890
Oil on canvas
25 11/16 × 21 5/8 in. (65.3 × 54.9 cm)
Art Institute of Chicago, Joseph Winterbotham Collection, 1925.753

However, it was his fellow painters, followed by a few critics, who ultimately promoted his work and contributed to his discovery by wider circles.

Indeed, during the 1870s and 1880s Cézanne came to the forefront as one of the artists most respected and admired by his Impressionist peers. Pissarro, who instigated a creative exchange with Cézanne between 1865 and 1885, was one of the first to support him. Degas' rich private collection, which was split up in 1917, included seven paintings by Cézanne, among them *Bather with Outstretched Arms* (ca. 1883), which now belongs to the artist Jasper Johns. Paul Gauguin owned six works by Cézanne, including *Still Life with Fruit Dish* (1879–1880, fig. 11), which seemed to be his favorite: "The Cézanne that you want from me is an exceptional pearl," he wrote to the painter Émile Schuffenecker, "as dear to me as the apple of my eye, and unless it were vitally necessary I would hang on to it even after parting with my last shirt; besides, what madman is prepared to pay for this painting, you haven't told me!"[7] Gauguin went so far as to refer to the painting in one of his own compositions, *Woman in Front of a Still Life by Cézanne* (1890, fig. 12), reinforcing the nod to Cézanne evident in the model's pose. Gauguin had met Cézanne in Pontoise in 1881, but the relationship between the two artists remained distant despite Gauguin's admiration for his elder. In works such as *Still Life with a Fan* (cat. 60), Gauguin even adopted, in addition to the apple motif, the oblique, parallel hachures so characteristic of Cézanne's work of the 1880s.

From the early 1890s the critic Félix Fénéon identified those artists who belonged to the "Cézanne tradition," among them Paul Sérusier (whose *Still Life: The Artist's Studio* [1891, cat. 26] pays homage to the master), Émile Bernard, Charles Laval, Schuffenecker, and Denis.[8] They all discovered Cézanne's paintings through the Parisian paint merchant Julien-François Tanguy, known as *le père* Tanguy, whose shop was to Denis "the Salon Carré[9] for the master from Aix, the only place in Paris . . . where you can see his absurd, splendid works."[10] Around the same time, in 1894, at the instigation of his friend Monet, the critic and novelist Gustave Geffroy devoted a major article to Cézanne;[11] Cézanne later undertook to paint his portrait, an ambitious monumental work that was left unfinished (cat. 29).

This was the context of reappraisal that surrounded the first solo exhibition devoted to Cézanne. Vollard had difficulty finding the artist's work, but in the end he managed to gather, according to his count, 150 paintings. (There were probably considerably fewer, given the small size of the gallery.) The exhibition offered a panorama of Cézanne's art for the first time, from the beginning to the recent developments of 1894. And it was a shock, even to the artist's old Impressionist associates. Pissarro commented: "While I was admiring that curious, disconcerting side of Cézanne's work that I have felt for years now, Renoir arrived. But my enthusiasm was nothing compared to Renoir's. Degas himself also succumbed to the charming nature of this refined savage. Monet, everybody."[12]

By 1890 Cézanne's compositions had become increasingly rich and complex: eschewing a traditional depiction of perspective, he combined multiple viewpoints, as seen in *Kitchen Table* (1888–1890, cat. 20). With the exception of Chocquet, the painter's rare collectors, such as Caillebotte, Pissarro, Eugène Murer, Paul Gachet, and Zola, owned only works dating from before 1880.[13] Vollard's exhibition served to bring Cézanne into the history of modernism. It was no coincidence that Denis, in his *Homage to Cézanne* (1900, cat. 28) chose to pay tribute to the master in the gallery of the art dealer, whom we see behind the easel where some

of the Nabis have gathered. In the foreground, Sérusier, a great admirer of the artist, stands before a still life by Cézanne, none other than the *Still Life with Fruit Dish* that was so favored by Gauguin, its previous owner. This still life also reminds us of Cézanne's desire to "astonish Paris with an apple."[14] He wanted to make an impact with a simple, trivial motif, thereby affirming the power of representation and style as opposed to imitation.[15] Still life was the art form most readily accepted by those who continued to find Cézanne's work disconcerting, but the importance granted to Cézanne's exploration of that genre must not overshadow the immense fascination exerted by his nudes. In works such as *Bathers* (ca. 1890, cat. 24), sensuousness and anatomical precision have been banished in favor of a radical reinterpretation of the body and an emphasis on compositional harmony.

His quest for a "plastic beauty" through a method founded on a "logic of organized sensations,"[16] and on what Henri Matisse called "laws of architecture that are very useful to a young painter,"[17] showed the way to a "universal language"[18] for the generation of artists in the first half of the twentieth century. Universal, indeed, if we stop to think that at the dawn of the century, after the renewed shock of the Cézanne retrospective at the Salon d'Automne in 1906, artists as diverse as Georges Braque, Pablo Picasso, Matisse, the Fauvist Charles Camoin, and even Kasimir Malevich hailed Cézanne as a paragon. He was "the father of us all," in the words of Picasso,[19] who owned the very beautiful *Rocks near the Caves above the Château Noir* (cat. 25), and "the master of us all,"[20] as Matisse called him while gazing at the *Portrait of Madame Cézanne* (cat. 22), one of the jewels in his collection of Cézanne's works.

Translated from the French by Alison Anderson

NOTES

I would like to thank Sara Tas for her help.

1 Maurice Denis, "Cézanne," *L'Occident*, September 1907, reprinted in Maurice Denis, *Le ciel et l'Arcadie*, ed. Jean-Paul Bouillon (Paris: Hermann, 1993), 129ff.

2 He was accepted to the Salon only once, in 1882.

3 Georges Rivière, "L'exposition des impressionnistes," *L'Impressionniste*, April 14, 1877, 1–4.

4 See Theodore Reff, *Cézanne's Constructive Stroke* (Detroit: Detroit Institute of Art, 1962), 214–227.

5 The collection of the Musée d'Orsay contains all thirty-eight paintings of the Caillebotte bequest.

6 Maurice Denis, "L'époque du symbolisme," *Gazette des Beaux-Arts*, March 1934, reprinted in Denis, *Le ciel et l'Arcadie*, 208.

7 Letter from Gauguin to Émile Schuffenecker, June 1888, published in Paul Gauguin, *Lettres à sa femme et à ses amis*, ed. Maurice Malingue (Paris: Grasset, 1946), 149. The "madman" referred to by Gauguin is Schuffenecker himself.

8 Félix Fénéon, "M. Gauguin," *Le Chat Noir*, May 23, 1891, reprinted in Félix Fénéon, *Oeuvres plus que complètes*, vol. 1, ed. Joan U. Halperin (Geneva: Droz, 1970), 192–193.

9 The Salon Carré was one of the most prestigious rooms in the Louvre, where the Salon exhibitions were held and masterpieces such as Paolo Veronese's *Wedding at Cana* (1563) were displayed.

10 Denis, "L'époque du symbolisme," 208.

11 Gustave Geffroy, "Paul Cézanne," *Le Journal*, March 25, 1894, quoted in *Conversations avec Cézanne*, ed. P. M. Doran (Paris: Macula, 1978), 2.

12 Letter from Pissarro to his son Lucien, November 21, 1895, in *Correspondance de Camille Pissarro*, vol. 4, ed. Janine Bailly-Herzberg (Paris: Presses Universitaires de France: 1989), 119.

13 Chocquet had five paintings dated after 1882. See Robert Jensen, "Vollard and Cézanne: An Anatomy of a Relationship," in *Cézanne to Picasso: Ambroise Vollard, Patron of the Avant-Garde*, by Rebecca A. Rabinow et al. (New York: Metropolitan Museum of Art; New Haven, Conn.: Yale University Press, 2007), 39–57.

14 Gustave Geffroy, *Claude Monet: Sa vie, son oeuvre* (Paris: G. Crès, 1922), 106.

15 However, the motif is hardly trivial; the apple is linked to Cézanne's childhood and has a rich symbolic significance (Eve's apple of temptation). See Meyer Schapiro, "The Apples of Cézanne: An Essay on the Meaning of Still Life," in *Modern Art, Nineteenth and Twentieth Centuries: Selected Papers* (New York: George Braziller, 1978), 1–38.

16 Lawrence Gowing, "The Logic of Organized Sensations," in *Cézanne: The Late Work*, ed. William Rubin (New York: Museum of Modern Art, 1977), 55–71.

17 Henri Matisse, *Écrits et propos sur l'art*, ed. Dominique Fourcade (Paris: Hermann, 2005), 84. First published 1972.

18 Paul Sérusier, "Que pensez-vous de Cézanne?" *Le Mercure de France*, 1905, quoted in Michel Hoog, *Cézanne: Puissant et solitaire* (Paris: Gallimard, 1989), 154.

19 As told to Brassaï in 1943. Vincent David and Isabelle Mancarella, *Brassaï/Picasso: Conversations avec la lumière* (Paris: Musée Picasso, 2000).

20 Raymond Escholier, *Matisse, ce vivant* (Paris: Fayard, 1956), quoted in Matisse, *Écrits et propos sur l'art*, 84.

20

PAUL CÉZANNE

Kitchen Table (Still Life with Basket) (La table de cuisine [Nature morte au panier]), 1888–1890
Oil on canvas
25 5/8 × 31 1/2 in. (65 × 80 cm)

"The main thing is the modeling; one should not even say modeling, but modulating." With these words Cézanne exposed the essence of his practice, in which form and volume are represented not by shading but by subtly modulated colors. Exceptional among his still lifes, *Kitchen Table* is a complex assembly of various objects rendered from multiple viewpoints. It is through the repetition of similar shapes and the harmonious arrangement of yellows, reds, and greens that Cézanne masterfully brought his otherwise discordant composition into perfect balance.

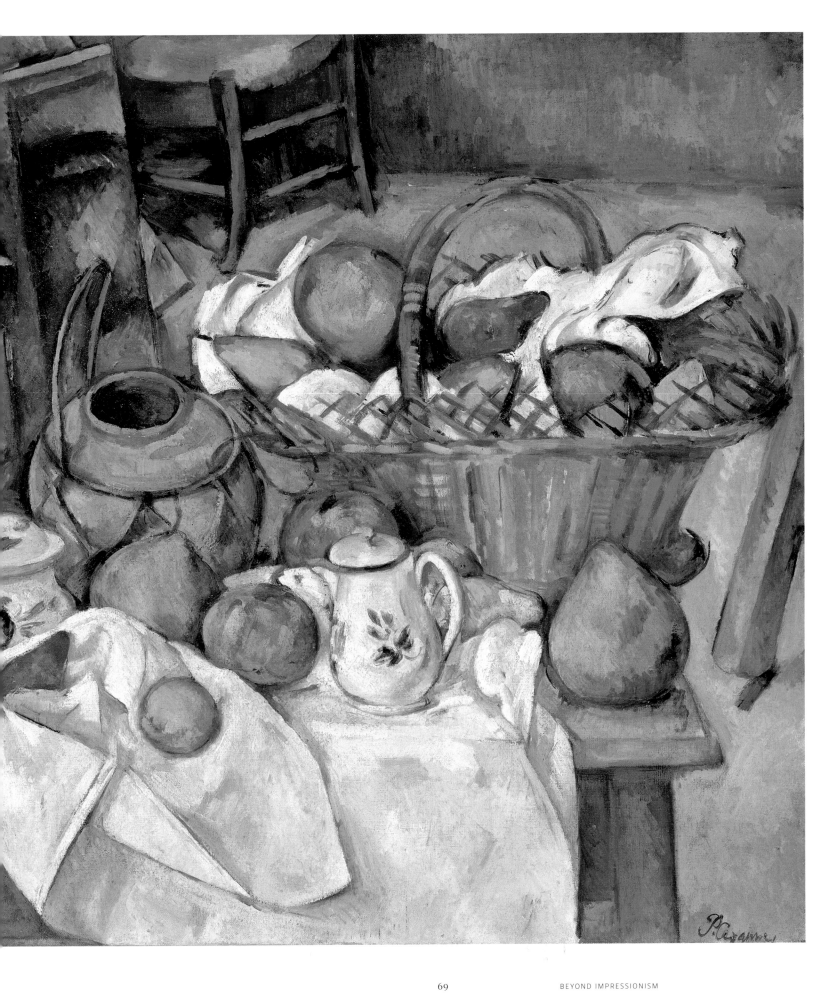

　　　BEYOND IMPRESSIONISM

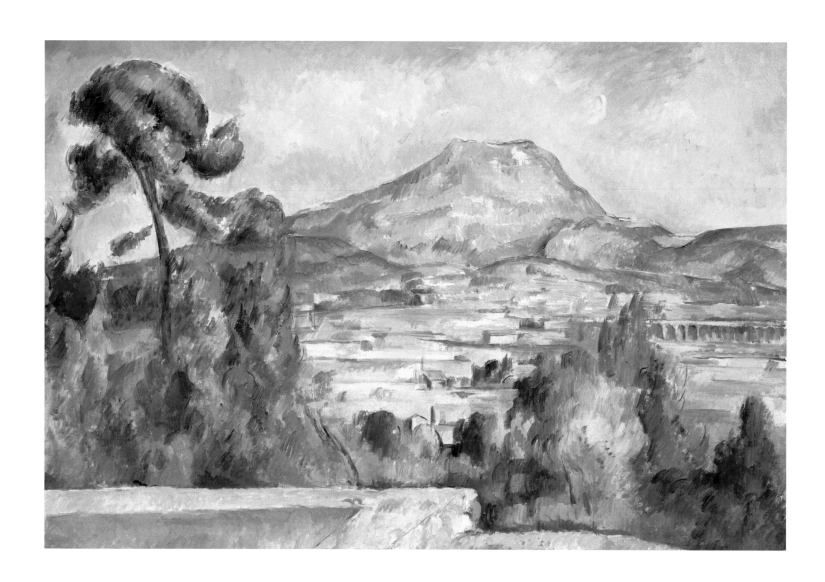

21

PAUL CÉZANNE

Mont Sainte-Victoire (*La Montagne Sainte-Victoire*), ca. 1890
Oil on canvas
25 ⁵⁄₈ × 36 ¹⁄₄ in. (65 × 92 cm)

From 1878 to 1890, Cézanne produced at least thirty paintings and numerous watercolors of Mont Sainte-Victoire in his native region of Aix-en-Provence. Framing this particular view with a balustrade and pine trees, he created an opposition between the objects in the foreground and the mountain in the background, which appears simultaneously near and far. Constructing his forms through the meticulous application of parallel brushstrokes, Cézanne achieved a unity of surface, composition, and expression that inspired generations of artists.

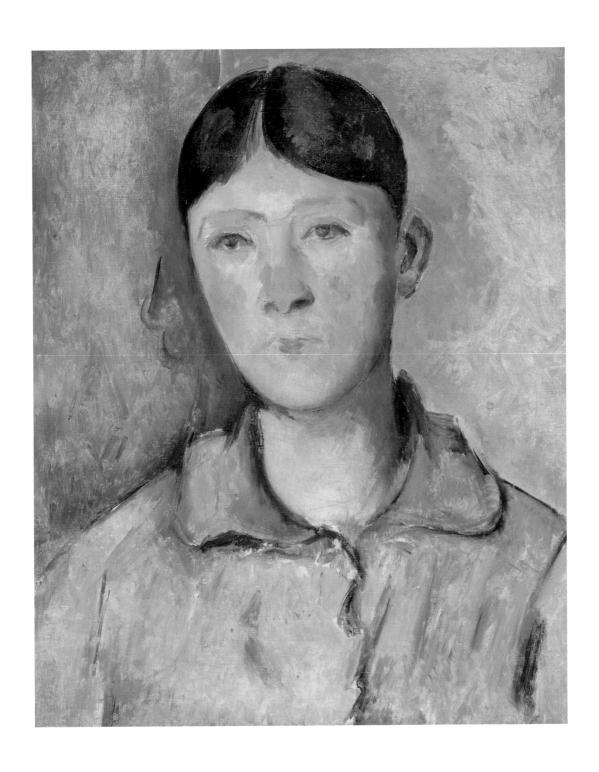

22

PAUL CÉZANNE

Portrait of Madame Cézanne (*Portrait de Madame Cézanne*), 1885–1890

Oil on canvas

18 1/2 × 15 3/8 in. (47 × 39 cm)

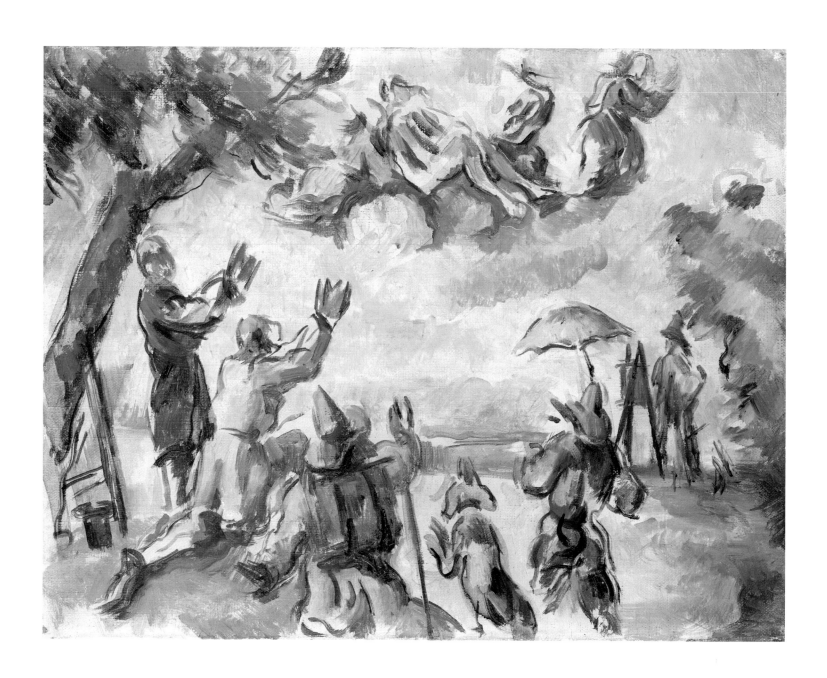

23

PAUL CÉZANNE

Apotheosis of Delacroix (*Apothéose de Delacroix*), 1890–1894
Oil on canvas
10 ⁵/₈ × 13 ³/₄ in. (27 × 35 cm)

Cézanne had a profound admiration for the nineteenth-century Romantic painter Eugène Delacroix, whose example had taught him the primacy of color in creating volume and shape. Though he began making studies as early as 1875, Cézanne never realized his dream to dedicate a finished painting to his hero. According to Bernard, this preparatory sketch includes, among others, Pissarro at his easel, Monet under an umbrella, and Cézanne with a walking stick paying tribute to Delacroix, who is being borne to heaven by angels.

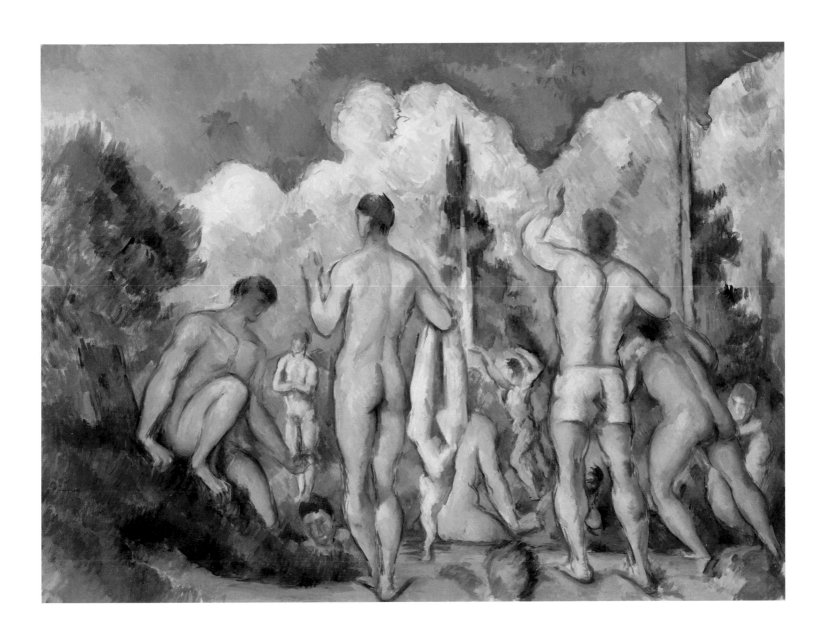

24

PAUL CÉZANNE

Bathers (Baigneurs), ca. 1890

Oil on canvas

23 ⅝ × 32 ¼ in. (60 × 82 cm)

25

PAUL CÉZANNE

Rocks near the Caves above the Château Noir (*Rochers près des grottes au dessus du Château Noir*), ca. 1904
Oil on canvas
25 5/8 × 21 1/4 in. (65 × 54 cm)

From 1890 until his death, Cézanne turned repeatedly to the rocky crags and gnarled trees on the grounds of the Château Noir. Representing fragments of landscapes without horizons or perspective, he invented a non-illusionistic pictorial space in which three-dimensional forms are reduced to multiple facets of shimmering color. Cézanne's revolutionary deconstruction of the natural world pushed representational painting to its limits and paved the way for the Cubism of Pablo Picasso and Georges Braque.

26

PAUL SÉRUSIER

Still Life: The Artist's Studio (*Nature morte: L'atelier de l'artiste*), 1891
Oil on canvas
23 ⅝ × 28 ¾ in. (60 × 73 cm)

Sérusier was drawn to the way Cézanne stripped his compositions of narrative
in order to explore the purely formal properties of painting. Here he adopted
Cézanne's preferred still-life motif of a fruit bowl and wrinkled white tablecloth.
Whereas in Cézanne's pictures a knife placed at an angle suggests spatial recession,
Sérusier's bright blue blade, which vibrates against the red tabletop, negates any
sense of depth. This insistence upon the utter flatness of the picture plane is a char-
acteristic of the Nabi aesthetic that he helped to develop in the late 1880s.

27

PAUL CÉZANNE

Still Life with Onions (Nature morte aux oignons), 1896–1898
Oil on canvas
26 × 32¼ in. (66 × 82 cm)

BEYOND IMPRESSIONISM

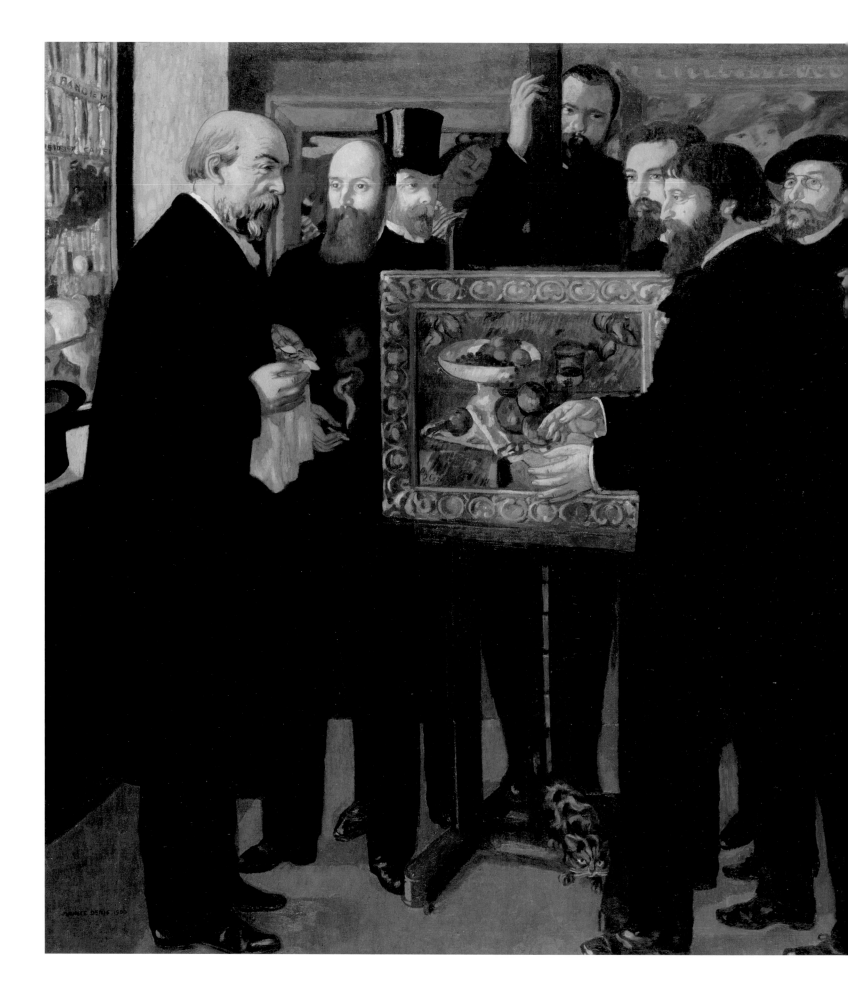

28

MAURICE DENIS

Homage to Cézanne (*Hommage à Cézanne*), 1900
Oil on canvas
70 7/8 × 94 1/2 in. (180 × 240 cm)

In this unusual group portrait set in Ambroise Vollard's
Parisian gallery, Redon, Vuillard, the critic and collec-
tor André Mellerio, Vollard, Denis, Sérusier, Ranson,
Roussel, Bonnard, and Marthe Denis are shown paying
homage to Cézanne's *Still Life with Fruit Dish* (fig. 11).
Abandoning his initial plan to celebrate Redon as the
father of Symbolism, Denis brought together all those
who recognized Cézanne as the master of a new means
of formal expression. This shift in subject reflects the
classicizing direction that Denis' art began to take
around 1900.

29

PAUL CÉZANNE

Gustave Geffroy, 1895–1896

Oil on canvas

43 ¼ × 35 in. (110 × 89 cm)

30

PABLO PICASSO

Large Still Life (*Grande nature morte*), 1917
Oil on canvas
34 1/4 × 45 5/8 in. (87 × 116 cm)

Painted in Avignon, a southern town in Provence, this work reflects Picasso's desire to establish himself as the direct heir to Cézanne's legacy. Borrowing one of Cézanne's preferred motifs, that of a still life on a wood table, Picasso both emulated and deconstructed his predecessor's unique transcription of three-dimensional space. Going one step further, he eliminated both modeling and color modulation, creating form and a sense of depth solely through the juxtaposition of angled geometric planes.

TOULOUSE-LAUTREC:
HIGH AND LOW IN MONTMARTRE

STÉPHANE GUÉGAN

His only rule: to be amused.

PAUL LECLERCQ[1]

Although his life was brief—he died in 1901 at the age of thirty-six—Henri de Toulouse-Lautrec was acknowledged in his time as one of the new and powerful forces of the fin-de-siècle period.[2] In Paris, Brussels, and London, admirers of his paintings and posters did not try to conceal their debt to him.[3] The eager young artist Pablo Picasso, around 1900, went so far as to imitate Toulouse-Lautrec's style and particular subject matter to an extreme degree. By 1886, the year he began illustrating sheet music for the songwriter Aristide Bruant, Toulouse-Lautrec had already begun to apply his specific style to depictions of the sordid pleasures of the Butte Montmartre. The bohemian neighborhood at the north side of Paris was known for its brothels and notorious nightclubs such as the Moulin Rouge and the Moulin de la Galette, the latter beloved by Renoir. Though he became a fixture among the neighborhood's performers, prostitutes, avant-garde artists, and literary anarchists, Toulouse-Lautrec never rejected his aristocratic roots, which went deep into his native Gascony. Related for centuries to the counts of Toulouse, his family had no qualms about enjoying the entitlements and activities that came with privilege, whether horseback riding or hunting. Did the artist betray his milieu through the immodesty of some of his images, as the Catholic press claimed after 1890? Because of his aristocratic and provincial background, it was not that easy, after all, to challenge social rules. By pointing a finger at a society that enjoyed its pleasures and vices behind closed doors, Toulouse-Lautrec followed in the footsteps of Jean-Louis Forain and Edgar Degas with the clear intention of capitalizing on their successes.

In the beginning, Toulouse-Lautrec's behavior did not especially scandalize his family, who were not terribly bourgeois in their attitudes. His father, of course, would have preferred that he pursue another kind of life and different artistic options. Correspondence between Count Alphonse and his son during the summer of 1886 showed a certain amount of disagreement. With some embarrassment and a lot of humor, the painter confessed to his grandmother in December that he went to Montmartre more to observe what went on there

than to misbehave.[4] The prostitutes, chanteuses, and cancan dancers who populate Toulouse-Lautrec's art are not there to make political statements; likewise, his pseudorealistic sketches for Bruant and the performer Jane Avril do not show any signs of social protest. At best one can sometimes detect in Toulouse-Lautrec's work a hint of commiseration with the wretched lot of the poor. In short, unlike Théophile Alexandre Steinlen and other politically involved artists, Toulouse-Lautrec did not take it upon himself to denounce the rich. In literary terms, his approach toward the debauched distractions offered in Montmartre is more reminiscent of early Joris-Karl Huysmans or the Goncourt brothers than of Émile Zola, who tended to moralize his approach to Parisian leisure. The world of cabarets and brothels was the perfect place for Toulouse-Lautrec to uncover human truths, such as the licentious freedom of the body or the insolence of a facial expression, which he conveyed with bold intensity in his art.

The young aristocrat from Albi was a conscientious and ambitious student. After receiving his baccalaureate degree, at the beginning of 1882 he started his training at the Paris studio of René Pierre Charles Princeteau. Toulouse-Lautrec had long been familiar with pencils and brushes, as his notebooks and correspondence show. One letter from this era points to his "rudimentary inspiration" and to his desire to "portray what is true, not what is ideal."[5] Compounding a congenital disorder, two childhood fractures to his thighbones prevented him from growing any taller than the five feet recorded in his papers. His face was no more attractive than his stunted adult body. It took courage and determination to confront the Parisian art world and its daubers. Princeteau, a friend of Toulouse-Lautrec's father and a good painter in the lineage of Alfred de Dreux and John Lewis Brown, soon became aware of the talent of his "studio nursling."[6] The apprentice's first sketches were bursting with bold lines and incredible color; henceforth, horses, with their beguiling strength, became part of Toulouse-Lautrec's heartfelt and expressive vocabulary.

In April 1882, on Princeteau's advice, Toulouse-Lautrec went to study with the more official Léon Bonnat. A letter to his grandmother records his new master's initial assessment: "Yes, there is something resembling color in you, but you will have to draw and draw."[7] It would be wrong to underestimate the importance of this transition, for it is an indication of just how great an interest Toulouse-Lautrec showed in the celebrities of the Salon, from Jean-Paul Laurens to Alfred Roll.[8] From 1880, just after the democratic shift of the Third Republic, Édouard Manet began receiving considerable attention at the annual exhibition. This was also the moment of glory for Jules Bastien-Lepage's rural scenes. The Naturalism of these painters, tempered to varying degrees, acted as a powerful stimulant to the young artist, and their impact soon became apparent in his work.

In autumn 1882 Bonnat closed his private studio to teach at the École des Beaux-Arts. Like a number of his fellow disciples, Toulouse-Lautrec decided to move to the studio of Fernand Cormon, who was known for preparing students for the various academic competitions. He explained to his father that it would be advantageous to continue his training with a painter who was "young and already famous." Speaking of the artist of the famous *Cain* (1880, Musée d'Orsay), presented two years earlier at the Salon, Toulouse-Lautrec wrote: "A powerful talent, austere and original. . . . Princeteau applauded the choice. I would have liked to try [Émile-Auguste] Carolus[-Duran], but that prince of color only produces second-rate draftsmen, which would be fatal as far as I'm concerned. Besides, we're not wedded for life!"[9]

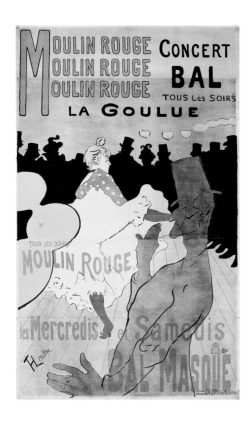

FIG. 13 **HENRI DE TOULOUSE-LAUTREC**
Moulin Rouge, 1891
Color lithograph
76 ¾ × 48 ⅜ in. (195 × 123 cm)
Musée des Arts Décoratifs, Paris, Inv. 11970

Toulouse-Lautrec's constant obsession was to delineate, emphasize, and characterize. To Bonnat and Cormon he clearly owed much of his future ease in using harsh light, activating perspective, accentuating bodies, and capturing faces with directness and even savagery. While he sometimes expressed a desire to enroll at the École des Beaux-Arts, Toulouse-Lautrec stayed with the amiable Cormon for five years, though he quickly reached the limits of his master's level of tolerance where modern art was concerned. But how could one expect a student of Alexandre Cabanel to appreciate the art of the painter of *Olympia*: "Long live the revolution! Long live Manet!" wrote the rebellious Toulouse-Lautrec in April 1883. "A wind of Impressionism is blowing through the studio. I am radiant, because for too long now I alone was targeted by Cormon's thunderbolts."[10] Toulouse-Lautrec's paintings—peasants at work, scantily dressed models—gained clarity in color and lightness in treatment under Cormon's tutelage.

After finishing his studies, during which time he became acquainted with Vincent van Gogh, Louis Anquetin, Émile Bernard, and many others, Toulouse-Lautrec set off under his own sails. At the end of 1886 his first drawings were published in the press, an initial sign of the vital link he would maintain with the media until his death. It was an era when illustration, posters, and pictorial advertising were enjoying a commercial and creative boom. Like Van Gogh and Bernard, with whom he exhibited in November 1887, Toulouse-Lautrec belonged to the informal group of the so-called Impressionists of the Petit Boulevard, whose work displayed the growing influence of Japanese art (see the essay "Van Gogh and Gauguin: The Resurrection of Delacroix?" in this volume). An aesthetic and thematic evolution had begun, yielding its first masterpieces by 1890. Flattened perspectives, diagonal compositions, simplified drawing, planes of sharp color: a new style was being born in the shadow of Montmartre. One example from this period, *Redhead (Bathing)* (1889, cat. 31), is related to two important events in modern painting: in January 1890 it appeared at the Salon des XX, the stronghold of the Brussels avant-garde;[11] and in December 1891 it was presented at the first exhibition of the Galerie Le Barc de Boutteville.[12] The model's pose was still within the bounds of decency, despite her gaping thighs and the sight of her black stocking. The Japanese influence is inherent in the composition, and the streaks of color are reminiscent of Degas' pastels, particularly those exhibited in 1886 at Boussod, Valadon et Cie.[13] The art dealer Theo van Gogh, who was associated with that gallery, supported the early efforts of his brother Vincent's friend and brought him into the fold. In 1890 the Salon des Indépendants also opened its doors to Toulouse-Lautrec, notably with *At the Moulin Rouge: The Dance* (1890, Philadelphia Museum of Art).

Around this time the lionesses of the Moulin Rouge, especially La Goulue, began to invade Toulouse-Lautrec's work with their audacious silhouettes. His poster for the popular cabaret, featuring La Goulue and the male cancan dancer Valentin le Désossé, was seen all over Paris at the end of 1891 (fig. 13). Suddenly, the famous posters of Jules Chéret were no longer in fashion. A victory.[14] Toulouse-Lautrec's first color lithographs were followed by illustrated books and stained-glass designs for the art dealer Siegfried Bing and Louis Comfort Tiffany. The dominance of drawing in his art led to a style related to Cloisonnism, characterized by the use of clear, bold lettering and strongly outlined planes. Given the success of his posters, some forgers began to imitate his sparse graphic style. In the anarchist publication *Le Père Peinard*, the critic Félix Fénéon, a friend of the artist's, encouraged his readers to tear down Toulouse-Lautrec's posters from the walls around Paris. Toulouse-Lautrec nurtured good relations with

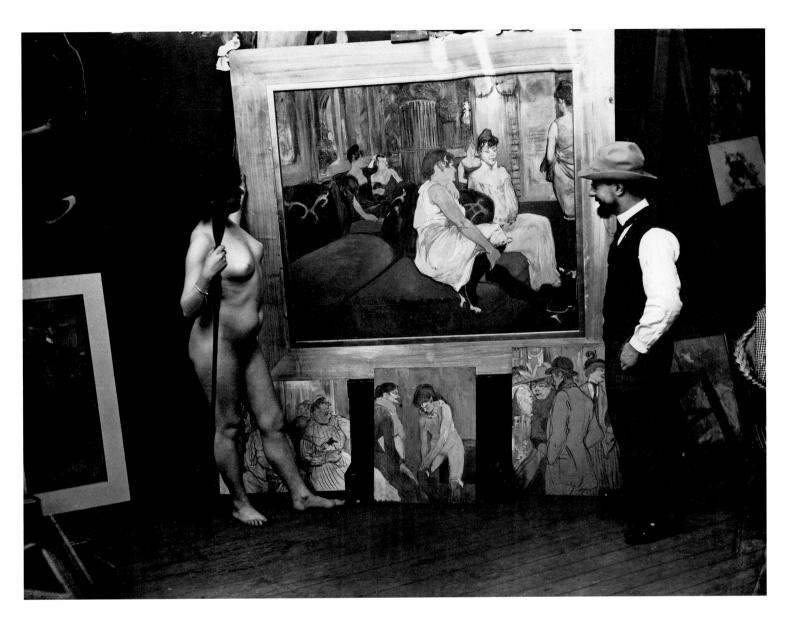

FIG. 14 **PAUL SESCAU**
*Henri de Toulouse-Lautrec and Model Viewing the
Painting* At the Salon *in His Studio*, ca. 1894
Gelatin silver print
5 1/8 × 13 9/16 in. (13 × 34.4 cm)
Fine Arts Museums of San Francisco, museum
purchase, Achenbach Foundation for Graphic Arts
Endowment Fund, 2000.140

a number of progressive critics, such as Claude Roger-Marx, who was closely connected to the revolution in printmaking in the 1890s.

Stimulated by the success of his posters, Toulouse-Lautrec began painting with increased concision. *Woman with a Black Boa* (1892, cat. 32) says it all in a few brushstrokes, streaks of mostly dark blue and lemon yellow, in the middle of which are gleaming feline eyes, an impish mouth, and the white powder of a face that, to this day, has not been identified. Is she the forgotten sister of La Goulue? The dancer Jane Avril, the singer Yvette Guilbert, or the clown Cha-U-Kao? His painting of the latter (1895, cat. 34) burns with its golden yellows and reds, the likes of which only Degas, Forain, or Paul Gauguin could hope to equal. By this era Toulouse-Lautrec had already painted his first brothels, whose melancholy denizens, with their vacant and somewhat bored expressions, convey a sense of calm as they wait for their customers. These scenes offered a world of women in the gaze of a grateful client, a man who was neither arrogant nor cynical but almost tender. In contrast, other images, like *Woman Pulling Up Her Stockings* (ca. 1894, cat. 33, and fig. 14), pointed out "the brutish sexuality of the *fille de maison*"[15] and the hierarchical relations of the brothel environment.

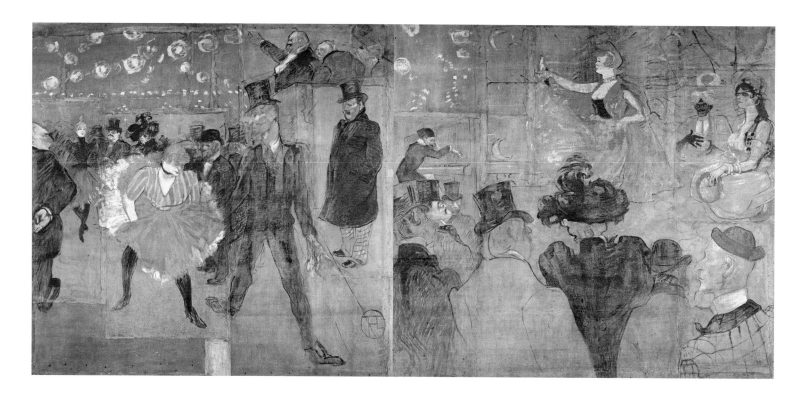

FIG. 15 **HENRI DE TOULOUSE-LAUTREC**
*Panels for the Booth of La Goulue, La Foire du Trône,
Paris* (*Panneaux pour la baraque de la Goulue, à la
Foire du Trône à Paris*), 1895
Oil on canvas
117 3/8 × 124 3/8 (298 × 316 cm)
Musée d'Orsay, RF 2826

In the mid-1890s the avant-garde literary circle associated with *La Revue Blanche*, founded by the Natanson brothers, and the revival of the theater contributed to the close connection between Toulouse-Lautrec and the Nabis, especially Pierre Bonnard and Édouard Vuillard. (See the essay "The Nabis and Symbolism in 1890s Paris" in this volume.) In 1894 Arthur Hic, a critic, grasped the divisions in the contemporary art world: under the label *néo-traditionnistes* he put Maurice Denis and Paul Ranson; and the category *néo-réalistes* brought Toulouse-Lautrec and Anquetin closer to Félix Vallotton, Bonnard, and Vuillard. It would be hard to imagine Denis painting La Goulue's stage for the audience at the Foire du Trône (1895, fig. 15), or lesbian lovers, or Oscar Wilde, or the down-and-out habitués of Le Rat Mort. Toulouse-Lautrec had chosen sides.

While his career continued to thrive—his friend Maurice Joyant, Theo van Gogh's successor at the gallery, was able to sell all of his production—the artist began to suffer increasingly from the combined effects of alcoholism and syphilis. In 1899 he was sent to an asylum for two months of detoxification treatment. A broken man, Toulouse-Lautrec lived only two more years, during which he never ceased drawing and painting. His style changed one last time, growing darker and returning to the chiaroscuro of his early work. On July 23, 1891, he left Paris to go and die at his family home.

Translated from the French by Alison Anderson

NOTES

1. Paul Leclercq, *Autour de Toulouse-Lautrec* (Geneva: P. Cailler, 1954), 18–25. First published 1921.

2. Two publications have contributed to a reinterpretation of the art and career of Toulouse-Lautrec, thereby informing this brief introduction: Claire Frèches-Thory, Anne Roquebert, Richard Thomson, and Danièle Devynck, *Toulouse-Lautrec* (New Haven, Conn.: Yale University Press, 1991); and Richard Thomson, Phillip Denis Cate, and Mary Weaver Chapin, *Toulouse-Lautrec and Montmartre* (Washington, D.C.: National Gallery of Art, 2005).

3. See Anna Gruetzner Robins and Richard Thomson, *Degas, Siskert, and Toulouse-Lautrec: London and Paris 1870–1910* (London: Tate Publishing, 2005).

4. See, for example, the letter from Toulouse-Lautrec to his grandmother Madame Raymond-Casimir de Toulouse-Lautrec, December 28, 1886: "I'd like to speak to you a bit about what I am doing, but it is so special, so outside the law. Papa would treat me, of course, as an *outsider*. I've had to make an effort because, you know as well as I do, against my will, I've landed right in the midst of a Bohemian sort of life and I'm not getting used to this environment. I'm all the more ill at ease in the Butte Montmartre in that I feel I am being held back by a number of emotional considerations that I absolutely must forget if I am to get anywhere." See Henri de Toulouse-Lautrec, *Correspondance*, ed. Herbert Schimmel (Paris: Gallimard, 1992), 142.

5. Toulouse-Lautrec to Étienne Devismes, October 1881, reprinted in ibid., 88–89.

6. See Claire Frèches and José Frèches, *Toulouse-Lautrec: Scenes of the Night* (New York: Harry N. Abrams, 1994), 21.

7. Toulouse-Lautrec to Madame R.-C. de Toulouse-Lautrec, January 2, 1882, reprinted in Toulouse-Lautrec, *Correspondance*, 92.

8. On the artist's Naturalist and academic background, see Gale Barbara Murray, *Toulouse-Lautrec: The Formative Years* (Oxford: Oxford University Press, 1990).

9. Toulouse-Lautrec to Count Alphonse de Toulouse-Lautrec, September 1882, reprinted in Toulouse-Lautrec, *Correspondance*, 98.

10. Toulouse-Lautrec to his mother, April 1883, reprinted in ibid., 104.

11. He had exhibited his work at the Salon des XX for the first time in 1888.

12. The inaugural exhibition, introduced as the exhibition of "Impressionist painters and Symbolists," showed seven works by Toulouse-Lautrec.

13. On Toulouse-Lautrec's connection with Degas' pastels, see the essay by Richard Thomson in Frèches-Thory et al., *Toulouse-Lautrec*, 128.

14. Toulouse-Lautrec to his mother, December 26, 1891, reprinted in Toulouse-Lautrec, *Correspondance*, 185: "We've just opened a shop, a sort of perpetual exhibition, on the rue Le Peletier [the Le Barc de Boutteville gallery]. The newspapers behaved very kindly toward your offspring. I'm sending you an excerpt, written with honey ground in incense. My poster [of the Moulin Rouge] was a success on the walls, despite a few malapropisms on the part of my printer that have disfigured my product somewhat."

15. Thomson in Frèches-Thory et al., *Toulouse-Lautrec*, 419.

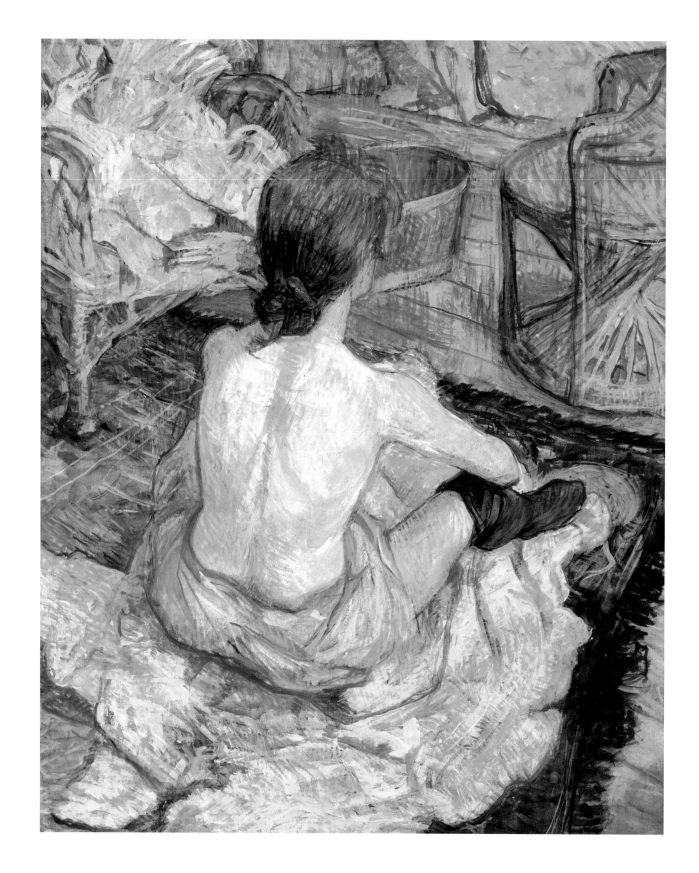

31

HENRI DE TOULOUSE–LAUTREC

Redhead (Bathing) (*Rousse [La toilette]*), 1889
Oil on board
26 3/8 × 21 1/4 in. (67 × 54 cm)

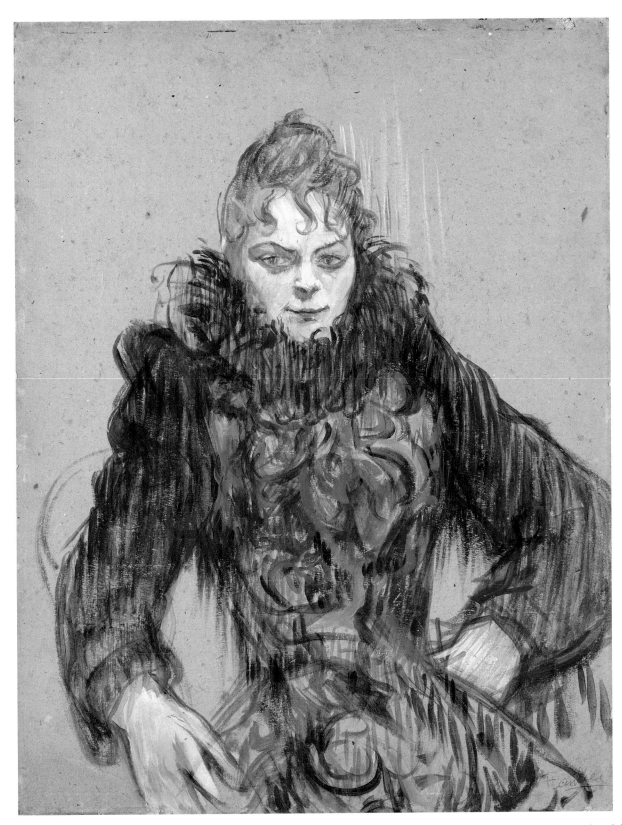

32

HENRI DE TOULOUSE-LAUTREC

Woman with a Black Boa (*Femme au boa noir*), 1892
Oil on board
20 7/8 × 16 1/8 in. (53 × 41 cm)

Though born into an aristocratic family, Toulouse-Lautrec preferred the seedy underworld of Montmartre and became a keen observer of the denizens of its cabarets and dance halls. Applying methods of caricature with rapid execution, he captured the essence of his sitters' personalities, as in this portrait of a smirking woman whose identity remains unknown. Playing up her garish white makeup and ruffled black attire, Toulouse-Lautrec exposed the artificiality that characterized the demimonde at the turn of the century.

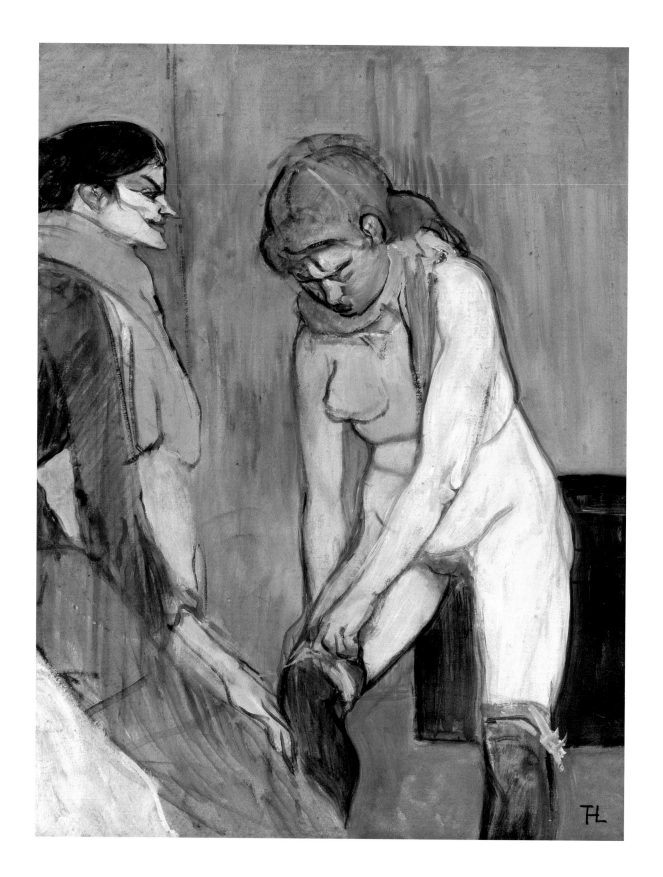

33

HENRI DE TOULOUSE-LAUTREC

Woman Pulling Up Her Stockings (*Femme tirant son bas*), ca. 1894
Oil on board
22 7/8 × 18 1/8 in. (58 × 46 cm)

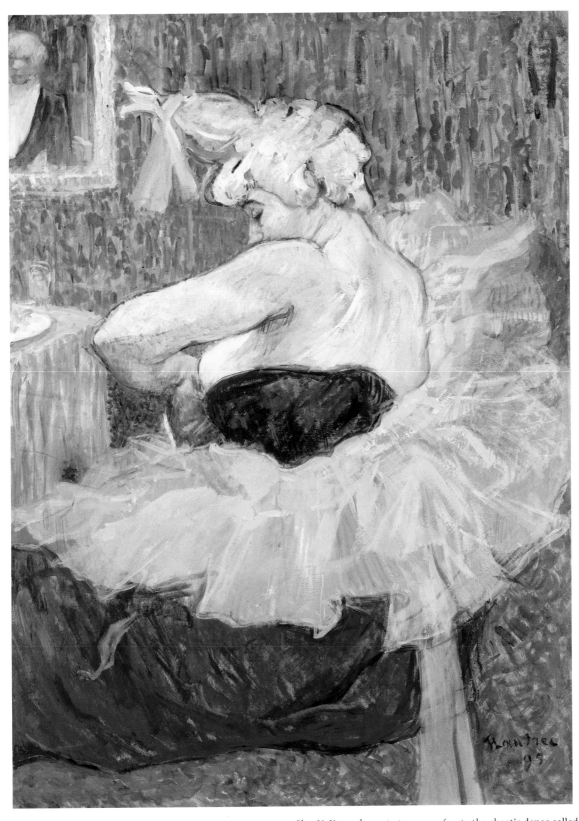

Cha-U-Kao, whose stage name refers to the chaotic dance called *le chahut*, was both a clown and a dancer in Montmartre's famed entertainment venues. One of Toulouse-Lautrec's favorite celebrities, she was frequently depicted by him dancing onstage, though here we are offered a rare glimpse behind the scenes. While it would seem we are observing an act of personal intimacy, the reflection of a man in the mirror at the upper left, perhaps a client, suggests that she is still in character and performing before an audience of one.

34

HENRI DE TOULOUSE-LAUTREC

The Clown Cha-U-Kao (*La clownesse Cha-U-Kao*), 1895
Oil on board
25 ¼ × 19 ¼ in. (64 × 49 cm)

NEO-IMPRESSIONISM: A METHODICAL UTOPIA

STÉPHANE GUÉGAN

·

After all, an apple by Cézanne, a thigh by Degas: are they not more revolutionary than any work of propaganda, if it has been given an academic execution?

PAUL SIGNAC[1]

In an article published in 1951, Henri Matisse conceded his debt to the inspiring example of Paul Signac, from whom he had learned a great deal between 1900 and 1905. His confession contained serious reservations, however:

> All the canvases of [the Neo-Impressionist] school produced the same effect: a bit of pink, a bit of blue, a bit of green, a very limited palette with which I was not at all at ease. [Henri Edmond] Cross told me I would not adhere to their theory for very long, but he didn't explain why. Later, I understood. My dominant colors, which were supposed to be supported and emphasized by contrasts, were in fact being devoured by those same contrasts, which I had made as important as the dominant ones. This led me to paint using flat tints. This was Fauvism.[2]

There was a decisive break, therefore, between the two movements. In opposition to the Neo-Impressionism of Signac and his circle—too balanced, too even, and too docile—after 1905 Fauvism became aesthetically shocking, more ardent, and less academic. In his statements, Matisse deliberately overlooked Signac's chromatic ardor after 1892, as seen in the cadmium yellow of *Women at the Well* (1892, cat. 50), and Cross's fiery bacchanals, such as *The Evening Air* (1893–1894, Musée d'Orsay).

The search for chromatic and linear harmony had indeed been a principle dear to Signac and his group. Baptized the Neo-Impressionists in 1886 by the critic Félix Fénéon, these painters were the obvious heirs to Claude Monet and Pierre Auguste Renoir, attentive to both Eugène Delacroix's example and Charles Baudelaire's texts. They redirected these precedents toward a more reasoned, if not scientific, aesthetic. Over time, research into optics, particularly concerning the active perception of colors and the law of complementary colors, enhanced the

Impressionists' lessons. The Neo-Impressionists moved beyond their predecessors, forging a different path through new themes of urban modernity, from manual labor to leisure, from the anonymity of city life to popular entertainment. And if contemporary society played a significant role in the group's paintings, it was also for political reasons.

Most of the Neo-Impressionists dabbled in social anarchism, something Camille Pissarro had been closely involved with well before his unexpected conversion to the style, as seen in *Hoarfrost, Peasant Girl Making a Fire* (1888, cat 49).[3] The dominant figures of the movement, Georges Seurat and Signac, came to maturity at the time of the Republican transition following the election of Jules Grévy in 1879. The disappointed hopes of true political change also produced other artists, such as Maximilien Luce. The art of this socially activist circle found its formal language and vocabulary between 1880 and 1886.

The brief career of Seurat, the most brilliant of the group in terms of inventiveness, followed a decisive academic experience. The instruction he received at the École des Beaux-Arts, beginning in 1878, and at the studio of Henri Lehmann severed him from the aesthetic principles espoused by Jean-Auguste-Dominique Ingres. Right from the start Seurat was anxious to be associated with a Neoclassical lineage. He was an admirer of Pierre Puvis de Chavannes, whose *Poor Fisherman* (1881, cat. 100) he incorporated into a landscape painting (ca. 1881, cat. 99). A series of copies based on antiquity and the Old Masters, from Raphael to Ingres, survives from this period of his life.[4] Other influences soon became apparent in his work. *The Little Peasant in Blue (The Jockey)* (cat. 36) belongs to a series of vaguely rustic figures that Seurat painted about 1882, echoing the work of the successful Naturalists Jean-François Millet and Jules Bastien-Lepage. There are overtones of Impressionism, but they are associated with a firmly constructed manner and the emphatic silence of the face. In the areas of pure color, where there was no division into primary and complementary colors, the young painter employed very broad brushstrokes that were still a long way from his later pointillist technique.

Seurat's study for *Bathers at Asnières* (1883, cat. 35) remained largely indebted to Impressionism, except for the references to the Italian masters in its sharp layout. It was preparation for a large canvas that would combine the monumental scale of a *grand genre* painting with a socially topical subject—that of laborers bathing in the Seine near an industrial suburb of Paris. *Bathers at Asnières* (1884, fig. 16) was shown at the very first Salon des Indépendants, in 1884. Charles Angrand and Albert Dubois-Pillet, future Neo-Impressionists, also participated in that exhibition. Angrand's *Couple in the Street* (1887, cat. 51) is comparable to what Van Gogh developed quickly after he settled in Paris. The newcomer was also interested in merging the pointillist technique and the working-class subject matter that were dear to Signac's friends. Seurat, meanwhile, quickly abandoned his portrayals of the *petit peuple* in order to focus on the petty bourgeoisie of his own background. His second opus, *A Sunday on La Grande Jatte—1884* (1884–1886, fig. 8), was first shown publicly at the eighth and final Impressionist exhibition in 1886. In this Sunday-outing scene, with hints of irony befitting Honoré de Balzac, Seurat criticized differences of class and gender in contemporary society.

Seurat and Signac participated in the Impressionist exhibition thanks to the influence of their friend and new disciple, Pissarro, who chose deliberately to show his works alongside theirs. His son Lucien did the same. It had been an uphill battle to overcome the reluctance of Edgar Degas and Paul Gauguin. But the one who had been most opposed to the

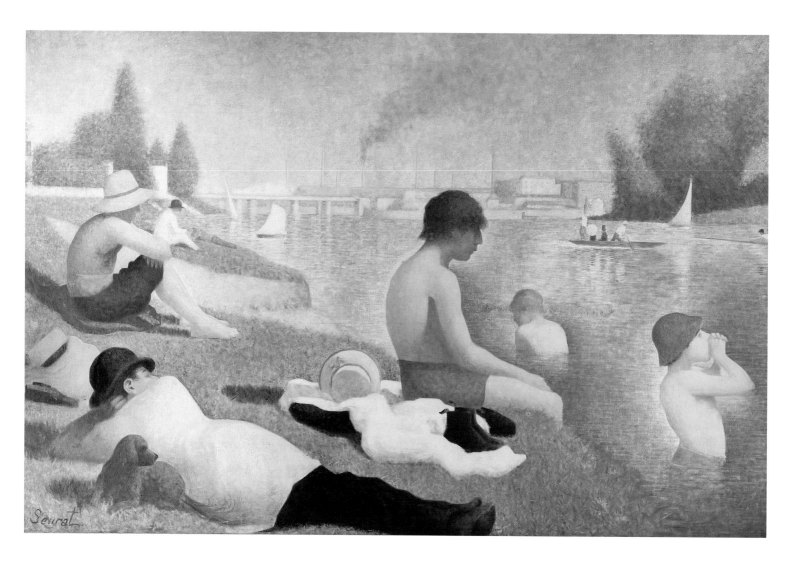

FIG. 16 **GEORGES SEURAT**

Bathers at Asnières (*Une baignade, Asnières*), 1884
Oil on canvas
79 1/8 × 118 1/8 in. (201 × 300 cm)
National Gallery, London, NG3908

arrival of the young Neo-Impressionists was certainly Eugène Manet, Berthe Morisot's husband and the painter's brother. A letter from Pissarro to his son, dated May 8, 1886, clearly reveals the tension that led very quickly to a definitive break: "Yesterday I had a fairly heated row with M. [Eugène] Manet regarding Seurat and Signac; Signac was there as well, as was [Armand] Guillaumin. You can be sure that I gave him a rough time, straight out. M. Manet wanted to keep Signac from exhibiting his figurative tableau. I protested."[5] The painting by Signac that caused much trouble was clearly *The Milliners* (1885–1886, Foundation E. G. Bührle Collection, Zurich).[6]

A Sunday on La Grande Jatte established what Seurat referred to as "my technique."[7] The little sketches in the Orsay collection (cats. 37–38) are a modest testament to his method, with their refined, crosshatched brushstrokes relating to the color wheel that was theorized by Michel Eugène Chevreul, Charles Blanc, and Charles Henry. The application of the pigments in these sketches strove for maximum luminosity and a continuous optical vibration on the surface. Contemporary criticism was sensitive to the surprising brilliance of the new recruits in the Impressionist group:

> They have managed to produce intense coloring with the help of observation as precise as it is simple. . . . They've avoided any muddiness in their painting by using tiny brushstrokes,

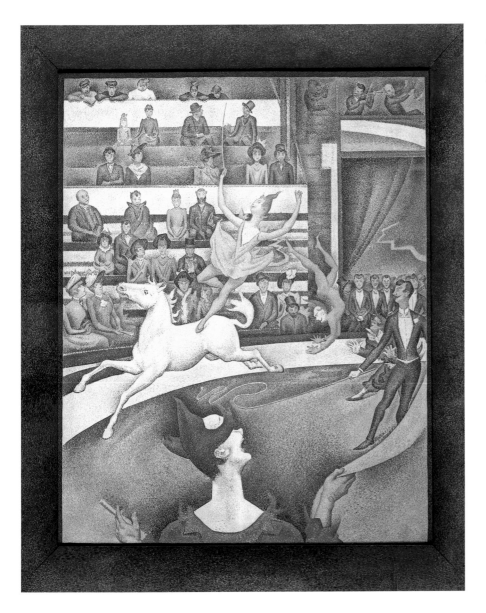

FIG. 17 **GEORGES SEURAT**
The Circus (*Le cirque*), 1891
Oil on canvas
73 × 60 in. (185.5 × 152.5 cm)
Musée d'Orsay, RF 2511

little dotted points, or the juxtaposition of colors: the mixture occurs in the eye, not on the palette. They paint by attenuating, by modifying the local color of an object through reflections of the strongest adjacent color. They have, so to speak, restored the virginity of the eye, forgetting conventional colors in order to find, on their own, the right note. And they have succeeded.[8]

The last masterpiece of Seurat's brief career, *The Circus* (1891, fig. 17), emphasizes social hierarchy by using a vertical composition to arrange the horsewoman's spectators in tiers according to their rank. The sketch for the final painting (cat. 1) is a pure demonstration of the pattern of colored dots that characterizes the artist's technique, which is as instinctive as it is methodical. There are strong contrasts of green and red, blue and orange, and so on. But also striking are the vigorous lines and curved diagonals that give structure to the composition. The flying gallop of the bluish horse, whose form is certainly not up to date with the motion discoveries of the photographer Eadweard Muybridge (see fig. 5), calls into question the artist's so-called scientific obsession.

FIG. 18 **PAUL SIGNAC**

In the Era of Harmony (*Au temps d'harmonie*),
1893–1895
Oil on canvas
118 1/8 × 157 1/2 in. (300 × 400 cm)
Mairie de Montreuil, Paris

Just as Théodore Géricault's untimely death liberated Delacroix in 1824, Seurat's death in 1891, at the age of thirty-one, made Paul Signac into a very efficient leader of the group. He had the strength for it, as well as the "rage," as Pissarro called it. The publication of his book *D'Eugène Delacroix au néo-impressionnisme* designated him in 1899 as the theoretician of the aesthetics he had forged with Seurat but practiced independently since the mid-1880s. Critics quickly noticed his tendency to use bolder and brighter colors, to paint more and more proudly. One year after Seurat died, Signac settled in Saint-Tropez, having discovered Cassis and painted its pink beaches. His move to this sunny resort town would quickly reorient his painting without altering its political implications. Leaving behind the concerns of the working class and the neuroses of the bourgeoisie, Signac henceforth made light and pure air the symbols of a better life, in which humanity would reunite and renew its pact with nature. The golden age lay ahead. But spreading the message of this imminent Arcadia called for painting on a large scale—decoration that was public, tonic, and colorful. So, like Gauguin, Signac was convinced of the necessity to produce "colored Puvis" tableaux.[9] *In the Era of Harmony* (1893–1895, fig. 18), a vast Mediterranean panorama, "incarnated all the bucolic dreams contained in the

innocent anarchism practiced ecstatically by all young people in those days."[10] Exhibited at the Salon des Indépendants in 1893, *Women at the Well* (1892, cat. 50) was reminiscent in its construction of Seurat's *Bathers at Asnières* and made explode a lemon yellow worthy of Van Gogh. This joyful painting, exquisitely rustic, was intended to be "decoration for a panel in the half-light."[11] To his friend Cross, who was also drawn to producing vast canvases, such as *Madame Hector France* (1891, cat. 52), Signac wrote:

> We have to produce big paintings. . . . Who will follow the great decorators, Giotto and Delacroix? . . . As Seurat was closer than Puvis to coming in third. . . . Without daring to compare ourselves to such names, shouldn't we try to go that way all the same. . . . Why, since we both know and love this land of sunshine, don't we try together to produce a decorative monument to it . . . and support each other with mutual advice.[12]

The two friends, to the very end, nourished their ambition to make "great decoration"—the subject of one of the sections of this exhibition. Their loyalty to the Neo-Impressionist program of the 1890s did not prevent them from developing their pointillism in order to achieve a more virile technique, one less disciplined and more in line with the repercussions of Fauvism at the dawn of the new century.

Translated from the French by Alison Anderson

NOTES

1 Paul Signac, "Préface," in *Vingt-trois artistes soviétiques* (Paris: Galerie Billet, 1933).

2 E. Tériade, "Matisse Speaks," *Art News* (November 8, 1951): 40–71; reprinted in *Art News Annual*, no. 21 (1952).

3 On Neo-Impressionism's political dimension, see John G. Hutton, *Neo-Impressionism and the Search for Solid Ground* (Baton Rouge: Louisiana State University Press, 1994). For an inspired and convincing sociohistorical approach, see Richard Thomson, *Seurat* (London: Phaidon, 1985).

4 Ingres seems to be the master Seurat chose most often when executing his copies. There is even a copy of *Self-Portrait* by Nicolas Poussin (1650, Musée du Louvre) after an etching from *The Apotheosis of Homer* (1827) by Ingres. See Robert L. Herbert et al., *Seurat* (New York: Metropolitan Museum of Art, 1991), 55–59. Therefore, it may be a mistake to portray Seurat as having admired exclusively the work of Puvis de Chavannes, who was perhaps the only modern artist who gave a fresh interpretation to the great masters of the past. The influence of Ingres on Seurat is as worthy of study as is his influence on Degas.

5 Letter from Pissarro to his son Lucien, May 8, 1886, quoted in Anne Distel, *Signac au temps d'harmonie* (Paris: Gallimard/Réunion des Musées Nationaux, 2001), 23.

6 See Françoise Cachin and Marina Ferretti-Bocquillon, *Signac: Catalogue raisonné de l'oeuvre peint* (Paris: Gallimard, 2000), no. 111, 171. This publication is the essential work on the artist.

7 Letter from Seurat to Félix Fénéon, June 20, 1890, reprinted in Herbert et al., *Seurat*, 383.

8 Jean Ajalbert, "Le Salon des impressionnistes," *Revue Moderne*, June 20, 1886.

9 See the letter from Gauguin to Émile Bernard, October–November 1888, in *Correspondance de Paul Gauguin: Documents, témoignages*, ed. Victor Merlhès (Paris: Fondation Singer-Polignac, 1984), 176.

10 Gustave Kahn, "Images et souvenirs: Paul Signac," *Le Quotidien*, August 21, 1935, 2.

11 At the 1893 Salon des Indépendants, the whole title was given as *Jeunes provençales au puits, décoration pour un panneau dans la pénombre* (*Young Women from Provence at the Well, Decoration for a Panel in the Shadows*). See Cachin and Ferretti-Bocquillon, *Signac*, 210.

12 Distel, *Signac au temps d'harmonie*, 70–71.

35

GEORGES SEURAT

Study for Bathers at Asnières
(*Étude pour* Une baignade à Asnières), 1883
Oil on panel
6 1/8 × 9 7/8 in. (15.5 × 25 cm)

Taking on the popular Impressionist subject of outdoor urban leisure, Seurat worked for a year making studies along the banks of the Seine in the industrial Parisian suburb of Asnières. This small panel is one of the fifteen resulting preparatory sketches for his first major canvas, *Bathers at Asnières* (fig. 16). The highly structured composition recalls the organization of ancient Egyptian and Greek friezes and reveals the formal classicism that characterizes Seurat's monumental canvases.

36

GEORGES SEURAT
The Little Peasant in Blue (The Jockey) (*Le petit paysan en bleu [Le jockey]*), ca. 1882
Oil on canvas
18 1/8 × 15 in. (46 × 38 cm)

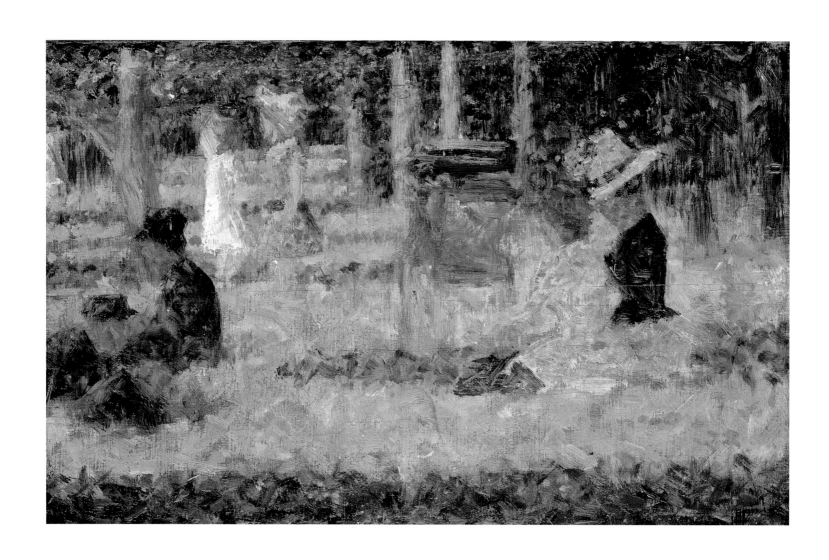

37

GEORGES SEURAT

Study for A Sunday on La Grande Jatte—1884 (*Étude pour
Un dimanche après-midi à l'île de la Grande Jatte*), 1884–1886
Oil on panel
6¼ × 9⅞ in. (16 × 25 cm)

38

GEORGES SEURAT

Study for A Sunday on La Grande Jatte—1884 (*Étude pour*
Un dimanche après-midi à l'île de la Grande Jatte), 1884
Oil on panel
6 ⅛ × 9 ⅞ in. (15.5 × 25 cm)

As he did for all his large canvases, Seurat made numerous small-scale studies in preparation for *A Sunday on La Grande Jatte—1884* (fig. 8), his great pointillist masterpiece. Painted with loose, often crisscrossing strokes, these sketches seem to record Seurat's spontaneous transcription of various social types relaxing on the banks of La Grand Jatte, an island located in the Seine. The static, solidly rendered figures, however, foreshadow the final painting, in which Seurat transformed the fleeting and ephemeral into the concrete and eternal.

BEYOND IMPRESSIONISM

39
GEORGES SEURAT
Model Standing, Facing the Front or *Study for* The Models
(*Poseuse debout, de face* ou *Étude pour* Les poseuses), 1886
Oil on panel
10 1/4 × 6 1/8 in. (26 × 15.7 cm)

40

GEORGES SEURAT

Model from the Front (*Poseuse de face*), 1887
Oil on panel
9 ⁷⁄₈ × 6 ¼ in. (25 × 16 cm)

Seurat made numerous sketches for his third large canvas, *The Models* (1886–1888), a modern version of the Three Graces set within the artist's studio. In selecting the academic genre of the nude, Seurat intended not only to demonstrate the application of his technique to indoor subjects but also to situate Neo-Impressionism within France's great tradition. Freely painted, these studies have an astonishing vibrancy and sensuality that are lacking in the finished picture.

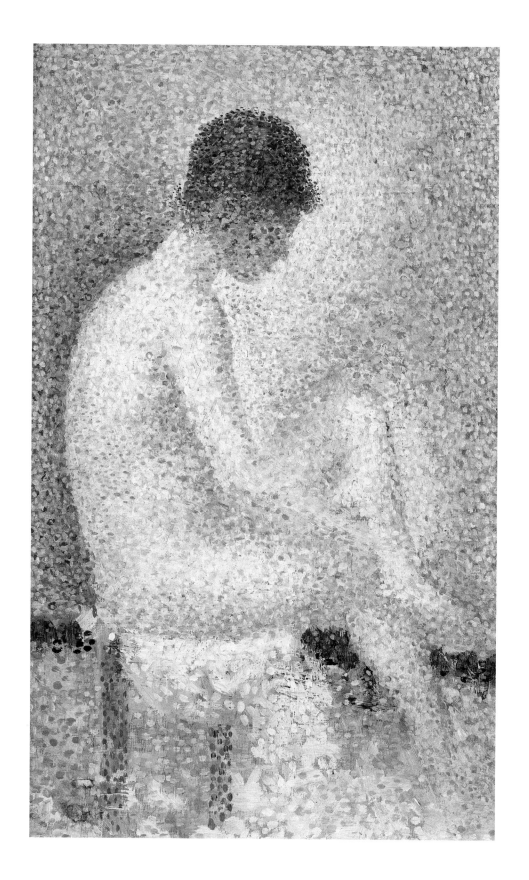

41

GEORGES SEURAT

Model in Profile (*Poseuse de profil*), 1887
Oil on panel
9 ⁷/₈ × 6 ¹/₄ in. (25 × 16 cm)

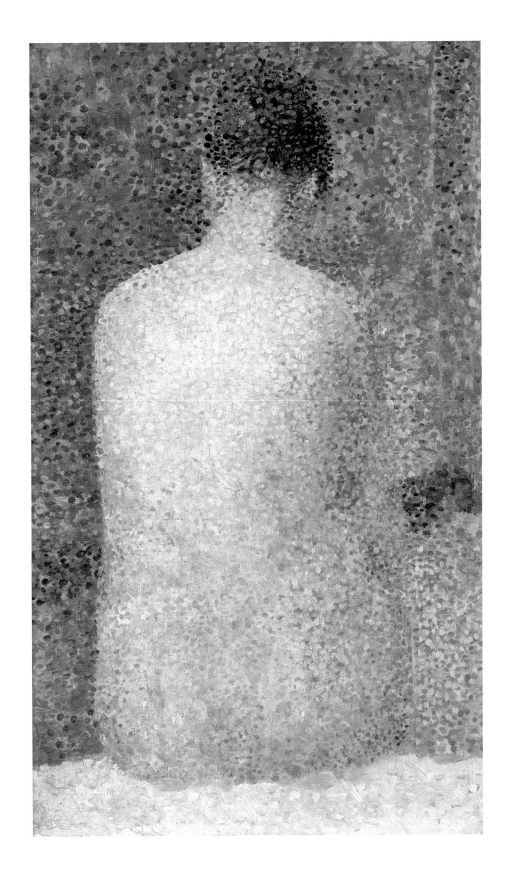

42

GEORGES SEURAT

Model from the Back (*Poseuse de dos*), 1887

Oil on panel

9 ⁵/₈ × 6 ¹/₈ in. (24.5 × 15.5 cm)

43
GEORGES SEURAT
Port-en-Bessin at High Tide (*Port-en-Bessin, avant-port,*
marée haute), 1888
Oil on canvas
26 ³⁄₈ × 32 ¹⁄₄ in. (67 × 82 cm)

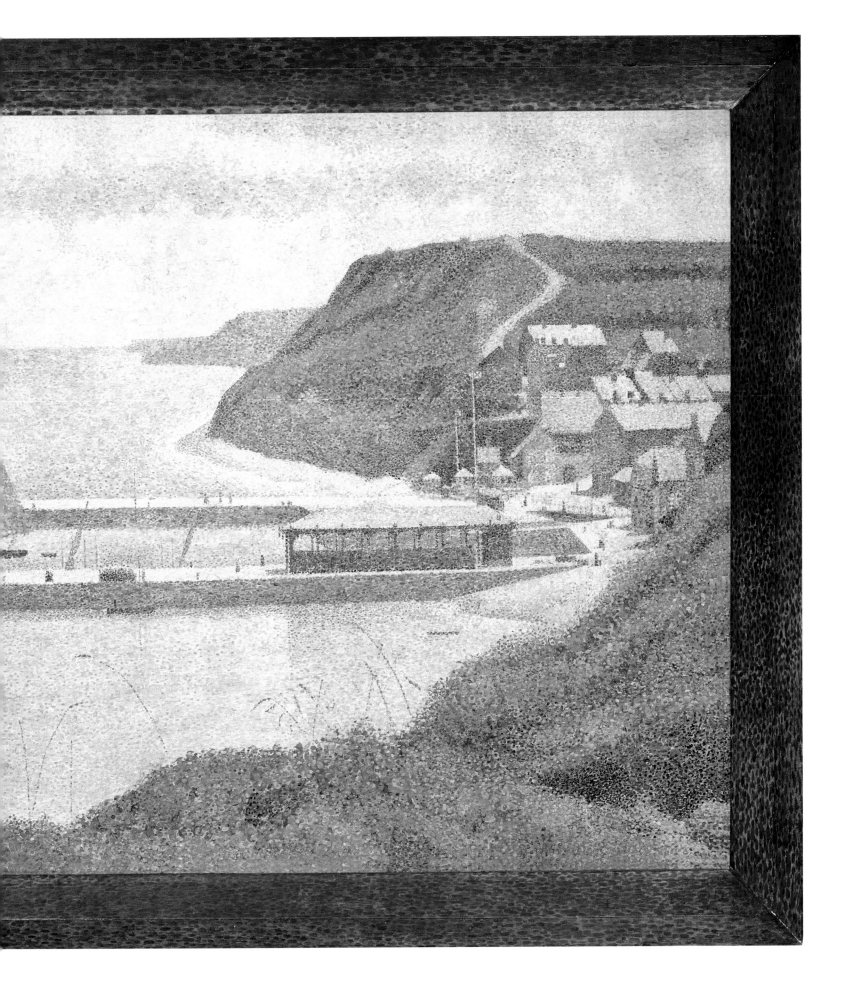

BEYOND IMPRESSIONISM

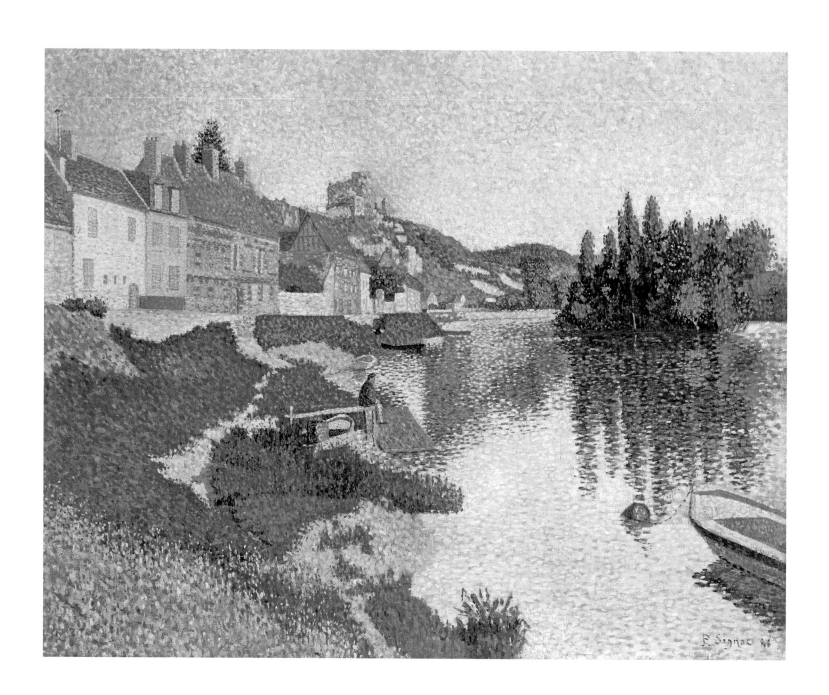

44

PAUL SIGNAC

Les Andelys (The Riverbank) (*Les Andelys [La berge]*), 1886
Oil on canvas
25 ⅝ × 31 ⅞ in. (65 × 81 cm)

Les Andelys (The Riverbank) is one of ten landscapes that Signac painted during the summer of 1886 in the small Norman town of the same name. Whereas his style was previously based on an Impressionistic brushstroke, this innovative series announced his adoption of Seurat's divisionist technique. Lauded at the 1887 Salon des Indépendants, this painting positioned Signac as a key player in the emerging Neo-Impressionist group, which he would lead after Seurat's death in 1891.

45

MAXIMILIEN LUCE

The Seine at Herblay (*La Seine à Herblay*), 1890
Oil on canvas
19⅞ × 31¼ in. (50.5 × 79.5 cm)

Exhibiting divisionist works for the first time in 1887, Luce was recognized immediately as a promising newcomer and was befriended by Pissarro, Signac, and eventually Seurat. In 1889 he was invited to join Signac in the western town of Herblay, where he produced several Neo-Impressionist paintings depicting the Seine under varying atmospheric conditions. The most outstanding among them, *The Seine at Herblay* is a virtuosic study of color and light at sunset, Luce's favorite time of day.

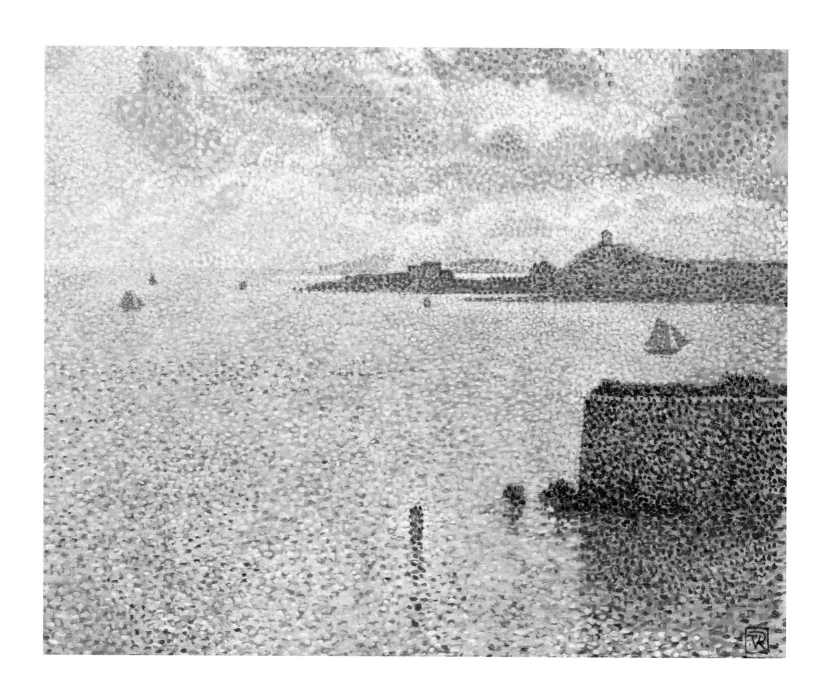

Van Rysselberghe was among the members of the Belgian avant-garde group Les XX (The Twenty) who adopted the Neo-Impressionists' method for transcribing light through vibrant flecks of pure color. Here he incorporated Seurat's divisionist technique into a coastal view, a preferred subject of Seurat's in the late 1880s. Van Rysselberghe's use of a more naturalistic palette and looser brushstrokes, however, lend this seascape a degree of realism and airiness that is typically missing from those of his French counterpart.

46

THÉO VAN RYSSELBERGHE

Sailing Boats and Estuary (*Voiliers et estuaire*), ca. 1887
Oil on canvas
19 ¾ × 24 in. (50 × 61 cm)

47

THÉO VAN RYSSELBERGHE

The Man at the Tiller (*L'homme à la barre*), 1892

Oil on canvas

23 ¾ × 31 ⅝ in. (60.2 × 80.3 cm)

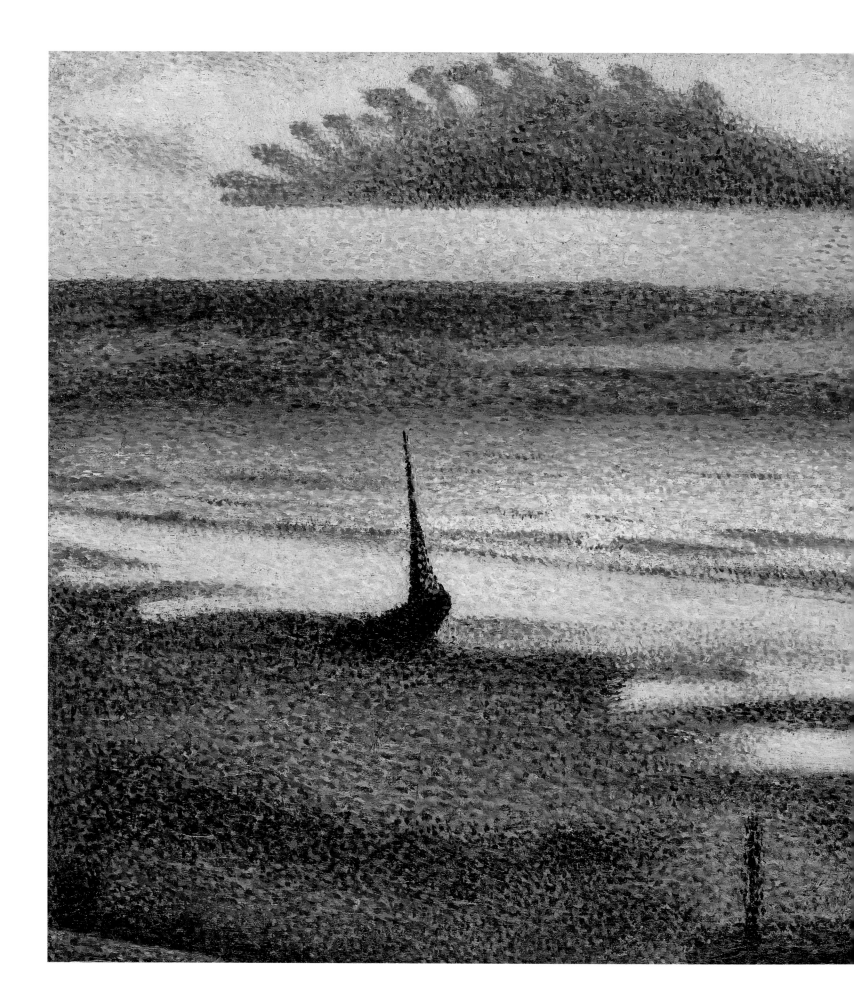

48

GEORGES LEMMEN
Beach at Heist (*Plage à Heist*), 1891
Oil on panel
14 3/4 × 18 in. (37.5 × 45.7 cm)

Profoundly influenced by the exhibition of Seurat's
paintings at the Belgian Salon des XX in 1887, Lemmen
immediately adopted the pointillist technique and be-
gan producing vibrant seascapes such as *Beach at Heist*.
While both the subject and the complementary color
scheme reveal Lemmen's lasting debt to Seurat and
Signac, his stylized treatment of organic forms, such as
the swirling shadows in the foreground and the wispy
lobes of the solitary cloud, reflect his budding involve-
ment in the decorative-arts movement.

49

CAMILLE PISSARRO

Hoarfrost, Peasant Girl Making a Fire (*Gelée blanche, jeune paysanne faisant du feu*), 1888

Oil on canvas

36½ × 36⅜ in. (92.8 × 92.5 cm)

Seeking new formal means to add greater stability to his compositions, Pissarro began experimenting with Neo-Impressionist brushwork and color theory. *Hoarfrost, Peasant Girl Making a Fire* reveals his transformation of pointillism into a series of small, variegated brushstrokes that are woven together to create a dense, yet luminous, tapestry of color. Never completely abandoning his Impressionist roots, Pissarro favored agrarian subjects of peasants toiling in the countryside, as they allowed him to work outdoors and record his sensations before nature.

50

PAUL SIGNAC

Women at the Well or *Young Women from Provence at the Well, Decoration for a Panel in the Shadows* (*Femmes au puits* ou *Jeunes provençales au puits, décoration pour un panneau dans la pénombre*), 1892

Oil on canvas

76 ¾ × 51 ⅝ in. (195 × 131 cm)

51

CHARLES ANGRAND

Couple in the Street (*Couple dans la rue*), 1887
Oil on canvas
15 1/8 × 13 in. (38.5 × 33 cm)

A founding member of the Salon des Indépendants, Angrand emerged in Paris as a progressive painter in the mid-1880s. Initially working in an Impressionist style, he abandoned Monet's loose brushwork in favor of pointillism after forming friendships with Seurat and Signac in 1887. Rather than emphasizing bold color contrasts, however, Angrand favored muted tones that lend his everyday urban subjects, such as this working class couple, an air of quiet intimacy.

52

HENRI EDMOND CROSS

Madame Hector France, 1891

Oil on canvas

81 7/8 × 58 5/8 in. (208 × 149 cm)

This life-size portrait of Irma France marked a turning point in Cross's career. Its inclusion in the 1891 Salon des Indépendants announced not only his assimilation of Neo-Impressionist brushwork but also his entry into the Parisian avant-garde. Although its dazzling technique and daring composition display the utmost modernity, the full-length format and sumptuous details that convey the sitter's elevated social standing belong to the realm of conventional society portraits.

VAN GOGH AND GAUGUIN: THE RESURRECTION OF DELACROIX?

STÉPHANE GUÉGAN

.

When Vincent van Gogh traveled to Paris to join his brother, Theo, at the end of February 1886, his knowledge of the Impressionists was almost zero. He admitted as much in a letter to H. M. Livens, an English painter he knew in Belgium, in which he conveyed, with a sense of optimism, the reasons for his departure for France.[1] While the cost of living was higher in Paris, and painters there were more vulnerable to material hardships, these drawbacks would be offset by the city's broader commercial potential. In the same letter he presented a glimpse of the Parisian art scene:

> There is much to be seen here—for instance Delacroix, to name only one master. In Antwerp I did not even know what the Impressionists were, now I have seen them and though *not being one of the club* yet I have much admired certain Impressionists' pictures—*Degas* nude figure—*Claude Monet* landscape.[2]

It is worth noting that Van Gogh compared Impressionism with the work of Eugène Delacroix, who had died in 1863 but was still seen as the most innovative painter of recent times. For the Dutch newcomer, Delacroix's work embodied a modern use of colors and an attempt to make painting operate in the same way as music or poetry. At the time, Delacroix was a force in anti-academic artistic circles, as evidenced by Henri Fantin-Latour's homage to him (1864, fig. 19). Consequently, we can understand why Van Gogh was attracted to Delacroix and regarded the Impressionists as followers of the master. Ultimately, Van Gogh would exploit the legacy of Delacroix, as Paul Signac would put it in 1899, in a more daring way than the Impressionists did.[3]

Van Gogh arrived in Paris ready to profit from the painters he discovered there, from Claude Monet to Georges Seurat. This ought to dissuade art historians from proposing that Post-Impressionism was a concerted reaction against Impressionism, yet many still do. The art historian John Rewald, who posited such a notion in the 1940s, undervalued the very active presence of the young Paul Gauguin in the Impressionist exhibitions between 1879 and 1886.[4] In fact, Van Gogh and Gauguin, who came together in Arles in 1888, are case studies in the complexity of the art world in Paris at the time.[5] Unless you look at their work from a reductive and simplistic perspective, Van Gogh and Gauguin are testaments to the fluidity of this aesthetic field. Post-Impressionism cannot be summarized merely as the defeat of Impressionism.

It is no accident that questions persist today as to Van Gogh's and Gauguin's exact places in this artistic context. How should they be situated in relation to Monet, Seurat, and Paul Cézanne, and also in relation to Symbolism, which produced its own manifesto in 1886? And what of the other traditions that these two artists tapped? It would be neglectful to ignore not only Van Gogh's connection to the Salon painters but also the Romantic legacy that Gauguin turned to his advantage. Nothing appalled these two artists more than the sectarianism that took hold of critical discourse in the 1880s. The November 1887 exhibition of the so-called Impressionists of the Petit Boulevard—who sought to distinguish themselves from the established Impressionists—brought Van Gogh together with Émile Bernard, Louis Anquetin, and Henri de Toulouse-Lautrec. Van Gogh made it clear through the group's name that he and his friends intended to revitalize Impressionism by "a certain back-street dynamic."[6] For him, modernity demanded flexibility among its proponents rather than the imposition of formalist definitions.

PAGE 118
VINCENT VAN GOGH
Restaurant de la Sirène at Asnières
(*Le restaurant de la Sirène à Asnières*), 1887
Detail of cat. 53

For Françoise Cachin

FIG. 19 **HENRI FANTIN-LATOUR**
Homage to Delacroix (*Hommage à Delacroix*), 1864
Oil on canvas
63 × 98 ³⁄₈ in. (160 × 250 cm)
Musée d'Orsay, RF 1664

VAN GOGH'S ROAD TO ARLES

If Van Gogh idealized the friendship and warmth of the Impressionist group, it was because in his youth he had experienced the distress of true solitude. Born in North Brabant in 1853, Van Gogh was a difficult and less-than-precocious child who grew up in a benevolent family of pastors and art dealers. His father had followed the former path, while his uncle, another Vincent, embraced the latter. After a mediocre performance at school, for which the unstable teenager was poorly suited, in 1869 Van Gogh took his first steps toward a career as a dealer, apprenticing with his uncle in The Hague. A competent but fickle dealer, Van Gogh came into close contact with the works of the Barbizon School of landscape painters and their Dutch disciples. He pinned prints by Rembrandt van Rijn, Salomon van Ruysdael, Jean-François Millet, and Charles-François Daubigny to the walls of his room. In these years he also traveled to Paris and London, discovering the museums of those capitals.

Van Gogh gave up the career of art dealer in 1876 and undertook studies in theology to qualify as a lay preacher. He went to work in the Borinage area of the Hainaut province of Belgium, where poverty-stricken miners were being ground down by the pace of runaway industrialization and the worst imaginable working conditions. However, this would-be savior of the poor realized that he was hardly in a position to bring them the light. During the summer of 1880 he made the decision to take up painting, in which he sensed another way of spreading the gospel of Christ. Theo, four years his junior and by then an employee of the Paris gallery Boussod, Valadon et Cie, sent him art supplies and training manuals. A dedicated autodidact, Van Gogh quite quickly mastered the first principles of drawing, which were reinforced by a few months of study at the Académie des Beaux-Arts in Brussels and by the advice lavished on him by his cousin Anton Mauve, a prominent landscape artist of The Hague School. He made rapid progress.

In search of a supposedly more authentic, rural world, Van Gogh decided to go to Drenthe, a remote and desolate region of the Netherlands, to live amid the poverty and draw from it a truth that he could translate into his work. He painted craggy-faced peasants and

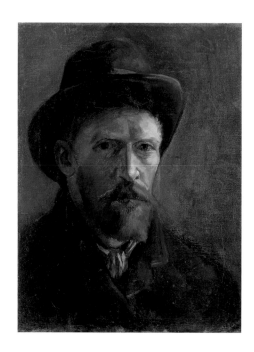

FIG. 20 **VINCENT VAN GOGH**
Self-Portrait with Felt Hat (Autoportrait), 1886
Oil on canvas
16 1/2 × 13 in. (42 × 33 cm)
Van Gogh Museum, Amsterdam, s 0162 V/1962

modest tradespeople in the colors of the soil. However, the artist soon found the harshness and deadly isolation of this world unbearable. In 1885 he set himself up in Antwerp, where he attended the painting academy and made a few artistic contacts. In front of his mirror he produced his first self-portraits, which reflected a gloomy personal life plagued by romantic disappointments and venereal disease. His father, who had been his main source of support, died in March 1885. Theo's help and understanding became indispensable. Emboldened by his first paintings worth exhibiting—at least he thought so—Van Gogh felt the need to brave Paris, the world's premier artistic arena. He moved there in 1886 and stayed for almost two years—a time spent appropriating the different elements of French modernity.[7]

SELF-PORTRAITS

Van Gogh painted about twenty-eight self-portraits in Paris between March 1886 and late February 1888. They form a kind of personal diary, in which the artist confronted his lurking malaise and the disappointments of his new life while also challenging himself against the master painters of the genre. Therefore, it was not from fear of losing his sense of self that he set up a watchful mirror by his easel. It is true that Van Gogh belonged to an era, explored in the fiction of Émile Zola and Guy de Maupassant, in which the ravages of family heredity were well known. Several generations of Van Goghs had been stricken by the most serious mental illnesses. However, the painter's pathology—his schizophrenic and melancholic tendencies, medically speaking—was far from being the sole determinant of his personality and creative ambition.[8]

For this painter, burdened with a heavy genetic legacy, the self-portrait recorded every jolt in a risky career path. He was torn constantly between pugnacious artistic choices and self-doubts about his talent, between self-affirmation and psychological troubles of increasing severity. But beyond being a response to very real personal crises, the self-portrait provided Van Gogh with a means of integrating himself into the community of innovative artists in Paris. To wit, he often portrayed himself with an air of respectability, signaled by a dark felt hat, a groomed beard, and a calm and determined gaze, as seen in an example from 1886 (fig. 20).

The self-portraits of 1887 (cat. 56)—with their extreme pointillist technique and strident palette—summarize the painter's first months spent in France, during which the lessons of the Louvre were multiplied tenfold by the profound impact of Seurat, the bedazzling discovery of Japanese woodcut prints, and the influence of the cosmopolitan circle he met at the atelier of the academic painter Fernand Cormon on boulevard de Clichy. Two of Van Gogh's fellow disciples at the studio, the Australian artist John Russell and Toulouse-Lautrec, painted portraits of the "newcomer"—the first artist depicting him as a Dutch gentleman (1886, Van Gogh Museum, Amsterdam), the second as a predator ready to pounce (1887, fig. 21). Bernard also associated with the Dutchman. He would describe him as "red-haired . . . with an eagle eye and a cutting mouth, so to speak . . . stocky . . . [making] sharp movements, [having] a jerky walk, vehement in his views."[9] Van Gogh admired the Japonisme of Bernard and Anquetin, and he even exhibited alongside these artists in the winter of 1887. However, he did not adopt their Cloisonnist style, which separated form into flat planes of color and betrayed the shimmering palette of Seurat, thus denying Delacroix's legacy. Apart from his self-portraits and a few bouquets of fritillaries (cat. 55)—in which the influence of Monet is apparent—Van Gogh's Parisian work remained, in style and substance, within the limits of a fairly sober Neo-Impressionism.

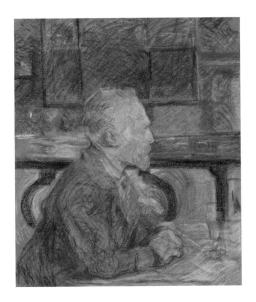

FIG. 21 **HENRI DE TOULOUSE–LAUTREC**
Portrait of Vincent van Gogh (*Portrait de Vincent van Gogh*), 1887
Chalk
22½ × 18⅛ in. (57 × 46 cm)
Van Gogh Museum, Amsterdam, d 0693 V/1962

Only the iconography, which started to incorporate motifs drawn from the cafés and brothels of Montmartre, as cultivated by the Impressionists of the Petit Boulevard, created a real distance from his friend Signac. Van Gogh also met Gauguin at this time, although the latter firmly dissociated himself from the group around Seurat.

At the Salon des Indépendants, where artistic differences were heightened, Van Gogh exhibited three paintings in January 1888: two views of the Butte Montmartre and one still life. He then headed for the south of France—to Provence, the sunny locale of the Naturalist writer Alphonse Daudet and the painter Adolphe Monticelli.[10] He dreamed of gathering Bernard, Gauguin, and Charles Laval around him in Arles. The *atelier du midi* ("studio of the South") was conceived as the southern equivalent of Brittany's Pont-Aven group, with whom Van Gogh had been corresponding throughout 1887. The exchange of self-portraits reinforced the ties between these four painters without ever bringing them together physically. Only Gauguin would join Van Gogh at Arles—for a short time, beginning in November 1888. Until then, with Theo's support, Van Gogh drew and painted many things, including his symbolic bunches of sunflowers, which distilled for him a private world.

Van Gogh also turned his attention to nocturnal scenes, which showed an atmosphere of rare intensity. It would be an overstatement to attribute the painter's marked inclination toward the theme of the night sky simply to his madness. For this student of Rembrandt and Millet, the Provençal stars were like bearers of a soothing music. He called this harmony of the starry sky his grand "silence," in which "the voice of God" made itself heard.[11] Moreover, the Musée d'Orsay's version of *Starry Night* (1888, cat. 57) presented new ambitions in relation to his previous formats. In *Starry Night*, painted in the summer of 1888, Van Gogh confirmed his calling to modern painting with a fully realized work. The painter kept Theo informed of the work's progress, a demonstration of the value he attached to it and of his concern to explain its "expressionism"—so as to avert suspicions of his mental disturbance. The artist Eugène Guillaume Boch, whose portrait Van Gogh painted against another starry background (1888, cat. 58), received a sketch of this *Starry Night*.[12]

Starry Night's dynamic composition of three gently curving bands emphasizes height, or ascent, instead of depth, drawing the eye upward rather than into the painting. It creates a subtle connection between the two lovers in the foreground (representing the transcendence of the heart) and the radiant constellation of stars at the top (the transcendence of the sky). Against a palette of muted blues and greens, the painter made his precious yellow dance all the more vividly. Emphatic brushstrokes, repeating in a rhythm, cause the canvas to vibrate with the murmuring of Provençal nights. In a letter to Theo, Van Gogh stressed the deliberate interplay between the lights of the town and the lights of the sky, the latter charged with a heavenly message. Here, the infinite does not suggest human angst, solitude, and vulnerability. Instead, Van Gogh's sky speaks positively; behind its magnificence is the implied presence of the divine. It is a sky of summer and true hope.

After having declined Theo's suggestion to go to Arles in July in order to work alongside Vincent, Gauguin eventually left Pont-Aven at the end of October. He also responded to Van Gogh's own pressing invitations to join him—though less out of a desire to partake in a communal utopia than to get into the good graces of the painter's art-dealer brother.

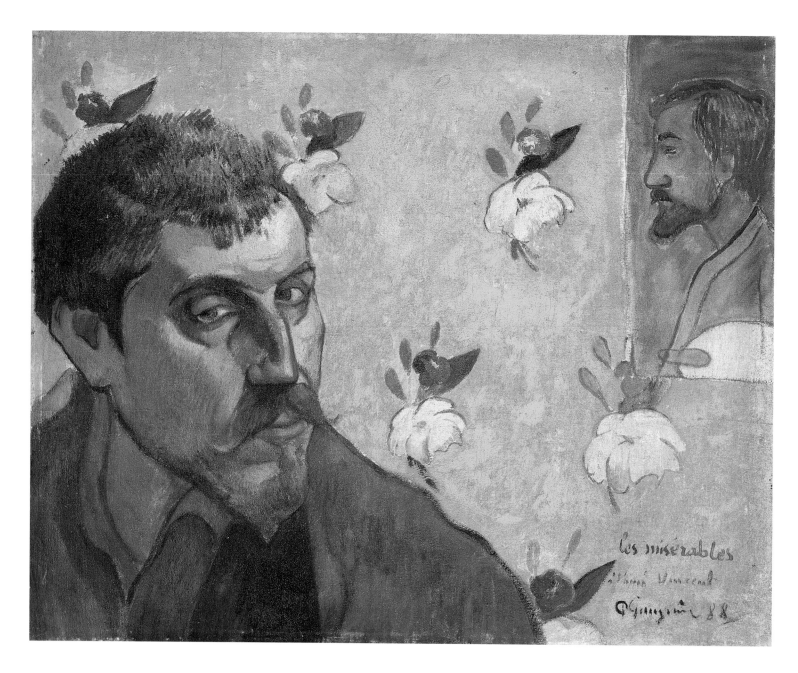

FIG. 22 **PAUL GAUGUIN**
Self-Portrait with Portrait of Bernard
(*Les misérables*), 1888
Oil on canvas
17³/₄ × 19⁵/₈ in. (45 × 50 cm)
Van Gogh Museum, Amsterdam, d 0224 V/1962

GAUGUIN'S ROAD TO ARLES

For a long time it was thought that Gauguin did not come into his own as an artist until he entered his forties, around 1888, after an experimental phase whose only virtue was to prepare him for his true beginning: the paintings from his sojourn in Martinique and his first stay in Pont-Aven, in Brittany. Perhaps this man—reputed to be hostile to the values of the West, a rebel fleeing Paris and its compromises—required this double rupture in order to create himself. Rewald, in 1946, almost dismissed the artist from his *History of Impressionism*, a book that determined for thirty years how Gauguin was interpreted.[13] More space was devoted in that book to Cézanne and Édouard Manet than to Gauguin, even though Gauguin had exhibited five times with the Impressionist group—as many times as Monet, and more often than Pierre Auguste Renoir and Alfred Sisley. A stockbroker turned "primitive" painter, Gauguin retold the story of his artistic journey many times and elaborated on his Peruvian background, giving credence to the broad outlines of a myth forged during his lifetime.[14] How could we doubt

124

the existential quest and deep aesthetic wellsprings of a man who had suffered so much to bring his art to fruition?

Gauguin's self-portraits (see fig. 22), like Van Gogh's, have made no small contribution to the sanctification of his persona and thus to the simplification of his real biography. It has been said often in print that the man who had made his fortune in banking also intended to make a successful career in painting. His social habits no doubt changed after breaking with his family and embracing a cosmopolitan and vaguely self-destructive bohemian lifestyle. Gauguin created a destiny for himself as a stateless saint. His romanticism was solid as a rock. Was he not born on June 7, 1848, between two revolutions in France?[15]

After the premature death of his father, Clovis, a Republican journalist, and a childhood spent in Peru with his mother's family, Gauguin returned to France around the age of eight to attend Catholic boarding school. After years of schooling unmarked by brilliance, yet equipping him with a solid foundation of high culture, the young man signed on to the merchant navy, serving as a navigator for three years on the *Jérôme Napoléon*. Discharged in April 1871, he returned to the French capital, which was then in the throes of turmoil and bloodshed following the recent battles of the Paris Commune. At the beginning of 1872 he and his sister, Marie, rented an apartment near place Bréda that was close to the apartment of Gustave Arosa—a family friend and one of the most enlightened connoisseurs of modern art in Paris. With Arosa's support, Gauguin gained a position with a broker, ensuring him a comfortable income. It was during this time that he met Émile Schuffenecker, who was then on the verge of devoting himself to painting. In Arosa's circle, Gauguin also made the acquaintance of Mette Gad, a Danish woman whom he married in November 1873. He made his debut in painting that year.

The Gauguins set up house in 1875 on rue de Chaillot, in the middle of Paris's sixteenth arrondissement, not far from the banks of the Seine, where Gauguin sometimes brought his easel. The landscapes produced by the young painter display a sort of rural bonhomie, coupled with a great proficiency beneath their spontaneity; these stuttering works herald the future alliance of Gauguin and Camille Pissarro. In 1877 the Gauguins moved to Vaugirard, a rural community where housing was less expensive.[16] Over the course of the 1870s Gauguin lost some of his social ranking but gained artistic status in the eyes of painters such as Pissarro and his group, whose work he collected. In April 1879 Gauguin was invited at the last minute to take part in the fourth Impressionist exhibition; the invitation seems to have come from Pissarro, and Gauguin took the opportunity to strengthen his recently made connection with him. At this time three important elements coalesced in the development of Gauguin's career: his entrepreneurial personality, his relationship with Arosa, and his debt to the examples he found in Arosa's collection of modern masters—Delacroix, Jean-Baptiste-Camille Corot, Honoré Daumier, and Gustave Courbet. There is no doubt, however, that it was Pissarro who made the deepest impression upon Gauguin, at least until 1886.

These aesthetic preferences reveal Gauguin's orientation within the Impressionist scene. In style and substance, technique and emotional register, his work owed less to the example of Monet and Renoir than it did to the emanating influence of Manet, Cézanne, Degas, and Pissarro. It was also characterized by the combined practice of painting and sculpture. Thus began Gauguin's period of professionalization, which he pursued with determination

amid increasing material difficulties. Alongside landscapes in Pissarro's style, figure paintings became more numerous, in response to the success of Gustave Caillebotte and Degas. While nudes remained the exception in Gauguin's work during this period, there were interior scenes that made the everyday seem unfamiliar. Some very curious still lifes, with their asymmetry and shimmering hues, anticipated Gauguin's later tendency toward the baroque in his Tahitian work. Similarly, a primitivist tendency appeared at this time in the bas-relief and high-relief sculptures that Gauguin modeled with admirable vigor.

When financial crisis forced him to leave Paris at the very end of 1883, Gauguin went to Rouen for a time before moving to Denmark. His painting became denser, to the point of claustrophobia, and it gained intensity with heightened surface effects and the energetic structuring of space. The vibration of his colors echoed the styles of Delacroix and Cézanne. At the same time, Gauguin's execution became more disciplined, as outlined in his *Notes synthétiques*, which he wrote by 1884 following the inspiration of Charles Blanc and Charles Baudelaire. His work underwent a formal and theoretical reorientation, accompanied by an increased freedom in the use of nonmimetic color. The time had come for the artist's definitive emancipation from the Impressionist group—which broke up with the eighth and final Impressionist exhibition, in 1886.

In the summer of that year, Gauguin returned to Brittany, following many others who had been moved by the unrefined and mysterious qualities of an environment not yet entirely discovered by the rest of the world. The Pension Gloanec in Pont-Aven, where he took a room, sheltered a range of cosmopolitan folk under its roof. In contrast to Paris, the place suggested for these seekers a preserved social and cultural authenticity. The painter quickly realized, however, that he was idealizing these "domestic primitives." His painting, however, substituted a newly archaic style for the Celtic primitivism he could not find in real life.

In his letters, Gauguin described himself as being surrounded by friends and listeners. He crossed paths with Bernard. Laval, another Cormon disciple, accompanied him to the French Caribbean colony of Martinique, where the painting of the two artists blossomed as it underwent a process of Orientalizing. But the trip, lasting from April to mid-November 1887, was disastrous for their health and their financial situations. By the end of January 1888, having sold three paintings to Theo van Gogh and seen Vincent move from Paris to the south of France, Gauguin returned to Brittany and the Pension Gloanec. He was penniless, or almost so, and pursued by fevers contracted in Martinique. His work had encountered a weak reception and little comprehension from the time he began to modify his Impressionism with a more Symbolist language, but Gauguin still had his "rage to paint."[17] In 1891 the critic Albert Aurier described the Japonisme of Gauguin's painting—which gathered colors into dense, delimited zones and used uncommon framing devices to divide up the canvas—as being highly subjective, giving excessive emphasis to a Platonic or idealist reading of his art.[18] Aurier would have been more inspired if he had reviewed the work in the context of what the members of Gauguin's circle were doing. It is clear, in fact, that the transformation that had occurred in Gauguin's work would have been less dramatic without the stimulating presence of Bernard and Laval. As Gauguin wrote to Schuffenecker in August 1888: "The group is getting larger. 'Le petit Bernard' is here and he has brought back some interesting things from Saint-Briac [Brittany]. There's a man who has no fear."[19]

This is Gauguin's veiled way of acknowledging both his artistic debts, which are evident in his paintings, and the competition engendered by the artistic interactions in the Pont-Aven group. Looking at the paintings that Bernard signed and dated in 1887—still lifes and bathers (cat. 66)—confirms the radical clarity of the young artist's choices. A year later he exchanged ideas on an equal footing with Gauguin: both used flat, vivid patches of color and Synthetist designs. But Bernard's beautiful portrait of his sister (1888, cat. 2), styled like a recumbent medieval tomb sculpture, took on the softened colors of a lover's daydream and embodied the emerging iconography of Symbolism. Moreover, Bernard soon threw in his lot with the religiously inspired Rosicrucian group and aligned himself with the Nabis in 1891. In 1888 Paul Sérusier, whose artistic journey was not without its parallels to Gauguin's, painted his famous *Talisman, the Aven at the Bois d'Amour* (cat. 77), a work that summed up his encounter with the Pont-Aven group. In retrospect, this almost abstract landscape could be seen to form the Nabis' "New Commandments." (For more on the Nabis, see "The Nabis and Symbolism in 1890s Paris" in this volume.) Like Bernard, Sérusier went on to give increasing prominence to religious subjects and archaic devotional forms—whose mythology Gauguin would develop for himself before departing for Tahiti and transposing it to the tropics.

FROM ARLES TO TAHITI

At the end of 1888, Gauguin joined Van Gogh in Arles. Over a two-month period, the artists experienced an intense collaboration, an episode that has been overshadowed misleadingly by the incident of Van Gogh cutting off his ear and their violent break with each other. Temperaments and aesthetics may well have been at cross purposes in Arles, but the men's discord would prove artistically productive. It would be better to speak of healthy competition between the two artists, for it was through the clash of their irreconcilable positions that each affirmed his own orientation—more expressionistic in Van Gogh's case, more contemplative in Gauguin's. It is impossible to deny that they shared a desire to push color and imagery to the extreme. Throughout this time, Gauguin remained in contact with his "Breton" friends—especially Bernard. In a famous letter to Bernard that reflects this triangular relationship, Gauguin summarized what he was looking for in his painting, a tension between the life force of reality and the harmony of Synthetist art: "It's funny, Vincent sees [Honoré] Daumier to be done in this environment, I, on the other hand, see some colorful Puvis [de Chavannes] mixed with Japan."[20] It is a definition that, going on the evidence, applies to Gauguin's most noted works from his adventure in Arles, such as *Les Alyscamps* (cat. 62), which is shorn of any allusion to the old cemetery that made such an impression on Van Gogh.

By mutilating himself after a banal dispute with Gauguin on December 23, 1888, Van Gogh put an end to their strange artistic cohabitation and acknowledged his need for medical treatment. He soon chose to be hospitalized. When released, he returned to the north and played out his final passion for painting in Auvers. Gauguin lived on with the guilt surrounding their messy falling-out and Van Gogh's subsequent death. Compounding his guilt, in 1889, while Van Gogh was still alive, the Pont-Aven painter redoubled the promotional efforts of his circle. In February Gauguin exhibited his work in Brussels; in June, on the occasion of the Exposition Universelle, the "Exhibition of the Impressionist and Synthetist Group" was held at the Café Volpini. Gauguin was surrounded by all the young artists: Bernard, Anquetin, Laval, and Schuffenecker.[21]

The Symbolist reviewers gave a mixed reception to the new label. The most enthusiastic critic was Aurier, who had just published two articles by Gauguin in *Moderniste Illustré*, of which he was editor in chief.[22] In these pieces the painter lauded the inventiveness of the Eiffel Tower and the revival of the decorative arts in the name of an alliance between modern materials and nonindustrial production.[23] In his hatred for the manufactured goods of the old Europe—a decrepit world in his view—Gauguin expressed a desire for the "unknown." After being electrified by what he saw in the Asian pavilions at the exposition that year, he announced to Bernard his intention to get a position in the French colony of Tonkin (Vietnam). He planned to recharge himself there and, after living in the colonies for two years, return to France more "robust."[24]

Although he returned to Brittany in the summer of 1889, Gauguin's thoughts were already taking him far away. Pont-Aven now seemed too civilized to him, overrun with daubers arriving from all directions. A few kilometers away, the smaller and more isolated fishing village of Le Pouldu better represented the basic way of life that he considered necessary for his painting. In reality, however, he staggered back and forth between Pont-Aven and his new place of retreat.

In the letters he sent to Van Gogh, whom he never forgot, Gauguin confessed his desire to paint, through his models, "the savageness . . . that is also in me."[25] Using a deliberately clumsy visual language, his painting emphasized this internal, hallucinatory otherness. In his *Portrait of the Artist with* The Yellow Christ (1890–1891, cat. 63), a manifesto of archaism, we can nevertheless discern a confidently trained artist. The painting is presented like an unusual collage, with Gauguin's fine, intense face firmly inscribed between the rustic Christ of a Breton church and a would-be Peruvian vessel from which a third face emerges. Like the Romantics had done before him, Gauguin, in his choice to identify himself with Christ, sanctified his independence as an artist who idealized his solitude and as a man wounded by a society in which he had only a few disciples.[26] But references to non-Western cultures also make an appearance at this time, serving as the source of a regenerated painting style in terms of form and symbolism.

This monumental work, however modest its actual physical dimensions, has a softness, a harmony, an order, and a gravity that suggest another side to Gauguin's artistic personality. This "primitive" had a certain genius for publicity. While objecting to the proposal to exhibit Van Gogh's work (as put forth by Bernard after Van Gogh's suicide in July 1890) as a means to control the growth of the dead painter's reputation, Gauguin extended his connections in the Symbolist writing scene for his own sake. He had been back in Paris since February 1890 and was busy on all fronts, especially with regard to his planned move to the tropics. He dreamed of another home base, in French Polynesia: "Even Madagascar," he wrote to Odilon Redon in September, "is too near the civilized world; I shall go to Tahiti. . . . I judge that my art, which you like, is only a seedling thus far, and out there I hope to cultivate it for my own pleasure in its primitive and savage state."[27] Gauguin was determined to make this total immersion (moving "toward the distant horizons and toward himself," as the Symbolist poet Stéphane Mallarmé expressed it[28]) seem feasible and productive. The poet and his circle contributed to the project's realization by supporting the auction that Gauguin organized before his departure. The sale, on February 23, 1891, brought in less than 10,000 francs (around 35,000 euros or 47,800 U.S. dollars)—a modest result—but the publication of several long articles by Octave Mirbeau

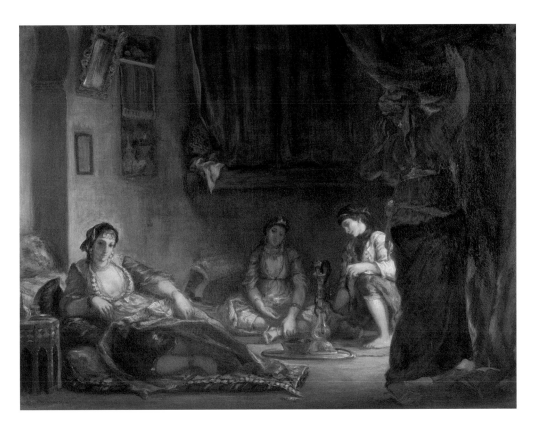

FIG. 23 **EUGÈNE DELACROIX**
Women of Algiers in Their Apartment
(*Femmes d'Alger dans leur intérieur*), 1849
Oil on canvas
33 ½ × 44 ⅛ in. (85 × 112 cm)
Musée Fabre, Montpellier, France, Inv. 868.1.38

and Aurier strengthened the artist's position. While Aurier invoked Plato and Greek idealism to explain Gauguin, Mirbeau put the finishing touches on the myth of the stateless individual, nurtured from childhood on the example of the utopian socialist Charles Fourier and determined to flee civilization, "the better to listen to the inner voices that are suffocated by the clamor of our passions and disputes."[29]

Gauguin's Tahitian exile took place in stages. The primitives he initially discovered, in Papeete, were not those his heart desired. In this French colony, the indigenous population had abandoned most of its customs; amid this cultural amnesia, only a few tattoos preserved the "primitive means of art, the only means that are good and true."[30] Gauguin continued to attempt to reconstitute this lost (or, at the very least, hybridized) culture using different iconographic sources. However, he was not always the best judge of the authenticity of his sources—as in the case of photographs that he believed captured a precolonial state yet were actually a product of colonization.[31]

Gauguin arrived in Tahiti in June 1891, and by September he was already on the lookout for a place less tainted, both geographically and culturally. He was enchanted by Mataiea; in almost two years there, he completed several major paintings. Amid a landscape that had taken on a Baudelairean aspect—with its pink lagoons, its mauve or red soils, its luxuriant flowers, exotic fruits, and mysterious women—the painter created a dialectic between religions and cultures, forging a syncretism that was striking to his European audience. While *Tahitian Women* (1891, cat. 64) is reminiscent of Delacroix's *Women of Algiers in Their Apartment* (1849, fig. 23),[32] *Arearea* (1892, cat. 65) draws on the tradition of Egyptian art.

These were two of the forty-four paintings Gauguin exhibited at Paul Durand-Ruel's gallery in Paris in November 1893. Only eleven of those works sold; Degas was one of the few buyers. In the preface to the sale catalogue, which was decorated with woodcuts, Charles

Morice repeated the Gauguinesque idealization of "a Tahiti prior to [the arrival of] our terrible sailors and the perfumed pap of Mr. Pierre Loti."[33] The Paris press was a little disconcerted by the apparently barbaric subjectivity of the painter, who was able "to put so much mystery into so much brightness." The faithful Mirbeau also referred to Gauguin's "imaginative abundance" and "depth of thought."[34] Gauguin gave Eugène Tardieu, who was intrigued by this style of painting that had no clear instruction manual, a few keys to the "musical" operation of his works:

> I arrange lines and colors so as to obtain symphonies, harmonies that do not represent a thing that is real, in the vulgar sense of the word, and do not directly express any idea, but are supposed to make you think the way music is supposed to make you think, unaided by ideas or images, simply through the mysterious affinities that exist between our brains and such arrangements of colors and lines.[35]

Meeting with little sympathy for or understanding of his art, feeling bitter and tired of his living conditions, the artist returned to Tahiti, though without giving up hope on his Parisian career. Under contract with the dealer Ambroise Vollard beginning in 1900, he chose another island group in French Polynesia, the Marquesas, for the final phase of his *atelier des tropiques*. The syphilitic and alcoholic faux-primitive managed the reception of his works from a distance while continuing his dialogue with the masters: Lucas Cranach, the Greeks of the Parthenon, and, very often, Delacroix. Following his death in May 1903, Gauguin became one of the cultural shamans of the twentieth century. Two years earlier the Galerie Bernheim-Jeune had organized the first Van Gogh retrospective in Paris. Maurice de Vlaminck and André Derain, among others, were impressed by this exhibition. Drawing from Gauguin's and Van Gogh's innovations, the future Fauve painters would continue to emulate the so-called savageness of Delacroix.[36]

Translated from the French by Melissa McMahon.
A version of this essay was first published in Masterpieces from Paris: Van Gogh, Gauguin, Cézanne, and Beyond, Post-Impressionism from the Musée d'Orsay, *National Gallery of Australia Publishing, Canberra, 2009.*

NOTES

1 That said, the new edition of Van Gogh's letters leaves room for nuance. He had at least been in contact with Manet's painting and etching before he arrived in Paris, and not only through reproductions. See my review of Vincent van Gogh, *Les lettres*, ed. Leo Jansen, Hans Luijten, and Nienke Bakker (Arles, France: Van Gogh Museum / Huygens Institute, 2009), at http://www.latribunedelart.com/vincent-van-gogh-les-lettres-article002314.html.

2 Van Gogh to H. M. Livens, Paris, August–October 1886, letter 459a, www.vggallery.com/letters/553_V-T_459a.pdf, accessed September 16, 2009.

3 See Paul Signac, *From Eugène Delacroix to Neo-Impressionism*, trans. Willa Silverman (Paris: H. Floury, 1921), reprinted in Floyd Ratcliff, *Paul Signac and Color in Neo-Impressionism* (New York: Rockefeller University Press, 1992), 193–285. First published 1899.

4 See John Rewald, *The History of Impressionism* (New York: Museum of Modern Art, 1946).

5 See Richard Thomson, "The Cultural Geography of the Petit Boulevard," in *Vincent Van Gogh and the Painters of the Petit Boulevard*, ed. Cornelia Homburg (Saint Louis, Mo.: Saint Louis Art Museum; New York: Rizzoli, 2001), 64–107.

6 See ibid., 66.

7 See Françoise Cachin and Bogomila Welsh-Ovcharov, *Van Gogh à Paris* (Paris: Ministère de la Culture et de la Communication / Réunion des Musées Nationaux, 1988).

8 See François-Bernard Michel, *La face humaine de Vincent van Gogh* (Paris: Grasset, 1999).

9 Émile Bernard, "Souvenirs sur Van Gogh," *L'Amour de l'Art*, December 4, 1924, 393–400.

10 On the importance of Monticelli in relation to Van Gogh's "solar" style and his decision to spend time in Arles, see *Van Gogh, Monticelli*, ed. Marie-Paule Vial (Paris: Réunion des Musées Nationaux, 2008).

11 See Sjraar van Heugten, Joachim Pissarro, and Chris Stolwijk, *Vincent van Gogh and the Colors of the Night* (New York: Museum of Modern Art, 2008).

12 See Van Gogh's letter to Boch, Arles, October 2, 1888, letter 553b, www.vggallery.com/letters/670_V-E_553b.pdf, accessed August 27, 2009.

13 See Richard R. Brettell and Anne-Birgitte Fonsmark, *Gauguin and Impressionism* (New Haven, Conn.: Yale University Press, 2005), 368.

14 For a good overview, free from the myths that have long distorted our reading of the painter, see Belinda Thomson, *Gauguin* (London: Thames and Hudson, 1987).

15 The February 1848 revolution brought down the French monarchy; there was an unsuccessful rebellion in June; and a new Republican government was formed in December 1848.

16 By 1879 the Gauguin family included three children: Émile, Aline, and Clovis.

17 Gauguin to Vincent van Gogh, Pont-Aven, late February 1888, letter GAC 28, http://webexhibits.org/vangogh/letter/18/etc-Gauguin-GAC28.html.

18 Albert Aurier, "Le symbolisme en peinture: Paul Gauguin," *Le Mercure de France*, March 1891, 155–165.

19 Gauguin to Schuffenecker, August 1888, reprinted in *Correspondance de Paul Gauguin: Documents, témoignages*, ed. Victor Merlhès (Paris: Fondation Singer-Polignac, 1984), 210.

20 Gauguin to Bernard, November 1888, reprinted in ibid., 284.

21 See Heather Lemonedes et al., *Paul Gauguin: The Breakthrough into Modernity* (Cleveland: Cleveland Museum of Art; Amsterdam: Van Gogh Museum, 2009), notably Belinda Thomson's essay on the Volpini exhibition, 214–225.

22 See Albert Aurier, "La peinture à l'exposition," *La Pléiade*, 1889, 102–104.

23 See Stéphane Guégan, *Gauguin: Le sauvage imaginaire* (Paris: Éditions du Chêne, 2003), 116–119.

24 Gauguin to Bernard, June 1890, quoted in *Paul Gauguin: The Writings of a Savage*, ed. Daniel Guérin, trans. Eleanor Levieux (New York: DaCapo Press, 1996), 63–64.

25 Gauguin to Van Gogh, October 1889, quoted in *Gauguin by Himself*, ed. Belinda Thomson (Boston: Little, Brown, 1993), 106.

26 On the painter's Romantic sources, see Guégan, *Gauguin*.

27 Gauguin to Redon, September 1890, reprinted in Guérin, *Paul Gauguin*, 42.

28 See Jean-Michel Nectoux, *Mallarmé: Un clair regard dans les tenebres peinture, musique, poesie* (Paris: Adam Biro, 1998), 98.

29 Octave Mirbeau, "Paul Gauguin," *L'Echo de Paris*, February 16, 1891, reprinted in *Gauguin: A Retrospective*, ed. Marla Prather and Charles F. Stuckey (New York: Hugh Lauter Levin Associates, 1987), 136–147. Also reproduced in *Octave Mirbeau: Combats esthétiques*, vol. 1, ed. Pierre Michel and Jean-François Nivet (Paris: Séguier, 1993), 418–422.

30 See Jules Huret, "Paul Gauguin Discussing His Paintings," *L'Echo de Paris*, February 23, 1891, reprinted in Guérin, *Paul Gauguin*, 48.

31 See Elizabeth C. Childs, "The Colonial Lens: Gauguin, Primitivism, and Photography in the Fin de Siècle," in *Antimodernism and Artistic Experience*, ed. Lynda Jessup (Toronto: University of Toronto Press, 2001), 50–70.

32 An 1834 version is in the collection of the Musée du Louvre, Paris.

33 Pierre Loti was a popular French novelist and naval officer who published somewhat sentimental books based on his many travels.

34 Octave Mirbeau, "Retour de Tahiti," *L'Echo de Paris*, November 14, 1893.

35 Eugène Tardieu, "Interview with Paul Gauguin," *L'Echo de Paris*, May 13, 1895, reprinted in Guérin, *Paul Gauguin*, 109.

36 Around 1900 the young Derain made many copies after Delacroix in the Louvre.

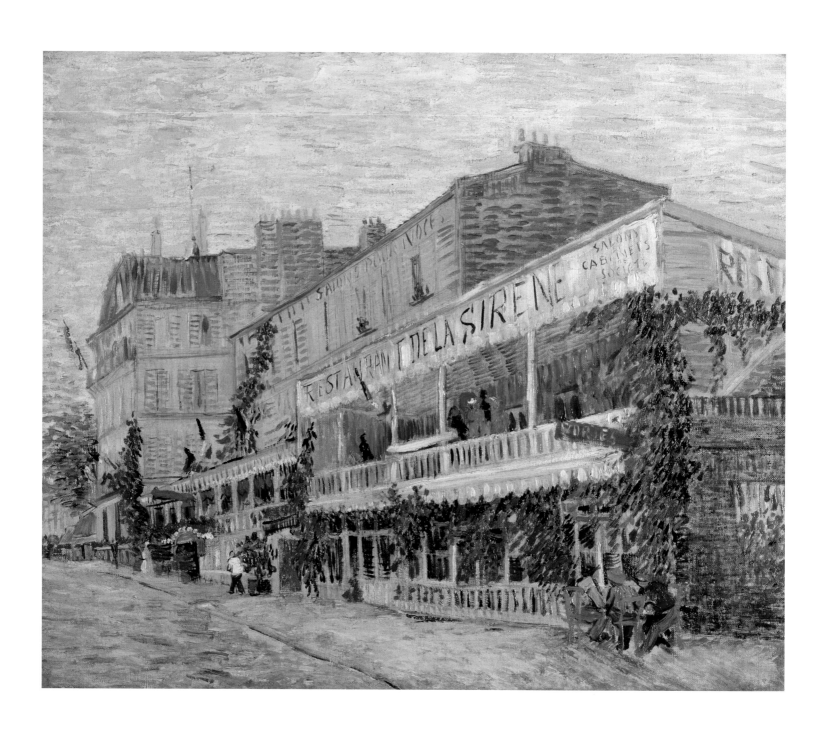

53

VINCENT VAN GOGH

Restaurant de la Sirène at Asnières (*Le restaurant de la Sirène à Asnières*), 1887

Oil on canvas

21 ½ × 23 ¾ in. (54.5 × 65.5 cm)

This stylistically experimental painting was created during Van Gogh's brief, yet crucial, stay in Paris. Working in Asnières alongside Bernard and Signac in the summer of 1887, Van Gogh painted views of the Seine and popular weekend leisure destinations such as the Restaurant de la Sirène. Here he explored Impressionism's bright palette and atmospheric effects, as well as Neo-Impressionism's division-ist technique, whose lessons in vibrant color contrasts would greatly inform the mature style of his Arles period.

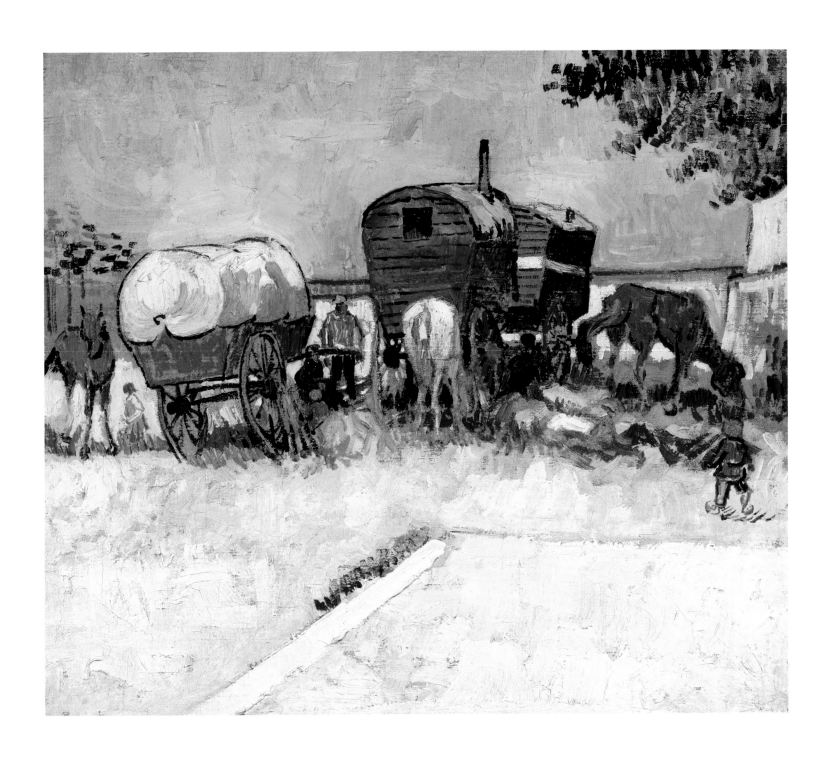

54

VINCENT VAN GOGH

Caravans, Gypsy Camp near Arles (*Les roulottes, campement de bohémiens aux environs d'Arles*), 1888
Oil on canvas
17 3/4 × 20 1/8 in. (45 × 51 cm)

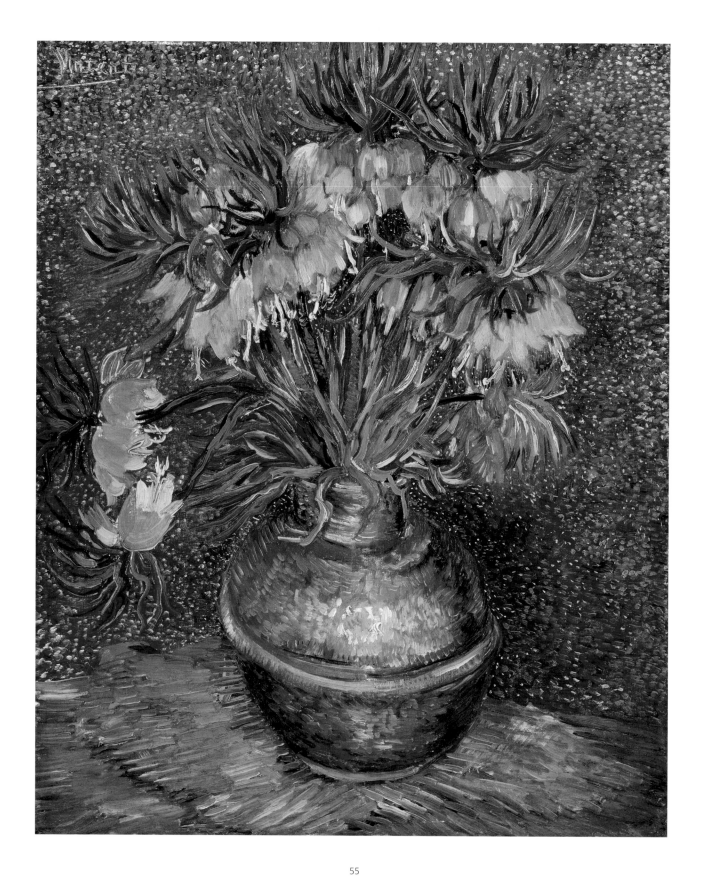

55

VINCENT VAN GOGH

Imperial Crown Fritillaries in a Copper Vase (*Fritillaires couronne impériale dans un vase de cuivre*), 1887
Oil on canvas
28 ¾ × 23 ⅞ in. (73 × 60.5 cm)

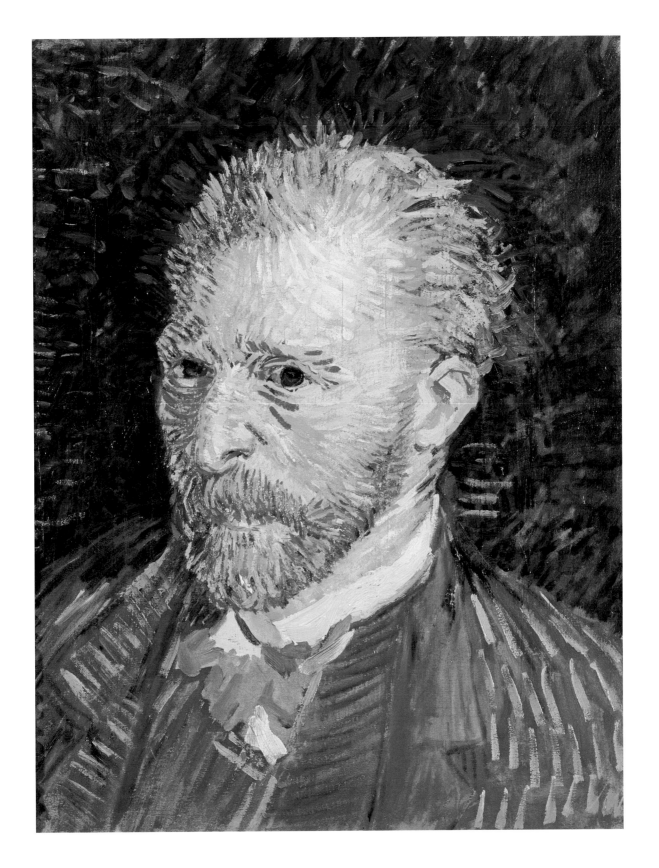

56

VINCENT VAN GOGH

Portrait of the Artist (*Portrait de l'artiste*), 1887

Oil on canvas

17 3/8 × 13 3/4 in. (44.1 × 35.1 cm)

57

VINCENT VAN GOGH

Starry Night (*La nuit étoilée*), 1888
Oil on canvas
28 ½ × 36 ¼ in. (72.5 × 92 cm)

VAN GOGH AND GAUGUIN

58

VINCENT VAN GOGH

Eugène Boch or *The Poet* (*Le poète*), 1888
Oil on canvas
23 5/8 × 17 3/4 in. (60 × 45 cm)

Upon meeting the Belgian artist Eugène Guillaume Boch in June 1888, Van Gogh was inspired to create a symbolic portrait, that of a poet. Applying expressive colors and brushstrokes, he sought to portray a dreamer highlighted against a dark background that symbolized infinity. Writing to his brother, Theo, he explained, "By the simple combination of a bright head against the rich blue background, I get a mysterious effect, like a star in the depths of an azure sky."

59

VINCENT VAN GOGH

Van Gogh's Bedroom at Arles (*La chambre de Van Gogh à Arles*), 1889

Oil on canvas

22 $^5/_8$ × 29 $^1/_8$ in. (57.5 × 74 cm)

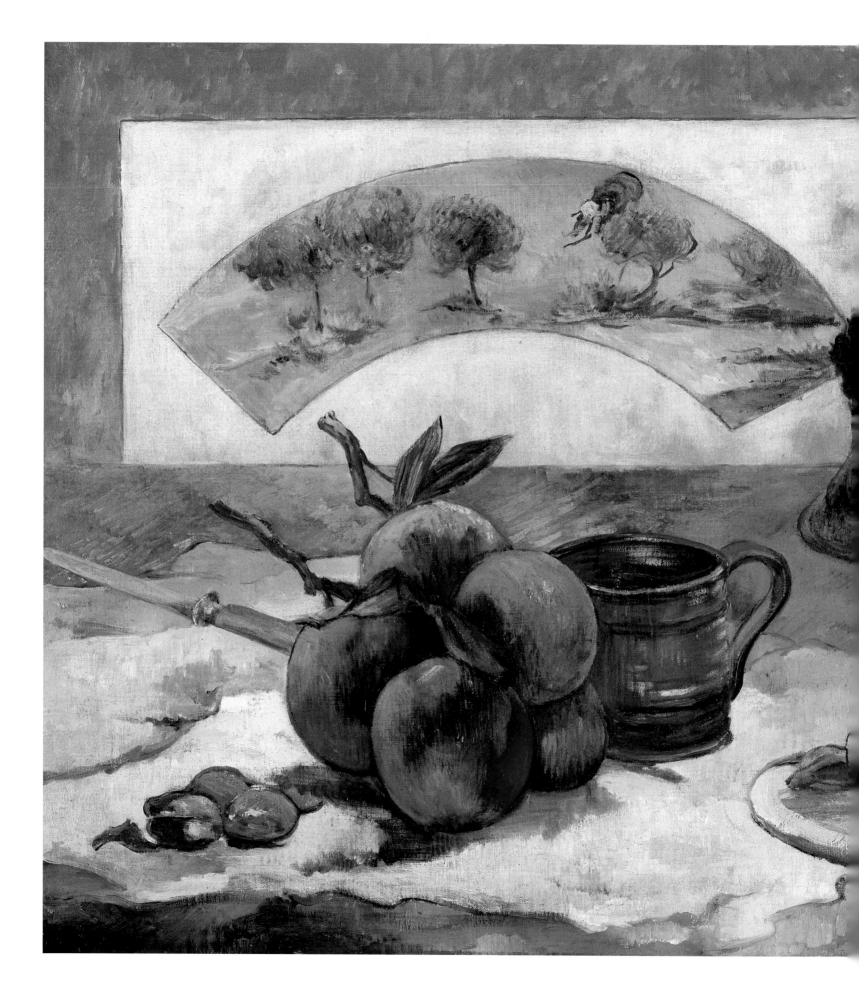

60

PAUL GAUGUIN

Still Life with Fan (Nature morte à l'éventail), ca. 1889
Oil on canvas
19 ³/₄ × 24 in. (50 × 61 cm)

Although Gauguin broke from the Impressionists in
1886, this painting seems to pay homage to those mem-
bers of the group whom he most admired. While the
fan in the background recalls those painted by Pissarro
and Degas, the apples in the foreground allude to those
of Cézanne, whose construction of form through color
had greatly influenced Gauguin's aesthetic. Inserting
himself among these artistic references, Gauguin in-
cluded his own oddly shaped ceramic sculpture, which
casts a shadow of mystery over the otherwise ordinary
still-life objects.

61

PAUL GAUGUIN

Washerwomen at Pont-Aven (*Les lavandières à Pont-Aven*), 1886
Oil on canvas
28 × 35 ³/₈ in. (71 × 90 cm)

P. Gauguin. 88

62

PAUL GAUGUIN

Les Alyscamps, 1888

Oil on canvas

36 × 28 ½ in. (91.5 × 72.5 cm)

Les Alyscamps is one of the fifteen works that Gauguin produced during his short stay with Van Gogh in Arles in the fall of 1888. Created shortly after Gauguin advised Sérusier on *The Talisman, the Aven at the Bois d'Amour* (cat. 77), the painting demonstrates the application of his newly formed Synthetist style. Through his abstraction of natural forms and the arbitrary use of color in the blue tree trunks and flaming red bush at right, Gauguin moved toward the highly expressive quality he was seeking in his art.

63
PAUL GAUGUIN
Portrait of the Artist with The Yellow Christ (*Portrait de l'artiste au* Christ jaune), 1890–1891
Oil on canvas
15 × 18 1/8 in. (38 × 46 cm)

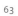

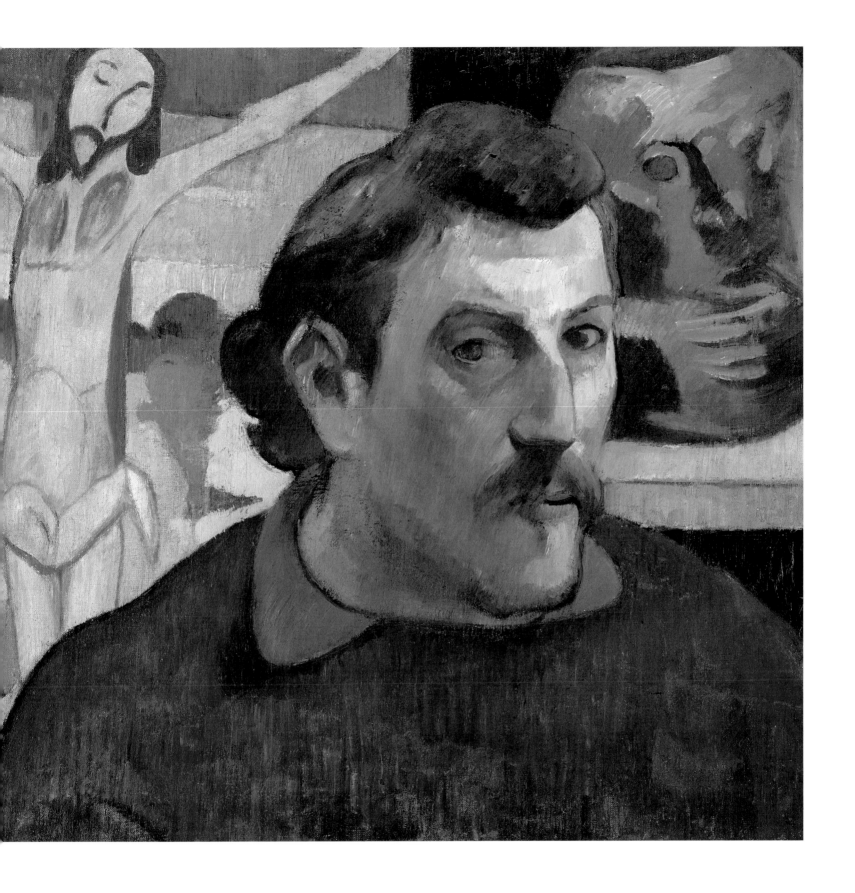

VAN GOGH AND GAUGUIN

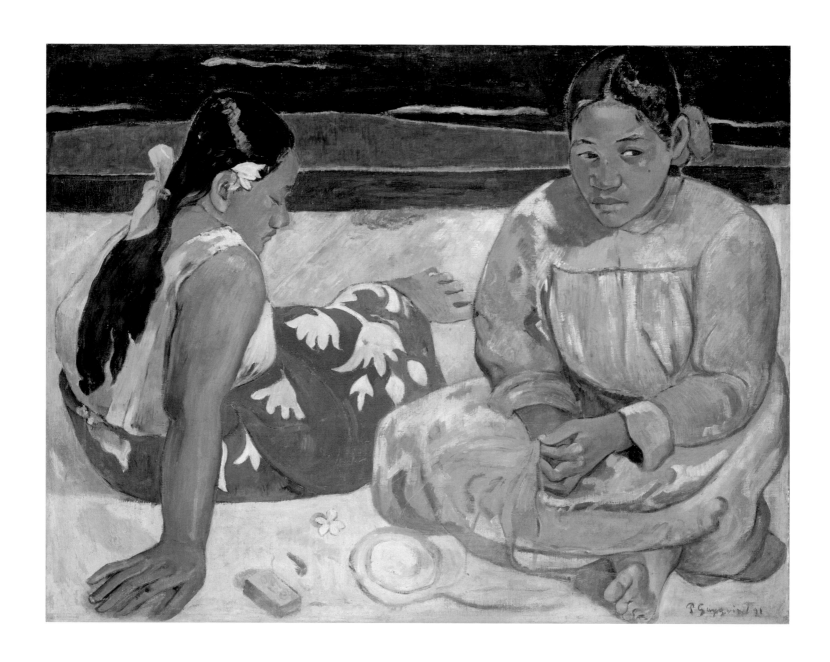

64

PAUL GAUGUIN

Tahitian Women (*Femmes de Tahiti*), 1891

Oil on canvas

27 1/8 × 36 in. (69 × 91.5 cm)

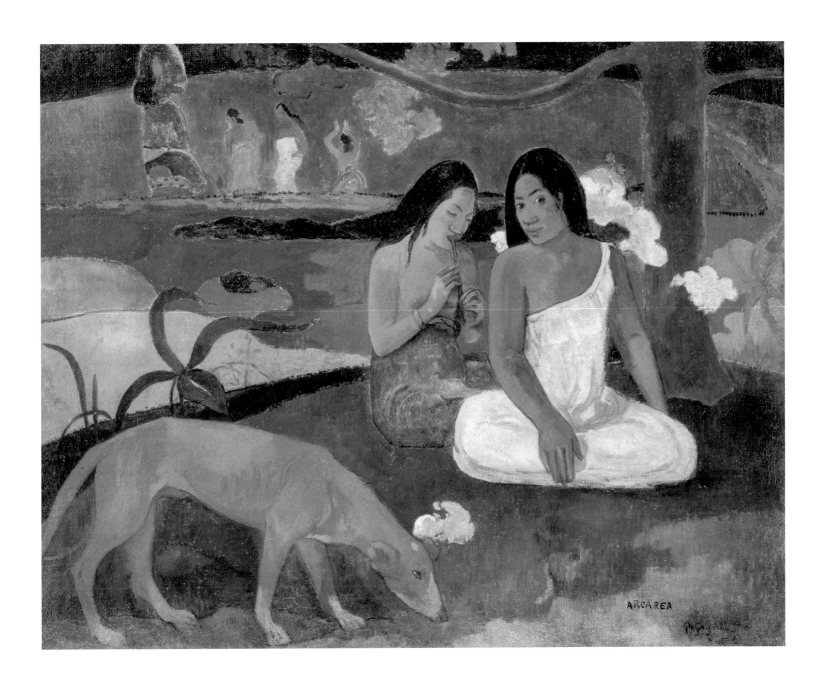

65

PAUL GAUGUIN

Arearea, 1892

Oil on canvas

29½ × 37 in. (75 × 94 cm)

Arriving in Tahiti in 1891, Gauguin was disappointed to discover that its present-day reality did not match the Arcadian paradise of his dreams. Using his imagination, he envisioned its long-forgotten religious rituals in a series of idyllic paintings to which *Arearea* (the Tahitian word for "joyousness") belongs. Although he intended its "symphony" of carefully arranged lines and colors to induce feelings of peace and happiness, *Arearea*, and its red dog in particular, baffled critics and artists alike when it was exhibited in Paris in 1893.

THE PONT-AVEN SCHOOL: FROM LEGEND TO LEGACY

STÉPHANE GUÉGAN

...the arrival in Brittany, where [Émile Bernard's] precocious mind encountered an evocative, somber landscape well-suited to his soul and the maturity of his talent.

ÉMILE SCHUFFENECKER[1]

While a "Pont-Aven School" did indeed exist, its definition cannot be reduced either to the artists of Paul Gauguin's circle or to a creed of shared aesthetics or iconography founded on Synthetism. No group exhibitions, manifesto, or controversy confirmed the existence of a movement in any way comparable to that of Impressionism or Neo-Impressionism. To be sure, Gauguin and his cohorts did everything they could to resist the influence of Georges Seurat and Paul Signac. Their opposition to the Neo-Impressionists' *ripipoint* (a pejorative word for pointillism), which they considered too rational and progressive, did not mean that they rejected that camp's modern subject matter and scientific approach to the world. Like Post-Impressionism, the Pont-Aven School started out as a myth of art history, and its legend was perpetuated by the Breton town's ultimate fate as an artistic tourist destination. Here, we examine only the achievements of Gauguin's circle.

Other than Vincent van Gogh, playing a decisive role from a distance, the participants in the Pont-Aven group were Émile Bernard, Charles Laval, and Paul Sérusier. Born in the same decade, they all received training that was, on the whole, academic. Following in the wake of Impressionism, these artists sought to push its limits, in particular its foundation in Realism. Bernard, like his friends Henri de Toulouse-Lautrec and Van Gogh, attended the studio of Fernand Cormon with a zeal that was well warranted. Cormon, the painter of *Cain* (1880, Musée d'Orsay), knew how to fill his paintings with energy and power, and he was similarly forceful in his teaching. By April 1886, Bernard, like Toulouse-Lautrec, found himself at the receiving end of his master's intolerance. The young painter's first trip to Brittany occurred shortly after his falling-out with Cormon.

In addition to the considerable number of Scandinavian and American artists already staying in Pont-Aven, Salon artists, such as Pascal Adolphe Jean Dagnan-Bouveret, had likewise heeded the enthusiasm for faraway provinces that were reputed to bring city dwellers closer to

nature and expose them to ancestral religions.[2] There was a commonly held belief among these artists that the dreariness of the Breton countryside and its somber inhabitants conferred a touch of poetic gravity to their work. During his first summer in Brittany, Gauguin merely crossed paths with the young Bernard; he was closer to Laval, a student of Léon Bonnat's who was drawn to Brittany not only by its reputation but also by his desire to make a profit from it. These artists were withdrawing from the modern, cosmopolitan world merely in appearance—or in their dreams.

The notion that one could immerse oneself in Brittany's unspoiled, traditional culture, provided one was drawn to its vestiges and nurtured the illusion of reconnecting with one's origins, was a myth inherited from Romanticism.[3] The definitive idea that Brittany and its people were archaic arose in the 1820s amid the nostalgic backlash against "the death of the provinces" brought about by the revolutionary organization of France's political districts, or *départements*. Taking its inspiration from Breton bards, who were known to be loyal to tradition, an entire literature depicted the primitiveness, whether good or strange, of the region's inhabitants, perpetuating the Celtic piety, the political independence, and the poetic effusiveness that were ingrained in Brittany's culture. Creating a legend of a place frozen in the past, these writers aroused nostalgia for a preindustrial, even precapitalist existence.

Moreover, there were economic factors that drew artists to Pont-Aven. Before his first stay in Brittany, from July to September 1886, Gauguin wrote to his wife, Mette: "If I sell a few paintings, I'll go … stay in an inn in some out-of-the-way place in Brittany, to paint and live modestly. In Brittany you can still live more cheaply than anywhere else."[4] Pont-Aven was then a lovely little village on a quick little stream, with fifteen hundred inhabitants and a temperate climate very favorable to working outdoors. The train from Paris stopped at Quimperlé, and from there the painters took a public carriage to Pont-Aven. Three inns housed the painters, who had come from all over the world. Gauguin found lodging in the renowned inn of Marie-Jeanne Gloanec.

During his first sojourn, Gauguin perfected a new style, using motifs that were then in vogue. As he was already on his way to becoming established in the vast Parisian art scene, it required no special effort for him to impose himself upon the little Pont-Aven group, which was far less demanding. However, one suspects that he was exaggerating somewhat when he asserted: "I'm the one who calls the shots in Pont-Aven. All the artists fear me and love me; not one of them resists my convictions."[5] Elsewhere he noted that he worked "a lot, and with success; I am respected as the best painter in Pont-Aven." It is doubtful whether such authority was granted Gauguin on the basis of his early Breton works, such as *Washerwomen at Pont-Aven* (1886, cat. 61), which are unadventurously Impressionist. The influence of Japanese woodcuts would become stronger in *Still Life with Profile of Laval* (fig. 24), which probably dates from the last months of 1886, after his return to Paris. Everything in this painting is original: the sudden intrusion of Laval's remarkable head, the vibrant red and green fruit, and the bizarre ceramic figure with no apparent purpose, radiating from the center of the canvas like an idol from a forgotten cult. The following year Gauguin went with Laval to Martinique, and then continued on to a stay in Panama that proved to be a failure. Sick, diminished, and bitter, they returned to France in November 1887.

During the summer of 1888 Bernard became better acquainted with Gauguin and Laval, and the three formed a sort of trio in Pont-Aven. Although Van Gogh was in Arles, he

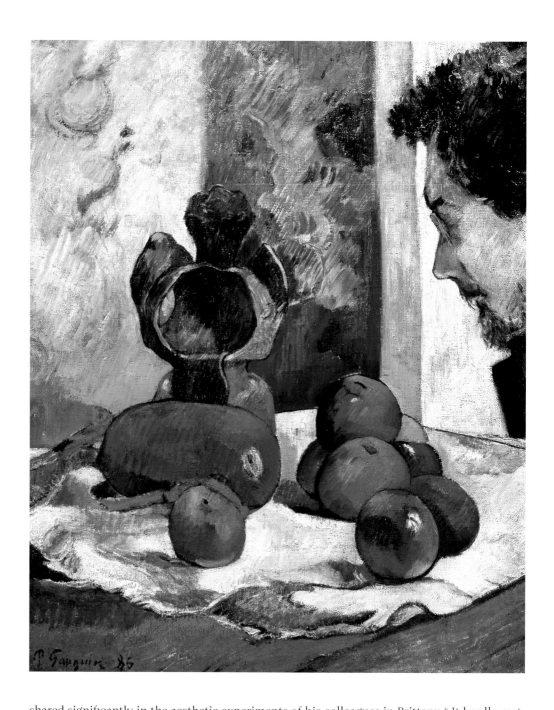

FIG. 24 **PAUL GAUGUIN**

Still Life with Profile of Laval (*Nature morte au profil de Laval*), 1886

Oil on canvas

18 1/8 × 15 in. (46 × 38.1 cm)

Indianapolis Museum of Art, Samuel Josefowitz Collection of the School of Pont-Aven, through the generosity of Lilly Endowment Inc., the Josefowitz Family, Mr. and Mrs. James M. Cornelius, Mr. and Mrs. Leonard J. Betley, Lori and Dan Efroymson, and other Friends of the Museum, 1998.167

shared significantly in the aesthetic experiments of his colleagues in Brittany.[6] It hardly matters that the Synthetist or Cloisonnist style Gauguin proclaimed to be his brainchild actually stemmed from the work of the younger artists. Who initiated it is probably less important than what each artist contributed to the group as a whole. Bernard's first Breton paintings, from the summer of 1886, showed a certain ongoing interest in Neo-Impressionist technique. Moreover, upon his return to Paris, he, along with Louis Anquetin, took part in the Salon des Indépendants, considered to be Seurat's stronghold. A few months later, a rapid change occurred. Bernard and Anquetin renounced pointillism, in which the rendition of form prevailed over the expression of an idea.[7] By April 1887 Bernard was back in Brittany. Expecting that Gauguin would be in Pont-Aven that summer, Bernard discovered to his bitter disappointment that his older colleague had left for Martinique. At this point, Cloisonnism—characterized by boldly outlined planes of flat color and simplified drawing—was being elaborated.

FIG. 25 **ÉMILE BERNARD**
Earthenware Pot and Apples
(*Pot de grès et pommes*), 1887
Oil on canvas
18 1/8 × 21 1/2 in. (46 × 54.5 cm)
Musée d'Orsay, RF 1977 40

Bernard's visual language—colors more expressive than descriptive, extremely simplified drawing—revealed early on a taste for order that has similarities with the work of Paul Cézanne, whom he would support eagerly. Evidence of this can be seen in *Earthenware Pot and Apples* (1887, fig. 25) as well as in the first paintings he produced alongside Gauguin in 1888. *The Harvest (Breton Landscape)* (1888, cat. 67), despite its excessively small format, combines the harmonious rhythms of Jean-François Millet with extreme formal concision. A use of yellow worthy of Van Gogh heightens the palette, but the scene is more serene than his friend's Arles landscapes. Though Bernard did not feel capable of painting the portrait Van Gogh requested from him in their abundant correspondence, he did send off the famous self-portrait dedicated to his friend (Van Gogh Museum, Amsterdam). The recipient considered it to be "chic like a true, true Manet."[8] In other words, Bernard used flat tints and emphatic lines like the painter of *The Fifer*.

Bernard furthered his ambition that summer by undertaking a large and very fine portrait of his younger sister, *Madeleine in the Bois d'Amour* (1888, cat. 2). One cannot imagine a more ambiguous picture. Laval loved her, Gauguin desired her, yet in her portrait she seems to be utterly incapable of earthly happiness. Her face, filled with a gentle reverie, provides the only link with her real existence. Her large body, with its supine stiffness, seems to have been chiseled rather than given life. In contrast to this picture's sense of repression and its overtones of the living dead, Bernard's fleshy bathers (1887, cat. 66), reminiscent of Cézanne's work, display unbridled eroticism and a sense of freedom. A deeply conflicted artist, as shown by some of his schizoid self-portraits, Bernard alternated religious subjects and scabrous images from 1889.[9]

An exhibition of the "Impressionist and Synthetist Group," with Gauguin at its center, was held in Paris at the Café Volpini in June 1889, at the same time as the Exposition Universelle. The owner of the venue, like many observers, did not understand the paintings and etchings, which he looked upon as if they were meaningless hieroglyphics. Laval, Anquetin, and Bernard were represented in the show, as well as other emulators of Gauguin, the obscure artists Léon Fauché and Louis Roy. On the whole, these artists hardly comprised a homogeneous phalanx where formal choices and subject matter were concerned.[10] The critics—Albert Aurier, Maurice Denis—valued not so much their unity of inspiration as their refusal of academic virtuosity and their rejection of Neo-Impressionism.[11] There lay the major antagonism. Bernard's evolution toward an accentuated form of Synthetism, as seen in *Breton Women with Umbrellas* (1892, cat. 74), and his later conversion to a deliberately reactionary art[12] are proof of this, as is the career of Sérusier.[13]

Sérusier is generally considered to be the first artist to convey the lessons learned at Pont-Aven to the future Nabis, who, like himself, had been students at the Académie Julian. Before the exhibition at the Café Volpini, Sérusier returned to Paris from Brittany—where he had stayed in 1888 and met Gauguin—and revealed to the Nabis his famous *Talisman, the Aven at the Bois d'Amour* (1888, cat. 77), the title later given to the Pont-Aven landscape he painted according to Gauguin's "direction."[14] Sérusier, who had been seasoned by Jules Bastien-Lepage's Naturalism, had just been awarded a special honor at the Salon for *The Breton Weaver* (1888, Musée d'Art et d'Archéologie, Senlis). His idealized Breton peasants were grave symbols of the age-old customs of the Armor region. But *The Talisman* heralded a stylistic change that would be confirmed by his paintings of 1889. The modest sketch quickly acquired value as an icon for all the young Nabis, especially for the part it played in the retrospective mythology of Pont-Aven fomented by Denis, who owned the work. An epiphany had occurred: "It was in the autumn of 1888 that Gauguin's name was revealed to us by Sérusier, back from Pont-Aven, and who showed us, somewhat mysteriously, a cigar lid on which you could see a landscape that was shapeless, by dint of the heavy influence of Synthetism, with violet, vermilion, Veronese green, and other pure colors."[15] The legend of a Pont-Aven School, equivalent to the School of Fontainebleau in the sixteenth century, arose even before Sérusier's death in 1927.[16] Post-Impressionism had produced its most flattering episode.

Translated from the French by Alison Anderson

NOTES

1 Émile Schuffenecker, notes on Émile Bernard, June 6, 1891, reprinted in MaryAnne Stevens et al., *Émile Bernard, 1868–1941: A Pioneer of Modern Art* (Amsterdam: Van Gogh Museum; Zwolle, Netherlands: Waanders Publishers, 1990), 379.

2 Antoine Terrasse, *Pont-Aven: L'école buisson-nière* (Paris: Gallimard, 1992), 16–17: "It was the American artists who first discovered Pont-Aven."

3 See Catherine Bertho, "L'invention de la Bretagne: Genèse sociale d'un stereotype," *Actes de la Recherche en Sciences Sociales*, no. 35 (November 1980): 45–62.

4 Letter from Gauguin to his wife, Mette, August 1885, in *Correspondance de Paul Gauguin: Documents, témoignages*, ed. Victor Merlhès (Paris: Fondation Singer-Polignac, 1984), 83.

5 Letter from Gauguin to his wife, Mette, August 1886, in ibid., 138.

6 See my essay "Van Gogh and Gauguin: The Resurrection of Delacroix?" in this volume.

7 When later analyzing Cézanne's career, he would refer to the break in 1886–1887. By then the painter from Aix had begun his "serious" period, more intellectual than his Impressionist phase. See Émile Bernard, "Paul Cézanne," *Les Hommes d'Aujourd'hui* 8, no. 387 (1890).

8 Vincent van Gogh to Theo van Gogh, October 4 or 5, 1888, letter 697, at http://vangoghletters.org/vg/letters/let697/letter.html.

9 On Bernard's deeper personality, see Schuffenecker's remarkable and moving notes for an article in *Les Hommes d'Aujourd'hui*, which was not published, in Stevens et al., *Émile Bernard*, 376–379. This manuscript, dated June 6, 1891, was enriched by long conversations with Bernard covering topics such as the great piety of his youth, his probably frustrated sexuality at that time, his training at Cormon's studio, his admiration for Cézanne, his friendship with Van Gogh, and the "long private moments in the evening spent with a beloved sister, who was an exquisite musician." While Bernard's discovery of Brittany is mentioned, Gauguin is not discussed in the abandoned article. By this time the relationship between the two former friends had cooled considerably. Bernard did not appreciate Aurier's article on Gauguin (*Le Mercure de France*, March 1891), in which Gauguin appears as the dominant figure of Symbolist painting. More-over, Gauguin's first departure for Tahiti had put an end to any projects in common.

10 See Heather Lemonedes et al., *Paul Gauguin: The Breakthrough into Modernity* (Cleveland: Cleveland Museum of Art; Amsterdam: Van Gogh Museum, 2009), notably the essay by Belinda Thomson on the Volpini exhibition, 214–225.

11 See Albert Aurier, "Concurrence," *Le Moderniste*, June 27, 1889; and the famous article by Maurice Denis, "Définition du Néo-Traditionnisme," *Art et Critique*, August 23 and 30, 1890, reprinted in Denis, *Le ciel et l'Arcadie*, ed. Jean-Paul Bouillon (Paris: Hermann, 1993).

12 Once he had broken off with Gauguin, Bernard joined forces with the Rosicrucian group, and after 1891 he created closer ties with the Nabis. In 1892 he returned to Pont-Aven, where he created important works such as *Breton Women with Umbrellas* (cat. 74), which is reminiscent of Seurat's *A Sunday on La Grande Jatte—1884* (1884–1886, fig. 8). In 1941 Denis read Bernard's funeral oration.

13 For an overview of Sérusier's aesthetic approach and career, see Caroline Boyle-Turner, "Paul Sérusier," in *Nabis, 1888–1900*, ed. Claire Frèches-Thory and Ursula Perucchi-Petri (Munich: Prestel; Paris: Réunion des Musées Nationaux, 1993), 249–250.

14 On the back of the sketch Sérusier had written, "Created in October 88 under Gauguin's direction, by Paul Sérusier in Pont-Aven."

15 Maurice Denis, "Paul Sérusier, sa vie, son oeuvre," in *ABC de la peinture*, by Paul Sérusier (Paris: Floury, 1942), 42. The first edition of Sérusier's book was published in 1921.

16 See Émile Bernard, "Notes sur l'École dite de Pont-Aven," *Le Mercure de France*, December 1903. It is interesting to note Bernard's slight reservation regarding the myth he had helped to establish.

66

ÉMILE BERNARD

Bathers with Red Cow (*Baigneuses à la vache rouge*), 1887
Oil on canvas
36 3/8 × 28 1/2 in. (92.5 × 72.5 cm)

67

ÉMILE BERNARD

The Harvest (Breton Landscape) (*La moisson [Paysage Breton]*), 1888
Oil on panel
22¼ × 17¾ in. (56.5 × 45 cm)

The Harvest is a powerful illustration of Cloisonnism, an aesthetic that Bernard developed in collaboration with Louis Anquetin in 1887–1888. Inspired by medieval enamels and stained-glass windows as well as Japanese woodblock prints, this innovative style is characterized by broad areas of solid color and boldly outlined shapes. The decorative effect of Bernard's radically simplified and flattened forms was a revelation to the young Nabi painters who rallied around Gauguin and the Pont-Aven School in the 1890s.

68

PAUL GAUGUIN

Yellow Haystacks (The Golden Harvest) (*Les meules jaunes*
[La moisson blonde]), 1889
Oil on canvas
29 × 39 ³/₈ in. (73.5 × 92.5 cm)

The Breton harvest is a recurrent theme in Gauguin's
paintings of the late 1880s. In this work, he used the
swelling form of golden haystacks to block out the
horizon line, transforming an idyllic scene of rural life
into a rhythmic patchwork of matte tonalities. Equating
style and subject, Gauguin proclaimed, "I find [in
Brittany] the savage, the primitive. When my clogs
resound on the granite soil, I hear the muffled, dull,
powerful tone that I seek in my painting."

69

PAUL GAUGUIN

Seascape with Cow (At the Edge of the Cliff)
(*Marine avec vache [Au bord du gouffre]*), 1888
Oil on canvas
28 1/2 × 24 in. (72.5 × 61 cm)

Drawn to Le Pouldu's wild landscape and precarious perch above the sea, Gauguin made several visits to the Breton town in 1888 to paint the view from its cliff top. In this daring composition, we are positioned looking down onto the rocky coastline below. While the plunging perspective, bold cropping, and unusual vantage point demonstrate Gauguin's knowledge of Japanese woodblock prints, the ordering of nature into geometric planes of contrasting colors reveals his debt to Cézanne.

70

CHARLES LAVAL

Landscape (Paysage), 1889–1890
Oil on paper mounted on canvas
21 5/8 × 18 1/8 in. (55 × 46 cm)

Upon meeting Gauguin in Pont-Aven in 1886, Laval became one of his most stead-fast admirers. The two worked side by side in Brittany and traveled together to Martinique and Panama in 1887. Painted after his return to France, *Landscape* reveals Laval's development of a personal style that combines Cézanne's thinly painted parallel brushstrokes with the compressed space, contoured forms, and matte hues of Gauguin's Synthetism.

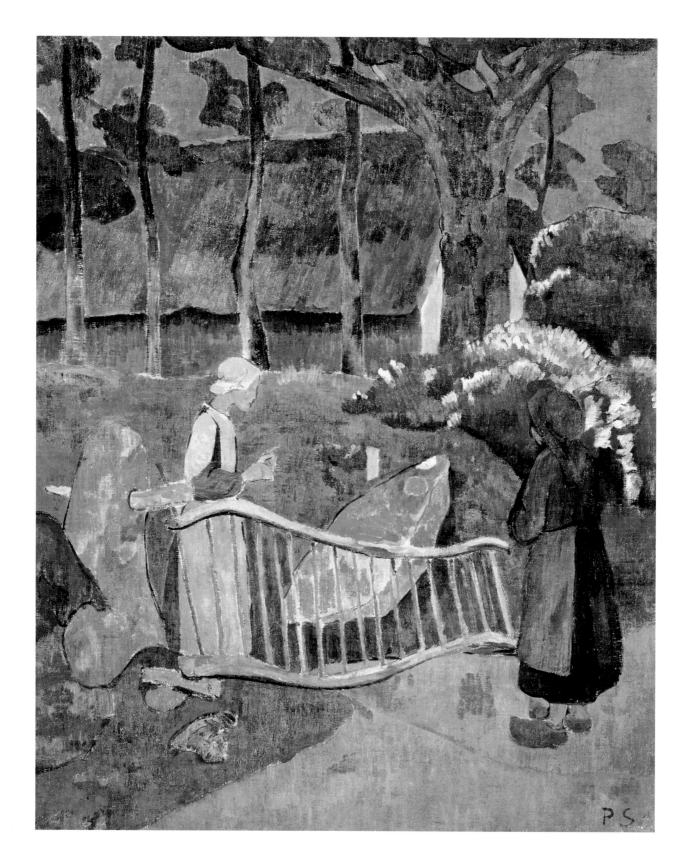

71

PAUL SÉRUSIER

The Flowery Fence, Le Pouldu (*La barrière fleurie, Le Pouldu*), 1889
Oil on canvas
28 3/4 × 23 5/8 in. (73 × 60 cm)

72

PAUL SÉRUSIER

The Fence (*La barrière*), 1890

Oil on canvas

20 × 24½ in. (50.7 × 62.3 cm)

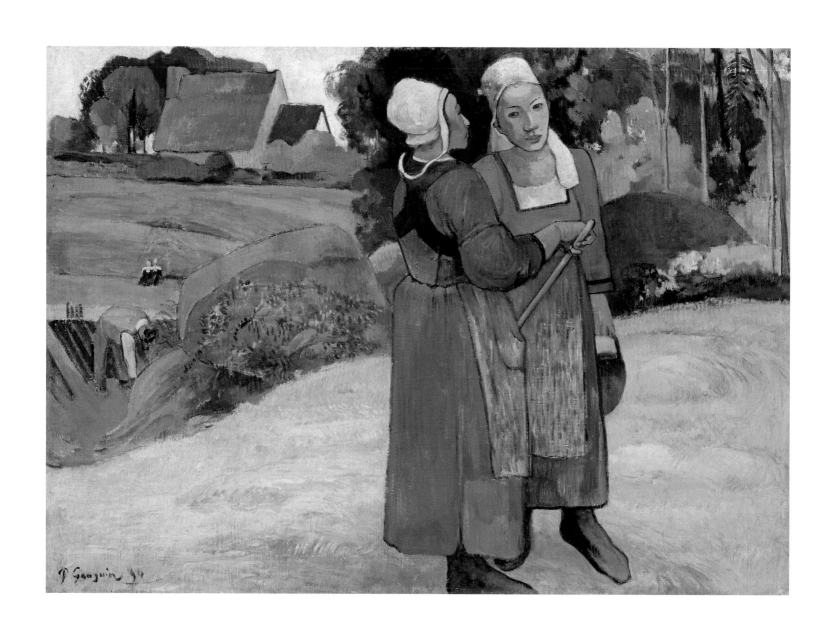

73

PAUL GAUGUIN

Breton Peasant Women (*Paysannes bretonnes*), 1894

Oil on canvas

26 × 36 ³/₈ in. (66 × 92.5 cm)

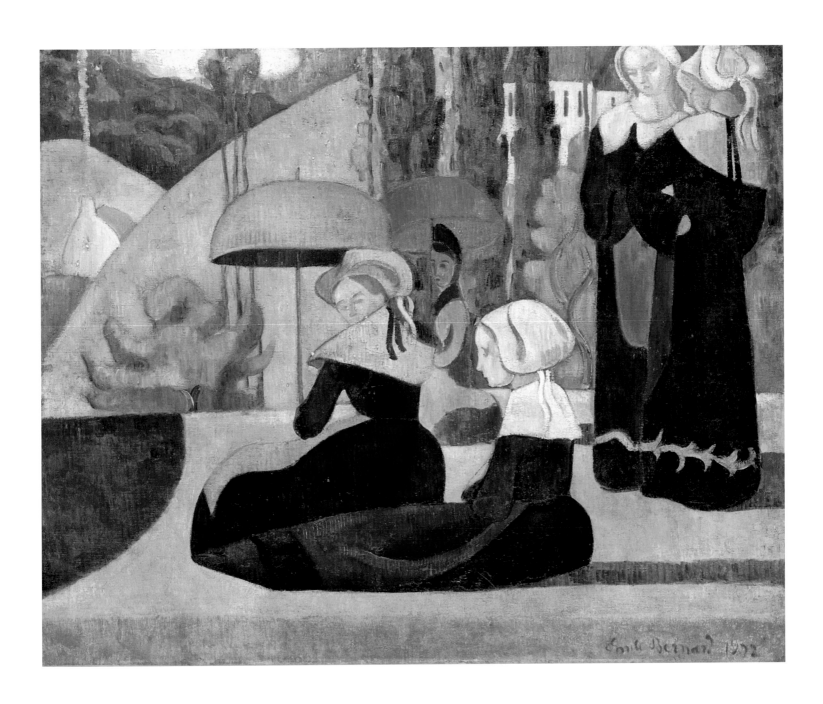

74

ÉMILE BERNARD

Breton Women with Umbrellas (Les bretonnes aux ombrelles), 1892
Oil on canvas
31⅞ × 41⅜ in. (81 × 105 cm)

Like Gauguin, Laval, and Sérusier, among others, Bernard was drawn to the
"uncivilized" region of Brittany, which seemed to defy the rapid industrialization
that characterized France in the late nineteenth century. In *Breton Women with
Umbrellas*, Bernard employed bold colors and greatly simplified forms in order to
evoke the "primitive" qualities of his subject. The timeless image of Breton women
dressed in traditional folk costume is contrasted with the absolute modernity of
the painting's style.

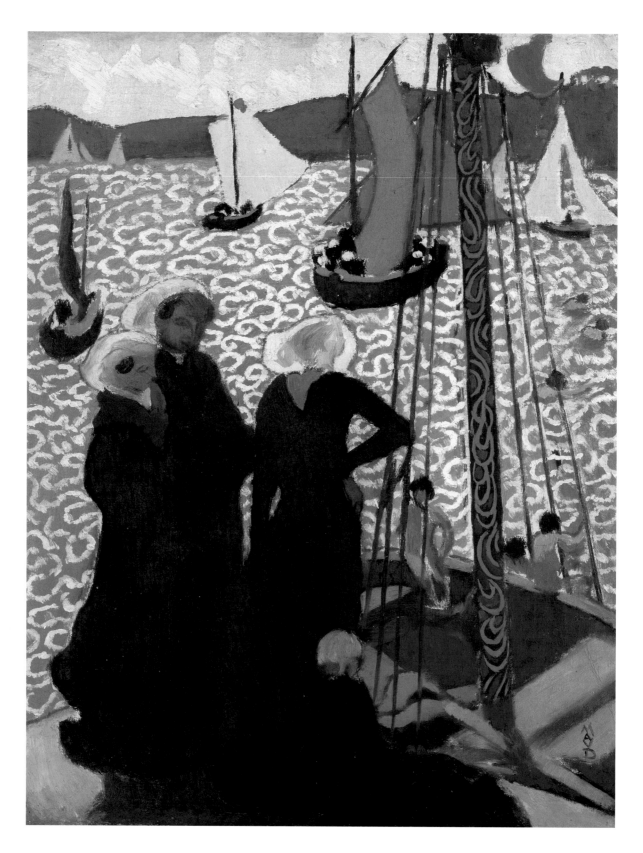

75

MAURICE DENIS

Regatta at Perros-Guirec (*Régates à Perros-Guirec*), 1892
Oil on canvas
16 ⅝ × 13 ¼ in. (42.2 × 33.5 cm)

A frequent visitor to the Breton coastal town of Perros-Guirec, Denis rendered its sparkling bay in the decorative aesthetic of the newly formed Nabi group. Combining a high horizon line with extremely stylized forms, he produced a startling image that superposes figures and boats against an utterly decorative treatment of rippling water. Denis incorporated the triangular sails and swirling lines of the white-capped waves into the graphic pattern of a wallpaper design in 1893.

76

PAUL GAUGUIN

Breton Village in the Snow (*Village breton sous la neige*), ca. 1894

Oil on canvas

24³⁄₈ × 34¹⁄₄ in. (62 × 87 cm)

THE NABIS AND SYMBOLISM IN 1890S PARIS

SYLVIE PATRY

·

There was a revolution in painting that claimed to take its inspiration from Gauguin, but which did not owe everything to Gauguin's influence alone. There were Symbolist poets and musicians, an era, a climate favoring the ideal.

MAURICE DENIS[1]

In 1901 Maurice Denis exhibited *Homage to Cézanne* (1900, cat. 28). In this ambitious painting, the painter Odilon Redon, at the left, is joined by those who originated the Nabi movement at the end of the 1880s. Motioning toward Redon, in front of Cézanne's *Still Life with Fruit Dish* (1879–1880, fig. 11), is Paul Sérusier. The others are, from left to right: Édouard Vuillard, with a red beard; the critic and collector André Mellerio, wearing a top hat; behind the easel, the dealer Ambroise Vollard, in whose Paris gallery the scene is set; Denis; Paul Elie Ranson, wearing glasses and a hat; Ker-Xavier Roussel, in profile; Pierre Bonnard; and Denis' wife, Marthe. Mellerio has just introduced the young artists to Redon, and all of them seem to be listening to Sérusier, whose forward stance is a nod to the decisive role he played in forming the Nabis and developing their aesthetic credo.

BIRTH OF A MOVEMENT

Sérusier, the second oldest in the group after Ranson, preferred the Académie Julian to the École des Beaux-Arts, which he had also attended, because it was an independent school, like several others in Paris, where artists could paint living models. The artist was also a *massier* (student in charge) of the "little studios" of Jules Joseph Lefebvre and Gustave Boulanger, which were offshoots of the Académie Julian. By 1887 Ranson, Denis, Vuillard, Bonnard, Roussel, Henri Gabriel Ibels, and René Piot had all trained at the Julian, often in addition to the instruction they received at the École des Beaux-Arts, where Denis, Vuillard, Bonnard, and Roussel were unenthusiastic students. These artists were all around twenty years old in 1887; the youngest was Denis, at seventeen, and the oldest was Ranson, at twenty-five. Most of them had grown up in Paris or nearby, except for Ibels, Piot, and Ranson. Vuillard, Roussel, and Denis had been fellow students at the prestigious Lycée Condorcet, where Sérusier had studied previously.

They all had a solid background in the classics. At the time they met, none had yet developed a particular style, but they shared a vocation and a vivid desire to be part of the flourishing contemporary art scene in Paris. Much later, Bonnard referred to how, as a youth, he was attracted to the "life of an artist, with everything that implied, to my mind, in the way of fantasy and the freedom to do what I wanted. I had certainly been drawn to painting and drawing for a long time already, but it had not been an irresistible passion; whereas I did want to escape, at any price, from a monotonous life."[2] In the diary that he kept from the age of thirteen, Denis also noted his aspiration to "this pure, holy pleasure, this gentle artist's life."[3]

Sérusier was a very cultivated man, and he inspired the admiration of his younger comrades. He became a sort of intellectual and artistic mentor, as suggested by his position in Denis' painting mentioned above. In addition to his oeuvre as a painter and sculptor, Sérusier wrote poetry and plays. He exhibited for the first time at the Salon of 1888, showing *The Breton Weaver* (1888, Musée d'Art et d'Archéologie, Senlis). His realistic subjects, including craftsmen and peasants, were portrayed in the Naturalist mode that was very much in fashion in the 1880s. Sérusier was born in Paris, but he liked to say that he was "born spiritually"[4] in Brittany,

PAGE 166
MAURICE DENIS
Landscape with Green Trees (Green Trees) (Procession under the Trees) (Paysage aux arbres verts [Les arbres verts] [La procession sous les arbres]), 1893
Detail of cat. 101

For Françoise Cachin

where he spent the summer of 1888 in the village of Pont-Aven. There he met Paul Gauguin, who, along with Émile Bernard, was experimenting in the development of a simplified painting style in which shapes were sharply delimited by bold outlines.[5] This encounter proved to be a seminal event. Although Sérusier was disappointed by their initial contact, Gauguin subsequently invited him to a session of painting in the Bois d'Amour, along the Aven river. Sérusier came away with a landscape, executed on a modest wooden panel, that is now known as *The Talisman, the Aven at the Bois d'Amour* (1888, cat. 77). As Denis later recounted what Sérusier had told him of the experience: "'How do you see those trees?' asked Gauguin; 'If they are yellow, then make them yellow; and that bluish shadow, paint it with pure ultramarine; and those red leaves? Use vermilion.'"[6] When he returned to Paris in the autumn of 1888, Sérusier presented his composition, in which the formal elements (trees, shore, house, light on the water) were re-created by means of simplified patches of pure color, making the landscape "shapeless by virtue of being synthetically formulated."[7] The work made a strong impression on his young comrades at the Académie Julian—although he would have to wait until the early 1890s to see the impact of his landscape on their art.

The lessons of *The Talisman*, whose title alone suffices to convey the seminal value the Nabis would attribute to it, were reinforced by paintings by Gauguin that the young artists admired at the gallery Boussod, Valadon et Cie, along with those by Émile Bernard, Charles Laval, and Louis Anquetin. The work of these artists was brought together for the memorable exhibition of the "Impressionist and Synthetist Group" at the Café Volpini, on the sidelines of the Exposition Universelle in Paris, in June 1889.[8] Still, although it was decisive, "Gauguin's influence"[9] was not the only example leading Denis, Vuillard, Bonnard, and the others down a new path. Pierre Puvis de Chavannes, with his *grande manière*, albeit simplified, was much admired by the Nabis at an exhibition in 1887. Also essential to them were the past innovations and recent developments of Impressionism—seen in Cézanne's work, in particular—as well as the great art of the past that these regular visitors to the Louvre were discovering with awe. The art of Japan also earned special admiration in 1890, when it was the subject of a major exhibition of prints at the École des Beaux-Arts. Furthermore, poetry, philosophy, theater, and music all contributed to nourishing the Nabis' curious, enthusiastic minds. Taking all of these influences together, they came to be convinced of the senselessness of the Naturalist, imitative approach in painting, and in art in general: "And so we learned that any work of art was a transposition, a caricature, the passionate equivalent of a received sensation," recalled Denis.[10] The emergence of the Nabi movement was part of a rich blossoming of Symbolism in the visual, musical, and literary arts.

"THIS INDEFINABLE CHARACTERISTIC THAT I TRANSLATE AS NABI"

The intersection of these decisive influences and experiences led to the creation in 1889 of the Nabi group. The name comes from the Hebrew and Arabic word *nebiim*, meaning "prophet." It was suggested by the writer and occasional painter Auguste Cazalis, a friend of Sérusier's. He compared these young painters—advocates of a new aesthetic—"to the colleges of [biblical] prophets who practiced sacred music and received the inspiration of Yahweh, in lofty places comparable to our own Butte Montmartre. . . . We were, therefore, the Nabis, that is, the Inspired Ones, prophets facing the Philistines who had become the Pelichtim, our adversaries, the

world of those who refused to embrace the new painting."[11] The term *Nabi*, deliberately rare and scholarly, embodied the interest in theosophy and occult sciences of some of the movement's adherents, Sérusier and Ranson in particular. It also signified that art could not be confined to the description of an observed exterior reality but had to express an inner vision, for what is visible is a manifestation of the invisible. The artist was a "prophet" insofar as he was an intermediary between these two dimensions. Through shapes and colors, the painter provided a material translation of states of being. The "prophets" were also those who had come before the "revolution in painting"[12] at the end of the 1880s and whose aim had been to define new paths for the art to come.

During the 1890s the artists did not refer to any of their joint exhibitions as "Nabi" events; on occasion they were introduced as "Impressionist and Symbolist painters," as at the Galerie Le Barc de Boutteville between 1891 and 1896.[13] The Nabis were often qualified as belonging to the "Gauguin school." In 1895 Denis recorded the list of labels that had been used since 1891 to designate them by "those who followed, from the beginning, the evolution of these painters, referred to in succession as Cloisonnists (Dujardin, *Revue Indépendante*, 1886), Synthetists (1889), Neo-Traditionists (Pierre Louis, *Art et Critique*, 1890), 'Ideists' (A[lbert] Aurier, [*Le*] *Mercure* [*de France*], 1891), Symbolists and distorters (A. Germain)."[14] *Nabi* remained a term used in the studio, and it was also linked, not without humor, to the coded formulas that the artists exchanged among themselves. For example, they often signed their letters "En ta P.M.V.E.T.P."—*En ta paume mon verbe et ta pensée*, "In your palm my verb and your thought."

The founding of the group also represented something of a dream, shared by Van Gogh and Gauguin, of creating a *confrérie*, or brotherhood, that was, in Sérusier's words, "unencumbered, consisting solely of confirmed artists, in love with what is beautiful and good, filling their works and their behavior with this indefinable characteristic that I translate as Nabi."[15] For the first few years, the young artists were in the habit of meeting in a modest restaurant in the passage Brady, not far from the Académie Julian; and on Saturdays they met in Ranson's studio at 25 boulevard du Montparnasse, quickly baptized "the Temple." Ranson's wife, France, became the "light" of the Temple. Each of the artists had a nickname: Sérusier was the "Nabi with the rutilant beard"; Bonnard, the "very Japanesy Nabi"; Denis, the "Nabi of the beautiful icons"; Vuillard, the "Zouave." The newcomers who joined the group in 1889 or the early 1890s did not want to be outdone: the Dutch artist Jan Verkade, who was tall, was nicknamed the "Nabi obelisk," and Georges Lacombe the "Nabi sculptor." The nicknames referred to personal traits in an amusing manner, as in the case of Cazalis, who stuttered, and who became the "Nabi Ben Kalyre—the Nabi of the hesitant verb." Writers and musicians also joined, such as Pierre Hermant and Paul Percheron, as well as the actor and future theater director Aurélien Lugné-Poë.

Sérusier's *Portrait of Paul Ranson in Nabi Costume* (1890, cat. 79) is very evocative of the reigning atmosphere, in which jokes and facetiousness were not uncommon.[16] For example, Nabi meetings concluded with skits of puppets inveighing against the bourgeois order. In Sérusier's portrait, Ranson appears as a "great initiate," to quote the title of a work by Édouard Schuré that had a lasting influence on some of the Nabis and a number of Symbolist artists.[17] The orange disc around Ranson's head suggests a prophet's light or illumination, as described by Schuré. Sérusier frequently mentioned the esoteric treatises Ranson kept in his bountiful library on boulevard du Montparnasse. The portrait also reflects the fascination with occult

sciences that Sérusier shared with Ranson.[18] In addition, Ranson wears a priestly robe (despite being outspokenly anticlerical) and holds a scepter, which, although it may have existed solely in Sérusier's imagination, nevertheless confirms the lofty concept of the artist's role as prophet that is at the foundation of the Nabi movement.[19] Is he not the artist who deciphers a mysterious manuscript for us? Like the term *Nabi*, the portrait apparently did not leave the studio very often. Ranson kept it until his death in 1909 and did not exhibit it during his lifetime. It was a controversial article by Denis—distributed when Sérusier, Denis, Bonnard, and others took part in exhibitions—that made the group known on the art scene in the early 1890s.

DEFINING "NEO-TRADITIONISM"

In August 1890, in the small, recently founded journal *Art et Critique*, Denis published (under the pseudonym Pierre Louis) a "Definition of Neo-Traditionism," a term that he did not succeed in imposing. Denis was not yet twenty. He shared a tiny studio at 28 rue Pigalle with Bonnard, Vuillard, and Lugné-Poë. His text begins with a phrase that has become famous: "Remember that a picture, before being a battle horse, a nude, an anecdote, or whatnot, is essentially a flat surface covered with colors assembled in a certain order."[20] Denis was calling, forcefully, for a reversal. A painting's irreducible elements—color, flatness, line—were to express the "mood" of the artist and not the subject or the story being told. Denis took a strong stand against academic painting, which went no further than the imitation of reality using hackneyed subject matter, but he also rejected a certain type of Symbolism that he qualified as "literary."[21]

By "literary" Denis was targeting the Symbolist sensibility that had developed in literature and painting during the 1880s. More precisely, he was contesting a certain interpretation of Symbolism that was theorized by the poet Jean Moréas. In *Le Figaro* on September 18, 1886, Moréas published the manifesto of Symbolism in literature. Confronted with what he deemed an impoverishment in poetry, he identified a new school, with Charles Baudelaire as its precursor. He included in this trend Stéphane Mallarmé, Paul Verlaine, and Théodore de Banville: "However, the Supreme enchantment has not been entirely consumed: an opinionated and jealous labor solicits newcomers." He went on to describe the aesthetics of this future poetry as Symbolist: "Symbolist poetry seeks: to cloak the idea in a sensible form that, nevertheless, will not be an end in itself but that, while serving to express the idea, will remain subject to it. The Idea, in turn, must never be deprived of the magnificent robe of external analogies; for the nature of Symbolism consists in never going as far as the conception of the Idea in itself."[22] Together with these poets, who were "the enemies of instruction, declamation, false sensibilities, and objective description,"[23] artists reacted against the ambient Naturalism and Impressionism—at least as practiced in vulgarized form by "best-selling" painters—that was often held to be a "dimwitted" Realism, to use Redon's term.[24] Redon was considered one of the principal heralds of a new sensibility, alongside Gustave Moreau and Pierre Puvis de Chavannes, who were the true tutelary figures of the new tendencies. At this time, art critics, poets, and writers in general played an important role by forging unprecedented alliances with painters, in particular Moreau and Puvis, whom those who adhered to Symbolism in the late nineteenth century would regard as father figures.

Moreau and Puvis remained independent of any group, despite their bonds of friendship. The two men belonged to the same generation: Puvis was born in 1824, and Moreau two

FIG. 26 **GUSTAVE MOREAU**

The Apparition (*L'apparition*), ca. 1876

Watercolor

41 1/4 × 28 7/16 in. (106 × 72.2 cm)

Musée du Louvre, Paris, RF 2130

years later. They both died in 1898. They each had received a classical education that led them to a formative experience in Italy (in 1848 for Puvis and in 1857–1859 for Moreau). Above all, they greatly admired the Romantic painter Théodore Chassériau, who had a lasting influence. Moreau and Puvis began to exhibit at the Salon in the 1850s.[25] Their studios were near each other, Puvis' at place Pigalle and Moreau's at rue de la Rochefoucauld (now the Musée nationale Gustave-Moreau). Letters, a drawing, and a painting are all testaments to the relations between the two artists.[26] By the late 1870s and early 1880s they were known to be exploring new paths, going against both the Realist, imitative conception of art and the academic tradition, which they fought on its own territory of historical and decorative painting. In 1884 the novelist Joris-Karl Huysmans published *À rebours*, whose hero, des Esseintes, a reclusive aesthete, sits and contemplates works by Moreau, such as the major watercolor *The Apparition* (ca. 1876, fig. 26), which concerns the theme of Salomé.[27] The novel made Moreau better known and

promoted the image of him as an enigmatic, phantasmagorical painter, creating the myth of the perverse femme fatale in the reclusion of his Parisian studio. Very much in tune with Huysmans' interpretation, critics of the early 1880s praised Moreau for the "particular strength of his dreamlike creations"[28] and identified his distinctive position as an artist who had broken with both academic painting and the anti-establishment Impressionist movement. Confronted with these two "giants," Moreau devised an idealistic concept of art that anticipated the Symbolism of the 1880s and 1890s: "I can believe neither what I touch nor what I see. I can believe only what I cannot see, only what I can feel. My brain, my reason seem ephemeral to me and of doubtful reality; my inner feeling alone seems eternal, and indisputably certain."[29]

This credo was fully, brilliantly embodied in *Orpheus* (1865, cat. 98), a seminal painting presented at the Salon in 1865 and the Exposition Universelle in 1867. Purchased by the French government, it was the only painting by Moreau to be seen in a public collection in France until the artist's death in 1898. While his works became well known through reproductions, insofar as Moreau stopped exhibiting at the Salon after 1880, *Orpheus* assumed an important position with regard to the younger generation. The subject, the young Thracian girl holding the head of the poet Orpheus, has references to Italian painting. The work is close in spirit to that of the English Pre-Raphaelites: its decorative embellishments add to its suggestiveness and mystery, and the artist identifies strongly with the figure of the poet with closed eyes.

Similarly, as of the 1880s Puvis had adopted a more personal style. The easel works and major decorative paintings that came to typify his career, from the stairway panels of the museum in Amiens to his unfinished project at the Panthéon in Paris, are characterized by a timeless atmosphere, as if the scenes are bathed in a dream. *The Poor Fisherman* (1881, cat. 100) had the power of a manifesto and was a milestone in his evolution. Exhibited at the Salon of 1881, it was a response to the Naturalism of painters such as Pascal Adolphe Jean Dagnan-Bouveret, who was very much in fashion. Puvis chose one of Realism's favorite subjects in the figure of the fisherman and his evocation of dire poverty. Puvis had been struck by the real impoverished conditions he witnessed during a stay in Saint-Valéry-sur-Somme, on the northern coast of France, which is no doubt where he conceived the painting, in 1879. The theme of poverty is accentuated by the choice of protagonists (a fisherman, with his children, the elder of whom must look after the baby because their mother has died). An emphasis is placed on their torn, muddy clothes. And yet the poverty does not belong to a particular geographic, historical, or social context. Léon Werth spoke out in protest: "I have seen my share of poor fishermen . . . and they were not like those depicted by M. P. de C. They had a short earthenware pipe and a cap. I've also seen fishermen's wives. They did not wear draperies nor did they pick flowers." Puvis challenged the spirit of the time: "We find ourselves increasingly in an atmosphere that is absolutely inimical to imaginative concepts. Photography and sewing machines are the true expression of our time. It is only a short step to a total eclipse of any personal or poetic aspiration."[30] In the 1890s the Symbolist artists would turn to Puvis' example for its distance from the modern world and for its internalization of the subject. In his own words, Puvis was painting a "vision of poverty" that he "borrowed only from [him]self."[31] He emphasized the subjectivity of the artist and viewed meditation upon the subject as an essential filter between reality and art. Instead of a social situation, he sought to express a feeling or a state of mind, filled with melancholy and prayer. It is an attitude that was derived openly from the peasants

FIG. 27 **JEAN-FRANÇOIS MILLET**
The Angelus (*L'Angélus*), 1857–1859
Oil on canvas
21 7/8 × 26 in. (55.5 × 66 cm)
Musée d'Orsay, RF 1877

in Jean-François Millet's *Angelus* (1857–1859, fig. 27), one of the most famous paintings of the nineteenth century.

By the 1890s Moreau and Puvis were emulated. Artists such as Edgard Maxence (a student of Moreau's), Alexandre Séon, and Alphonse Osbert followed in their footsteps. They may be assimilated with those whom Bernard called the "artists of the ideal," who united under the title "painters of the soul" in 1896[32] and exhibited at the annual Salon de la Rose + Croix (Salon of the Rose + Cross), organized between 1892 and 1897 by Joséphin Péladan. These events became the primary forum for Symbolist art in search of noble, literary, mystical subjects, eager to make use of a complex iconography. Péladan, an art critic as of 1881, was a larger-than-life individual who proclaimed himself "Sâr Péladan."[33] By the early 1890s he was a famous author and very much in fashion. A member of a group of renewed Rosicrucians, an esoteric religious brotherhood, he created the Catholic Ordre de la Rose + Croix and declared himself the grand master. Every year this society organized an art exhibition with the aim of combating Realism through idealism and restoring meaning to the image. The "Rule of the Annual Salon de la Rose + Croix" (1895) sought to encourage the "Catholic Ideal and mysticism. Below that, Legend, Myth, Allegory, Dreams, the Paraphrase of Great Poets and finally all of Lyricism, while favoring works of a mural nature as a superior essence." This rule was followed by lists of all the subjects and genres that were proscribed—such as modern private life and still lifes, "no matter how perfect the execution"—and of those that were accepted, "no matter how imperfect the execution."[34] As defined by Péladan, the program established a strict hierarchy of subjects and genres.[35] Above all, it fixed the degree of idealism in a work of art by its subject alone.

FIG. 28 **PIERRE BONNARD**
France-Champagne, 1891
Color lithograph
30 1/2 × 22 3/4 in. (77.5 × 57.8 cm)
Museum of Modern Art, New York, Abby Aldrich
Rockefeller Fund, 471.1949

It was against that concept, which even today is all too often used to sum up Symbolism, that Denis and the Nabis came out in force.[36] In opposition to being annexed by Péladan, and as an associate of Redon, Moreau, and Puvis, Denis claimed, for example, to be a direct heir of Redon. According to Denis, Redon was the "Mallarmé of painting,"[37] and he initially intended to pay tribute to him in what became his *Homage to Cézanne*. But he was also an heir to Puvis by virtue of the powerfully suggestive visual technique at work in *The Poor Fisherman*: "And this eternally sad man whom Puvis constructed in *Poor Fisherman*, who was he? The aesthetes' universal triumph of the imagination over unthinking imitation, the triumph of the emotion of beauty over Naturalist lying," wrote Denis in 1890 in "Definition of Neo-Traditionism."[38] In 1934 he would again refer to the role of "Puvis de Chavannes, the Puvis of the *Poor Fisherman*, the great forgotten master, whose enormous influence on the late nineteenth century can never be overstated."[39]

What Denis and, more generally, the artists of the Post-Impressionist circles—especially the Neo-Impressionists Georges Seurat and Paul Signac—retained from Puvis' example was that this poignant expression of poverty was conveyed not by resorting to anecdote or story but by visual means alone. As Denis wrote:

> However sad the chosen subject might be, however dreary the picturesque elements that compose it, the painting will never . . . give the impression of sadness if the dominant characteristics of the lines, colors, and tone do not agree visually with the feelings the artist is seeking to express. If the mast of the boat in Puvis de Chavannes' *Poor Fisherman* were not inclined in the direction of inhibition (counterclockwise), this painting would not evoke sadness. Puvis, a student of [Nicolas] Poussin, knew how to handle the elements of composition. . . . Those eternal rules . . . use the pictorial to reinforce the fragility of the picturesque.[40]

More fundamentally, from the beginning of the 1890s, Denis deplored the way some artists "enjoyed confusing mystical and allegorical tendencies, that is, the search for expression through the subject, and Symbolist tendencies, that is, the search for expression through the work of art."[41] For him, this "expression through the work of art" was the surest way toward Symbolism, therefore, the expression of an ideal.

Gauguin was not saying anything different in 1888 to his friend the painter Émile Schuffenecker: "A piece of advice, don't copy too much from nature. Art is an abstraction. Take it from nature while you dream in its presence and think more about creativity than about the result: that is the only way to rise toward God while doing just what our divine master is doing, creating."[42] Thus, in what would become the first manifesto of "Symbolism in painting," published by the critic Albert Aurier on March 15, 1891, in *Le Mercure de France*, Gauguin was proclaimed the leader of a style of painting in which lines and colors were "directly significant characters" and had to be the object of a "necessary simplification." He enumerated five points that characterize a work of art:

> 1. *Ideist*, because its only ideal will be the expression of an idea. 2. *Symbolist*, because it will express the idea through forms. 3. *Synthetist*, because it will write those forms, those signs, according to a general mode of comprehension. 4. *Subjective*, because the object

FIG. 29 **MAURICE DENIS**
Preparatory Drawing for the Frontispiece of
Sagesse by Paul Verlaine, 1889–1890
Ink on paper
4 ³⁄₄ × 3 ¹⁄₃ in. (12 × 8.4 cm)
Musée d'Orsay, RF 52911

will never be considered as an object but as the sign of an idea perceived by the subject.
5. (And this is a consequence) *Decorative*, because decorative painting per se, the way
the Egyptians understood it, and probably the Greeks and the Primitives, is nothing other
than a manifestation of art that is all at the same time subjective, Synthetist, Symbolist,
and Ideist.[43]

Aurier's manifesto was a culminating event, brilliantly and effectively expressing the aesthetic redefinition sought by the Nabis and, more generally, the "school of Gauguin."

"TO EXALT COLOR AND SIMPLIFY FORM"

With these words, Sérusier defined the goals of Symbolism in a letter to Denis, written while he was with Gauguin in Pont-Aven during the summer of 1888.[44] In 1890, adding to the lesson of *The Talisman* two years earlier, Denis affirmed, "From the canvas itself, a flat surface covered with color, emotion emerges, bitter or consoling."[45] The emphasis placed on flatness, line, and color is perceptible in the work of the Nabis as of 1889–1890. During their weekly meetings, the "brothers" were in the habit of exchanging little panels on which they experimented freely with the expressive power of the painting's material elements: Denis' *Sunlight on the Terrace* (1890, cat. 78) is not at all like an Impressionist study of light through the foliage. Denis reduced figures, trees, shadows, and light to juxtaposed areas of pure, vivid color. Details are proscribed in favor of simple, synthetic forms. The colors, spread flat over the canvas without being mixed or modulated, assert the notion that painting is two-dimensional and should not aim to imitate real volume or space. The sinuous outlines echo and follow each other, distorting the motif and tracing vigorous arabesques, as also seen in Vuillard's *Profile of a Woman in a Green Hat* (ca. 1891, cat. 84). "Even a simple search for lines . . . has an affective value," added Denis at the end of his manifesto in 1890.[46]

The same principles are to be found in the works the Nabis exhibited in 1890–1891, when they emerged on the Paris art scene with not only paintings but also works of graphic art—for example, Bonnard's France-Champagne poster (1891, fig. 28) and Denis' illustrations for Verlaine's poetry collection *Sagesse* (1889–1890, fig. 29).[47] The young painters made the most of the independent salons and shows in art galleries, which had been increasing in number since the 1880s. They did not exhibit separately from the other members of the Post-Impressionist avant-garde. Instead, they hung their paintings alongside those by Anquetin, Henri de Toulouse-Lautrec, and even the Neo-Impressionists, whose pointillist brushstroke can be found in Nabi paintings such as Denis' *Princess Maleine's Minuet (Marthe at the Piano)* (1891, cat. 87).

The first half of the 1890s was a fertile period, which Denis would qualify as "decisive years of work, theory, effervescence." The group was enriched by new recruits who had come to Paris from abroad. Paris was the true art capital at that time, yet some of these artists went first to Brittany, where Sérusier was continuing his Synthetist experiments, along with Gauguin, the Dutch artist Meyer Isaac de Haan, and Denis. The newcomers included the Danish Mögens Ballin, who was particularly close to Sérusier, and Verkade, who arrived in Paris from Holland in February 1891 and became very close to Denis.[48] In 1893 the Swiss artist Félix Vallotton exhibited for the first time with the Nabis; he had been in Paris for nearly nine years and had shown his work at the Salon between 1885 and 1890.

FIG. 30 **KATSUSHIKA HOKUSAI**

Cresting Wave off the Coast of Kanagawa (The Great Wave) (Kanagawa oki uranami), from the series *Thirty-Six Views of Mount Fuji (Fugaku sanjūrokkei)*, ca. 1831–1834

Color woodcut

9 13/16 × 14 1/2 in. (25 × 36.9 cm)

Fine Arts Museums of San Francisco, museum purchase, Achenbach Foundation for Graphic Arts Endowment Fund, 1969.32.6

Vallotton, who was also a critic and a novelist, was well connected in artistic and literary circles in Paris from 1891 onward, thanks to the woodcuts he published in avant-garde journals. Endowed with a vast cultural knowledge, he was a regular visitor to the Louvre and had his very own pantheon, whose influence is obvious in the sharp line and strange realism of his work. His *Self-Portrait* or *My Portrait* (1897, cat. 93) expresses his deep admiration for Jean-Auguste-Dominique Ingres and Hans Holbein the elder. His subject matter brings him particularly close to Vuillard and Bonnard; the same attitude of biting humor informs their relentless curiosity about subjects drawn from everyday life.

Within the group was the "Nabi sculptor" Georges Lacombe, who met Sérusier in 1892 and maintained lasting ties with him. His paintings, such as *The Violet Wave* (1895–1896, cat. 5), explore the decorative dimension of Japanese woodcuts, which are reinforced by nuanced colors and radically free of any penchant for imitation; see, for example, Katsushika Hokusai's work on the same theme (ca. 1831–1834, fig. 30). Lacombe's seascapes also share with his wood sculptures a primitivist power that he would accentuate over the years.

During the 1890s the Nabis participated in a constant stream of exhibitions, showing at the Salon des Indépendants and at the Galerie Le Barc de Boutteville, one of their main venues, which presented their work from 1891 to 1896. From 1893 the dealer Vollard also showed their work, taking over a primary role upon Louis-Léon Le Barc's death in 1896; it is therefore not

FIG. 31 **PIERRE BONNARD**
Portrait of Vuillard (*Portrait de Vuillard*), 1892
Oil on panel
5 ¹¹⁄₁₆ × 8 ⁹⁄₁₆ in. (14.5 × 21.8 cm)
Musée d'Orsay, RF 1993 7

surprising that Denis set *Homage to Cézanne* in Vollard's gallery. Solo exhibitions brought the first signs of recognition for the artists. In the early 1890s a network of admirers formed around the Nabis, including varied personalities such as the painter Henry Lerolle; the three Natanson brothers, the publishers of *La Revue Blanche*; Misia Natanson, wife of Thadée Natanson, and her brother, Paul Desmarais; the Natansons' cousin, the composer Ernest Chausson; and Coquelin Cadet, a famous actor from the Comédie-Française. They bought finished works or commissioned decorative paintings, thus enabling the Nabis, in their efforts to abolish the hierarchical barriers between easel paintings and decoration, to successfully bring their project to fruition.[49] Misia Natanson, a muse and mutual friend of Vallotton, Vuillard, and Bonnard, posed for the three painters and commissioned work from them: for example, *Misia at Her Dressing Table* (1898, cat. 90) by Vallotton; and the decorative panels *Water Games (The Voyage)* and *Pleasure* (1906–1910, cats. 116–117) by Bonnard, whose patron was by then known as Misia Edwards.

The painters also experimented in etching, posters, illustration, embroidery, tapestry, ceramics, and stained glass, in part due to the support of Siegfried Bing, an art dealer in Art Nouveau, who made them the centerpiece of a renaissance in applied arts at the end of the nineteenth century. The Symbolist journals—in particular the Natanson brothers' *La Revue Blanche*—helped to make their paintings and etchings known. In addition, the Nabis established close ties with the theatrical avant-garde: they designed set decoration and programs for the Théâtre d'Art and the Théâtre de l'Oeuvre, thus linking their names with the introduction in France of playwrights such as Maurice Maeterlinck, Henrik Ibsen, and August Strindberg.

Numerous mutual portraits are a testament to the friendships and exchanges among the Nabis: for example, Sérusier's portrait of Ranson, mentioned earlier (cat. 79); Roussel in the figure of Vuillard's *Reader (Portrait of K.-X. Roussel)* (ca. 1890, cat. 83); Vuillard depicted by Bonnard (1892, fig. 31); and Vallotton by Vuillard (ca. 1900, cat. 3). In a way, Denis' *Homage to Cézanne* of 1900 can be seen as part of the broader Nabi phenomenon of the intimate, friendly portrait—despite the divisions that had arisen within the group by the time it was painted.

1895–1900: DIVERGENCE AND EPILOGUE

By the mid-1890s the Nabis had achieved a certain prominence in a number of fields. During the second half of the decade, the differences among the artists, each of whom had his own distinct personality, developed into a deep-rooted divergence. On the one hand, Denis, Sérusier, and Verkade were eager to base their work on absolute rules, adapting Nabi aesthetics to the requirements of a classical, monumental, and collective language that was reinforced by a strong Catholic and spiritual commitment.[50] Bonnard and Vuillard, on the other hand, sought to apply an instinctive approach, painting modern life in its most transitory aspects (as seen, for example, in Bonnard's 1899 lithographs *Some Scenes of Parisian Life*) and displaying a preference for the interplay of colors and textures, sometimes with a sharp, humorous criticism of bourgeois morality. At the end of the 1890s, the division between these two Nabi sensibilities was exacerbated. However, Denis' *Homage to Cézanne* brings together the proponents of the "Latin taste" (that is, the classical camp of Sérusier and Ranson) and the supporters of a more—in Denis' terms—"stenographic" painting (Bonnard, Vuillard, and Roussel). The exhibition of *Homage to Cézanne* in 1901 anticipated the group's last joint exhibition, which took place in 1902 at the Galerie Bernheim-Jeune in Paris, until the retrospective exhibitions of 1934 and 1943.[51]

The dispersal of the Nabis at the end of the 1890s would not put an end to their common endeavors, exchanges, and friendships, even if they never did constitute a group on the model of the twentieth-century avant-garde (a collective of artists united through their shared belief in a well-defined aesthetic program). The Nabis would remain close all their lives, until the last one, Bonnard, died in 1947, following Vuillard, Denis, and Roussel earlier in that decade.[52] These four artists had been the dominant figures in French painting in the interwar period. Thus, the end of the Nabi and Symbolist adventure in the late 1890s did not endanger the fertility of their shared aesthetic principles. As Denis declared, "One has to acknowledge that these theories favored each artist's personal expression, and in no way stifled what represented an emotion, a human value, a veritable artistic gift."[53]

Translated from the French by Alison Anderson

NOTES

1 Maurice Denis, "Paul Sérusier, sa vie, son oeuvre," in *ABC de la peinture*, by Paul Sérusier (Paris: Floury, 1942), 39. The first edition of Sérusier's book was published in 1921.

2 Quoted in Antoine Terrasse, *Bonnard: La couleur agit* (Paris: Gallimard, 1999), 13.

3 "And then I shall make Art, Art in masses, in everything, everywhere. I will stuff myself, get drunk on this pure, holy pleasure, this gentle artist's life, that I so desire" (July 1885). Maurice Denis, *Journal*, vol. 1 (Paris: La Colombe, 1957), 30.

4 Quoted in Claire Frèches-Thory and Antoine Terrasse, *The Nabis: Bonnard, Vuillard, and Their Circle* (New York: Harry N. Abrams, 1991), 29.

5 See Stéphane Guégan's essay "The Pont-Aven School: From Legend to Legacy" in this volume.

6 Denis, "Paul Sérusier, sa vie, son oeuvre," 42.

7 Maurice Denis, "L'influence de Paul Gauguin," *L'Occident*, October 1903, 160–164, reprinted in Denis, *Le ciel et l'Arcadie*, ed. Jean-Paul Bouillon (Paris: Hermann, 1993), 74.

8 *Catalogue de l'exposition de peintures du groupe impressionniste et synthétiste: Faite dans le local de M. Volpini au Champ-de-Mars* (Paris: Volpini, 1889; repr., Paris: Watelet-Arbelot, 1971).

9 From the title of an article by Maurice Denis, "L'influence de Paul Gauguin," reprinted in Denis, *Le ciel et l'Arcadie*. Denis became the chief memoirist of the Nabi movement.

10 Ibid., 75.

11 Maurice Denis, "Préface," *L'école de Pont-Aven et les Nabis, 1888–1908* (Paris: Galerie Parvillée, 1943), unpaginated [1–2].

12 Ibid., [1].

13 *Nabi* did not appear in the title of an exhibition until 1943. Denis wrote about the origins of the movement in the exhibition catalogue; see note 11.

14 Maurice Denis, "À propos de l'exposition d'Armand Séguin," *La Plume*, March 1, 1895, 118–119.

15 Letter from Paul Sérusier to Maurice Denis, Pont-Aven, not dated [summer 1889, according to Denis], quoted in Sérusier, *ABC de la peinture*, 47. See also Frèches-Thory and Terrasse, *The Nabis*, 24.

16 One of the Nabis, Jan Verkade, emphasized that the artists used the term "half in jest, half seriously." See Jan Verkade, *Le tourment de Dieu: Étapes d'un moine peintre* (Paris: L. Rouart et J. Waterlin, 1923), 72.

17 Édouard Schuré's *Les grands initiés* was published in 1889.

18 In particular, *Traité élémentaire de science occulte* by Papus, published in 1888.

19 Maurice Denis subsequently explained the iconography. The scepter in the portrait apparently did not exist. See Alexander Sturgis et al., *Rebels and Martyrs: The Image of the Artist in the Nineteenth Century* (London: National Gallery, 2006), 150.

20 The text is published in Denis, *Le ciel et l'Arcadie*, 5–21.

21 On the difficulty of defining a homogeneous Symbolist movement, and on "Symbolisms," see Sharon Hirsh, "Editor's Statement: Symbolist Art and Literature," *Art Journal* 45, no. 2 (1985): 95–97; and Jean-Paul Bouillon, "Le moment symboliste," and Dario Gamboni, "Le 'symbolisme en peinture' et la littérature," *Revue de l'Art*, no. 96 (1992): 5–13 and 13–23.

22 Jean Moréas, "Le symbolisme: Manifeste de Jean Moréas," reprinted in *Curiosités littéraires: Les premières armes du symbolisme* (Paris: Léon Vanier, 1889), 33–34.

23 Ibid., 33.

24 Odilon Redon, *À soi-même: Journal, 1867–1915; Notes sur la vie, l'art et les artistes* (Paris: Corti, 1961), 96.

25 In 1859 for Puvis de Chavannes, after multiple rejections beginning in 1851; and in 1852 for Moreau.

26 The letters, now held at the Musée nationale Gustave-Moreau, Paris, cover the period from 1865 to 1890. See also, for example, Moreau's *Puvis et Delaunay se rendant chez Gustave Moreau* (undated, Musée nationale Gustave-Moreau); and Puvis' *Portrait of Gustave Moreau* (ca. 1865–1870, Musée des Beaux-Arts, Rouen).

27 Moreau exhibited a version of *Salomé* at the Salon of 1876 (Hammer Museum, Los Angeles).

28 G. Schéfer et al., *L'exposition des beaux-arts (salon de 1880)* (Paris, 1880), quoted in Peter Cooke, "Symbolism, Decadence, and Gustave Moreau," *The Burlington Magazine* 151, no. 1274 (May 2009): 314n19.

29 Peter Cooke, ed., *Écrits sur l'art par Gustave Moreau*, vol. 1 (Fontfroide, France: Fata Morgana, 2002), 163.

30 Letter from Puvis de Chavannes, September 28, 1879, private collection, quoted in Aimée Brown Price, "*The Poor Fisherman*: A Painting in Context," in *Pierre Puvis de Chavannes* (Amsterdam: Van Gogh Museum, 1994), 52n8.

31 Quoted by Marius Vachon, *Puvis de Chavannes: Un maitre de ce temps* (Paris: Société d'Éditions Artistiques, 1900), 160.

32 The exhibition in 1896 of "painters of the soul" included Osbert, Séon, Émile Schwabe, Armand Point, and others.

33 *Sâr* means "magician" in Persian. Péladan claimed he was the descendant of a Babylonian king.

34 See Jean Da Silva, *Le Salon de la Rose + Croix* (Paris: Syros-Alternatives, 1991), 112–116.

35 See, for example, Françoise Cachin, "Some Notes on Pissarro and Symbolism," in *Studies on Camille Pissarro*, ed. Christopher Lloyd (London: Routledge and Kegan Paul, 1986), 95–98.

36 Denis, the sole theoretician of the group, published "Notes sur la peinture religieuse" in 1896 to set himself apart from the "painters of the soul." Reprinted in Denis, *Le ciel et l'Arcadie*, 32–48.

37 Ibid., 213.

38 Maurice Denis, "Définition du néo-traditionnisme," *Art et Critique*, August 23 and 30, 1890, reprinted in Denis, *Le ciel et l'Arcadie*, 20.

39 Denis, "L'époque du symbolisme," *Gazette des Beaux-Arts*, March 1934, reprinted in ibid., 207.

40 Ibid., 176–177.

41 Maurice Denis, "Le salon du champ de mars: L'exposition de Renoir," *La Revue Blanche*, June 25, 1892.

42 Letter from Gauguin to Schuffenecker, August 14, 1888, reprinted in *Correspondance de Paul Gauguin: Documents, témoignages*, ed. Victor Merlhès (Paris: Fondation Singer-Polignac, 1984), 210.

43 Albert Aurier, "Le symbolisme en peinture: Paul Gauguin," reprinted in Aurier, *Le symbolisme en peinture* (Caen, France: L'Échoppe, 1991), 26.

44 Letter from Sérusier to Denis, quoted in Frèches-Thory and Terrasse, *The Nabis*, 19.

45 Reprinted in Denis, *Le ciel et l'Arcadie*, 17.

46 Ibid.

47 The illustrated edition was finally published in 1911.

48 In 1894 the Hungarian painter József Rippl-Rónai joined the group. He had been living in Paris for over five years when the Nabis came to him. Roussel, Bonnard, and Vuillard were greatly impressed by his elegant, *Intimiste* painting. After he returned to Hungary in 1900, he helped to make the work of his Parisian friends known in central Europe. It was also through him that Aristide Maillol came into contact with the Nabis, in 1894.

49 See the essay "The Great Art We Call Decorative" in this volume.

50 As an adolescent, Denis had wanted to be a Christian artist. Ballin and Verkade converted to Catholicism.

51 For 1934, see note 53; for 1943, see note 11.

52 Vuillard died in 1940, Denis in 1943, and Roussel in 1944.

53 Denis' article "L'époque du symbolisme," published in *La Gazette des Beaux-Arts* in March 1934, concerned the exhibition organized by the Galerie des Beaux-Arts, titled "Gauguin et ses amis: L'école de Pont-Aven et l'Académie Julian." Reprinted in Denis, *Le ciel et l'Arcadie*, 217.

77

PAUL SÉRUSIER

The Talisman, the Aven at the Bois d'Amour
(*Le Talisman, l'Aven au Bois d'Amour*), 1888
Oil on panel
10 5/8 × 8 1/2 in. (27 × 21.5 cm)

Sérusier painted this strikingly abstract landscape under the supervision of Gauguin, who instructed him to use the most vivid colors of his palette to accentuate his sensations before nature. Unveiled to Denis, Bonnard, Ranson, and Ibels at the Académie Julian, the aptly named *Talisman* became an icon of the Nabi movement. Denis summed up Gauguin's revelatory lesson in 1890: "Remember that a picture, before being a battle horse, a nude, an anecdote, or whatnot, is essentially a flat surface covered with colors assembled in a certain order."

78

MAURICE DENIS

Sunlight on the Terrace (*Taches de soleil sur la terrasse*), 1890
Oil on board
9 1/2 × 8 1/8 in. (24 × 20.5 cm)

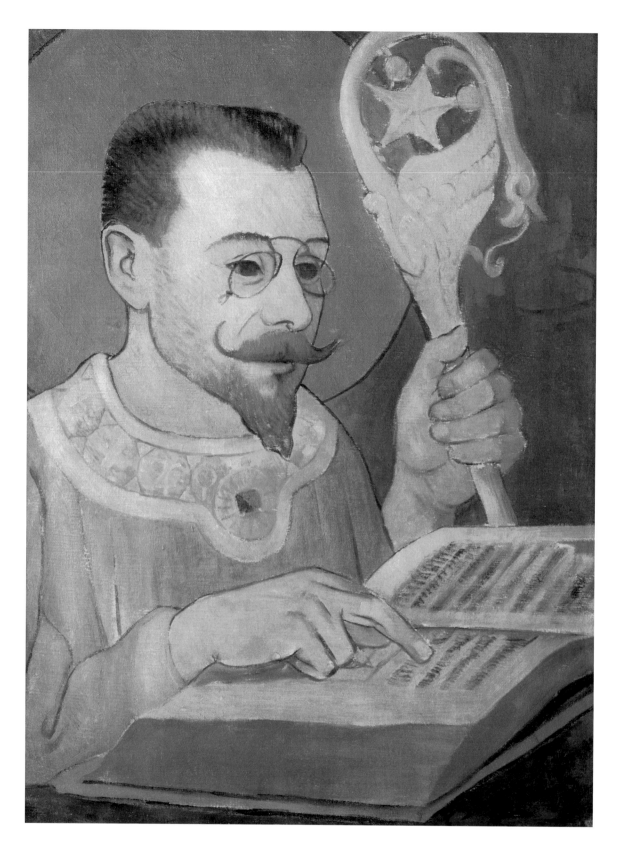

79

PAUL SÉRUSIER

Portrait of Paul Ranson in Nabi Costume (*Portrait de Paul
Ranson en tenue nabique*), 1890
Oil on canvas
24 × 18 ¼ in. (61 × 46.5 cm)

This portrait of Ranson can be seen as a manifesto of the Nabis' aesthetic innovations as well as their spiritual ideals. One of the founding members of the group, Ranson was particularly close to Sérusier, with whom he shared a fascination for esotericism, mysticism, alchemy, and Theosophy. Holding a scepter and wearing a fictitious costume, Ranson is portrayed as a prophet (the Hebrew translation of the word *nabi*), deciphering an ancient manuscript to reveal modern-day truths.

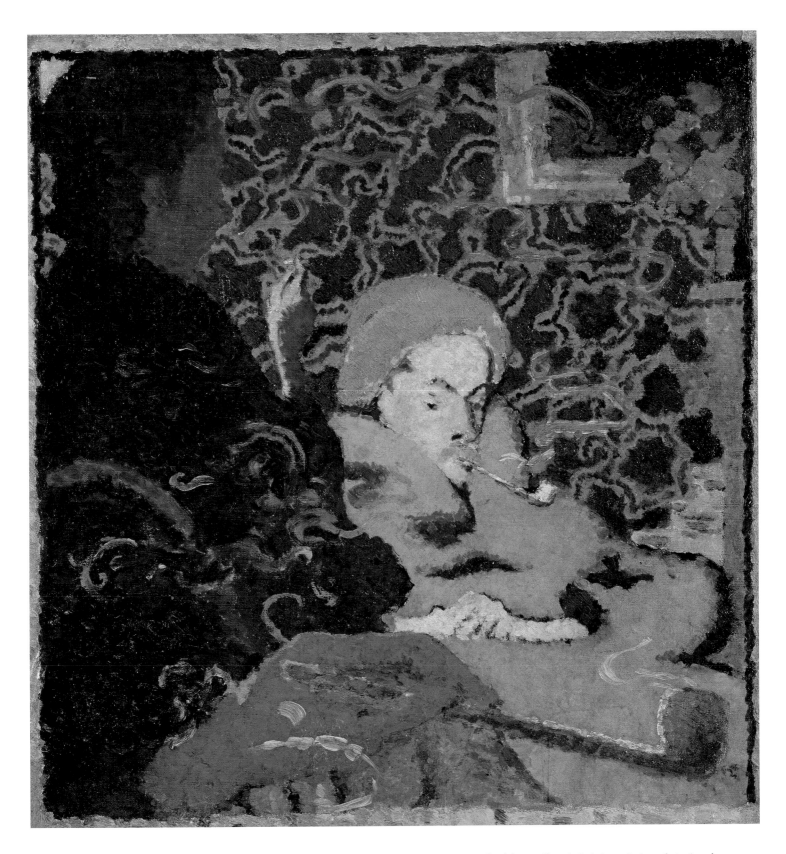

80

PIERRE BONNARD

Intimacy (Portrait of Monsieur and Madame Claude Terrasse)
(*Intimité [Portrait de Monsieur et Madame Claude Terrasse]*), 1891
Oil on canvas
15 × 14⅛ in. (38 × 36 cm)

Intimacy is an example of the small-scale *Intimiste* paintings, featuring close-up compositions and quiet domestic subjects, for which the Nabis were known. In this densely constructed, spatially compressed interior, Bonnard portrayed his sister, Andrée; her husband, Claude; and, in the foreground, his own hand clasping a pipe. The mingling swirls of smoke and wallpaper emphasize the flatness of the picture plane and reinforce the Nabis' credo that, first and foremost, painting is decoration.

81

PIERRE BONNARD

*Checked Shirt (Portrait of Madame Claude Terrasse at
Twenty)* (*Le corsage à carreaux [Portrait de Madame Claude
Terrasse à vingt ans]*), 1892
Oil on canvas
24 × 13 in. (61 × 33 cm)

The exhibition of Japanese woodblock prints held at the École des Beaux-Arts in
1890 made a deep and lasting impression on the young Bonnard. Above all, this
fortuitous encounter revealed the expressive possibilities of pure color, which could
be arranged to depict subjects and convey emotions without recourse to illusionis-
tic modes of representation. The visual tension Bonnard produced by incorporating
flat, vibrant surface patterns within depictions of three-dimensional space, as in
Checked Shirt, remained a lifelong pursuit

82

PIERRE BONNARD
The White Cat (*Le chat blanc*), 1894
Oil on board
20 ⅛ × 13 in. (51 × 33 cm)

83
ÉDOUARD VUILLARD
The Reader (Portrait of K.-X. Roussel) (*Le liseur*
[Portrait de K.-X. Roussel]), ca. 1890
Oil on board
13 ¾ × 7 ½ in. (35 × 19 cm)

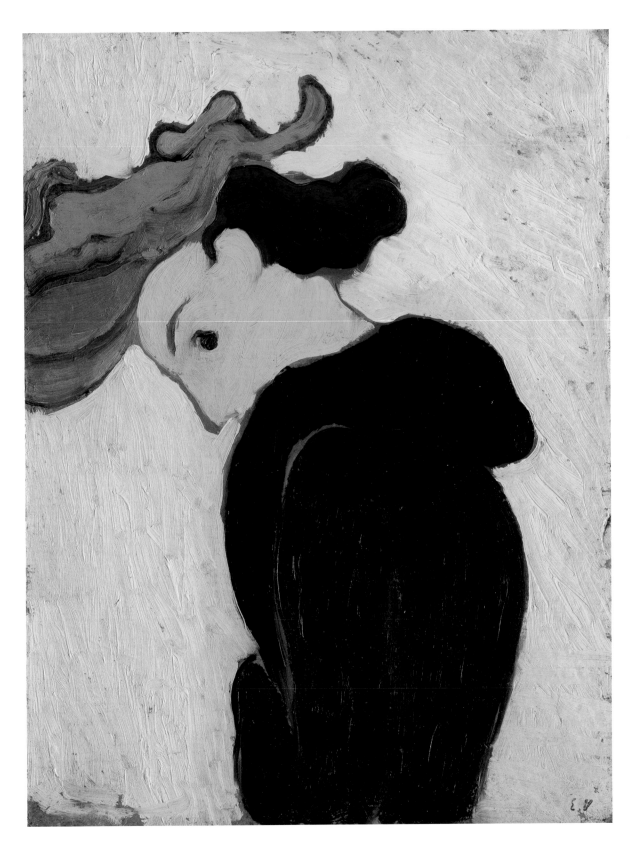

84

ÉDOUARD VUILLARD

Profile of a Woman in a Green Hat (*Femme de profil au chapeau vert*), ca. 1891

Oil on board

8 ¼ × 6 ¼ in. (21 × 16 cm)

Profile of a Woman in a Green Hat is among the incredibly experimental pictures from Vuillard's early days as a Nabi. Verging on caricature, the form of this elegantly dressed woman is drastically reduced to a few solid areas of unmodulated color that are circumscribed by thick blue lines. Vuillard's development of a highly personal formal language, one that is radically simplified and freed from naturalistic representation, opened the door to Henri Matisse and Fauvism in the following decade.

SYMBOLIST AND NABI *INTIMISME*

SYLVIE PATRY

In 1900, in what he would qualify as the "confused uncertainty of art," the critic Camille Mauclair identified a group of "painters of *Intimisme*."[1] Some of the artists claimed the term for themselves during a first *Intimiste* exhibition organized at the Henri Graves galleries in 1905, prompting the critic Raymond Bouyet to write at the time, "*Intimisme* is everywhere."[2] The term referred to those artists who preserved the supple, vibrant brushstroke of Impressionism and Neo-Impressionism, as well as a light palette, and depicted portraits and interior scenes. They sought to convey restrained emotions, often touched by reverie, in the manner of painters such as Eugène Carrière and Henri Fantin-Latour. Édouard Vuillard and Pierre Bonnard figured alongside the artists most often associated with this tendency, such as Ernest Joseph Laurent, Lucien Lévy-Dhurmer, Edmond François Aman-Jean, and René Ménard. The *Intimiste* label later served to ascribe their paintings to a minor genre that was sometimes considered bourgeois and consigned to the edges of modernity. However, the meditative atmosphere of the Nabis' muted interiors reflects a broader "need to enunciate the soul"[3] that was identified with Symbolism and idealist art as it developed after the 1890s. Vuillard, Bonnard, and the Nabi group more generally defined an art of the intimate moment within a radically new style that was both in tune with Symbolism and keen to break away from it.

Their exploration was centered on women—enigmatic, idealized, either distant or belonging to the artist's personal, everyday realm. *Marie Monnom* (1887, cat. 92), the first portrait of a young girl painted by the Belgian Fernand Khnopff, already demonstrates the vocabulary that the artist later employed to depict the secretive, remote, solitary women who haunt his work. The sitter was the future spouse of the painter Théo van Rysselberghe and the daughter of Émile Verhaeren, the Belgian publisher of the prestigious journal *L'Art Moderne*, who was also a poet and an advocate of Post-Impressionist circles. The portrait reveals no real indication of the social, literary, and artistic milieu to which the young girl belongs; rather, its economy immerses her in an atmosphere of serene, faraway interiority, typical of the Symbolist aesthetics that Khnopff was developing as a member of the Belgian avant-garde. Monnom is viewed in profile, seated in such a way that her gaze is focused somewhere beyond the painting and beyond reality, on a place we cannot reach. The golden disk, a motif that Khnopff later used to

decorate the house he had built in Brussels between 1900 and 1902, is associated with infinity and perfection, but it may also be seen as a representation of an individual's concentration on the self. One of Khnopff's obsessions was to delimit his creative space by a golden circle and to conceive his home, in his words, as a "Temple of Self."[4] Verhaeren qualified Khnopff's life as one of "perpetual confinement."[5] A sense of enclosure and seclusion is tangible in this commissioned portrait: the blue curtain, the door, the baseboard, and the chair create lines that enclose the sitter in a succession of frames.

Almost twenty years later, the Danish painter Vilhelm Hammershøi used comparable devices to suggest a withdrawal tinged with solitude in *Rest* (1905, cat. 91). The interplay of light and composition alone, as no psychological description is possible, is enough to convey the impressions of silence and repose within a melancholy void. The everyday space becomes a projection of self. In fact, the model—Ida, the artist's wife—is shown in the painter's apartment at 30 Standgate in Copenhagen, which would provide inspiration for numerous paintings. In the theater of this *Intimiste* Symbolism, purely pictorial means suffice to transfigure reality.

The Nabis began to offer a dazzling illustration of this concept in the early 1890s. Maurice Denis, Bonnard, and Vuillard turned to everyday life for their subjects. Their family circles of mothers, sisters, and spouses; their close friends; their houses; and ordinary activities such as sewing—these were the common motifs of a new mode of painting that sought to convey feelings through the resources of the painting alone. Bonnard had his sister, Andrée, pose for *Intimacy (Portrait of Monsieur and Madame Claude Terrasse)* (1891, cat. 80), which is emblematic among Nabi paintings dealing with its theme, and *Checked Shirt (Portrait of Madame Claude Terrasse at Twenty)* (1892, cat. 81). Following her marriage to the composer and musician Terrasse, with whom Bonnard was very close, Andrée and her family continued to model for her brother until her death.

In *Intimacy*, Claude is shown wearing indoor clothing and a cap; the informal nature of the painting is reminiscent of Jean-Siméon Chardin's self-portraits in which he wears a cap, such as *Self-Portrait with Spectacles* (1771, Musée du Louvre, Paris). The viewer is immediately immersed in the couple's private space, which is depicted without frills. The modest, square format of the painting reinforces the quiet ambience of the scene while enhancing the decorative power of the pattern that covers the entire surface of the canvas, making it almost illegible. The white scrolls of cigarette and pipe smoke emanating from the sitters and the painter—whose hand we can see in the foreground—disrupt the arrangement of planes and compress the space. The atmosphere is almost suffocating. Andrée's outsize silhouette, like the painter's hand, is not immediately recognizable, a device that Bonnard relied on throughout his career. The depiction of space in the painting is off-kilter, affecting the time needed to read the work; these distortions lend a touch of wry humor. The artist used color and the effects of light to separate the two protagonists of this strange "intimacy." Claude is portrayed in daylight and bright colors, whereas Andrée is veiled in a *contre-jour* shadow, giving her a ghostlike character.

At the heart of Bonnard's scene reigns an impression of confinement, a feeling that one also encounters in Félix Vallotton's interiors, which convey a similar ambiguity. In Vallotton's *Dinner, by Lamplight* (1899, cat. 94), shadows hide faces and part of the scene, allowing for effects of distortion and caricature. There is often a darkly humorous spirit, an element of satire, in the Nabi interiors by Bonnard, Vuillard, and Vallotton.

FIG. 32 **GUSTAVE MOREAU**
Study of Michelangelo's Dying Slave, n.d.
Graphite
5 7/16 × 6 3/16 in. (13.8 × 15.7 cm)
Musée nationale Gustave-Moreau, Paris, Des.2884

Denis also found inspiration in his private circle, both before and after he met Marthe Meurier. She became his favorite model, first as his fiancée and then as his wife (in 1893), in the service of a broader meditation on love and purity. In *Princess Maleine's Minuet (Marthe at the Piano)* (1891, cat. 87), his first isolated portrait of her, the artist paid tribute to the beauty of his beloved and referenced their fervent conversations about Symbolist theater and music (the score shown on the piano is by the poet Pierre Hermant, who was inspired by Maurice Maeterlinck's play *La Princesse Maleine*). This portrait is a testament to the supreme mission Denis attributed to both love and art: to reconcile the flesh and the spirit. With its suggestion of musical harmony, the intensely meditative composition is achieved through muted tones and arabesques that connect the different planes of the painting, erasing any description of space and inventing a decorative surface that does not attempt to mimic reality.

The same process informs *Young Women at the Lamp* (1891, cat. 88), for which Marthe posed with her sister, Eva. As in *Princess Maleine's Minuet (Marthe at the Piano)*, the sinuous, interlacing lines are enriched by scattered pointillist brushstrokes that Denis borrowed from the Neo-Impressionists, who also sought to exploit the suggestive, expressive power of line and color. As demonstrated by Henri Edmond Cross's *Hair* (ca. 1892, cat. 89), the effort to obtain harmony through balanced lines and the division of tones hardly aspired to scientific realism; rather, it created a feeling of unreality and could be considered to serve, in the artist's words, the "glorification of an inner vision."[6] Paul Signac affirmed this idea, writing, "Subjecting color

FIG. 33 **PAUL GAUGUIN**
Vision of the Sermon (Jacob Wrestling with the Angel)
(*Vision du sermon [Lutte de Jacob avec l'ange]*), 1888
Oil on canvas
28 ³⁄₈ × 35 ⁷⁄₈ in. (72.2 × 91 cm)
National Galleries of Scotland, Edinburgh, purchased
1925, NG 1643

and lines in this way to the emotion he has felt and seeks to express, the painter will do the work of a poet, a creator."[7]

The theme of sleep provided a fitting motif for the rich dialectic between inwardness and "unreality." It could be said that Gustave Moreau's *Orpheus* (1865, cat. 98) led the way for the exploration of this theme in the late nineteenth century. In the handsome face of Orpheus's decapitated head, piously held by a young Thracian girl, one might see the portrait of the artist as a poet. For the face, Moreau borrowed from Michelangelo's sculpture *The Dying Slave* (1513–1515, Musée du Louvre, Paris), seen in a study by the artist (fig. 32). The figure's closed eyes signal a withdrawal into the self.

This sculpture also had a profound effect on Odilon Redon. In *Eyes Closed* (1890, cat. 103), Redon referred to Michelangelo's sculpture in what may seem like a self-portrait (but was, in fact, inspired by his wife). The artist declared, "Beneath the closed eyes of his slave, there is so much going on! He sleeps, and the worried dream that unfolds under that marble

forehead leads our own into a world full of thought and emotion. The sleep of a slave, arousing our dignity."[8] Sleep and, by extension, dreams were significant to the Symbolists. Long before Sigmund Freud's work became known, they read essays on the subject of sleep with great interest. But the creative dream, which leads the artist to create "according to his dream," does not occur with one's "eyes closed," asserted Redon: "I made my art according to myself. I did it with my eyes open onto the marvels of the visible world and, whatever one might say about it, constantly attentive to obeying the laws of what is natural, of what is life."[9]

Redon's balance between dream and reality made him an example and a guide for the young Nabis, as well as for artists such as Émile Bernard and Armand Séguin who were working alongside Gauguin in Pont-Aven. In the paintings *In Bed* (1891, cat. 86) and *Sleep* (1892, cat. 85), Vuillard took possession of one of Symbolism's signature themes. The state of withdrawal from the world that accompanies sleep and dreaming is suggested by the dull tonalities and the serene rhythm of the lines (though one cannot overlook the touch of humor in the detail of the knees tucked up under the blanket). Similarly, Bernard's *Symbolist Self-Portrait (Vision)* (1891, cat. 4) is situated in an ambiguous reality. Do the bathers in the background represent a vision, the projection of a work that he dreamed about, or simply the walls of his studio, which could have been decorated with bathing women? This ambiguity also evokes the tormented visions of the "unsavable self,"[10] another aspect explored in Symbolism and Post-Impressionism. Above all, the passage from external reality to the expression of an internal state is presented as a seamless transition, bringing to mind Gauguin's seminal painting *Vision of the Sermon (Jacob Wrestling with the Angel)* (1888, fig. 33), in which the "ambient reality"[11] (that is, the elements that describe an observed reality) vanishes before the "representative materialization"[12] of inwardness. This was the very definition of Symbolism in painting, according to Albert Aurier, one of the movement's most influential theoreticians.

Translated from the French by Alison Anderson

NOTES

1 Camille Mauclair, "Les peintres d'intimité," *La Revue* (1st semester 1901): 25.

2 In *Le Bulletin de l'Art Ancien et Moderne*, July 28, 1906, 213, quoted in *Autour de Lévy-Dhurmer: Visionnaires et intimistes en 1900*, ed. Antoinette Faÿ (Paris: Éditions des Musées Nationaux, 1973), 10.

3 Camille Mauclair, "Quelques peintres idéalistes français," *L'Art Décoratif*, no. 36 (September 1901): 226, quoted in ibid.

4 The house, now destroyed, was located at 41 avenue des Courses in Brussels. The architect of the house, Edmond Pelseneer, had been inspired by Viennese Secessionist architecture.

5 Émile Verhaeren, "Silhouettes d'artistes," quoted in *Fernand Khnopff et ses rapports avec la Sécession viennoise*, by Catherine De Croës and Gisèle Olinger-Zinque (Brussels: Musées Royaux des Beaux-Arts de Belgique, 1987), 15.

6 Quoted by Émile Verhaeren in his preface to a catalogue for an exhibition on Henri Edmond Cross (Paris: Galerie Druet, 1905); quoted in Rodolphe Rapetti, *Le symbolisme* (Paris: Flammarion, 2007), 129.

7 Paul Signac, *D'Eugène Delacroix au néo-impressionnisme*, ed. Françoise Cachin (Paris: Hermann, 1978), 104.

8 Odilon Redon, *À soi-même: Journal, 1867–1915; Notes sur la vie, l'art et les artistes* (Paris: Corti, 1961), 95.

9 Ibid., 9.

10 Jean Clair, "Le moi insauvable," in *Paradis perdu: L'Europe symboliste*, ed. Pierre Théberge (Montreal: Musée des Beaux-Arts de Montréal, 1995).

11 Albert Aurier, "Le symbolisme en peinture: Paul Gauguin," in *Oeuvres posthumes* (Paris: Mercure de France, 1893), 208; reprinted in Albert Aurier, *Le symbolisme en peinture* (Caen, France: L'Échoppe, 1991).

12 Ibid., 211.

85

ÉDOUARD VUILLARD

Sleep (*Le sommeil*), 1892
Oil on canvas
13 × 22 ³⁄₈ in. (33 × 64.5 cm)

Vuillard treated sleeping and dreaming figures, a popular theme among the Symbolists, to a much different effect. Instead of evoking the mysteries of the unconscious mind, he presented his slumbering subjects as purely graphic arrangements of solid shapes. Fitted together like the pieces of a jigsaw puzzle, the distinct zones of color render the pictorial space completely flat, placing emphasis on the aesthetic, rather than narrative, qualities of the picture.

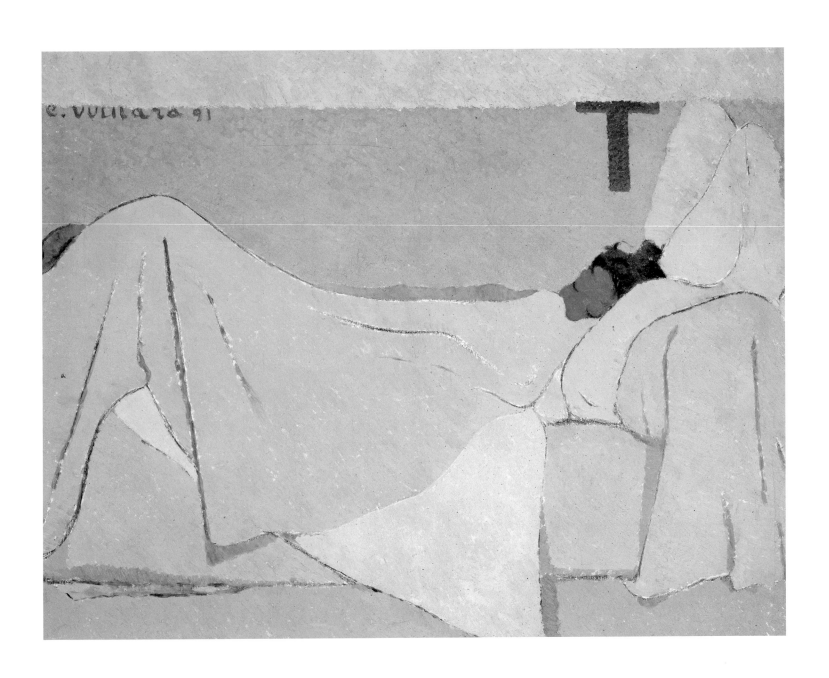

86

ÉDOUARD VUILLARD

In Bed (*Au lit*), 1891

Oil on canvas

28 3/4 × 36 3/8 in. (73 × 92.5 cm)

87

MAURICE DENIS

Princess Maleine's Minuet (Marthe at the Piano) (*Le menuet de la princesse Maleine [Marthe au piano]*), 1891

Oil on canvas

37 3/8 × 23 5/8 in. (95 × 60 cm)

88

MAURICE DENIS

Young Women at the Lamp (Jeunes filles à la lampe), 1891

Oil on canvas

14 ⅛ × 25 ⅝ in. (36 × 65 cm)

Denis frequently painted Marthe Meurier, his future wife, and her sister, Eva. Talented musicians, Eva is shown here playing the piano while Marthe leans over its side, perhaps preparing to sing. Using pointillist brushstrokes, Denis transcribed the soft glow of the gas lamp as a decorative pattern of scintillating dots. More than a simple genre scene, the composition produces a rhythm of undulating lines that can be seen as an evocation of music itself.

89

HENRI EDMOND CROSS

Hair (*La chevelure*), ca. 1892

Oil on canvas

24 × 18⅛ in. (61 × 46 cm)

Hair is a reflection of Cross's admiration for both Degas, who had painted this subject numerous times, and Seurat, whose signature style is adapted here to a wholly original end. Applying small points of muted, complementary colors over a densely painted ground, Cross produced an atmospheric effect in which forms simultaneously materialize and dissolve before our eyes. Apart from Signac, Cross remained the only other artist to use the divisionist technique until the end of his career.

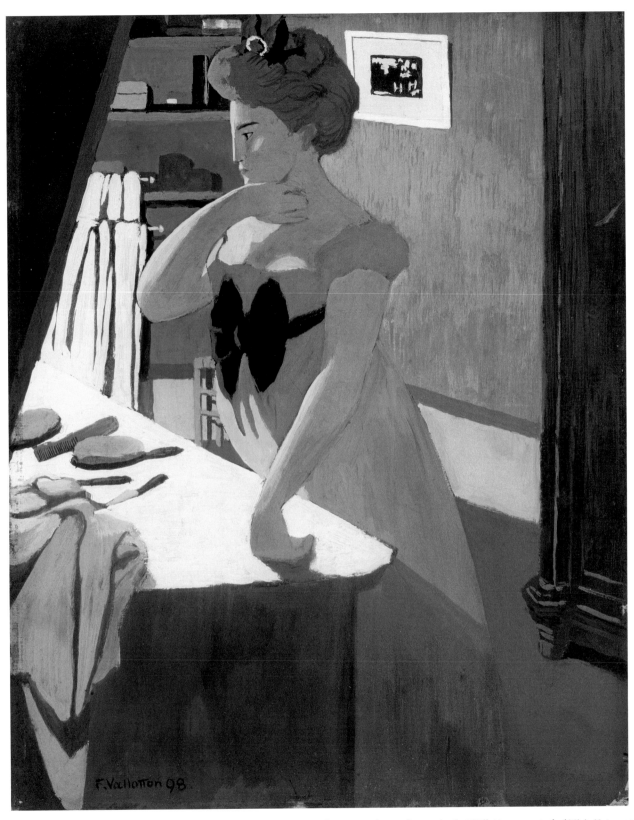

90
FÉLIX VALLOTTON
Misia at Her Dressing Table (*Misia à sa coiffeuse*), 1898
Tempera on board
14 1/8 × 11 3/8 in. (36 × 29 cm)

This is one of several portraits that Vallotton executed of Misia Natanson, who was both a muse and patron of the Nabis. Primarily a printmaker, Vallotton applied the same aesthetic to his paintings as he did to his woodcuts. The precise contours, stark contrasts of light and dark, and solid blocks of color lend this painting the appearance of a hand-colored print. As if to emphasize these similarities, Vallotton included one of his own black-and-white graphic works on the wall in the background.

91

VILHELM HAMMERSHØI
Rest (*Hvile*), 1905
Oil on canvas
19 ½ × 18 ¼ in. (49.5 × 46.5 cm)

The Danish painter Hammershøi is best known for his *Intimiste* paintings of solitary women occupying predominantly gray interiors, of which *Rest* (or *Hvile* in Danish) is a particularly poignant example. While the painting is reminiscent of Jan Vermeer's atmospheric scenes of quiet domesticity, its absolute exclusion of anecdotal details, as well as its unusual portrayal of a sitter viewed from behind, produces a different effect: that of isolation, mystery, and silent introspection.

92

FERNAND KHNOPFF
Marie Monnom or *Miss M. M . . . (Mlle. M. M . . .)*, 1887
Oil on canvas
19¹/₂ × 19³/₄ in. (49.5 × 50 cm)

A founding member of Les XX (The Twenty), Khnopff was a sought-after portraitist among Brussels high society in the late 1880s. Influenced by the aesthetic of James Abbott McNeill Whistler's tonalist paintings, which were exhibited at the Salon des XX in 1884 and 1886, Khnopff invented an entirely new genre of portraiture. As exemplified by this painting of Marie Monnom, the daughter of an avant-garde publisher, Khnopff infused his realistic style with the Symbolist fascination with reverie and the mysterious realm of the inner life.

93

FÉLIX VALLOTTON

Self-Portrait or *My Portrait* (*Autoportrait* ou *Mon portrait*), 1897

Oil on board

23 1/4 × 18 7/8 in. (59.2 × 48 cm)

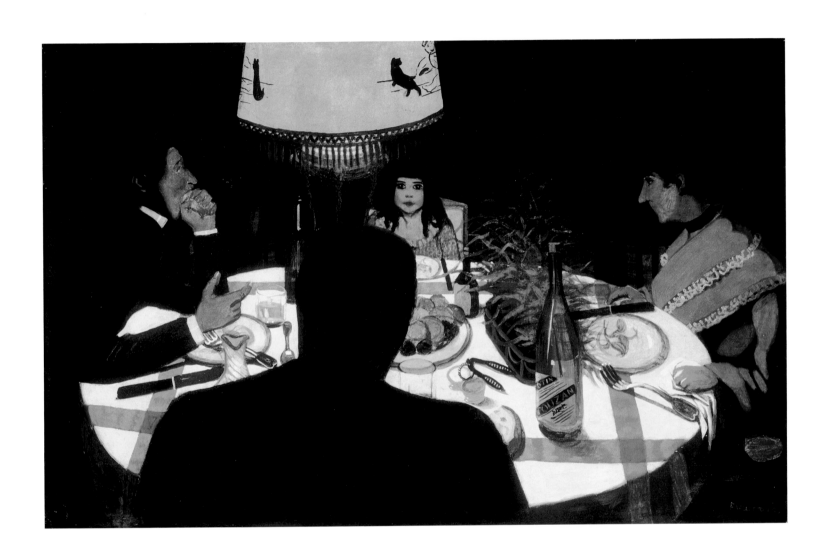

94

FÉLIX VALLOTTON

Dinner, by Lamplight (*Le diner, effet de lampe*), 1899

Oil on board mounted on panel

22 ¹/₂ × 35 ¹/₄ in. (57 × 89.5 cm)

95

FÉLIX VALLOTTON

The Ball or *Corner of the Park with Child Playing with a
Ball* (*Le ballon* ou *Coin de parc avec enfant jouant au
ballon*), 1899
Oil on board mounted on panel
18 ⁷/₈ × 24 in. (48 × 61 cm)

Although it portrays the common Nabi subject of
women and children in a park, Vallotton's unique
treatment of the theme distinguishes *The Ball*
from works such as Vuillard's *Public Gardens*
(cats. 111–115). Dividing the picture along a diagonal
axis, Vallotton produced a masterpiece of contrast
between light and shadow, flatness and depth, near
and far. The drastic reduction of the landscape into
two colored planes gives the composition a feel-
ing of emptiness and casts an unexpected sense of
malaise over this innocent scene of childhood play.

THE NABIS AND SYMBOLISM

96

PIERRE BONNARD

*Woman Dozing on a Bed (Indolent Woman) (Femme assoupie
sur un lit [L'indolente])*, 1899
Oil on canvas
37 3/4 × 41 3/4 in. (96 × 106 cm)

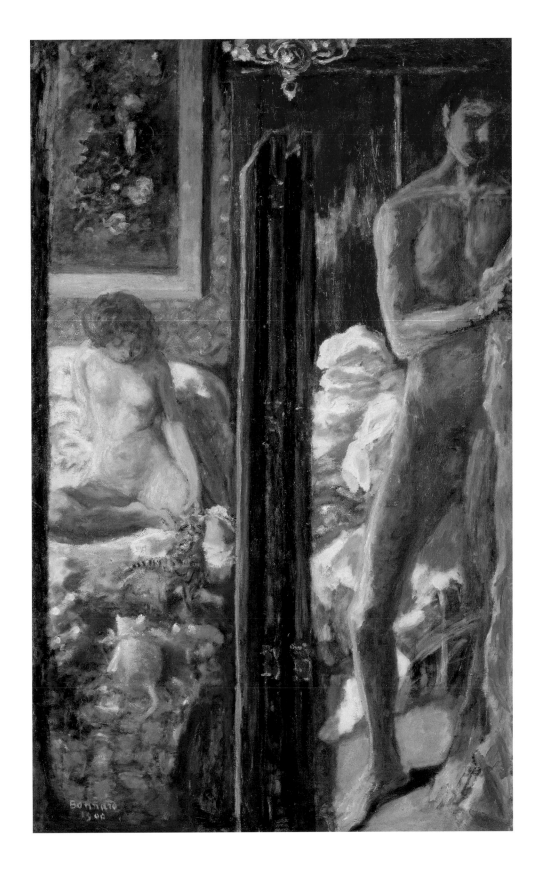

97

PIERRE BONNARD

The Man and the Woman (*L'homme et la femme*), 1900
Oil on canvas
45 ¼ × 28 ½ in. (115 × 72.5 cm)

98

GUSTAVE MOREAU

Orpheus (Orphée), 1865

Oil on panel

60 ⅝ × 39 ⅛ in. (154 × 99.5 cm)

Orpheus, the poet and musician of Greek mythology, was a favored theme among the Symbolists. Envisioning the aftermath of his gruesome death, Moreau conceived an oddly tranquil scene in which a mysterious woman contemplates Orpheus's disembodied head lying upon a lyre. Moreau's seamless synthesis of Italianate and academic styles, seen here in the golden-hued, atmospheric landscape and crisply contoured figures, earned him great success in the Salons of the 1860s.

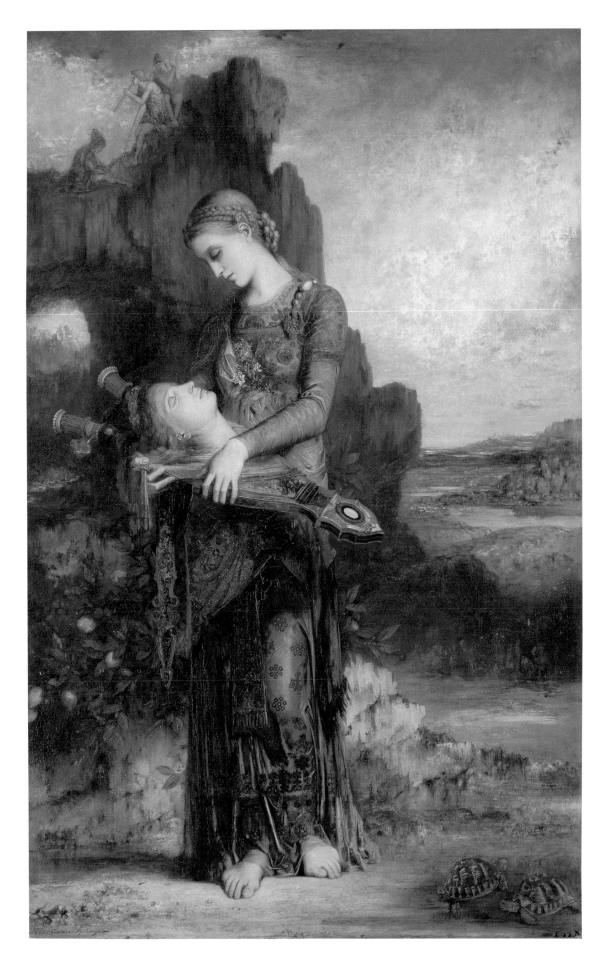

THE NABIS AND SYMBOLISM

99

GEORGES SEURAT

Landscape with The Poor Fisherman *by Puvis de Chavannes*
(*Paysage avec* Le pauvre pêcheur *de Puvis de Chavannes*), ca. 1881
Oil on panel

6 ⁷/₈ × 10 ³/₈ in. (17.5 × 26.5 cm)

Along with Gauguin, Redon, and Signac, Seurat was deeply moved by the exhibition of Puvis' *The Poor Fisherman* at the Salon of 1881. Painting most likely from memory, he recorded his impression of the original over the right half of a landscape sketch. Seurat incorporated the timeless effect of Puvis' hieratic and monumental figures in his development of an aesthetic that combined stylistic innovation with the French academic tradition.

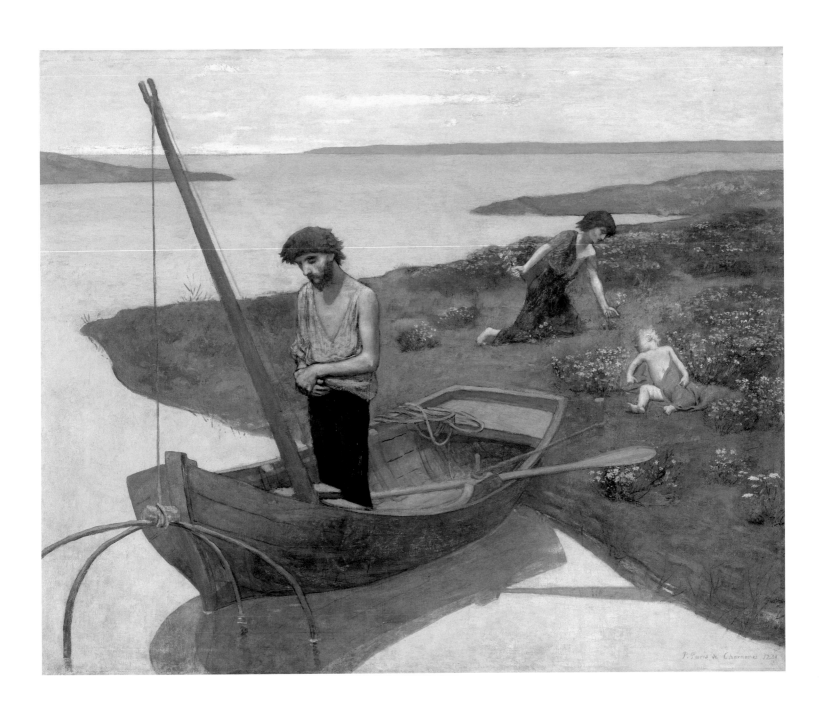

100

PIERRE PUVIS DE CHAVANNES

The Poor Fisherman (*Le pauvre pêcheur*), 1881

Oil on canvas

61¼ × 75¾ in. (155.5 × 192.5 cm)

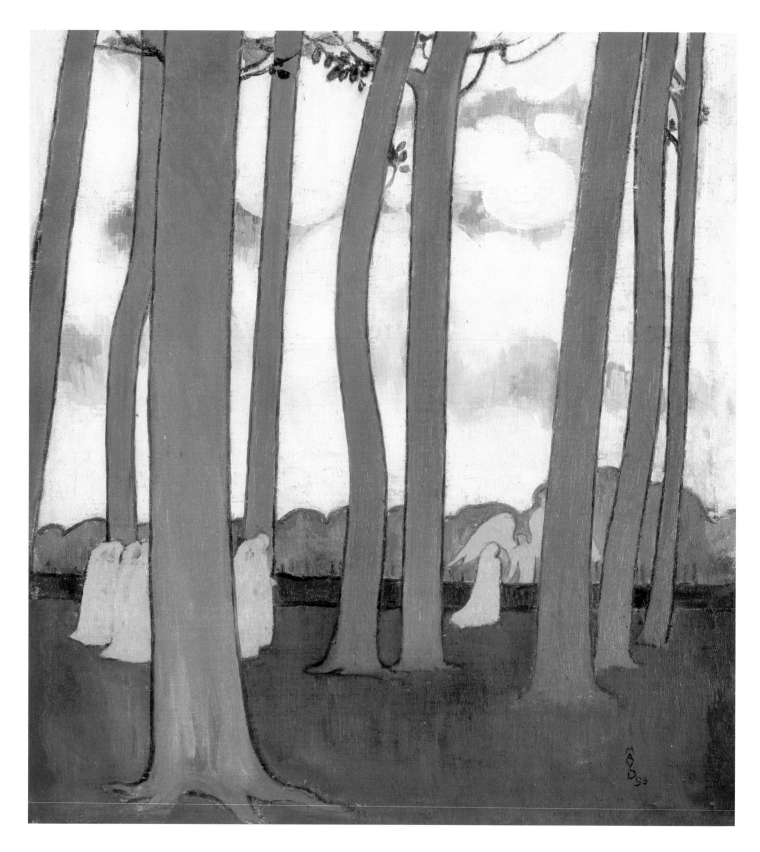

101

MAURICE DENIS

Landscape with Green Trees (Green Trees) (Procession under the Trees)
(*Paysage aux arbres verts [Les arbres verts] [La procession sous les arbres]*), 1893
Oil on canvas
18 1/8 × 16 7/8 in. (46 × 43 cm)

214

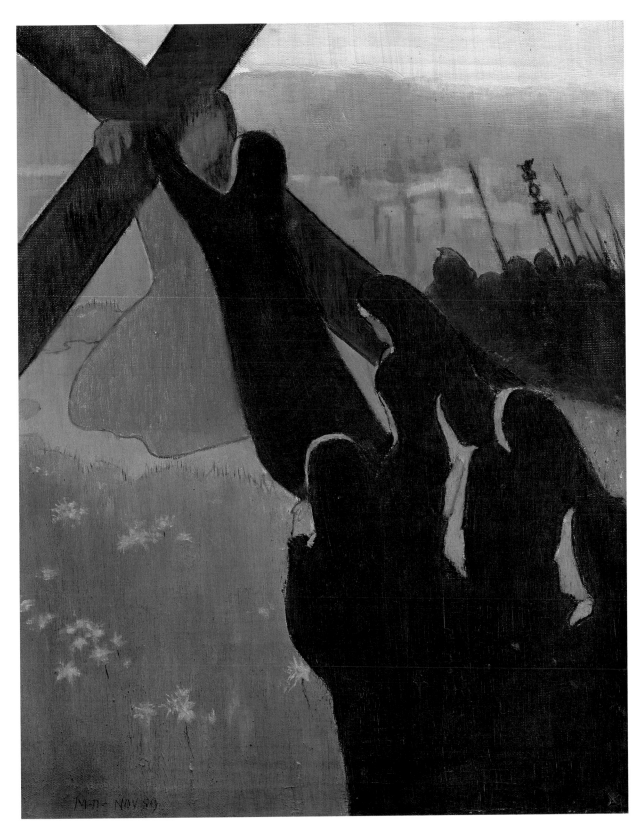

102

MAURICE DENIS
Calvary (Climbing to Calvary) (*Le Calvaire [La montée au calvaire]*), 1889
Oil on canvas
16 1/8 × 12 13/16 in. (41 × 32.5 cm)

Calvary reflects Denis' momentous encounter with the works of Gauguin and Bernard at the Café Volpini exhibition in 1889. Adopting their anti-naturalistic color schemes and radically simplified shapes, Denis detached his image from reality and gave form to the mystical vision shared by the nuns praying in the foreground. Affectionately called the "Nabi of the beautiful icons," Denis aimed to restore a spiritual function to art through his depiction of religious themes.

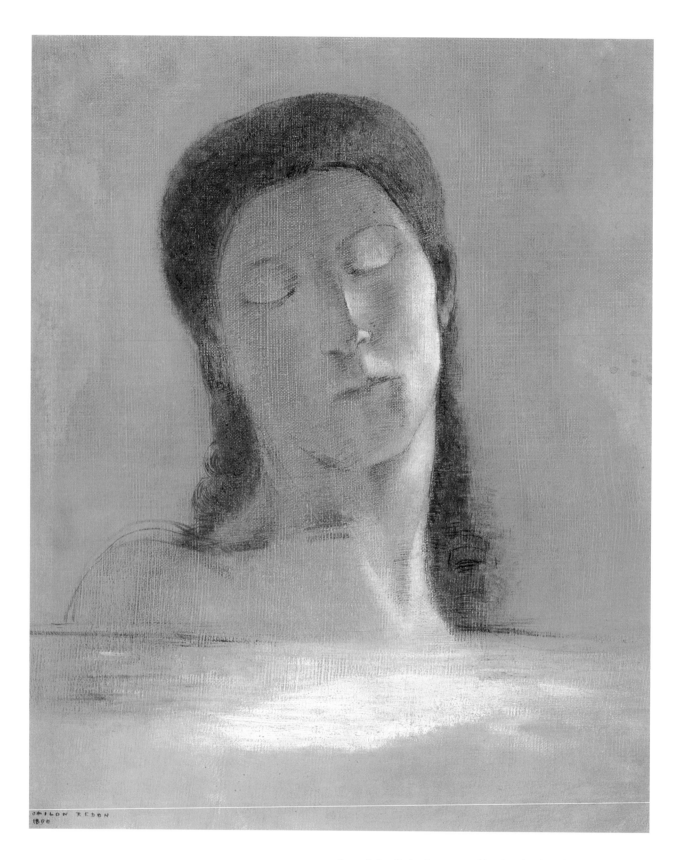

ODILON REDON
1890

103

ODILON REDON
Eyes Closed (*Les yeux clos*), 1890
Oil on canvas mounted on board
17³/₈ × 14¹/₈ in. (44 × 36 cm)

Around 1890 Redon began remaking in color the subjects of his earlier black-and-white works, including this portrait of his wife, Camille. Referencing Renaissance sculpture and the face of Michelangelo's *Dying Slave* in particular, Redon rendered a strange image of a female bust floating serenely within an indeterminate space. The figure's closed eyes evoke simultaneously states of sleep and death, a confluence that was frequently explored in Symbolist literature and artwork.

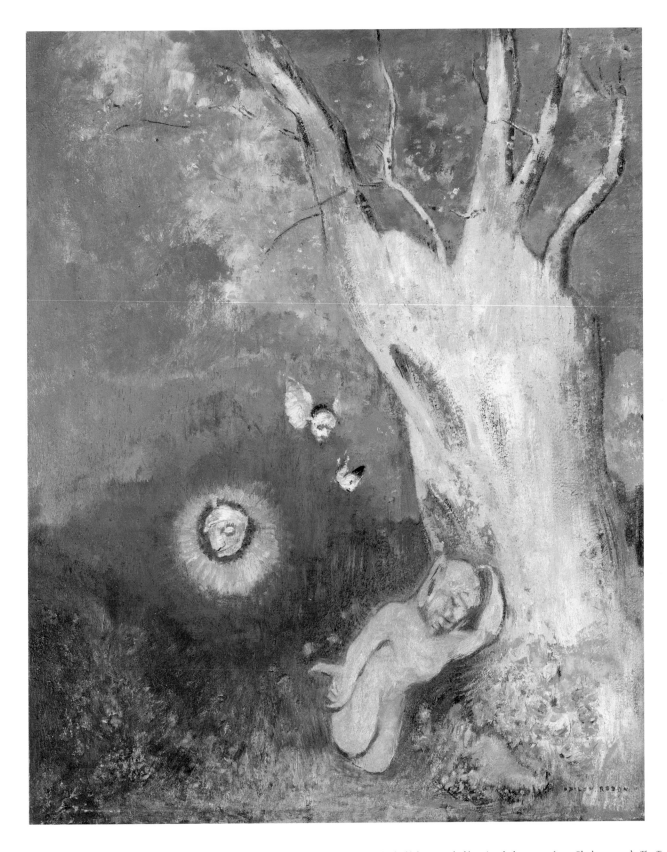

104

ODILON REDON

The Sleep of Caliban (*Sommeil de Caliban*), 1895–1900
Oil on panel
19 × 15 ⅛ in. (48.3 × 38.5 cm)

Caliban, the half-human, half-animal character from Shakespeare's *The Tempest*, is a recurrent motif in Redon's oeuvre. Appearing frequently in his monochrome, often melancholic drawings of the 1870s, here the theme is revisited in vibrant, glowing hues. Exploring the expressive potential of color, Redon evoked the mysterious island of Shakespeare's tale while blurring the line between Caliban's dream and the fantastical world in which he lives.

LE DOUANIER ROUSSEAU: WAR AND PEACE

STÉPHANE GUÉGAN

Rousseau had come at the right time.

WALDEMAR GEORGE[1]

Henri Rousseau became an artistic naïf voluntarily, not instinctively, as a result of ambition, not humility.[2] Self-taught, he made a strength of his weaknesses, combining an extraordinary number of visual sources in his falsely ingenuous paintings. Republican in spirit, he charged his deliberately dreamlike world with solid social and secular convictions. In short, the childlike innocence and primitive mentality ascribed to him by his first biographers merely helped to build a legend of which he was the conscious, clever beneficiary. And while he was not unlike Odilon Redon in the way in which he distorted his image in the press, Rousseau also shared with Paul Gauguin a talent for exotic mythmaking.

In 1909 the critic Arsène Alexandre exalted Rousseau's "drive to express form the way one feels it, and with the means that one finds directly, involuntarily, in oneself, without giving it the least thought."[3] All in all, the naive painter was "incapable of willing what he has done." Nothing was premeditated or intentional. Today we know that this was a fallacy, for nothing was more artfully conceived than the magic of his tropical landscapes, hieratic portraits, and political allegories. Nevertheless, his painting continues to fascinate us with its offbeat charm, its strange visual potency, and its power to make us forget what lies hidden behind its apparent purity.

Rousseau's biography is shrouded in a mystery he never sought to dispel. He even allowed Guillaume Apollinaire to embellish on an alleged trip to Mexico. Born in Laval in 1844 to parents of modest means, Rousseau began his career in uniform, a soldier of the Second Empire. In 1863 the young man joined the fifty-first regiment of heavy infantry as a means to escape from the law and from the poverty of his upbringing. While it is doubtful Rousseau saw action in Mexico, where Napoléon III had well-known ambitions, some of his comrades had indeed served there. In 1868, the year Édouard Manet painted *The Execution of Emperor Maximilian*, Rousseau left the army and settled in Paris. His years of service relieved him of the obligation to go to the front during the Franco-Prussian War (1870–1871). Called up during

the era of the Défense Nationale, when the country was suffering the inexorable advance of the Prussian troops, Rousseau was spared more than others because of his family situation. At the time he was his mother's sole support after the death of his father, and he was living with Clémence Boitard, a modest seamstress, with whom he would have seven children (five died in infancy). The penniless father had to find a profession, and so he entered the civil service as a customs officer. At the gates of Paris and along the quays of the Seine, the transportation of merchandise was still subject to taxation.

It is still unclear at what point, and how, this civil servant began to paint. One of Rousseau's first color sketches, *The Battle of Champigny* (1882, Musée d'Art Moderne de la Ville de Paris), demonstrated what he was already capable of in the early 1880s. From that point on, he did not hesitate to borrow ideas wholesale from the popular press. Taking literal inspiration from a famous panorama by Alphonse de Neuville and Édouard Detaille, published in *Le Monde Illustré* on November 4, 1882, Rousseau's little canvas, though rudimentary in its technique, inaugurated the themes of war and patriotism in his work.[4] An episode from the siege of Paris on December 2, 1870, the battle of Champigny was later celebrated as a Republican victory. Right from the start, Rousseau associated painting with memorializing the nation's history.

Rousseau's interest in military painting and Salon art, which arose at the time when Impressionism was destabilizing the primacy of the figurative tradition, goes some way toward explaining why he later claimed a place among "our best Realist painters."[5] We would like to know more about the connections he made with the true representatives of the academic tradition. It is known that he approached Félix Auguste Clément, who obtained the first Grand Prix de Rome, in 1856, for the seraphic *Return of the Young Toby*. As a result of their conversations, Rousseau probably received the legacy of Jacques-Louis David and François André Vincent, the primary reformers of French painting in the eighteenth century. In 1884 came further evidence of his kinship with the Old Masters: Rousseau obtained a copyist's card from the Louvre, allowing him to study the collection. He exhibited his work for the first time the following year.

In 1885 the Salon des Indépendants was held for the second consecutive year. Rousseau remained loyal to this alternative venue, dominated by the Neo-Impressionists Georges Seurat and Paul Signac, for it was the only place that might conceivably exhibit his work. The canvases he presented there until the early 1890s alternated between urban landscapes, country views, and fantastical scenes, and they relied on the eccentricity of his deliberately naive aesthetic. Very quickly the press took notice, making gibes at an art that was as captivating as it was disturbing. In addition, by 1890 Rousseau's repertoire was beginning to include his first jungle tableaux, which were more savage and shocking than the Orientalist canvases of the Salon from which they were derived. A certain Darwinian violence was set loose in these scenes.[6]

At the Salon des Indépendants in 1891, Rousseau exhibited *Surprised!* (1891, fig. 34), a large painting that combines the strangeness of wild vegetation with the incongruity of a tragicomic situation. An inveterate plagiarist, the artist condensed an etching by Eugène Delacroix and a painting by Jean-Léon Gérôme into this stiffly conceived rendering of a virgin forest. It was the source of much laughter. Only a penetrating mind like Félix Vallotton's could grasp its ironic poetry and formal barbarity, not to mention the self-promotion inherent in the work: "M. Rousseau becomes more stupefying with each passing year, but here he imposes and, in any event, claims some very nice publicity for himself. . . . It is, moreover, a terrible neighbor;

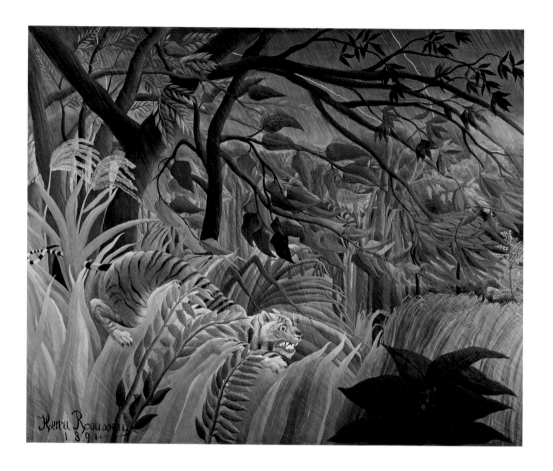

FIG. 34 **HENRI ROUSSEAU**
Surprised! (*Surpris!*), 1891
Oil on canvas
51 1/8 × 63 3/4 in. (129.8 × 161.9 cm)
National Gallery, London, bought, with the aid
of a substantial donation from the Hon. Walter H.
Annenberg, 1972, NG6421

it crushes everything."[7] But is Rousseau's tiger surprised or ready to pounce on its prey? The painter left the scene open to interpretation. The latency of the image—its exciting power of suggestion—reveals a kinship to the tenets of the Symbolist movement.

Even his allegories obeyed this oblique semantic regime, as shown in *War* (ca. 1894, cat. 105), which he exhibited in 1894 at the Salon des Indépendants. However, its interpretation was augmented by a caption: "Terrifying, wherever it passes it leaves despair, tears, and ruin in its wake."[8] Reflecting the idealistic pacifism that the Republicans exalted when promoting the idea of universal concord among nations, *War* was largely inspired by an elementary and anonymous etching, *The Czar*, which appeared in *L'Égalité* on October 6, 1889.[9] The etching portrays the monarch on horseback, riding across the page above piles of corpses. In his painting, Rousseau resorted to the principle of the "flying gallop" beloved by Théodore Géricault, which the photographer Eadweard Muybridge's motion studies had proven to be a distortion of the horse's true movement (see fig. 5). Through bold color, sharp contrasts, flatness of form and space, and the child's terrifying visage and carnivorous mouth, the artist very effectively conveyed the desolation and destruction of war. To his criticism of human savagery he applied a formal language that was itself considered barbaric. The concord between Rousseau's message and the archaism of his style caught the attention of several avant-garde critics, such as Louis Roy and Alfred Jarry. The earth stripped of its greenery, the trees with broken branches—a recurrent symbol in Rousseau's work, here echoing the mutilated bodies—contrasted with the painter's jungle paintings.

After completing *Surprised!*, it took Rousseau six years to realize the extent to which the jungle, whether serene or bloody, was what the public, enlightened critics, and his first

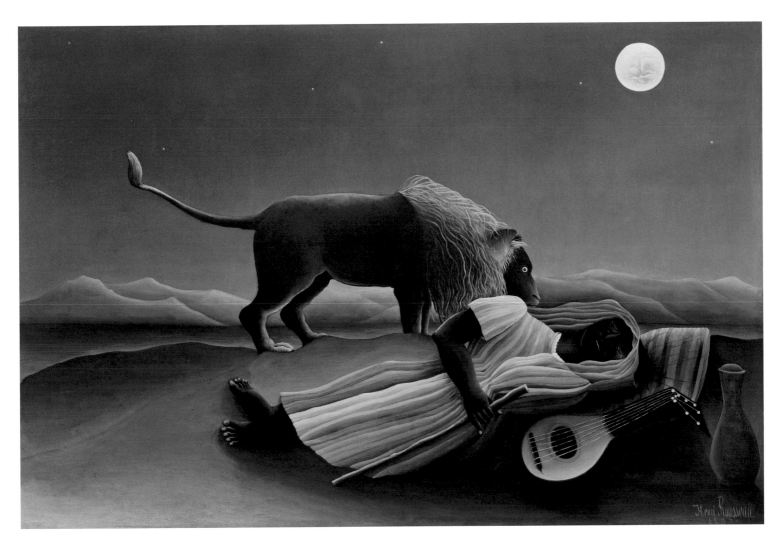

FIG. 35 **HENRI ROUSSEAU**
The Sleeping Gypsy (*La bohémienne endormie*), 1897
Oil on canvas
51 × 79 in. (129.5 × 200.7 cm)
Museum of Modern Art, New York, gift of Mrs. Simon
Guggenheim, 646.1939

collectors expected of him. At the time, the Parisian avant-garde was eager for a return to "wild-ness" in the arts, and the public's curiosity toward "primitive" art was heightened by the era's colonialism.[10] Gauguin was creating his own mythology around a Tahitian Eden and the return to one's roots. As orchestrated by the art dealer Ambroise Vollard, who was also interested in Rousseau, Gauguin's growing popularity must have contributed to triggering the visibility of Rousseau, who also played the primitivist card—even to excess. In 1897 Vollard exhibited *The Sleeping Gypsy* (1897, fig. 35), which depicts a slumbering "negress" being sniffed by a lion, to use the painter's own terms.

During the last five years of his life, Rousseau exploited the jungle theme more than ever, importing multiple sources, from Salon paintings to postcards to the stuffed animals at the Jardin des Plantes, the laboratory of his reveries.[11] His art, like Manet's, was inseparable from the media flow around it. This continuous recycling of images is peculiar to modern communica-tion. For Rousseau, it meant combining and dressing up imagery taken from *Le Petit Journal*, *Le Magasin Pittoresque*, and the albums of the Galeries Lafayette in order to capture the flavor of a lost or unknown authenticity.[12]

Without a doubt, the great tropical forests, with their buzzing insects and wild animals, saturated with violence and humor, are the best canvases he produced. *The Snake Charmer* (1907, cat. 106), presented at the Salon d'Automne in 1907, transposes the theme of

FIG. 36 **JEAN–LÉON GÉRÔME**
The Snake Charmer (*La charmeuse de serpents*),
ca. 1870
Oil on canvas
33 × 48 ⅛ in. (83.8 × 122.1 cm)
Sterling and Francine Clark Art Institute, Williamstown,
Massachusetts, acquired by Sterling and Francine Clark,
1942, 1955.51

The Snake Charmer by Gérôme (ca. 1870, fig. 36) to a dreamlike atmosphere filled with fantastical vegetation and ethereal light. A black Venus, endowed with magnificent hair and playing a flute, is the incarnation of absolute otherness, representing an ethnic "addiction" that Rousseau shared with his friend Pablo Picasso.[13] There is a touch of humor in the visual association of the musician's breasts, her eyes, and the two birds perched on the upper right. A third bird, with his spoon-billed beak and pink feathers, adds a more direct note of amusement. The huge serpents are both monstrous and ludicrous, infusing the subject with an erotic resonance. This vast Salon painting must be viewed in counterpoint to both the scenes of violence and the peaceful allegories that are equally represented in the artist's oeuvre. Between critiques of war and aspirations for peace, between excessive cruelty and orphic harmony, Rousseau's imagined world recognized the fundamental pendulum of human existence.

Translated from the French by Alison Anderson

NOTES

1 Waldemar George, "Le miracle de Rousseau," *Les Arts à Paris*, no. 18 (July 1931): 4, quoted in *Le Douanier Rousseau: Jungles à Paris*, by Christopher Green et al. (Paris: Réunion des Musées Nationaux, 2006), 163.

2 On Rousseau's deliberately naive manner, see most recently Christopher Green, "Souvenirs du Jardin des Plantes: Rendre l'exotique étrange à nouveau," in ibid., 30–49. See also Philippe Büttner et al., *Henri Rousseau* (Basel: Fondation Beyeler, 2010).

3 Arsène Alexandre, "Le Salon des Indépendants," *Comoedia*, April 3, 1909.

4 See François Robichon, *L'armée française vue par les peintres 1870–1914* (Paris: Herscher / Ministère de la Défense, 1998), 30.

5 This comes from an unpublished biographical notice written in 1894, which had been meant for publication in *Portraits du prochain siècle*. Quoted in Gilles Plazy, *Le Douanier Rousseau: Un naïf dans la jungle* (Paris: Gallimard, 1992), 47.

6 Subsequently the artist's felines became even more voracious, as in a lost canvas of 1898, *The Struggle for Life*. The title reflects the nineteenth century's preoccupation with Darwinism.

7 Quoted in Green et al., *Le Douanier Rousseau*, 143.

8 The caption was printed in the booklet for the Salon des Indépendants in 1894, quoted in ibid., 105.

9 See M.-T. De Forges, *Art de France* 4 (1964): 361, quoted in Dora Vallier, *Tout l'oeuvre peint de Henri Rousseau* (Paris: Flammarion, 1972), 96.

10 For a very different opinion, tending to remove Rousseau's art from any colonial implications, which were then as widespread on the left as on the right, see Green, "Souvenirs du Jardin des Plantes," 45.

11 In 1909 Rousseau confessed to Arsène Alexandre that he had "never traveled farther than the greenhouses at the Jardin des Plantes." Old views of this curiosity of Belle Époque Paris explain the fascination it exerted. Lush vegetation, tropical heat and humidity, a heady sense of saturation: there is an obvious connection between nature as spectacle and the spectacle of nature, both assumed to be unspoiled.

12 See Vincent Gille, "Illusion des sources, sources de l'illusion: Le Douanier Rousseau dans les images de son temps," in Green et al., *Le Douanier Rousseau*, 50–65.

13 See Stéphane Guégan, "Les demoiselles d'Alger ou le bordel colonial," in *L'Algérie de Launois* (Les Sables d'Olonne, France: Musée de l'Abbaye Sainte-Croix, 2004). For more on *The Snake Charmer*, see Nancy Ireson, "Mystérieuses rencontres," in Green et al., *Le Douanier Rousseau*, 158–167.

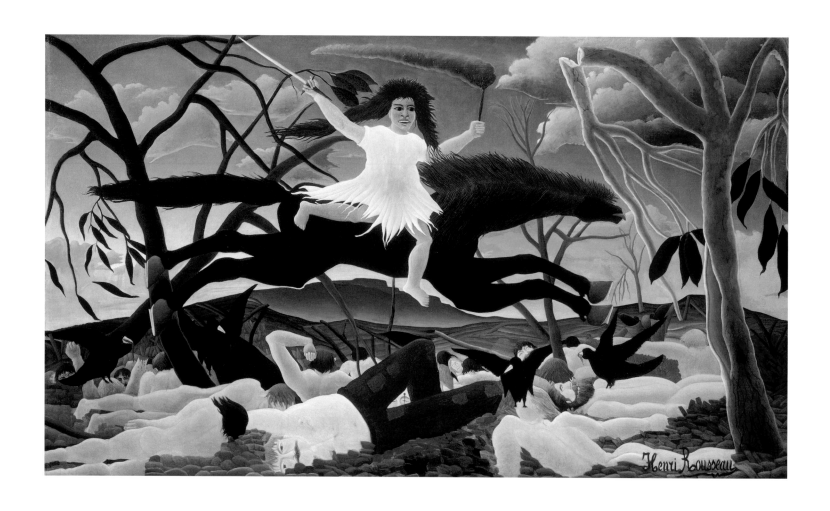

105

HENRI ROUSSEAU

War (*La guerre*), ca. 1894

Oil on canvas

44 7/8 × 76 3/4 in. (114 × 195 cm)

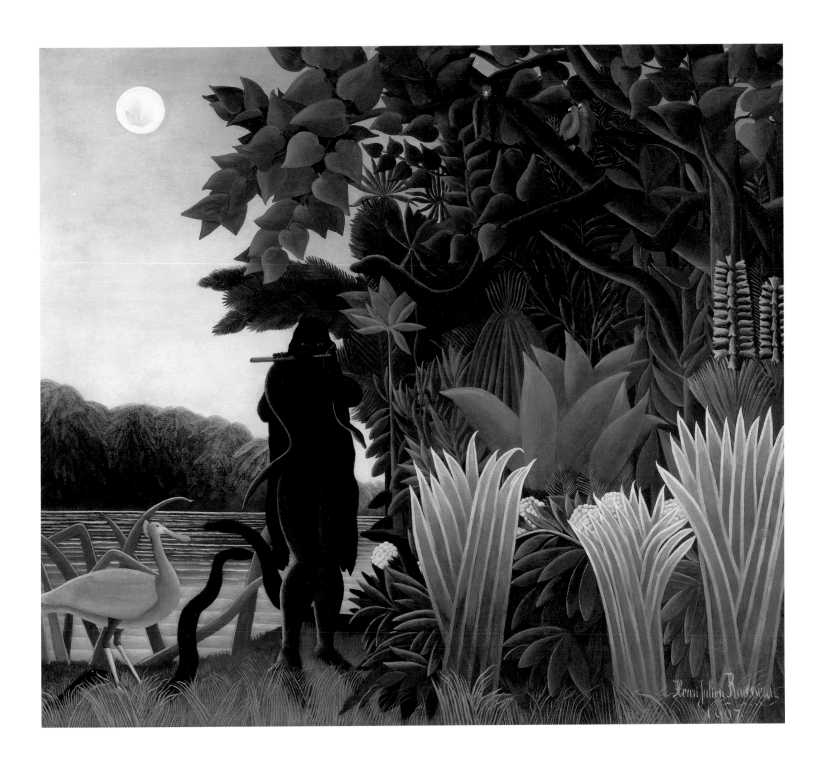

106
HENRI ROUSSEAU
The Snake Charmer (*La charmeuse de serpents*), 1907
Oil on canvas
66 ½ × 74 ⅝ in. (169 × 189.5 cm)

　　　THE NABIS AND SYMBOLISM

"THE GREAT ART WE CALL DECORATIVE"

SYLVIE PATRY

At the beginning of 1890, a war cry echoed from one studio to the next: "No more easel painting! Down with useless furnishings! Painting must not wrongfully assume a freedom that isolates it from other art forms. The painter's work begins where the architect's has left off. Give us walls, we need walls to decorate! . . . There are no paintings, there is only decoration!"[1] The Nabis rejected the artistic hierarchy that traditionally established boundaries between easel painting and applied arts, and they considered the *arts du décor*—both the usual decorative arts (such as furniture, screens, lamp shades, glass, and ceramics) and monumental painting—as a promising territory for exploration. The Nabi approach to what Maurice Denis deemed "the great art we call decorative"[2] was part of a broad experiment, beginning in the mid-nineteenth century with the Arts and Crafts movement in England, that called for an integration of art and daily life through the decorative arts. But for the Nabis, there were decisive aesthetic and formal implications at stake that gave rise to a profound reevaluation of the decorative arts, mural painting, and, ultimately, the foundations of what constitutes a work of art.

In mural painting, Pierre Puvis de Chavannes and Paul Gauguin had already led the way by the time the Nabis arrived on the scene. In an era when public buildings such as museums, town halls, and universities were being embellished with murals as never before, Puvis de Chavannes was in great demand. With each new commission he developed his idiom, based on an ever-increasing simplification of forms, a *grande manière* of painting, and a refusal to resort to illusionism or anecdote. As Jan Verkade emphasized, "The wall must remain a surface and must not be pierced by the representation of infinite horizons."[3] Gauguin, too, envisioned a greater role for mural painting—it had been his desire to decorate the church in Pont-Aven with *Vision of the Sermon (Jacob Wrestling with the Angel)* (1888, fig. 33).

Beginning in the early 1890s, when they were still unknown, the young Nabis sought recognition as decorative artists. This is what drove their initial ventures onto the Paris art scene. At the Salon des Indépendants in 1891, Pierre Bonnard displayed a screen as four separate panels because he found they were still "too much of a painting to be a screen," but the title he gave the work, *Decorative Panel 1.2.3.4*, sounds like a manifesto.[4] Today the panels are better known under the title *Women in the Garden* (1891, figs. 37–40). Bonnard also made a brilliant entry into

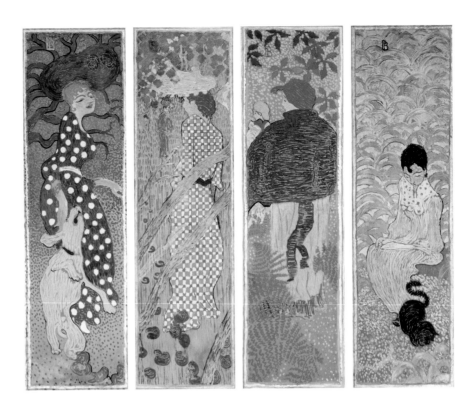

FIGS. 37–40 **PIERRE BONNARD**

Women in the Garden (*Femmes au jardin*), 1891
Distemper on paper mounted on canvas
Four panels, each: 63 × 18 ⅞ in. (160 × 48 cm)
Musée d'Orsay, RF 1984 159–162

the field of graphic arts with theater programs, engraved book and magazine illustrations, and poster designs, such as his commission for France-Champagne (1891, fig. 28).

Denis was equally precocious and enterprising. In 1892 he completed his first painted ceiling, *Poetic Arabesques for the Decoration of a Ceiling (Ladder in Foliage)* (Musée Départemental Maurice Denis, Saint-Germain-en-Laye), for the painter, collector, and music publisher Henry Lerolle. He also exhibited an ensemble of four *Panels for a Girl's Bedroom*, which have strong similarities to Bonnard's panels shown the previous year. Denis, like Bonnard, rendered the theme of the seasons with four young women wearing contemporary garments. The evocation of seasons through the female figure is a trope of decorative art, but Denis took it a step further with his intimate, highly stylized, and very personal iconography. By this time he had met Marthe Meurier, who not only became his wife in 1893 but also remained a central inspiration for his work, even after her death in 1919. It is Marthe we see in profile on the right in *September Evening* (1891, cat. 108), and again, in the same position, in *October Evening* (1891, cat. 109). The panels in the group, depicting the months of April (Kröller-Müller Museum, Otterlo, Netherlands), July (private collection), September, and October—winter was excluded—chronicle a young girl's path through life, from virginal purity to love. Love is heralded in *September Evening* in the form of the horsemen arriving below the terrace where the young girls are sitting. *October Evening* might be said to represent the acceptance and anticipation of married life, serenely evoked in the familiar setting of Saint-Germain-en-Laye, where the artist lived. This "poetic subject," as Denis referred to it in 1892, embodied the high spiritual ambition the artist attached to decoration, which was a reaction against the levity that was long considered to be the rule in such art forms as well as the narrative, descriptive, and deliberately edifying design of public art that was the standard under the Third Republic.

It might seem surprising that Denis chose to present these particular panels as a manifesto for the decisive reorientation of decorative painting. While their subject unfolds over

FIG. 41 **ÉDOUARD VUILLARD**
The Promenade (*La promenade*), 1894
Distemper on canvas
84 3/8 × 38 1/4 in. (214.3 × 97.2 cm)
The Museum of Fine Arts, Houston, The Robert Lee
Blaffer Memorial Collection, gift of Mr. and Mrs.
Kenneth Dale Owen, 53.9

several canvases, as in a traditional mural cycle, and their horizontal format recalls a classical frieze, the panels are small rather than monumental in scale. Denis showed them only once as an ensemble, in Paris in 1892; by the end of the year, they had been split up. The circumstances were such that Denis, like Bonnard with his *Women in the Garden*, had produced the paintings independently, not as a commission that would have kept the ensemble intact. In this project Denis was more concerned with drawing attention to a decorative vocabulary than with creating an ultimate ensemble. And, at the same time, he was hoping to attract a public commission.

That same year Denis took part in a competition for the design of the wedding space in the Montreuil city hall, just outside Paris. Competitions for major public commissions were common practice during that era. Other candidates for this project included Henri Matisse and René Piot, an artist who was close to the Nabis. Denis submitted a proposal for a cycle that was similar in form and spirit to the *Panels for a Girl's Bedroom*. For *Easter Procession* (1892, Peter Marino Collection), he chose the theme of a procession along the path of life, populated with figures ranging from a pure young bride dressed in white to a married couple. His proposal was not selected; the jury preferred an artist who has since been forgotten, Claude Charles Bourgonnier, for his Naturalist depiction of market scenes and families strolling through fields—precisely the sort of thing the Nabis found objectionable.

In 1893 Ker-Xavier Roussel tried his luck in a competition for the decoration of the town hall in Bagnolet. The mural was to cover four walls, amounting to almost twelve hundred square feet of surface. He designed a series of panels reflecting the seasons of life, a theme favored by Bonnard and Denis, as we have seen. *The Terrace* (ca. 1892, cat. 107) was one of the works he submitted. Like Denis, Roussel favored a friezelike format, in which he portrayed enigmatic young women moving through a stylized landscape. The Japanese influence is palpable in his work. Adding to the decorative quality of his style, which included elements similar to those adopted by Bonnard and Denis, the artist emphasized the patterns on the costumes. Like Denis', Roussel's proposal was rejected. The Nabis almost never managed to obtain any public commissions, a situation that would last until the 1930s, when a few of them were called upon to decorate the Théâtre de Chaillot in Paris (1937) and the League of Nations in Geneva (1938). The exception was Denis, who received commissions for religious buildings by the turn of the century.[5] Most of the Nabis' decorative paintings were acquired by private collectors, principally the Natanson brothers.

Alexandre, Thadée, and Alfred Natanson were the founding editors of *La Revue Blanche*, a Symbolist periodical to which the Nabis often contributed. It was more than a simple journal; it was an intellectual home, a state of mind. The Nabis exhibited their works at the journal's headquarters, and the brothers supported the artists by buying their art, giving them commissions, and playing a vital role in the group's development. Between 1894 and 1899, Édouard Vuillard created no fewer than four decorative cycles for the Natansons. Alexandre Natanson commissioned Vuillard for the Nabis' first set of large-scale panels, *Public Gardens* (1894). The nine paintings were initially set into the woodwork of the dining room in the client's residence at 74 avenue Foch.[6] In the cycle Vuillard offered a monumental interpretation of the modern urban environment, setting seven panels in the Bois de Boulogne and two in the Tuileries.[7]

Rather than portray heroic, historical scenes, Vuillard exercised his freedom to choose more modest subject matter—contemporary life, the family—for his complex ensemble,

creating a work in the spirit of the medieval tapestries that the artist admired at the Musée de Cluny. The airy scenes are connected by elements such as foliage, which forms a green backdrop in *Girls Playing*, *The Question*, *Conversation*, *Nurses*, and *The Red Parasol* (cats. 111–115) and carries over to the panel that followed, *The Promenade* (fig. 41). A compositional rhythm is achieved through a balance of crowded and empty spaces and the placement of arabesques. Vuillard used distemper in order to obtain the matte, frescolike finish (except for Piot, the Nabis did not practice the fresco technique). He preferred fresh, light colors.

The decade of the 1890s was a period of intense activity for both Denis and Vuillard, during which Denis produced ten decorative ensembles and Vuillard six. In addition to the Natansons, musicians, artists, and collectors such as Lerolle, Ernest Chausson, and the politician Denys Cochin called on them with commissions. Denis also worked free of any given context, such as when he created *The Muses* (1893, cat. 110), which contains echoes of *Sacred Wood, Dear to the Arts and Muses* (1884), the famous mural that Puvis de Chavannes created for the Musée des Beaux-Arts in Lyon. Here the theme of the inspiring muses is combined with an image of the pure young woman who is chosen for love (the tenth muse, at the back, in the sunlight). Marthe's repeated presence and the extremely stylized and simplified aspect of the landscape continued to define Denis' art throughout the 1890s.

By the early 1900s, when Bonnard and Roussel also began to receive commissions, the language of the Nabis had changed. In place of graphic outlines and solemn Symbolism, Bonnard turned to a vibrant fusion of shapes and colors in the service of his unbridled imagination, as illustrated by *Water Games (The Voyage)* and *Pleasure* (1906–1910, cats. 116–117), two of the four panels from the magnificent ensemble he created for the wealthy Misia Edwards, Thadée Natanson's former wife. The panels teem with activity, their surfaces treated like a densely colored tapestry. Bonnard's endeavor to use intensely rich and fluid colors proceeded with *View of Le Cannet* (1927, cat. 7), in which reality is transformed into a lush Eden bathed in light. Thus, even after the members of the Nabi group had gone their separate ways, Bonnard, Denis, Vuillard, and Roussel persisted in their search to "make the imagination comply with the eternal laws of decoration."[8]

Translated from the French by Alison Anderson

NOTES

1 Jan Verkade, *Le tourment de Dieu: Étapes d'un moine peintre* (Paris: L. Rouart et J. Waterlin, 1923), 94.

2 Maurice Denis, "Définition du néo-traditionnisme," *Art et Critique*, August 23 and 30, 1890, reprinted in Denis, *Le ciel et l'Arcadie*, ed. Jean-Paul Bouillon (Paris: Hermann, 1993).

3 Verkade, *Le tourment de Dieu*, 94.

4 Letter from Pierre Bonnard to his mother, quoted in Claire Frèches-Thory and Antoine Terrasse, *The Nabis: Bonnard, Vuillard, and Their Circle* (New York: Harry N. Abrams, 1991), 94. The sketches for the panels are in the Kunsthaus in Zurich.

5 His first commission (1899) was for the decoration of the chapel of the Collège Sainte-Croix in Le Vésinet. The work is on permanent loan to the Musée d'Orsay from the Union Centrale des Arts Décoratifs.

6 The ensemble was dismantled and sold in 1929.

7 The two Tuileries panels are in the collections of the Cleveland Museum of Art and the Musées Royaux des Beaux-Arts in Brussels. Five Bois de Boulogne panels reside in the holdings of the Musée d'Orsay; the remaining two panels are in a private collection and at the Museum of Fine Arts, Houston.

8 Maurice Denis, *Théories, 1890-1910: Du symbolisme et de Gauguin vers un nouvel ordre classique* (Paris: Bibliothèque de l'Occident, 1912), 22–23.

107

KER–XAVIER ROUSSEL

The Terrace (*La terrasse*), ca. 1892
Oil on canvas
28 × 35 ³/₈ in. (71 × 90 cm)

A painter, printer, and decorative artist, Roussel joined
the Nabis shortly after their formation. While decora-
tive cycles were a staple of the group's production, *The
Terrace* belongs to Roussel's only known mural project,
which comprises three paintings depicting women
on a terrace. The pastel hues, static figures, and visual
rhythm established by the repeating vertical forms
of the tree trunks, balustrade, and archway recall the
dreamlike murals of Puvis de Chavannes, whom the
Nabis strove to emulate.

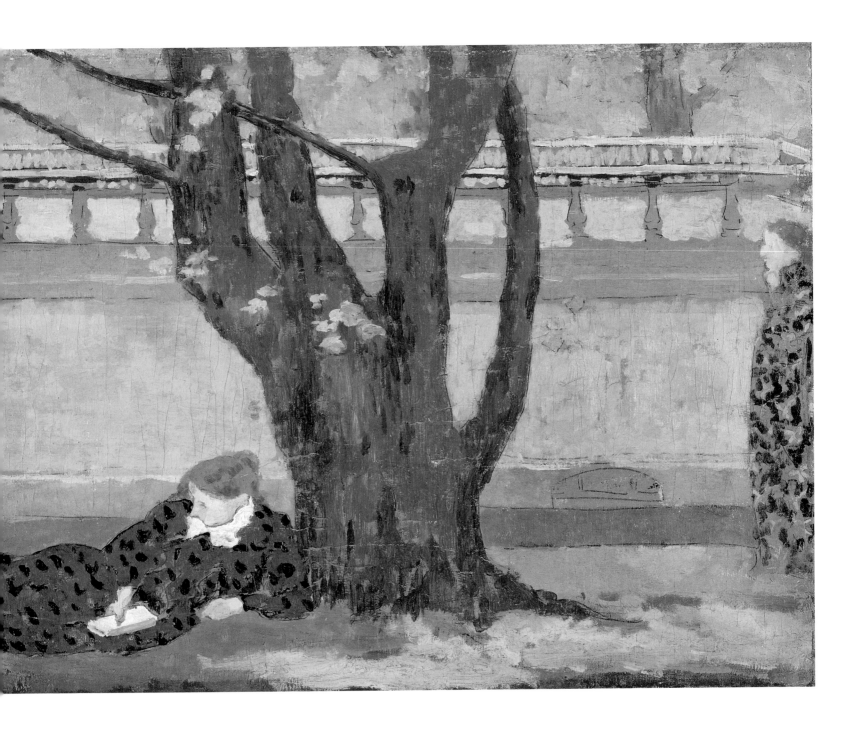

108

MAURICE DENIS
*Panel for a Girl's Bedroom: September Evening (Panneau
pour une chambre de jeune fille: Soir de septembre)*, 1891
Oil on canvas
15 × 24 in. (38 × 61 cm)

109

MAURICE DENIS

Panel for a Girl's Bedroom: October Evening (Panneau pour
une chambre de jeune fille: Soir d'octobre), 1891

Oil on canvas

14 ¾ × 23 ⅛ in. (37.5 × 58.7 cm)

Envisioned as decoration for a young girl's bedroom, these two panels belong to
an ensemble of paintings representing the seasons of life. Denis was inspired by his
love for Marthe Meurier, who later became his wife. The series symbolizes her
transformation from a young girl picking flowers to a mature woman on the brink
of marriage. Forgoing any great distinction between the seasons represented,
Denis created a harmonious, rhythmic cycle intended to illustrate what he called
"the poetry of the inner life."

110

MAURICE DENIS

The Muses (*Les muses*), 1893

Oil on canvas

$67\frac{1}{2} \times 54\frac{1}{8}$ in. (171.5 × 137.5 cm)

Denis exhibited *The Muses* as a "decorative panel" at the Salon des Indépendants of 1893. Inspired by Greek mythology, he rendered ten muses—the central trio all portraits of his fiancée, Marthe—within a highly stylized forest where chestnut trees are columns and the forest floor is an ornate carpet. The reduction of form to flattened silhouettes in matte tones gives the scene a dreamlike quality, a characteristic that aligns Denis with the Symbolists.

111–115

ÉDOUARD VUILLARD

Public Gardens (Jardins publics), 1894
Distemper on canvas

 111. *Girls Playing* (*Fillettes jouant*)
 84½ × 34⅝ in. (214.5 × 88 cm)

 112. *The Question* (*L'interrogatoire*)
 84½ × 36¼ in. (214.5 × 92 cm)

 113. *Conversation* (*La conversation*)
 83⅞ × 60⅝ in. (213 × 154 cm)

 114. *Nurses* (*Les nourrices*)
 84 × 28¾ in. (213.5 × 73 cm)

 115. *The Red Parasol* (*L'ombrelle rouge*)
 84¼ × 31⅞ in. (214 × 81 cm)

Created for the Parisian residence of Alexandre
Natanson, the director of the Symbolist journal *La
Revue Blanche*, these paintings belong to a series of
nine panels representing women and children relaxing
in the city's parks. Bringing nature indoors, Vuillard
sought to create a soothing refuge from the noise and
bustle of the modern city. The balance struck be-
tween the muted colors and rhythmic forms tran-
scends the panels' everyday subjects and envelops
the viewer in an atmosphere of calm and repose.

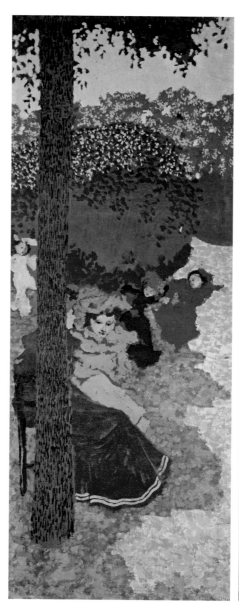

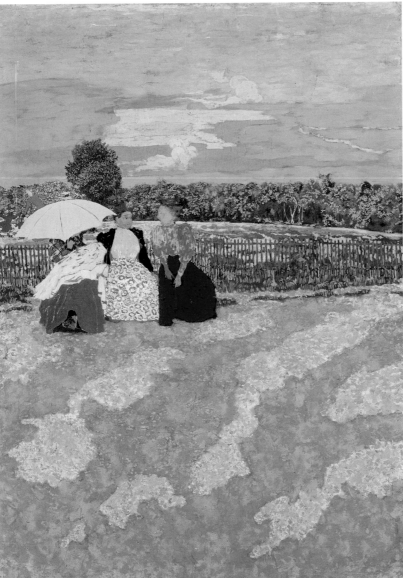

THE NABIS AND SYMBOLISM

116

PIERRE BONNARD

*Decorative Panel: Water Games (The Voyage) (Panneau
décoratif: Jeux d'eaux [Le voyage])*, 1906–1910
Oil on canvas
97 7/8 × 117 1/2 in. (248.5 × 298.5 cm)

These two panels are part of a decorative ensemble commissioned by Misia
Edwards, the former wife of Thadée Natanson, for the dining room of her new home.
Resembling tapestries in their organization, the paintings feature exotic lands,
whimsical figures, and timeless nudes framed within ornate borders. Leaving be-
hind the realistic subjects of his Nabi paintings, Bonnard evoked a mythical Arcadia
and unveiled the new direction his art would take in the twentieth century.

117

PIERRE BONNARD

Decorative Panel: Pleasure (*Panneau décoratif: Le plaisir*), 1906–1910
Oil on canvas
90¹⁄₂ × 118 in. (230 × 300 cm)

SUGGESTED FURTHER READING

·

CATALOGUE OF THE EXHIBITION

·

INDEX OF NAMES AND ARTWORKS

·

PAGE 240
HENRI ROUSSEAU
The Snake Charmer (La charmeuse de serpents),
1907
Detail of cat. 106

SUGGESTED FURTHER READING

The following bibliography presents English-language books and catalogues that offer additional context on Post-Impressionism and the artists in this exhibition.

Brettell, Richard R. *Post-Impressionists*. Chicago: Art Institute of Chicago; New York: Harry N. Abrams, 1987.

Brettell, Richard R., and Anne-Birgitte Fonsmark. *Gauguin and Impressionism*. New Haven, Conn.: Yale University Press, 2005.

Brettell, Richard R., et al. *The Art of Paul Gauguin*. Washington, D.C.: National Gallery of Art; Chicago: Art Institute of Chicago, 1988.

Cachin, Françoise, et al. *Cézanne*. Philadelphia: Philadelphia Museum of Art; New York: Harry N. Abrams, 1996.

Cogeval, Guy. *Édouard Vuillard*. Montreal: Montreal Museum of Fine Arts; Washington, D.C.: National Gallery of Art, 2003.

Collins, Bradley. *Van Gogh and Gauguin: Electric Arguments and Utopian Dreams*. Boulder, Colo.: Westview Press, 2001.

Conisbee, Philip. *Cézanne in Provence*. Washington, D.C.: National Gallery of Art; New Haven, Conn.: Yale University Press, 2006.

Denvir, Bernard. *Post-Impressionism*. New York: Thames and Hudson, 1992.

Dorra, Henri. *The Symbolism of Paul Gauguin: Erotica, Exotica, and the Great Dilemmas of Humanity*. Berkeley: University of California Press, 2007.

Druick, Douglas W., and Peter Kort Zegers. *Van Gogh and Gauguin: The Studio of the South*. Chicago: Art Institute of Chicago; New York: Thames and Hudson, 2001.

Facos, Michelle. *Symbolist Art in Context*. Berkeley: University of California Press, 2009.

Frèches-Thory, Claire, and Antoine Terrasse. *The Nabis: Bonnard, Vuillard, and Their Circle*. New York: Harry N. Abrams, 1991.

Frèches-Thory, Claire, et al. *Toulouse-Lautrec*. New Haven, Conn.: Yale University Press, 1991.

Groom, Gloria. *Beyond the Easel: Decorative Painting by Bonnard, Vuillard, Denis, and Roussel, 1890-1930*. Chicago: Art Institute of Chicago; New Haven, Conn.: Yale University Press, 2001.

Herbert, Robert L., et al. *Seurat 1859-1891*. New York: Metropolitan Museum of Art, 1991.

Homburg, Cornelia, ed. *Vincent van Gogh and the Painters of the Petit Boulevard*. Saint Louis, Mo.: Saint Louis Art Museum; New York: Rizzoli, 2001.

Jirat-Wasiutyeński, Vojtěch, and H. Travers Newton, Jr. *Technique and Meaning in the Paintings of Paul Gauguin*. Cambridge: Cambridge University Press, 2000.

Lemonedes, Heather, et al. *Paul Gauguin: The Breakthrough into Modernity*. Cleveland: Cleveland Museum of Art; Amsterdam: Van Gogh Museum, 2009.

Lewis, Mary Tomkins, ed. *Critical Readings in Impressionism and Post-Impressionism: An Anthology*. Berkeley: University of California Press, 2007.

Mathews, Patricia. *Passionate Discontent: Creativity, Gender and French Symbolist Art*. Chicago: University of Chicago Press, 1999.

Platzman, Steven. *Cézanne: The Self-Portraits*. Berkeley: University of California Press, 2001.

Rabinow, Rebecca A., et al. *Cézanne to Picasso: Ambroise Vollard, Patron of the Avant-Garde*. New York: Metropolitan Museum of Art; New Haven, Conn.: Yale University Press, 2007.

Roslak, Robyn. *Neo-Impressionism and Anarchism in Fin-de-Siècle France: Painting, Politics and Landscape*. Burlington, Vt.: Ashgate, 2007.

Solana, Guillermo. *Gauguin and the Origins of Symbolism*. London: Philip Wilson, 2004.

Stevens, MaryAnne, et al. *Émile Bernard 1868-1941: A Pioneer of Modern Art*. Amsterdam: Van Gogh Museum; Zwolle, Netherlands: Waanders Publishers, 1990.

Thomson, Belinda. *Gauguin*. London: Thames and Hudson, 1987.

———. *The Post-Impressionists*. Oxford: Phaidon, 1983.

———. *Van Gogh: Artists in Focus*. Chicago: Art Institute of Chicago, 2000.

Thomson, Richard, et al. *Toulouse-Lautrec and Montmartre*. Washington, D.C.: National Gallery of Art, 2005.

Watkins, Nicholas. *Bonnard*. London: Phaidon, 1994.

Wichmann, Siegfried. *Japonisme: The Japanese Influence on Western Art since 1858*. New York: Thames and Hudson, 1999.

CATALOGUE OF THE EXHIBITION

All works in this exhibition are from the collection of the Musée d'Orsay, Paris.

CHARLES ANGRAND
French, 1854–1926
Couple in the Street (*Couple dans la rue*), 1887 [cat. 51]
Oil on canvas
Signed and dated lower left: *Ch. Angrand 87*
15 1/8 × 13 in. (38.5 × 33 cm)
RF 1977 27

ÉMILE BERNARD
French, 1868–1941
Bathers with Red Cow (*Baigneuses à la vache rouge*),
1887 [cat. 66]
Oil on canvas
Signed and dated lower right: *EB 1887*
36 3/8 × 28 1/2 in. (92.5 × 72.5 cm)
RF 1984 21

The Harvest (*Breton Landscape*) (*La moisson [Paysage Breton]*), 1888 [cat. 67]
Oil on panel
Signed and dated lower left: *Emile Bernard 88*
22 1/4 × 17 3/4 in. (56.5 × 45 cm)
RF 1977 42

Madeleine in the Bois d'Amour or *Portrait of My Sister*
(*Madeleine au Bois d'Amour ou Portrait de ma soeur*),
1888 [cat. 2]
Oil on canvas
Signed and dated lower left: *Emile Bernard 1888*
Pont-Aven
54 3/8 × 64 1/8 in. (138 × 163 cm)
RF 1977 8

Symbolist Self-Portrait (*Vision*) (*Autoportrait symbolique [Vision]*), 1891 [cat. 4]
Oil on canvas
Signed lower middle: *Emile Bernard*; dated lower left: *1891*
31 7/8 × 23 7/8 in. (81 × 60.5 cm)
RF 2008 53

Breton Women with Umbrellas (*Les bretonnes aux ombrelles*), 1892 [cat. 74]
Oil on canvas
Signed and dated lower right: *Emile Bernard 1892*
31 7/8 × 41 3/8 in. (81 × 105 cm)
RF 1977 41

ALBERT BESNARD
French, 1849–1934
Madame Roger Jourdain, 1886 [cat. 9]
Oil on canvas
Signed lower left: *ABesnard*
78 3/4 × 60 1/4 in. (200 × 153 cm)
Salon de la Société des Artistes Français, Paris, 1886;
Exposition Universelle, Paris, 1900
RF 2302

PIERRE BONNARD
French, 1867–1947
Intimacy (*Portrait of Monsieur and Madame Claude Terrasse*) (*Intimité [Portrait de Monsieur et Madame Claude Terrasse]*), 1891 [cat. 80]
Oil on canvas
Dated: *1891*
15 × 14 1/8 in. (38 × 36 cm)
RF 1992 406

Checked Shirt (*Portrait of Madame Claude Terrasse at Twenty*) (*Le corsage à carreaux [Portrait de Madame Claude Terrasse à vingt ans]*), 1892 [cat. 81]
Oil on canvas
Signed and dated lower left: *P. Bonnard 1892*
24 × 13 in. (61 × 33 cm)
RF 1977 89

The White Cat (*Le chat blanc*), 1894 [cat. 82]
Oil on board
Signed and dated lower left: *Bonnard 94*
20 1/8 × 13 in. (51 × 33 cm)
RF 1982 74

Woman Dozing on a Bed (*Indolent Woman*) (*Femme assoupie sur un lit [L'indolente]*), 1899 [cat. 96]
Oil on canvas
Signed and dated lower left: *99 Bonnard*
37 3/4 × 41 3/4 in. (96 × 106 cm)
Secession, Munich, 1907–1908
RF 1977 75

The Man and the Woman (*L'homme et la femme*), 1900
[cat. 97]
Oil on canvas
Signed and dated lower left: *Bonnard 1900*
45 1/4 × 28 1/2 in. (115 × 72.5 cm)
RF 1977 76

Decorative Panel: Pleasure (*Panneau décoratif: Le plaisir*),
1906–1910 [cat. 117]
Oil on canvas
Signed lower right: *Bonnard*
90 1/2 × 118 in. (230 × 300 cm)
Salon d'Automne, Paris, 1910
RF 2007 22

Decorative Panel: Water Games (*The Voyage*) (*Panneau décoratif: Jeux d'eaux [Le voyage]*), 1906–1910 [cat. 116]
Oil on canvas
Signed lower right: *Bonnard*
97 7/8 × 117 1/2 in. (248.5 × 298.5 cm)
Salon d'Automne, Paris, 1910
RF 1996 18

View of Le Cannet (*Vue du Cannet*), 1927 [cat. 7]
Oil on canvas
Signed lower right: *Bonnard*
92 × 92 in. (233.6 × 233.6 cm)
RF 2008 52

PAUL CÉZANNE
French, 1839–1906
Portrait of Madame Cézanne (*Portrait de Madame Cézanne*), 1885–1890 [cat. 22]
Oil on canvas
18 1/2 × 15 3/8 in. (47 × 39 cm)
RF 1991 22

Kitchen Table (*Still Life with Basket*) (*La table de cuisine [Nature morte au panier]*), 1888–1890 [cat. 20]
Oil on canvas
Signed lower right: *P. Cézanne*
25 5/8 × 31 1/2 in. (65 × 80 cm)
Salon d'Automne, Paris, 1907
RF 2819

Bathers (*Baigneurs*), ca. 1890 [cat. 24]
Oil on canvas
23 5/8 × 32 1/4 in. (60 × 82 cm)
Salon d'Automne, Paris, 1904
RF 1965 3

Mont Sainte-Victoire (*La Montagne Sainte-Victoire*),
ca. 1890 [cat. 21]
Oil on canvas
25 5/8 × 36 1/4 in. (65 × 92 cm)
RF 1969 30

Apotheosis of Delacroix (*Apothéose de Delacroix*),
1890–1894 [cat. 23]
Oil on canvas
10 5/8 × 13 3/4 in. (27 × 35 cm)
RF 1982 38

Gustave Geffroy, 1895–1896 [cat. 29]
Oil on canvas
43 1/4 × 35 in. (110 × 89 cm)
RF 1969 29

Still Life with Onions (*Nature morte aux oignons*),
1896–1898 [cat. 27]
Oil on canvas
26 × 32 1/4 in. (66 × 82 cm)
RF 2817

Rocks near the Caves above the Château Noir
(*Rochers près des grottes au dessus du Château Noir*),
ca. 1904 [cat. 25]
Oil on canvas
25 5/8 × 21 1/4 in. (65 × 54 cm)
RF 1978 32

HENRI EDMOND CROSS
French, 1856–1910
Madame Hector France, 1891 [cat. 52]
Oil on canvas
Signed and dated lower left: *1891 Henri Edmond Cross*
81 7/8 × 58 5/8 in. (208 × 149 cm)
Salon des Indépendants, Paris, 1891
RF 1977 127

Hair (La chevelure), ca. 1892 [cat. 89]
Oil on canvas
Estate stamp lower left: *H. E. Cross*
24 × 18 1/8 in. (61 × 46 cm)
RF 1977 128

EDGAR DEGAS
French, 1834–1917
Dancers Climbing the Stairs (Danseuses montant un escalier), 1886–1890 [cat. 16]
Oil on canvas
Signed lower left: *Degas*
15 3/8 × 35 1/4 in. (39 × 89.5 cm)
RF 1979

MAURICE DENIS
French, 1870–1943
Calvary (Climbing to Calvary) (Le Calvaire [La montée au calvaire]), 1889 [cat. 102]
Oil on canvas
Signed and dated lower left: *M.D. nov. 89*
16 1/8 × 12 13/16 in. (41 × 32.5 cm)
RF 1986 68

Sunlight on the Terrace (Taches de soleil sur la terrasse), 1890 [cat. 78]
Oil on board
Dated lower right: *oct. 90*
9 1/2 × 8 1/8 in. (24 × 20.5 cm)
RF 1986 70

Panel for a Girl's Bedroom: October Evening (Panneau pour une chambre de jeune fille: Soir d'octobre), 1891 [cat. 109]
Oil on canvas
Signed with monogram and dated lower right: *MAVD 91*
14 3/4 × 23 1/8 in. (37.5 × 58.7 cm)
Salon des Indépendants, Paris, 1892; Salon des XX, Brussels, 1912
RF 2005 2

Panel for a Girl's Bedroom: September Evening (Panneau pour une chambre de jeune fille: Soir de septembre), 1891 [cat. 108]
Oil on canvas
Signed with monogram and dated lower right: *MAVD 91*
15 × 24 in. (38 × 61 cm)
RF 2009 16

Princess Maleine's Minuet (Marthe at the Piano) (Le menuet de la princesse Maleine [Marthe au piano]), 1891 [cat. 87]
Oil on canvas
Signed and dated lower left: *MAURICE DENIS 1891*; monogrammed upper right: *MAUD*
37 3/8 × 23 5/8 in. (95 × 60 cm)
RF 1999 3

Young Women at the Lamp (Jeunes filles à la lampe), 1891 [cat. 88]
Oil on canvas
Signed with monogram and dated middle left: *MAUD 91*
14 1/8 × 25 5/8 in. (36 × 65 cm)
RF 2001 10

Regatta at Perros-Guirec (Régates à Perros-Guirec), 1892 [cat. 75]
Oil on canvas
Signed with monogram and dated lower right: *MAUD*
16 5/8 × 13 1/4 in. (42.2 × 33.5 cm)
RF 2001 9

Landscape with Green Trees (Green Trees) (Procession under the Trees) (Paysage aux arbres verts [Les arbres verts] [La procession sous les arbres]), 1893 [cat. 101]
Oil on canvas
Signed with monogram and dated lower right: *MAUD/93*
18 1/8 × 16 7/8 in. (46 × 43 cm)
RF 2001 8

The Muses (Les muses), 1893 [cat. 110]
Oil on canvas
Signed with monogram and dated lower middle: *18 MAUD 93*
67 1/2 × 54 1/8 in. (171.5 × 137.5 cm)
Salon des Indépendants, Paris, 1893
RF 1977 139

Homage to Cézanne (Hommage à Cézanne), 1900 [cat. 28]
Oil on canvas
Signed and dated lower left: *Maurice DENIS 1900*
70 7/8 × 94 1/2 in. (180 × 240 cm)
Salon de la Société Nationale des Beaux-Arts, Paris, 1901
RF 1977 137

PAUL GAUGUIN
French, 1848–1903
Washerwomen at Pont-Aven (Les lavandières à Pont-Aven), 1886 [cat. 61]
Oil on canvas
Signed and dated lower left: *P. Gauguin 86*
28 × 35 3/8 in. (71 × 90 cm)
RF 1965 17

Les Alyscamps, 1888 [cat. 62]
Oil on canvas
Signed and dated lower left: *P. Gauguin 88*
36 × 28 1/2 in. (91.5 × 72.5 cm)
RF 1938 47

Seascape with Cow (At the Edge of the Cliff) (Marine avec vache [Au bord du gouffre]), 1888 [cat. 69]
Oil on canvas
Signed and dated lower left: *P. Gauguin 88*
28 1/2 × 24 in. (72.5 × 61 cm)
RF 1938 48

Yellow Haystacks (The Golden Harvest) (Les meules jaunes [La moisson blonde]), 1889 [cat. 68]
Oil on canvas
Signed and dated lower right: *P. Gauguin—89*
29 × 39 3/8 in. (73.5 × 92.5 cm)
Salon d'Automne, Paris, 1906
RF 1951 6

Still Life with Fan (Nature morte à l'éventail), ca. 1889 [cat. 60]
Oil on canvas
Signed lower right: *P. Gauguin*
19 3/4 × 24 in. (50 × 61 cm)
RF 1959 7

Portrait of the Artist with The Yellow Christ *(Portrait de l'artiste au Christ jaune)*, 1890–1891 [cat. 63]
Oil on canvas
15 × 18 1/8 in. (38 × 46 cm)
RF 1994 2

Tahitian Women (Femmes de Tahiti), 1891 [cat. 64]
Oil on canvas
Signed and dated lower right: *P. Gauguin 91*
27 1/8 × 36 in. (69 × 91.5 cm)
RF 2765

Arearea, 1892 [cat. 65]
Oil on canvas
Signed and dated lower right: *P. Gauguin 92*; inscribed lower right: *AREAREA*
29 1/2 × 37 in. (75 × 94 cm)
Salon d'Automne, Paris, 1906
RF 1961 6

Breton Peasant Women (Paysannes bretonnes), 1894 [cat. 73]
Oil on canvas
Signed and dated lower left: *P. Gauguin 94*
26 × 36 3/8 in. (66 × 92.5 cm)
RF 1973 17

Breton Village in the Snow (Village breton sous la neige), ca. 1894 [cat. 76]
Oil on canvas
24 3/8 × 34 1/4 in. (62 × 87 cm)
RF 1952 29

HENRI GERVEX
French, 1852–1929
Madame Valtesse de La Bigne, 1879; subsequently dated
by the artist 1889 [cat. 8]
Oil on canvas
Signed and dated lower left: *H. Gervex 1889*
78 ¾ × 48 in. (200 × 122 cm)
INV 20059

VILHELM HAMMERSHØI
Danish, 1864–1916
Rest (*Hvile*), 1905 [cat. 91]
Oil on canvas
19 ½ × 18 ¼ in. (49.5 × 46.5 cm)
RF 1996 12

FERNAND KHNOPFF
Belgian, 1858–1921
Marie Monnom or *Miss M. M . . .* (*Mlle. M. M . . .*),
1887 [cat. 92]
Oil on canvas
Signed and dated upper middle: *Fernand Khnopff 1887*
19 ½ × 19 ¾ in. (49.5 × 50 cm)
RF 1982 10

GEORGES LACOMBE
French, 1868–1916
The Violet Wave (*La vague violette*), 1895–1896 [cat. 5]
Oil on canvas
28 ¾ × 36 ¼ in. (73 × 92 cm)
RF 1988 18

CHARLES LAVAL
French, 1862–1894
Landscape (*Paysage*), 1889–1890 [cat. 70]
Oil on paper mounted on canvas
Signed and dated lower right: *Charles Laval 9 . . .*
21 ⅝ × 18 ⅛ in. (55 × 46 cm)
RF 1977 219

GEORGES LEMMEN
Belgian, 1865–1916
Beach at Heist (*Plage à Heist*), 1891 [cat. 48]
Oil on panel
14 ¾ × 18 in. (37.5 × 45.7 cm)
Salon des XX, Brussels, 1892
RF 1987 35

MAXIMILIEN LUCE
French, 1858–1941
The Seine at Herblay (*La Seine à Herblay*), 1890 [cat. 45]
Oil on canvas
Signed and dated lower right: *Luce 90*
19 ⅞ × 31 ¼ in. (50.5 × 79.5 cm)
RF 1977 232

CLAUDE MONET
French, 1840–1926
Frost (*Le givre*), 1880 [cat. 11]
Oil on canvas
Signed and dated lower right: *1880 Claude Monet*
24 × 39 ⅜ in. (61 × 100 cm)
RF 2706

Storm, Coasts of Belle-Île (*Tempête, côtes de Belle-Île*),
1886 [cat. 12]
Oil on canvas
Signed and dated lower left: *Claude Monet 86*
25 ⅝ × 32 ⅛ in. (65 × 81.5 cm)
RF 3163

Mount Kolsaas in Norway (*Le mont Kolsaas en Norvège*),
1895 [cat. 13]
Oil on canvas
Stamped lower right: *Claude Monet*
25 ¾ × 39 ⅜ in. (65.5 × 100 cm)
RF 1967 7

GUSTAVE MOREAU
French, 1826–1898
Orpheus (*Orphée*), 1865 [cat. 98]
Oil on panel
Signed and dated lower left: *1865. Gustave Moreau*
60 ⅝ × 39 ⅛ in. (154 × 99.5 cm)
Salon, Paris, 1866; Exposition Universelle, Paris, 1867;
Exposition Internationale des Arts, Munich, 1879
RF 104

PABLO PICASSO
Spanish, 1881–1973
Large Still Life (*Grande nature morte*), 1917 [cat. 30]
Oil on canvas
Signed lower right: *Picasso*
34 ¼ × 45 ⅝ in. (87 × 116 cm)
RF 1963 80

CAMILLE PISSARRO
Danish and French, 1831–1903
Hoarfrost, Peasant Girl Making a Fire (*Gelée blanche,
jeune paysanne faisant du feu*), 1888 [cat. 49]
Oil on canvas
Signed and dated lower right: *C.Pissarro.1888*
36 ½ × 36 ⅜ in. (92.8 × 92.5 cm)
Salon des XX, Brussels, 1889
RF 2000 83

Pont Boïeldieu, Rouen, Sunset, Misty Weather (*Le pont
Boïeldieu à Rouen, soleil couchant, temps brumeux*),
1896 [cat. 15]
Oil on canvas
Signed and dated lower left: *C. Pissarro 1896*
21 ¼ × 25 ⅝ in. (54 × 65 cm)
RF 1983 7

PIERRE PUVIS DE CHAVANNES
French, 1824–1898
The Poor Fisherman (*Le pauvre pêcheur*), 1881 [cat. 100]
Oil on canvas
Signed and dated lower right: *P. Puvis de Chavannes 1881*
61 ¼ × 75 ¾ in. (155.5 × 192.5 cm)
Salon de la Société des Artistes Français, Paris, 1881
RF 506

ODILON REDON
French, 1840–1916
Eyes Closed (*Les yeux clos*), 1890 [cat. 103]
Oil on canvas mounted on board
Signed and dated lower left: *Odilon Redon 1890*
17 ⅜ × 14 ⅛ in. (44 × 36 cm)
RF 2791

The Sleep of Caliban (*Sommeil de Caliban*),
1895–1900 [cat. 104]
Oil on panel
Signed lower right: *Odilon Redon*
19 × 15 ⅛ in. (48.3 × 38.5 cm)
RF 1984 48

PIERRE AUGUSTE RENOIR
French, 1841–1919
A Dance in the Country (*Danse à la campagne*), 1883
[cat. 17]
Oil on canvas
Signed and dated lower left: *Renoir 83*
70 ⅞ × 35 ⅜ in. (180 × 90 cm)
RF 1979 64

Young Girls at the Piano (*Jeunes filles au piano*), 1892
[cat. 18]
Oil on canvas
Signed lower right: *Renoir*
45 ⅝ × 35 ⅜ in. (116 × 90 cm)
RF 755

The Bathers (*Les baigneuses*), 1918–1919 [cat. 19]
Oil on canvas
43 ¼ × 63 in. (110 × 160 cm)
RF 2795

HENRI ROUSSEAU
French, 1844–1910
War (*La guerre*), ca. 1894 [cat. 105]
Oil on canvas
Signed lower right: *Henri Rousseau*
44 ⅞ × 76 ¾ in. (114 × 195 cm)
Salon des Indépendants, Paris, 1894
RF 1946 1

The Snake Charmer (*La charmeuse de serpents*), 1907 [cat. 106]
Oil on canvas
Signed and dated lower right: *Henri Julien Rousseau 1907*
66 ¹/₂ × 74 ⁵/₈ in. (169 × 189.5 cm)
Salon d'Automne, Paris, 1907; Salon des Indépendants, Paris, 1911
RF 1937 7

KER–XAVIER ROUSSEL
French, 1867–1944
The Terrace (*La terrasse*), ca. 1892 [cat. 107]
Oil on canvas
Signed lower left: *K.X Roussel*
28 × 35 ³/₈ in. (71 × 90 cm)
RF 1992 1

JOHN SINGER SARGENT
American, 1856–1925
La Carmencita, ca. 1890 [cat. 10]
Oil on canvas
Signed upper left: *John S. Sargent*
91 ³/₈ × 55 ⁷/₈ in. (232 × 142 cm)
Society of American Artists, New York, 1890; Royal Academy of Arts, London, 1891; Salon de la Societé Nationale des Beaux-Arts, Paris, 1892
RF 746

PAUL SÉRUSIER
French, 1864–1927
The Talisman, the Aven at the Bois d'Amour (*Le Talisman, l'Aven au Bois d'Amour*), 1888 [cat. 77]
Oil on panel
10 ⁵/₈ × 8 ¹/₂ in. (27 × 21.5 cm)
RF 1985 13

The Flowery Fence, Le Pouldu (*La barrière fleurie, Le Pouldu*), 1889 [cat. 71]
Oil on canvas
Signed lower right: *P.S.*
28 ³/₄ × 23 ⁵/₈ in. (73 × 60 cm)
RF 1980 52

The Fence (*La barrière*), 1890 [cat. 72]
Oil on canvas
Signed lower left: *P.S.*
20 × 24 ¹/₂ in. (50.7 × 62.3 cm)
RF 1981 4

Portrait of Paul Ranson in Nabi Costume (*Portrait de Paul Ranson en tenue nabique*), 1890 [cat. 79]
Oil on canvas
Signed and dated lower right: *P. Sérusier 90*
24 × 18 ¹/₄ in. (61 × 46.5 cm)
RF 2004 8

Still Life: The Artist's Studio (*Nature morte: L'atelier de l'artiste*), 1891 [cat. 26]
Oil on canvas
Signed and dated lower right: *P. Sérusier 91*
23 ⁵/₈ × 28 ³/₄ in. (60 × 73 cm)
RF 1984 11

GEORGES SEURAT
French, 1859–1891
Landscape with The Poor Fisherman *by Puvis de Chavannes* (*Paysage avec* Le pauvre pêcheur *de Puvis de Chavannes*), ca. 1881 [cat. 99]
Oil on panel
Inscribed lower right: *Puvisse de Chavannes*
6 ⁷/₈ × 10 ³/₈ in. (17.5 × 26.5 cm)
RF 2002 29

The Little Peasant in Blue (*The Jockey*) (*Le petit paysan en bleu* [*Le jockey*]), ca. 1882 [cat. 36]
Oil on canvas
18 ¹/₈ × 15 in. (46 × 38 cm)
RF 1982 54

Study for Bathers at Asnières (*Étude pour* Une baignade à Asnières), 1883 [cat. 35]
Oil on panel
6 ¹/₈ × 9 ⁷/₈ in. (15.5 × 25 cm)
Salon des Indépendants, Paris, 1892
RF 1965 13

Study for A Sunday Afternoon on La Grande Jatte—1884 (*Étude pour* Un dimanche après-midi à l'île de la Grande Jatte), 1884 [cat. 38]
Oil on panel
6 ¹/₈ × 9 ⁷/₈ in. (15.5 × 25 cm)
RF 1948 1

Study for A Sunday Afternoon on La Grande Jatte—1884 (*Étude pour* Un dimanche après-midi à l'île de la Grande Jatte), 1884–1886 [cat. 37]
Oil on panel
6 ¹/₄ × 9 ⁷/₈ in. (16 × 25 cm)
RF 2828

Model Standing, Facing the Front or *Study for* The Models (*Poseuse debout, de face* ou *Étude pour* Les poseuses), 1886 [cat. 39]
Oil on panel
10 ¹/₄ × 6 ¹/₈ in. (26 × 15.7 cm)
RF 2000 23

Model from the Back (*Poseuse de dos*), 1887 [cat. 42]
Oil on panel
9 ⁵/₈ × 6 ¹/₈ in. (24.5 × 15.5 cm)
RF 1947 15

Model from the Front (*Poseuse de face*), 1887 [cat. 40]
Oil on panel
Signed lower right: *Seurat*
9 ⁷/₈ × 6 ¹/₄ in. (25 × 16 cm)
Salon des Indépendants, Paris, 1887; Salon des Indépendants, Paris, 1892
RF 1947 13

Model in Profile (*Poseuse de profil*), 1887 [cat. 41]
Oil on panel
9 ⁷/₈ × 6 ¹/₄ in. (25 × 16 cm)
Salon des Indépendants, Paris, 1890; Salon des Indépendants, Paris, 1892
RF 1947 14

Port-en-Bessin at High Tide (*Port-en-Bessin, avant-port, marée haute*), 1888 [cat. 43]
Oil on canvas
26 ³/₈ × 32 ¹/₄ in. (67 × 82 cm)
Salon des XX, Brussels, 1889; Salon des Indépendants, Paris, 1890
RF 1952 1

The Circus (*Sketch*) (*Le cirque* [*esquisse*]), 1891 [cat. 1]
Oil on canvas
21 ⁵/₈ × 18 ¹/₈ in. (55 × 46 cm)
RF 1937 123

PAUL SIGNAC
French, 1863–1935
Les Andelys (*The Riverbank*) (*Les Andelys* [*La berge*]), 1886 [cat. 44]
Oil on canvas
Signed and dated lower right: *P. Signac 86*
25 ⁵/₈ × 31 ⁷/₈ in. (65 × 81 cm)
Salon des Indépendants, Paris, 1887
RF 1996 6

Women at the Well or *Young Women from Provence at the Well, Decoration for a Panel in the Shadows* (*Femmes au puits* ou *Jeunes provençales au puits, décoration pour un panneau dans la pénombre*), 1892 [cat. 50]
Oil on canvas
Signed and dated lower left: *P. Signac 92*; lower right: *Op. 238*
76 ³/₄ × 51 ⁵/₈ in. (195 × 131 cm)
Salon des Indépendants, Paris, 1893; La Libre Esthétique, Brussels, 1894
RF 1979 5

Entry to the Port of Marseille (*L'entrée du port de Marseille*), 1911 [cat. 6]
Oil on canvas
45 ⁷/₈ × 64 in. (116.5 × 162.5 cm)
Salon des Indépendants, Paris, 1911; Exposition Universelle, Gand, 1913
RF 1977 324

ALFRED SISLEY
French, 1839–1899
Moret Bridge (*Le pont de Moret*), 1893 [cat. 14]
Oil on canvas
Signed and dated lower left: *Sisley 93*
29 × 36 ³/₈ in. (73.5 × 92.5 cm)
RF 1972 35

HENRI DE TOULOUSE-LAUTREC

French, 1864–1901

Redhead (Bathing) (*Rousse [La toilette]*), 1889 [cat. 31]
Oil on board
Signed lower left: *Lautrec*
26 ³⁄₈ × 21 ¹⁄₄ in. (67 × 54 cm)
RF 2242

Woman with a Black Boa (*Femme au boa noir*),
1892 [cat. 32]
Oil on board
Signed lower right: *HTLautrec*
20 ⁷⁄₈ × 16 ¹⁄₈ in. (53 × 41 cm)
La Libre Esthétique, Brussels, 1902
INV 20140

Woman Pulling Up Her Stockings (*Femme tirant son bas*),
ca. 1894 [cat. 33]
Oil on board
Signed with monogram lower right: *HTL*
22 ⁷⁄₈ × 18 ¹⁄₈ in. (58 × 46 cm)
RF 1943 66

The Clown Cha-U-Kao (*La clownesse Cha-U-Kao*),
1895 [cat. 34]
Oil on board
Signed and dated lower right: *HTLautrec 95*
25 ¹⁄₄ × 19 ¹⁄₄ in. (64 × 49 cm)
RF 2027

FÉLIX VALLOTTON

Swiss, 1865–1925

Self-Portrait or *My Portrait* (*Autoportrait ou Mon
portrait*), 1897 [cat. 93]
Oil on board
Signed and dated lower right: *F. Vallotton 97*
23 ¹⁄₄ × 18 ⁷⁄₈ in. (59.2 × 48 cm)
RF 2007 6

Misia at Her Dressing Table (*Misia à sa coiffeuse*),
1898 [cat. 90]
Tempera on board
Signed and dated lower left: *F. Vallotton 98*
14 ¹⁄₈ × 11 ³⁄₈ in. (36 × 29 cm)
RF 2004 1

The Ball or *Corner of the Park with Child Playing with
a Ball* (*Le ballon* ou *Coin de parc avec enfant jouant au
ballon*), 1899 [cat. 95]
Oil on board mounted on panel
Signed and dated lower right: *F. Vallotton 99*
18 ⁷⁄₈ × 24 in. (48 × 61 cm)
RF 1977 353

Dinner, by Lamplight (*Le diner, effet de lampe*),
1899 [cat. 94]
Oil on board mounted on panel
Signed and dated lower right: *F. Vallotton. 99*
22 ¹⁄₂ × 35 ¹⁄₄ in. (57 × 89.5 cm)
RF 1977 349

VINCENT VAN GOGH

Dutch, 1853–1890

Imperial Crown Fritillaries in a Copper Vase
(*Fritillaires couronne impériale dans un vase de cuivre*),
1887 [cat. 55]
Oil on canvas
Signed upper left: *Vincent*
28 ³⁄₄ × 23 ⁷⁄₈ in. (73 × 60.5 cm)
RF 1989

Portrait of the Artist (*Portrait de l'artiste*), 1887 [cat. 56]
Oil on canvas
17 ³⁄₈ × 13 ³⁄₄ in. (44.1 × 35.1 cm)
RF 1947 28

Restaurant de la Sirène at Asnières (*Le restaurant de la
Sirène à Asnières*), 1887 [cat. 53]
Oil on canvas
21 ¹⁄₂ × 23 ³⁄₄ in. (54.5 × 65.5 cm)
RF 2325

Caravans, Gypsy Camp near Arles (*Les roulottes,
campement de bohémiens aux environs d'Arles*),
1888 [cat. 54]
Oil on canvas
17 ³⁄₄ × 20 ¹⁄₈ in. (45 × 51 cm)
RF 3670

Eugène Boch or *The Poet* (*Le poète*), 1888 [cat. 58]
Oil on canvas
23 ⁵⁄₈ × 17 ³⁄₄ in. (60 × 45 cm)
RF 1944 9

Starry Night (*La nuit étoilée*), 1888 [cat. 57]
Oil on canvas
28 ¹⁄₂ × 36 ¹⁄₄ in. (72.5 × 92 cm)
Salon des Indépendants, Paris, 1889
RF 1975 19

Van Gogh's Bedroom at Arles (*La chambre de Van Gogh à
Arles*), 1889 [cat. 59]
Oil on canvas
22 ⁵⁄₈ × 29 ¹⁄₈ in. (57.5 × 74 cm)
RF 1959 2

THÉO VAN RYSSELBERGHE

Belgian, 1862–1926

Sailing Boats and Estuary (*Voiliers et estuaire*), ca. 1887
[cat. 46]
Oil on canvas
Signed with monogram lower right: *TVR*
19 ³⁄₄ × 24 in. (50 × 61 cm)
RF 1982 16

The Man at the Tiller (*L'homme à la barre*), 1892 [cat. 47]
Oil on canvas
Signed with monogram and dated lower left: *18 TVR 92*
23 ³⁄₄ × 31 ⁵⁄₈ in. (60.2 × 80.3 cm)
RF 1976 79

ÉDOUARD VUILLARD

French, 1868–1940

The Reader (Portrait of K.-X. Roussel) (*Le liseur [Portrait
de K.-X. Roussel]*), ca. 1890 [cat. 83]
Oil on board
Estate stamp lower left: *E. Vuillard*
13 ³⁄₄ × 7 ¹⁄₂ in. (35 × 19 cm)
RF 1990 13

In Bed (*Au lit*), 1891 [cat. 86]
Oil on canvas
Signed and dated upper left: *e. vuillard 91*
28 ³⁄₄ × 36 ³⁄₈ in. (73 × 92.5 cm)
RF 1977 374

Profile of a Woman in a Green Hat (*Femme de profil au
chapeau vert*), ca. 1891 [cat. 84]
Oil on board
Estate stamp lower right: *E.V.*
8 ¹⁄₄ × 6 ¹⁄₄ in. (21 × 16 cm)
RF 1990 14

Sleep (*Le sommeil*), 1892 [cat. 85]
Oil on canvas
Signed upper left: *ev*; inscribed lower right: *E. Vuillard*
13 × 22 ³⁄₈ in. (33 × 64.5 cm)
RF 1977 369

Public Gardens (*Jardins publics*), 1894 [cats. 111–115]
Distemper on canvas
 111. *Girls Playing* (*Fillettes jouant*)
 Signed and dated lower right: *E. Vuillard 94*
 84 ¹⁄₂ × 34 ⁵⁄₈ in. (214.5 × 88 cm)
 RF 1978 46
 112. *The Question* (*L'interrogatoire*)
 84 ¹⁄₂ × 36 ¹⁄₄ in. (214.5 × 92 cm)
 RF 1978 47
 113. *Conversation* (*La conversation*)
 83 ⁷⁄₈ × 60 ⁵⁄₈ in. (213 × 154 cm)
 RF 1977 365
 114. *Nurses* (*Les nourrices*)
 84 × 28 ³⁄₄ in. (213.5 × 73 cm)
 RF 1977 365
 115. *The Red Parasol* (*L'ombrelle rouge*)
 84 ¹⁄₄ × 31 ⁷⁄₈ in. (214 × 81 cm)
 RF 1977 365

Félix Vallotton, ca. 1900 [cat. 3]
Oil on board mounted on panel
Signed lower right: *E. Vuillard*
24 ³⁄₄ × 19 ¹⁄₂ in. (63 × 49.5 cm)
RF 1977 390

INDEX OF NAMES AND ARTWORKS

Page numbers in *italics* refer to illustrations.

ACKNOWLEDGMENTS

The Parisian commissioners of the exhibition would like
to thank everyone at the Musée d'Orsay who contributed
to the successful implementation of this exhibition and
catalogue:

Thierry Gausseron
Olivier Simmat
Jean Naudin
Denis Thibaut

Elsa Badie Modiri
Stéphane Bayard
Martine Bozon
Jeanne Brosse
Myriam Bru
Isabelle Cahn
Evelyne Chatelus
Annie Dufour
Hélène Flon
Françoise Fur
Amélie Hardivillier
Matthieu Leverrier
Dominique Lobstein
Caroline Mathieu
Nathalie Mengelle
Anne Meny-Horn
Odile Michel
Virginie Noubissié
Anne Roquebert
Patrice Schmidt
Antoine Tasso and his team
Philippe Thiébaut
Araxie Toutghalian

PHOTOGRAPHY CREDITS

Figs. 1–2: © Wilmotte Associés; 3: © Réunion des Musées
Nationaux / Art Resource, NY / Hervé Lewandowski; 4:
image courtesy National Gallery of Art, Washington;
5: courtesy the San Francisco Museum of Modern Art;
6, 8, 12, 18: © Erich Lessing / Art Resource, NY; 7, 14,
30: Joseph McDonald, courtesy the Fine Arts Museums
of San Francisco; 9–10, 15, 17, 19, 27: © RMN (Musée
d'Orsay) / Hervé Lewandowski; 11, 35: digital image ©
The Museum of Modern Art / Licensed by SCALA / Art
Resource, NY; 13: photo Les Arts décoratifs, Paris / Jean
Tholance, tous droits réservés; 16, 34: © National Gallery,
London / Art Resource, NY; 20–22: Van Gogh Museum
Amsterdam (Vincent van Gogh Foundation); 23: Musée
Fabre, Montpellier, France / Giraudon / The Bridgeman Art
Library; 24: courtesy the Indianapolis Museum of Art; 25,
31, 37–40: © RMN (Musée d'Orsay) / Hervé Lewandowski,
© 2010 Artists Rights Society (ARS) / ADAGP, Paris; 26: ©
Réunion des Musées Nationaux / Art Resource, NY / Jean-
Gilles Berizzi; 28: digital image © The Museum of Modern
Art / Licensed by SCALA / Art Resource, NY, © 2010 Artists
Rights Society (ARS) / ADAGP, Paris; 29: © RMN (Musée
d'Orsay) / Thierry Le Mage, © 2010 Artists Rights Society
(ARS) / ADAGP, Paris; 32: © RMN / Stéphane Maréchalle;
33: © Art Resource, NY; 36: Sterling & Francine Clark Art
Institute, Williamstown, USA / The Bridgeman Art Library;
41: courtesy The Museum of Fine Arts, Houston, © 2010
Artists Rights Society (ARS) / ADAGP, Paris

Cats. 1, 5, 8–9, 11, 13–27, 29, 31–39, 40–41, 43–44, 46–
47, 50–52, 54–55, 57–62, 64–65, 68, 71–73, 76–77, 79,
89–90,92–95, 98–100, 103–104, 106: © RMN (Musée
d'Orsay) / Hervé Lewandowski; 2–4, 28, 45, 66, 74–75,
80–88, 101–102, 107, 109–112, 116: © RMN (Musée
d'Orsay) / Hervé Lewandowski, © 2010 Artists Rights
Society (ARS) / ADAGP, Paris; 6: Giraudon / The Bridgeman
Art Library; 7, 78, 108, 117: © Musée d'Orsay, Dist RMN /
Patrice Schmidt, © 2010 Artists Rights Society (ARS) /
ADAGP, Paris; 10, 48, 53, 56: © RMN (Musée d'Orsay) /
Gérard Blot; 12, 42, 63: © RMN (Musée d'Orsay) / René-
Gabriel Ojéda; 30: © RMN / Hervé Lewandowski, © 2010
Estate of Pablo Picasso /Artists Rights Society (ARS), New
York; 39, 91: © RMN (Musée d'Orsay) / Michèle Bellot;
49: © Musée d'Orsay, Dist RMN / Patrice Schmidt; 67: ©
RMN (Musée d'Orsay) / Jean-Gilles Berizzi, © 2010 Artists
Rights Society (ARS) / ADAGP, Paris; 69: Peter Willi /
The Bridgeman Art Library; 70: © RMN (Musée d'Orsay) /
Christian Jean; 96: © RMN (Musée d'Orsay) / Thierry Le
Mage, © 2010 Artists Rights Society (ARS) / ADAGP, Paris;
97: © RMN (Musée d'Orsay) / Gérard Blot, © 2010 Artists
Rights Society (ARS) / ADAGP, Paris; 105: © RMN (Musée
d'Orsay) / Droits réservés; 113–115: © RMN (Musée
d'Orsay) / Jean Schormans, © 2010 Artists Rights Society
(ARS) / ADAGP, Paris

COMMISSIONERS OF THE EXHIBITION

Guy Cogeval
Sylvie Patry
Stéphane Guégan
Musée d'Orsay

John E. Buchanan, Jr.
Lynn Federle Orr
Fine Arts Museums of San Francisco

Published in 2010 by the Fine Arts Museums of San Francisco and DelMonico Books, an imprint of Prestel Publishing, on the occasion of the exhibition *Van Gogh, Gauguin, Cézanne, and Beyond: Post-Impressionist Masterpieces from the Musée d'Orsay*.

de Young Museum, San Francisco
September 25, 2010–January 18, 2011

PRESENTING PARTNER

GRAND PATRON
Jeannik Méquet Littlefield

MAJOR PATRONS

San Francisco Auxiliary of the Fine Arts Museums
Diane B. Wilsey

PATRONS
Athena and Timothy Blackburn
Ray and Dagmar Dolby Family Fund
John A. and Cynthia Fry Gunn
William G. Irwin Charity Foundation
J. Burgess and Elizabeth B. Jamieson
Susan and James R. Swartz
Douglas A. Tilden

BENEFACTORS
Hope Aldrich and David Spencer
George Frederick Jewett Foundation
Mr. and Mrs. Steven MacGregor Read

SPONSORS
Frank and Patricia Carrubba
Mr. and Mrs. John P. Rohal

Generous support is also provided by the Lois E. Kalb 1986 Revocable Intervivos Trust and the estate of Hildegard Seidel, with additional support provided by Dr. N. L. Ascher, Mr. and Mrs. David H. S. Chung, Ransom and Nan Cook, Bill and Sonja Davidow, Juliet and André de Baubigny, Raj and Helen Desai, Mrs. George Hopper Fitch, Emma and Fred Goltz, Troy and Angelique Griepp, the Honorable and Mrs. Howard H. Leach, Mrs. James K. McWilliams, Greta R. Pofcher, Jeanne and Sanford Robertson, and Alan and Jennifer Varela.

Education programs presented in conjunction with this exhibition are generously underwritten by the William K. Bowes, Jr. Foundation and Douglas A. Tilden.

This exhibition is supported by an indemnity from the Federal Council on the Arts and the Humanities.

This exhibition is organized by the Fine Arts Museums of San Francisco with gratitude for the exceptional loan from the collection of the Musée d'Orsay.

Copyright © 2010 by the Fine Arts Museums of San Francisco. Layout and design © Prestel Verlag, Munich • Berlin • London • New York. All rights reserved. No part of this book may be reproduced or transmitted in any form or by any means, electronic or mechanical, including photocopy, recording, or any other information storage and retrieval system, or otherwise without written permission from the publisher.

Photography credits appear on p. 255.

Fine Arts Museums of San Francisco
Golden Gate Park
50 Hagiwara Tea Garden Drive
San Francisco, CA 94118–4502

Director of Publications: Ann Heath Karlstrom
Editor in Chief: Karen A. Levine

LIBRARY OF CONGRESS CATALOGING-IN-PUBLICATION DATA

Van Gogh, Gauguin, Cézanne, and beyond : post-impressionist masterpieces from the Musée d'Orsay / curated by Guy Cogeval, Sylvie Patry, and Stéphane Guégan.

p. cm.

Catalog of an exhibition held at the de Young Museum, San Francisco, Sept. 25, 2010–Jan 18, 2011.

Published also as a boxed set with: Birth of Impressionism : masterpieces from the Musée d'Orsay / curated by Guy Cogeval, Stéphane Guégan and Alice Thomine-Berrada.

Includes bibliographical references and index.

ISBN 978-3-7913-5046-2 (hardcover) — ISBN 978-3-7913-6299-1 (pbk.) — ISBN 978-3-7913-6296-0 (hardcover boxed set) 1. Post-impressionism (Art)—France—Exhibitions. 2. Painting, French—19th century—Exhibitions. 3. Painting—France—Paris—Exhibitions. 4. Musée d'Orsay—Exhibitions. I. Cogeval, Guy. II. Guégan, Stéphane. III. Patry, Sylvie. IV. Musée d'Orsay. V. M. H. de Young Memorial Museum. VI. Title: Post-impressionist masterpieces from the Musée d'Orsay.

ND547.5.P6V36 2010

759.409'03407479461—dc22

2010008214

The hardcover edition of this catalogue is published in association with Prestel, a member of Verlagsgruppe Random House GmbH.

Prestel Verlag
Königinstrasse 9
80539 Munich
Germany
Tel: 49 89 24 29 08 300
Fax: 49 89 24 29 08 335
www.prestel.de

Prestel Publishing Ltd.
4 Bloomsbury Place
London WC1A 2QA
United Kingdom
Tel: 44 20 7323 5004
Fax: 44 20 7636 8004

Prestel Publishing
900 Broadway, Suite 603
New York, NY 10003
Tel: 212 995 2720
Fax: 212 995 2733
E-mail: sales@prestel-usa.com
www.prestel.com

ISBN 978-3-7913-5046-2 (hardcover)
ISBN 978-3-7913-6299-1 (paperback)
ISBN 978-3-7913-6296-0 (hardcover boxed set)

Edited by Elisa Urbanelli
Designed by Bob Aufuldish, Aufuldish & Warinner
Typography by Bob Aufuldish and Michael Thompson
Translations by Alison Anderson and Melissa McMahon
Proofread by Dianne Woo
Index by Susan G. Burke
Printed in Singapore by CS Graphics Pte Ltd